FRENCH

EIGHTEENTH-CENTURY

PAINTING

FRENCH EIGHTEENTH-CENTURY PAINTING

DAVID
WAKEFIELD

GORDON FRASER

LONDON

First published 1984
The Gordon Fraser Gallery Ltd, London and Bedford
Copyright © David Wakefield 1984

BRITISH LIBRARY CATALOGUING IN PUBLICATION DATA
Wakefield, David
 French eighteenth century painting.
 1. Painting, French 2. Painting,
 Modern—17th/18th centuries—France
 I. Title
 759.4 ND546

 ISBN 0–86092–048–8

Text set by Keyspools Ltd, Golborne, Lancs
Monochrome origination by Morrison Scott Studios, Crawley, Sussex
printed by Fletcher and Son, Norwich
Colour origination by Adroit/Photo Ltd, Birmingham
printed by The Roundwood Press Ltd, Kineton, Warwick
Bound by Hunter & Foulis Ltd, Edinburgh
Designed by Peter Guy

Contents

Acknowledgements

My thanks are due first of all to the curators of many different museums – mostly in France – for their willing help in providing illustrations. Visiting their collections has made the groundwork for this book a pleasure rather than a duty. Several private collectors and dealers, especially the late David Carritt and MM. Cailleux in Paris, have been generous in opening their doors to me and answering queries, as has Alastair Laing of the Heim Gallery. Christopher Wright has given me invaluable help and advice with the compilation of the index of museums at the end of the book. I must also thank Simon Kingston of Gordon Fraser for his enthusiastic support of this project, and, most of all, Mrs Stuart Rose (aided by Catherine Diéval Dupouy in Paris) for her tireless efforts in tracking down photographs and illustrative material. Without her help, the book would never have seen the light of day. Picture sources are acknowledged in the captions.

The author and publishers are grateful to those who have allowed their works to be reproduced in the book. Figures 10, 22, 39, 45, 101, 102, 177 and Plate 10 are reproduced by permission of the Trustees, The Wallace Collection, London. Figures 26, 32 and 168 are reproduced by permission of the Trustees, The National Gallery, London. Other pictures are reproduced by kind permission of the sources indicated in the captions.

IN MEMORY OF MY MOTHER

Introduction

The art of France in the eighteenth century is still one of the most unjustly neglected periods in the entire history of art. Ignored by the general public, omitted from the academic syllabus, despised by the arbiters of fashion, the French eighteenth century seems irremediably tainted as a chocolate box art of powdered *marquises*, gallant abbés and frivolous eroticism. This may be true of a very limited aspect of the century, the Rococo style, but as an overall picture it is a gross distortion of the truth. Even at their most light-hearted, moreover, French artists of this period are nearly always rescued from banality by their superb verve and zest of handling. The basic misconception, it should be admitted, must be laid at the door of the leading and most talented protagonists of eighteenth-century art, the Goncourt brothers. For in their brilliant but highly selective *Art du dix-huitième siècle* (1854–75), which consists of a series of monographs on certain well-known – and some very minor – artists, but hardly provides a complete account of the period, they consciously set out to paint a picture of elegance and refinement inspired by their own nostalgia for the Ancien Régime. The eighteenth century became a haven for fastidious connoisseurship and the exclusive preserve of collectors. This was an unfortunate result which did an injustice not only to the art but also to the Goncourts themselves, whose pages are still as fresh and perceptive as any written since.

This approach has not found favour in contemporary eyes. As a result, the predictable reaction set in against the Goncourts' carefully contrived vignettes and, in so far as the art of this period is studied at all, this has usually been in the attempt to 'democratise' it. Leading artists like Watteau, Fragonard and Chardin, who still lack good modern monographs, have been relegated to second place, while Carle Vanloo, Natoire, Restout and many others have been rescued from the oblivion which settled on them soon after their deaths. Every year witnesses some new exhibition devoted to a hitherto forgotten name, artists known only to the assiduous visitor of French churches and provincial museums. History painting, in particular, represented by artists such as Brenet, Doyen and the pupils of the Ecole de Rome – ignored by the Goncourts – has become a favourite hunting-ground for scholars and historians. No one would deny that exploration of this kind is a useful and necessary exercise for the understanding of a historical period and of the curious vicissitudes of taste which made a Vanloo seem the greatest painter of his age to his own contemporaries. But in all this excitement for 're-appraisal' there is as much danger of misrepresentation as in the old-fashioned nineteenth-century view. That at least retained a firm sense of artistic values, whereas modern historians are so chary of any kind of critical stance that a sense of quality is either bypassed or dismissed as irrelevant. This leads to another kind of distortion: for historical convenience mediocre artists are given undue prominence, while great

ones, like Fragonard, are neglected because they fail to fit into the new scheme.

The time has come to take another look at the complex and often supremely beautiful painting of this century, but with as few preconceptions as possible. History, criticism and social factors must have a part to play in our attempt to understand the art of this period – or indeed of any other – but they should not be allowed to stand in the way of our enjoyment. The opinions of Diderot and other critics are quoted partly for the light they throw on the times, partly for their intrinsic merit; they must be accepted for what they are worth, which is usually a mixture of great perception and wrong-headed nonsense. The artist in eighteenth-century France was concerned above all to give pleasure, and this is the best vantage-point from which we can approach it today. The notion of *bon goût*, or the perception of beauty, was then accepted as a self-evident virtue in every educated spectator (the *honnête homme*, in eighteenth-century language), a notion which also implied the free expression of critical judgement. We must be prepared, therefore, to exercise the same faculties in the appreciation of this art, which calls for a hedonistic but discriminating sense of pleasure.

The eighteenth century was both sensual and idealistic at the same time. Its writers and critics believed that the pleasure given by works of art was a worthwhile pursuit, both for its own sake and as the means to moral and spiritual greatness. The overt cynicism of *Les Liaisons Dangereuses* has to be set against the spiritual fervour of *La Nouvelle Héloise*; Fragonard and David, at opposite aesthetic poles, are separated by little more than a decade and their careers partly overlap. Such obvious contrasts were legion throughout the eighteenth century, when contradictory styles were allowed to coalesce. There was no successful attempt by authority to impose an artificial unity on the arts, social life and thought, as there had been in France under Louis XIV. Freedom and variety are the main characteristics of French eighteenth-century art. Hence the multiplicity of talent, when scores of minor artists were free to pursue their own speciality, landscapes, seascapes, *fêtes galantes*, erotic scenes, mythology or history, or whatever they hoped would satisfy a client and earn them a living. In such a century there may be few artists of outstanding genius, with the exceptions of Watteau, Chardin and Fragonard. But there are many supremely good ones who deserve to be much better known, and still more who only produced a single masterpiece. These lesser-known artists, more perhaps than the most familiar names, evoke the tranquil, unspectacular side of eighteenth-century life, when intelligence, charm and innate good taste were the most prized qualities. If this book helps to show the century in a more sympathetic light and to reveal neglected talent, its purpose will have been achieved.

1 : The Opening of the Century

The art of France in the eighteenth century does not mark a radical break with previous tradition. Unlike the periods of the Renaissance or the Revolution, which produced an entirely new artistic impetus, French painting between 1700 and 1785 is remarkably consistent in character and shows only relatively minor stylistic changes throughout the century. It was a period of gradual refinement of technical virtuosity which produced no dramatic transformations of the order of those seen after the outbreak of the Revolution and the advent of Napoleon. Artists were usually content to execute variations on a theme and to elaborate on their predecessors. With the exceptions of Watteau, Chardin and Fragonard, there were few artists of outstanding originality, though many extremely gifted ones. It was also a period in which established practice was, on the whole, not seriously questioned; innovation was usually tentative, unselfconscious and not, until the years immediately before the Revolution, dominated by ideological motives. The achievements of French art under Louis XIV, Colbert and Lebrun, though temporarily eclipsed at the height of the Rococo fashion, were never entirely forgotten and continued to provide the standard against which eighteenth-century painters measured their abilities. Indeed, the nostalgia for the Grand Siècle runs like a persistent undercurrent throughout the eighteenth century. In literature Voltaire's tragedies closely echo the classical dramas of Corneille and Racine, just as painters from Lemoine to David were constantly haunted by the examples of Poussin, Le Sueur and Lebrun, whose names rapidly come to symbolize the glory of the French national past and the supremacy of the classical tradition, embodied in the doctrines of the Academy.

This continuity of the seventeenth-century tradition throughout the following century is a fact which has not escaped the attention of more recent historians. This is not to say that art remained unchanged, but that the change which painting underwent in the first decade of the eighteenth century was almost imperceptible. On the death of Lebrun in 1690, when the post of *Premier Peintre* was taken up by his much feebler successor, Mignard, the grand style history painting of Versailles lost much of its authority and prestige. At first there was no more than a slight variation of mood and atmosphere, a preference for light rather than heavy, sombre colour schemes and, above all, a reduction in scale. In response to the new demand from private patrons, art became decorative, light-hearted and intimate. As the social centre of gravity

moved away from Versailles to Paris during the last years of Louis XIV's reign, painters were no longer required to fill the interminable galleries of the royal palace with heroic battle scenes from the lives of Alexander and Constantine the Great, as Lebrun had done with such indefatigable energy. Instead, they were in demand by such connoisseurs as Jean de Julienne and patrons like Pierre Crozat and Samuel Bernard, the new financiers of the age, to decorate their recently constructed Parisian *hôtels*, in which the keynote was lightness and gaiety. Even the elderly Louis XIV, who had always favoured the grand historical manner of Lebrun, seems to have caught the new mood when he expressed his view that Mansart's proposed decorations for a new suite of rooms for the Duchesse de Bourgogne in the Château de la Ménagerie were too ponderous. In a typical edict he decreed that henceforward: '*Il faut qu'il y ait de la jeunesse mêlée dans ce que l'on fera.*'[1] These words might be read as an open invitation for such artists as Claude Audran, Gillot, Watteau and Oppenord to practise freely their fanciful, ornamental art which was soon to emerge as the Rococo style. This phase of taste began to dominate Parisian art and architecture around 1720 and will be discussed in the following chapter.

In the meantime, the serious historical manner of the Grand Siècle continued to survive into the new century in a number of guises, primarily in religious painting, which remained the principal refuge of the grand style throughout the eighteenth century. In order to understand the complex origins of French art in the eighteenth century we must reach well back into the reign of Louis XIV. This age, apparently unified, had in fact been a time of violent religious strife. The revocation of the Edict of Nantes in 1685, the unceasing polemics between Jesuits and Jansenists culminating in the closure of Port Royal in 1709, the suppression of Quietism and the persecution of Madame Guyon, were so many proofs that the uniformity of belief desired by Louis XIV could only be achieved by brutal enforcement of royal authority: schismatism of any kind was regarded as a threat to the State. This state of affairs did not, as it may be supposed, lead to any lessening of religious fervour in the first decades of the eighteenth century. Nothing could be further from the truth than the conventional view of the eighteenth century as an age of universal doubt and scepticism. The majority of people, including artists, remained profoundly devout and were untouched by the anti-religious sentiments of Voltaire and the Encyclopaedists. We have only to think of

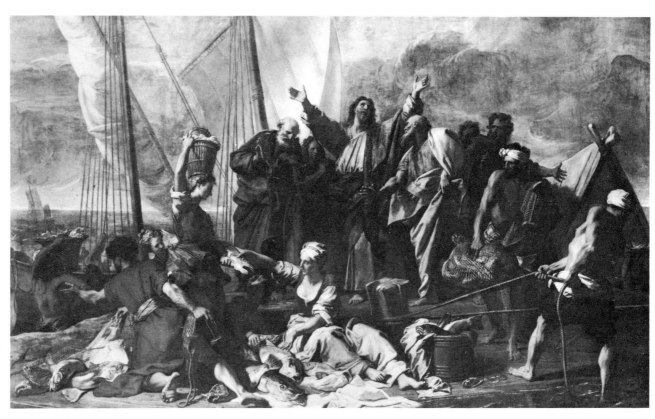

Watteau's deep sense of remorse on his death bed, having his studies of nudes destroyed and painting a *Crucifixion*; of Jean Baptiste Santerre, ashamed of the paganism which earned him notoriety; or of N.-B. Lépicié's final repentance on his premature death from consumption in 1784. The intensity of such religious crises is sufficient proof that the old faith was far from dead, and that the doctrines of the Church were still taken literally. Paintings like Subleyras' *Crucifixion* (1744, Milan, Brera), Jouvenet's *St Bruno* (Lyon) and Restout's pair *The Ecstasy of St Benedict* and *The Death of St Scholastica* (1730), bear witness to a fervent piety, bordering on the fanatical, which could not have been produced by an incredulous generation. They are equivalent in intensity of emotion to the works of the Italian Counter-Reformation.

In the first years of the eighteenth century, when the State role in patronage began to decline, the Church continued to commission paintings on a large scale and provided the mainstay for artists like Jouvenet, Charles de la Fosse and L. de Boullogne. Although badly paid, artists were grateful for the opportunity to display their works in churches at a time when regular public exhibitions did not exist. In his recent study of Jouvenet, the leading religious painter of the late seventeenth century, Monsieur Schnapper[2] has shown that other factors contributing to the revival of religious art at this time were the proliferation of seminaries like the Oratoire and St Sulpice; the improvement in the intellectual level of the clergy due to the growth of monastic libraries; and finally, and most importantly, the wealth of the Church, which enabled it to redecorate its buildings and adorn new ones on a lavish scale. These were the prime reasons behind the many important Church commissions executed by Jouvenet during the last years of the seventeenth century and the first decade of the eighteenth: the decoration of St Cyr and the church of Notre-Dame-de-Versailles in 1687, the *Christ curing the Sick* (Louvre), painted in 1689 for the choir of the Eglise des Chartreux in Paris, and finally, the climax of his career, the series of four enormous paintings, *The Miraculous Draught of Fishes*, *The Resurrection of Lazarus*, *Christ Expelling the Traders from the Temple* and *Christ in the House of Simon*, all painted for St-Martin-des-Champs and installed in 1706. Jean Jouvenet, born in Rouen in 1644, started his career in Paris under Lebrun, working at Versailles from 1671 to 1672 and later on the Trianon at Versailles and the decoration of the Chapelle des Invalides. His development is fairly typical of the last generation of Lebrun's pupils, who felt both indebted to their master's example and yet rejected his authoritarian role in favour of new models of inspiration. The years from 1690 (the year in which Lebrun died) to 1715 mark a period of somewhat confused eclecticism, in which artists turned to many different and mutually contradictory sources, including classical antiquity, Raphael, the Bolognese artists, Poussin, Rubens, Van Dyck and Venice. These multiple strands alternate in the different painters of this period. The result is usually a slightly freer and less rigid variant on the classicism of Poussin and Lebrun, but with some artists, Charles de la Fosse and Antoine Coypel notably, showing a strong

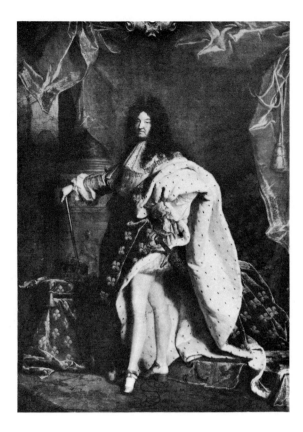

precursor, Van Dyck. They are the supreme public images of an age which firmly believed in the need for outward display of order and hierarchy, when the twin institutions of Monarchy and Church were secure in the divine origins of their authority. The leading Christian apologist of the time, Pascal, though a Jansenist, fully supported this view when he wrote in a *Pensée* that magistrates and prelates need their splendid external trappings in order to reinforce popular belief in their wisdom: '*Tout cet appareil auguste était fort nécessaire.*'[3] It was only later in the second half of the eighteenth century, when Voltaire and the Encyclopaedists had undermined the authoritarian principle, that the '*portrait d'apparat*' appeared definitely old-fashioned and finally yielded favour to the more intimate and personal portraits of La Tour and Perronneau.

Hyacinthe Rigaud was born in Perpignan in 1659 and studied painting in Montpellier under two obscure artists, Paul Pezet and Antoine Ranc. After a short period in Lyon in 1681, he moved to Paris, where he rapidly made a reputation for himself as a painter of the court and aristocracy. His first important commissions came in 1688 to paint the portraits of the King's brother and in 1689 that of his son, the duc de Chartres. Henceforward Rigaud—unlike his contemporary Largillierre, who retained many connections with the bourgeoisie—recruited his clientèle almost exclusively from the aristocracy and prominent courtiers at Versailles. The formal elegance and restrained grandeur of his art made him the ideal painter of the end of Louis XIV's reign. The portrait of *Bossuet* (Louvre), for example [Plate 1], in his flowing episcopal ermine and red robes, retains a kind of awesome majesty which no worldly eighteenth-century prelate could ever rival. These portraits seem to capture the last minutes of a social order and hierarchy which was rapidly to come under heavy attack on all sides. Rigaud's most illustrious sitter was the King himself. In the full-length portrait in the Louvre, *Louis XIV* (1701) and its variant at Chantilly, the King appears in complete regal attire, with sword and ermine cloak, proud, contemptuous and supremely confident of his own dignity. He steps forward towards the spectator in a movement of slight *contrapposto*, the portrait marking a synthesis between Van Dyck's Flemish naturalism and the rather archaic rigidity derived from Philippe de Champaigne.[4] Although Rigaud's reputation came to be associated with this type of grand official portraiture, he was also capable of painting in a more homely vein, as can be seen from works like the sensitive double portrait of *The Artist's Mother* (1695) in the Louvre and the portrait of *Fontenelle* (1713) in Montpellier. Both these paintings look significantly to Rembrandt for inspiration and the latter especially, in its mood of casual, domestic intimacy, marks the beginning of a specifically eighteenth-century type of portraiture.

2. Rigaud,
Louis XIV,
277 × 194 cm.
Musée du Louvre.
Photo: Musées nationaux, Paris

Plate 1 faces page 16

bias towards Venetian colour, while others like Rigaud and Largillierre retain an unmistakable affinity with the Flemish naturalism of Van Dyck. In the case of Jouvenet, in his mature phase of *The Miraculous Draught of Fishes*, the impulse is towards a vigorous but restrained form of the Baroque, with a distinct trace of Lebrun's emphasis on clearly articulated forms, gestures and expressions, and a powerful naturalism of detail which would have been inconceivable at the height of French classicism.

A similar continuity and respect for tradition can be seen in the portraiture of the late seventeenth and early eighteenth centuries. Hyacinthe Rigaud (1659–1743) and Nicolas de Largillierre (1656–1746) were the main creators of the official portrait, the '*portrait d'apparat*', designed to glorify noblemen, *grands bourgeois*, functionaries, magistrates and professional men, which remained the norm until about 1750. The chief accent in this type of portraiture was on pomp and splendour, on the sitter's official position manifested in his majestic robes, the flowing curls of his wig and professional attributes such as swords and official decorations, all fully exposed to public view and framed against a background of columns and draperies. There was correspondingly very little attempt to convey the psychological make-up of the sitter or his individual temperament. Such masterpieces as Rigaud's portraits of Louis XIV (1701), Bossuet in his bishop's robes, and *The First Earl of Portland* (1698–9) (Welbeck Abbey) in military uniform are typical and highly accomplished examples of this genre and superbly professional pieces of painting quite on a par with their

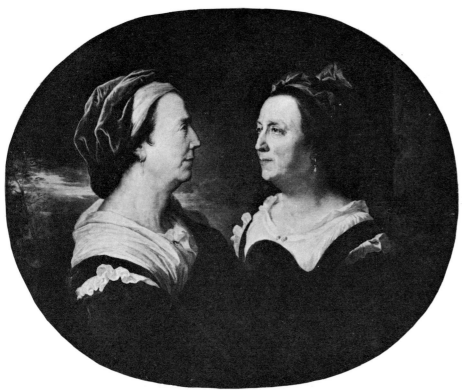

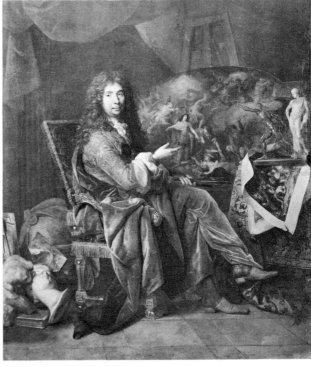

The background and career of Nicolas de Largillierre were slightly different. Born in Paris in 1656 into a prosperous family of hat makers, Largillierre moved when still a boy to Antwerp where he entered the studio of Antoine Goubaud; in 1672 he was received as a master in the Antwerp Guild. Deeply impressed by the works of Rubens and Van Dyck he saw in Antwerp, he was always later to view his native French tradition through Flemish eyes. This early training gave his work a direct- ness and breadth of handling which contrasts strongly with the artificial quality of many late seventeenth-century portraits, by Mignard, for example. It was probably this homely streak which made Largillierre so popular with the *grands bourgeois* of Paris who were his main clients. At the same time, he went to London in 1674 to seek his fortune in the footsteps of Van Dyck. There he entered the studio of Sir Peter Lely, the most fashionable artist of the time, and soon became familiar with the aristocratic society whose members flocked to have their portraits painted by his master. Largillierre was quick to realize the financial rewards of portrait painting and on his return to Paris in 1682 he established contact with the colony of Flemish artists who had settled there, including Philippe de Champaigne, Pourbus and Van der Meulen.

Largillierre's first major work was the portrait of *Lebrun* (1686) which he presented as his '*morceau de réception*' to the Academy. It shows the artist in his official position as the King's First Painter, a dignified figure conscious of his own authority, but in no way pompous or affected; on the easel in front of him is a sketch of his own picture of *Louis XIV Conquering the Franche Comté*, on the table another of the *Family of Darius at the Feet of Alexander*, on top of

which are statuettes of *Antinous* and *The Gladiator*. This is a portrait by a professional artist of another professional, surrounded by his own achievements and the classical Greek models which symbolized the foundation of his official doctrine. Despite this profession of personal loyalty, however, Largillierre remained loyal to his early Flemish training. In the series of group portraits of the *échevins*, or city elders, of Paris, which were to become his speciality, Largillierre was consciously looking back to Philippe de Champaigne, whose memorable groups of city dignitaries, grave, restrained and ranged in serried ranks in front of an ex-voto, provided the obvious proto- type for his art. The first of Largillierre's commissions by the *échevins* of Paris came in 1687 to celebrate the banquet of reconciliation at the Hôtel de Ville offered by the city to Louis XIV, on the occasion of his official pardon granted to the citizens of Paris for their part in the Fronde. The painting has not survived, but preliminary sketches are preserved at Amiens and the Hermitage which give some idea of the overall composition; the city fathers are seated in front of a table, facing the spectator, while a symbolic bust of a Roman emperor provides the focal point of attention. The only major surviving example by Largil- lierre of this type of group portrait, *The Echevins of the City of Paris Kneeling before St Genevieve* (1696), follows the same basic pattern. The *échevins*, some in full frontal positions, others half turned to face the spectator, are ranged in the foreground in an act of thanksgiving to the patron saint of Paris for saving the city from drought; the upper half of the picture is occupied by St Genevieve in prayer and her surrounding host of angels. This twin-tier arrangement closely follows the example set by Cham-

5. Largillierre,
*The Echevins of the City
of Paris Kneeling
before St Genevieve,*
500 × 350 cm.
Musée Carnavalet.
Photo: Giraudon

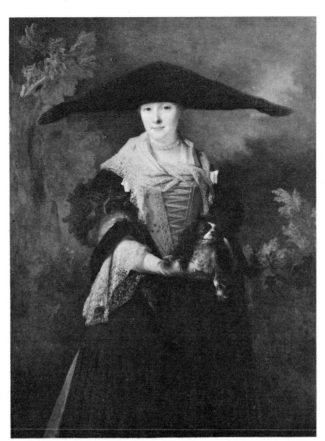

wife's dress and the autumnal tinge of the trees. As a portrayal of people enjoying their leisure in an outdoor setting, this is a key picture of the early eighteenth century.

Most social, political and artistic factors in the first decade of the eighteenth century tended, therefore, to reinforce the immobility of the status quo. Until a complete outsider, Watteau, arrived on the scene in 1702 there were no artists in Paris with a sufficiently strong or decisive originality to bring about any profound transformation in French art. The result is a generation of painters with divided loyalties, hovering between the strict academic tradition of Lebrun and the new tendency towards decorative painting lightened by Venetian colour. Another highly talented artist caught between two centuries who never quite fulfilled the expectations he raised was Antoine Coypel (1661–1722), the son of Noël Coypel and member of a distinguished family of painters. Although described by Dimier as 'the first of the twenty-third-century painters',[5] the start of Coypel's career followed orthodox seventeenth-century lines. Showing a precocious talent for painting, he followed his father to Rome in 1672 and at the age of twelve was granted a place by Colbert as pensioner at the Académié de France. After three years in Rome spent following the teachings of Bernini, Coypel travelled to Parma, where he fell in love with and copied Correggio's *Assumption of the Virgin*, and finally to Venice in order to study Titian and Veronese. On his return to Paris in 1676 he was soon charged with important commissions, including frescoes executed for La Grande Mademoiselle to decorate her pavilion (now destroyed) at Choisy. According to his biographer, Charles Coypel,[6] Antoine became the favourite of princes and princesses; he enjoyed personal good fortune and social success in equal measure. He was also, it seems, on terms of acquaintance with leading poets and dramatists of the day, Boileau, La Fontaine and Racine, and it is no accident that many of his paintings have literary subjects. Roger de Piles, the most influential art critic of the late seventeenth century, was another close friend, even though Coypel does not seem to have followed the critic in his whole-hearted enthusiasm for colour at the expense of design. As one would expect of an artist of his training and background, Coypel sought rather after synthesis and reconciliation of extremes.

The most significant event in French art of the early eighteenth century occurred in 1702, when Coypel's most influential patron, the duc de Chartres (later to become the Regent duc d'Orléans), began to remodel the main gallery in the Palais Royal, which the artist was commissioned to decorate with scenes from the *Life of Aeneas*.[7] This ambitious decorative ensemble was destroyed when the gallery was altered later in the eighteenth century, and can only be judged today by engravings, a series of preliminary drawings in the Louvre, and a few remaining

paigne in his numerous ex-voto paintings, but there is a subtle difference of atmosphere, a greater airiness, freedom and suggestion of space which already points to the eighteenth century.

Though these official group portraits provided the foundation of Largillierre's fame and reputation, he also painted numerous individual portraits of magistrates (the *Président de Laage*, in the Louvre), civil servants, artists (*Jean Forest*, his father-in-law, in Berlin), actors and actresses (*Madamoiselle Duclos dans le rôle d'Ariane*, Chantilly, Musée Condé), and writers (*Voltaire* aged twenty-four, in the Musée Carnavalet in Paris). All show a freedom of handling and rich, mellow colours far beyond the range permitted by the strict academic training of the time, and which were only made possible by Largillierre's early assimilation of the Flemish school and Van Dyck. One of the finest and most familiar of this type is the so-called *La belle Strasbourgeoise* (1704), the wife of a Strasbourg patrician, splendidly but not ostentatiously dressed in black with a white lace shawl, looking at the spectator with her fine intelligent eyes. But Largillierre's greatest painting is perhaps the portrait of *The Artist, his Wife and Daughter* (1710–12) in the Louvre [Plate 3], showing the artist in the casual posture of a country gentleman out for a day's shooting while his wife and daughter sing to amuse him. It is as if the artist has been caught off his guard, without any of the stiff formality of the group portraits, free to indulge his love of rich colours in the deep satin of his

Plate 3 faces page 32

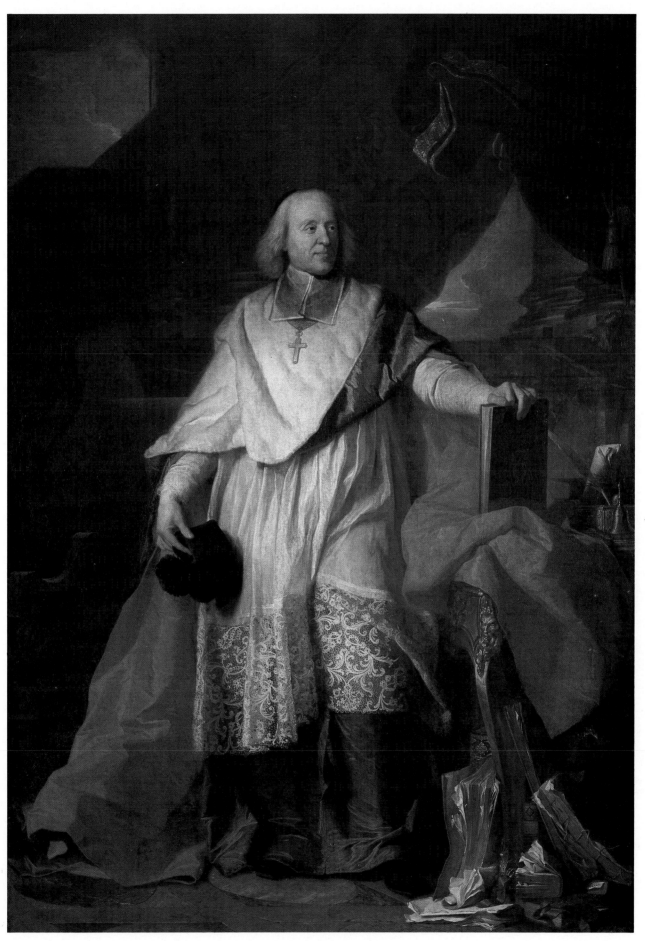

PLATE I. Rigaud, *Bossuet*,

240 × 165 cm. Musée du Louvre. Photo: Giraudon

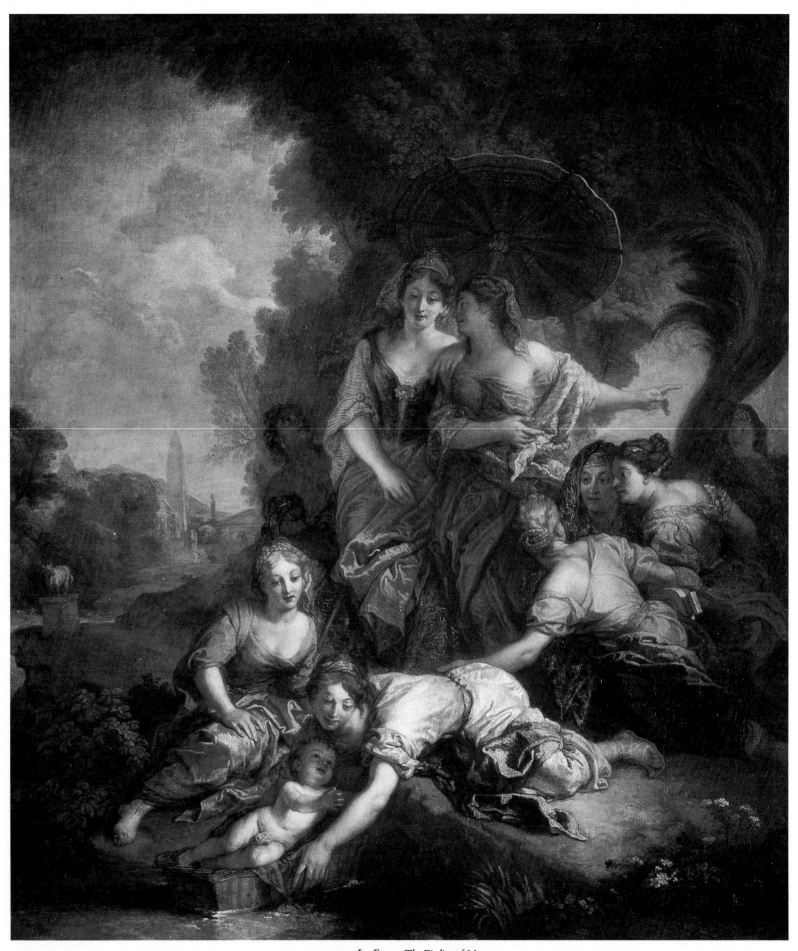

PLATE 2. La Fosse, *The Finding of Moses*,
125 × 110 cm. Musée du Louvre. Photo: Musées Nationaux, Paris

panels dispersed in the museums of Nantes, Angers and Montpellier like, for example, *Aeneas rescuing his Father from the Fire at Troy* and *The Death of Dido*. The scheme as a whole consisted of a series of central vaulted compartments illustrating Virgil's narrative – of which the climax was Olympus flanked by panels on the side walls decorated by trompe-l'oeil architecture, caryatids, terms, slave figures, flowers, garlands and ornament of all kinds. It would seem that although Roger de Piles collaborated on this project, there was nothing specifically 'modern', Rubensian or Venetian about it, rather that Coypel was looking back to the great Roman Baroque palaces for inspiration. The presence of such Baroque features in *Aeneas rescuing his Father* as the framework of vaulted architecture seen in perspective, the exaggerated *contrapposto* of the figures and a highly theatrical treatment of the episode, were all in sharp distinction to the restrained, somewhat anaemic classicism practised by Lebrun and his followers.

The Baroque tendency is equally marked in Coypel's only major decorative work to survive: the ceiling painted for the chapel of Versailles in 1708. This work revolves round the central composition of God the Father promising the Messiah to the World. In true Baroque fashion, God is represented as a venerable figure surrounded by the sun's rays, while groups of angels hover in the sky or perch vertiginously on cornices; the whole composition is designed to create the illusion of heaven literally bursting into the terrestrial realm.

The illusion may have been rather too strong for the taste of Louis XIV, who disliked trompe-l'oeil effects in art, and he initially criticized Coypel's figures for seeming too large when viewed from the gallery. The King only changed his mind when it was pointed out to him that the ceiling was designed to be seen from the ground and he was forced to acknowledge the painter's success. Moreover, the Versailles ceiling failed to satisfy Roger de Piles, who no doubt regarded Coypel's frank admiration for Roman Baroque prototypes in preference to Rubens and the Venetian models he himself had advocated as a step in the wrong direction.

Coypel has unfortunately fared no better at the hands of modern writers, who see in many of his paintings the dangers in his fatal fascination with literature and the theatre. The painter had a strong literary bent, which attracted him instinctively to subjects with a dramatic content and he borrowed an entire repertory of gestures and expressions from the theatre. As well as his *Life of Aeneas* from Virgil in the Palais Royal and a series of illustrations designed for *Don Quixote*, he showed a preference for subjects from ancient history like the *Farewell of Hector and Andromache* (Musée de Tours); others from the Old Testament, including the stories of *Esther before Ahasuerus* (Salon of 1704, Louvre), *Elijah and Rebecca*

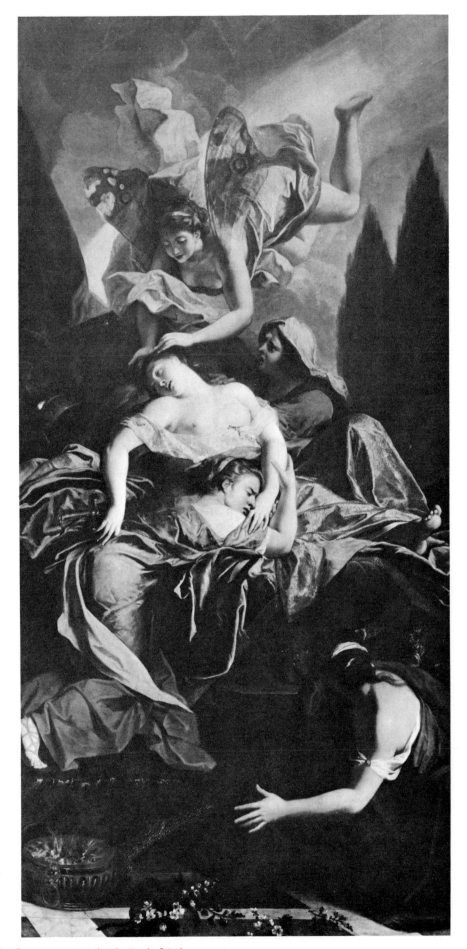

[17] 7. Coypel, *The Death of Dido*, 387 × 190 cm. Musée Faber, Montpellier. Photo: Claude O'Sughrue

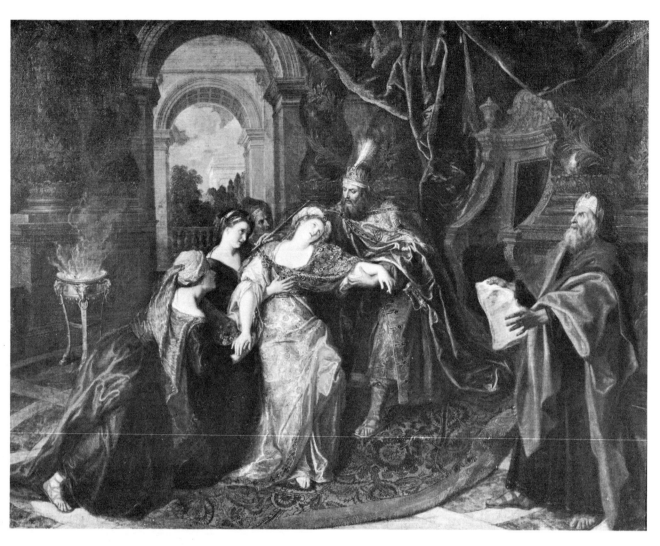

8. Coypel,
Esther before Ahasuerus
(detail),
105 × 137 cm.
Musée du Louvre.
Photo: Giraudon

(Louvre), *The Daughter of Jephthe* (Dijon) and an *Athalie driven out of the Temple* (Salon of 1699, Louvre). This last picture of *Athalie*, inspired by Racine's drama, summarizes the qualities and defects of all this group of works. Marred by self-consciously theatrical gestures and simpering, affected expressions, they only show how far off the mark Coypel was in his attempt to rival the great classical dramatist on his own ground. But the attempt was significant; henceforward, and especially during the reformist movement of the late eighteenth century, no artist could afford to remain illiterate and to ignore the writing of his own time. Theatre and literature were to exert a constant influence on French eighteenth-century art.

In his adherence to the monumental tradition of grand formal design, Coypel remains a somewhat *retardataire* figure, but the same cannot be said of the slightly older Charles de la Fosse. The difference between them may be partly due to the intervention of the influential Roger de Piles,[8] who played a leading role in the so-called debate on colour and on the respective merits of Poussin versus Rubens. This debate was, in effect, only a variant on the famous Quarrel of the Ancients and Moderns which divided the literary world in late seventeenth-century

France.[9] The key to the issue was whether the authors of classical antiquity had been, or could be, surpassed by modern writers. In the teeth of such staunch defenders of Homer as the learned Madame Dacier, translator of the *Iliad* (1699) and author of a violent diatribe against modern taste, *Des causes de la corruption du goût* (1714), writers like Houdar de la Mothe and Fénelon adopted a more conciliatory attitude, while the boldest of all, Claude Perrault, came out frankly in favour of the superiority of the Moderns in his *Parallèles des Anciens et des Modernes* (1688–92). Basing his argument on the notion of historical progress, Perrault believed that contemporary writers and artists held the advantage over their predecessors in terms of greater knowledge and technical skill. Hence his assertion: '*La peinture en elle-même est aujourd'hui plus accomplie que dans le siècle de Raphael, parce que, du côté du clair-obscur, de la dégradation des lumières et des diverses bienséances de la composition, on est plus instruit et plus délicat qu'on ne l'a jamais été.*'[10] Perrault was perhaps the first writer to dare to state that Raphael, though a great painter, was not above criticism and had in some respects been surpassed by Lebrun and Poussin. The point which concerns us here is not whether Perrault was right, but that in rejecting

the authority of classical precedent—for Raphael was regarded as the natural successor to Phidias and the Greeks—he was making a plea for the right of his contemporaries to develop their own style suited to their own times. The debate was closed on a slightly more conciliatory note by Fénelon's *Lettre à l'Académie* (1714). Though a great humanist and a fervent admirer of Homer and Virgil, Fénelon was responsive to the beauties of Corneille, Racine and La Fontaine, as well as the painters of his own day, Mignard, Rigaud and de Troy. The qualities he sought in art were simplicity, charm and 'le naturel', a kind of urbane and refined eclecticism which avoids all excess. In the fifth letter, Fénelon expressed his personal taste in words which might serve as a by-word for the eighteenth-century amateur: '*Ce n'est ni le difficile, ni le rare, ni le merveilleux que je cherche; c'est le beau simple, aimable, et commode que je goûte.*'[11]

The frequent use of pictorial comparisons in this debate shows how readily this primarily literary polemic could be extended to the visual arts. This is precisely what Roger de Piles did in a series of treatises, notably the *Dialogue sur le Coloris* (1673) and the *Conversations sur la Peinture* (1677), all of which called into question the official doctrines of the Academy and its rigid adherence to classical principles. This dispute became known as the Quarrel of Colour versus Drawing. As with the Quarrel of the Ancients and Moderns, the aim of 'modern' critics like de Piles was to show the absurdity of blindly worshipping the classics. Their principal attack was directed against academic teaching—derived partly from Renaissance theorists, partly from Poussin's precepts as codified by Félibien and Lebrun in the 1660s—which firmly maintained the superiority of line and draftsmanship over colour. Drawing, it was felt, was an intellectual exercise for the artist and appealed to the rational intelligence of the spectator, whereas colour merely appealed to the senses via the eye. In Lebrun's words, colour was only 'an accident produced by light which changes at every moment'. Colour, therefore, to the orthodox seventeenth-century theorist became synonymous with the unknown, the irrational, with dangerously fleeting emotions and the snares of the imagination which Pascal denounced as one of the '*puissances trompeuses*'. It was not, as it is commonly thought, that the seventeenth century disregarded the emotions, but that it was all too well aware of their power and feared their destructive force. The art of painting, therefore, in the view of the Academy, ought to be founded on reason, stability and permanence, or in the words of one of its official statements: '*Qui s'attache au principal et au solide de la peinture* [i.e. drawing], *acquiert toujours, en pratiquant, une assez belle méthode de peindre, sans qu'il soit nécessaire de s'entêter dans cette partie seule* [colour].'[12] It is obvious that a rigid adherence to this doctrine led to archaeological pedantry, an obsessive con-

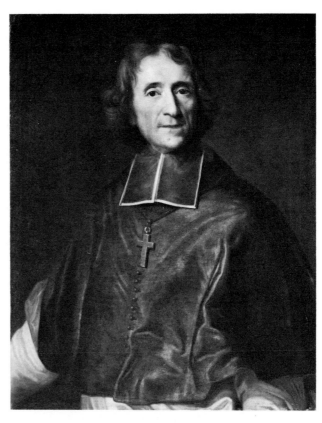

9. Vivien,
Fénelon,
81 × 64 cm.
Neue Pinakothek,
Munich

cern with anatomy and routine working habits at the expense of spontaneity, freedom and natural observation.

These dangers inherent in such an authoritarian system of the arts were explicitly stated by Roger de Piles in all his writings. His tone is never harsh or militant, and he was careful not to show any disrespect for Poussin, Lebrun and the Academy. Cast in the form of dialogues and discussions, his pamphlets were an open invitation to debate, addressed to a small intelligent readership of connoisseurs and men of taste, or the '*honnête homme*', as he was then known. '*Le peintre doit persuader les yeux comme un homme éloquent doit toucher le coeur.*'[13] He subtly understood that the best way to combat authoritarian doctrine was not by adopting an equally doctrinaire position, but by allowing people to air their views freely. Roger de Piles stood first of all for the right of an amateur to exercise independent critical judgment founded on broad eclectic taste: '*J'aime la diversité des Ecoles célèbres; j'aime Raphael, j'aime le Titien, et j'aime Rubens; je fais tout mon possible pour pénétrer les rares qualités de ces grands maîtres; mais, quelques perfections qu'ils aient, j'aime encore mieux la vérité*'.[14] He believed that Venetian art, hitherto despised, should play a much greater part in an artist's training and he advised young painters at the French Academy in Rome to spend more time in Venice 'to acquire a proper understanding of colour'. Of this trio of painters, however, there is no doubt that his greatest admiration was for Rubens, and in the *Seconde Conversation* he devotes a lengthy panegyric to the painter. Already in the 1670s he was advising his friend the duc de Richelieu to buy Rubens for his new collec-

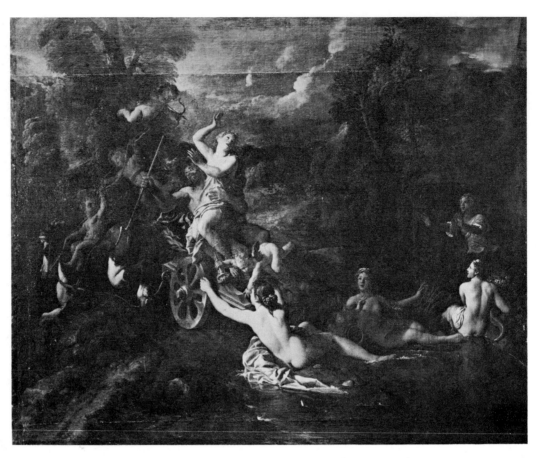

10. La Fosse,
The Rape of Proserpine
(detail),
145 × 180 cm.
Ecole des Beaux Arts, Paris.
Photo: Giraudon

tion. From then onwards and throughout the first half of the eighteenth century, Rubens' art exercises an increasing influence on French painting, at the expense of Poussin, whose insistence on classical modelling and form went temporarily out of fashion. It was only with the advent of Neo-Classicism after 1750 that Poussin's example, only partially eclipsed by Rubens, was revived and again revered as fervently as in the seventeenth century.

For de Piles and his contemporaries, Rubens signified colour, movement and freedom in place of the rigid academic system. His art seemed like a breath of new life, a form of liberation from the vexatious pedantry of official doctrine. In the *Marie de' Medici* cycle, then in the Luxembourg Palace, Rubens revealed a power of composition, an ingenuity in his treatment of political allegory and a vivid naturalism which made Lebrun's battle scenes and frescoes glorifying Louis XIV look like so much hack work executed by the square yard. Moreover, Rubens could show French artists that the distinction between colour and drawing was artificial, for he had already achieved the supreme synthesis of body and form, in which the two functions, separated by academic doctrine, were reunited. Rubens literally painted line with the brush full of colour, and thus created the best of both worlds, the classical Italianate world of volume and form and the northern Flemish world of colour and shadow. This was to be the ideal which haunted the first generation of painters of the eighteenth century, Largillierre, Rigaud,

Coypel, Charles de la Fosse, de Troy, all of whom were directly or indirectly affected by de Piles's writings.

Among the painters of this generation, Charles de la Fosse (1636–1716) was the most deeply marked by de Piles's ideas. La Fosse started life by studying under the engraver François Chauveau, a minor pupil of Lebrun, then from 1658 to 1663 travelled in Italy. In Rome, he met Poussin and a group of his followers and was deeply impressed both by Pietro da Cortona and the Bolognese school. He was in Venice from 1660 to 1663 and though it is not known whom he met or exactly what he saw there, he must have been deeply impressed by its painters, especially Tintoretto and Titian. His early works painted on his return to Paris in 1663, like *The Rape of Proserpine* (1673, Paris, Ecole des Beaux-Arts), bear witness to his fairly orthodox training and give little indication of the remarkably original artist he was to become. In *The Rape of Proserpine*, with its rather elongated artificial nudes, the Bolognese influence is still paramount, a compound of Domenichino and Albano, with only a hint of Venice in the trees and the sky. During the 1670s La Fosse continued to work under Lebrun at Versailles, on the Escalier des Ambassadeurs, in the Salon de Diane (for which he painted the *Sacrifice of Iphigenia*) and in the Salon d'Apollon, with its central panel showing the appearance of Apollo and corner scenes of the *Four Parts of the World*.

In the meantime, probably around 1675, he had become a close friend of Roger de Piles, and his art was

visibly influenced by the critic. In the *Dissertation* of 1681, dedicated to the duc de Richelieu, de Piles came out even more strongly than before in favour of Rubens, to the point of stating categorically that Italy had not produced a single artist who combined so many qualities at the same time. It is no coincidence that henceforward the Italianate (or at least classical and Bolognese) influence gives way to Rubens and the Venetians in La Fosse's art. The triumph

Plate 2
faces page 17

of Venetian colour is most fully manifest in the beautiful *Finding of Moses* (1675–80) in the Louvre [Plate 2]. The outlines are soft and fluent and have none of the harsh linearity of the *Rape of Proserpine*. The figures are fully but more delicately modelled, and recede naturally into the picture plane, while the landscape on the left, with its winding river and church spire, strikes an unusually fresh note in the French art of this period. His reputation firmly established around 1680, La Fosse began to emerge clear/ ly as the leading artist among the younger generation who succeeded Lebrun. Henceforward he was besieged with commissions from the Monarchy and the most prominent members of the court and Church. Following his work on the Escalier des Ambassadeurs and with the backing of the new Architecte du Roi, Jules Hardouin/Mansart, La Fosse painted two panels for the Grand Trianon, *Apollo and Thetis* and *Clytia Changed into a Sunflower* (1688), a poetic rendering of Ovid's story of the nymph who is abandoned by Apollo and metamorphosed into a flower permanently turned towards the vanishing sun. The artist's other main patrons of this period were Louis XIV's cousin, Mademoiselle de Montpensier, who built the Château de Choisy, Elisabeth de Guise, the marquise de Montespan and de Piles's friend, the duc de Richelieu. Then, in 1690, at the instigation of the English Ambas/ sador to France, La Fosse travelled to England, where he painted panels for Montague House in collaboration with Monnoyer and J. Rousseau. Two paintings, *Venus finds Mars asleep* and *The Rape of Europa* (in the Buccleuch Collection until 1955; now Lord Iliffe) are all that remain of the artist's stay in England.

Finally, on his return to France, work began on one of the most important projects of the late seventeenth century, the decoration of the dome of the Chapelle des Invalides. The commission was first entrusted to Mignard, but after his death in 1695 Mansart handed on the work to La Fosse and a team of other artists, including the Boullogne brothers; La Fosse himself contributed the scenes in the four pendentives and the central cupola, showing the patron *St Louis presenting his coat of arms to Christ*. The climax of La Fosse's career came in 1699 when he was nominated director of the Academy by Mansart. In the same year he was commissioned to paint the beautiful *Bacchus and Ariadne* (Dijon) for the central salon at Marly, a symbol of Autumn in a set of four seasons of which the other three were executed by Coypel, L. de Boullogne the

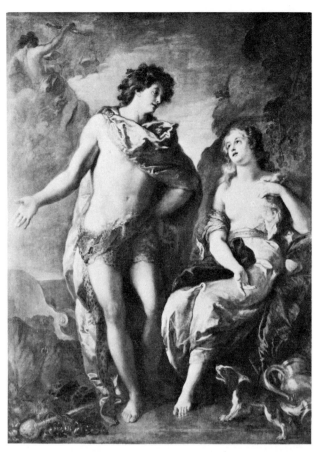

11. La Fosse,
Bacchus and Ariadne,
242 × 185 cm.
Musée de Dijon

younger and Jouvenet. Here the artist's ripe Venetian style has come to full maturity, in the red of Bacchus' cloak, in the harmonious colours and the soft langorous forms enveloped in chiaroscuro. At last, we feel, the rigid discipline imposed on French art by Lebrun has given way to something more sensuous and more attractive to a new generation no longer bound by the hierarchies of the Grand Siècle. Pleasure has taken the place of edification, and for the first time a French artist paints not for the sake of academicians and pedants but for the amateur, the *honnête homme*, whose taste was gradually to change the course of art during the eighteenth century. The soft breath of new life seems to pulse through La Fosse's gently undulating forms and fleeting, evanescent colours — in/ herited from the Venetians, from Correggio and from Rubens. His preference for a harmonious palette of clear blond tonalities and soft outlines which seem literally to melt into the surrounding atmosphere marks a definite move away from the dark muddy effects of much Italianate art in the seventeenth century and a step towards '*la peinture claire*', which reached its peak in the mid/ eighteenth century. This strong element of originality in Charles de la Fosse was clearly perceived by his last and most influential patron, Pierre Crozat, for it was through Crozat that Watteau was introduced to the older man's work and was visibly impressed by its clarity and fresh/ ness. Thus the link between the last artist of the old century and the first of the new one was forged.

2: Watteau and the Regency

The last years of the reign of Louis XIV were in many ways an anti-climax after the peak of splendour reached between 1660 and 1680. The French armies, which had formerly swept unimpeded through Europe, suffered a succession of humiliating defeats at the hands of Marlborough, culminating in the Treaty of Utrecht in 1713. The elderly King no longer seemed the reincarnation of Apollo or Alexander the Great as immortalized in the ceilings of Versailles but a gloomy and morose autocrat, dominated by the unrelenting piety of his last mistress and, finally, wife, Madame de Maintenon. Life at the court of Versailles seemed moribund, as the general atmosphere of joylessness pervaded its corridors. Inhibited by the new tone of austerity which emanated from Scarron's widow (as Madame de Maintenon was still known), courtiers were not even permitted the distraction of 'la galanterie' with which they used to while away their idle hours. Instead, inevitably, they turned elsewhere for their social and artistic pleasures, to the metropolis. In the early years of the eighteenth century, Paris gradually began to regain the ascendancy it had enjoyed before the establishment of Versailles, during the heyday of the Hôtel de Rambouillet. Enterprising hostesses like the duchesse du Maine and Madame de Lambert, in her rooms in the Hôtel Colbert, revived the seventeenth-century institution in the literary *salon*, throwing their doors open to artists, writers, aristocrats, in fact anybody of talent or distinction, where they met on a more or less equal footing to enjoy themselves in sophisticated pleasures or to discuss the latest books and works of art. Many famous writers, like Montesquieu, who first read his *Lettres Persanes* (1721) aloud at the *salon* of Madame de Lambert, made their literary debut in this way. In the eighteenth century, both for artists and for writers, social success often went hand in hand with artistic fame. Even that refractory genius, Jean-Jacques Rousseau, never managed to alienate his well-to-do patrons and hostesses, whose adoration of him seemed to increase the more he abused them and the conventions of polite society. The implications of the *salons* for the visual arts will be discussed in a later chapter, for it was only later in the century that painters and sculptors gradually acquired some of the social prestige which writers had long enjoyed.[1]

The death of Louis XIV in 1715 was greeted with a sense of relief by many Frenchmen, tired of the incessant wars, the puritanical hypocrisy and the oppressive autocracy of the last years of his régime. Power then passed to the hands of Philippe d'Orléans (1674–1723), the son of Louis XIV's brother, who reigned as Regent during the minority of Louis XV by means of Councils of State. The eight years of his reign, known as the Regency [*Régence*], have become synonymous in text books with extreme moral depravity and gross waste of public funds, partly on account of the Regent's dissolute personal behaviour, but mainly due to the failure of the so-called 'Law system'. This was a banking system devised by a suspect financier from Edinburgh, John Law, who gained the confidence of the Regent, rose to the position of Contrôleur-Général des Finances and founded the Compagnie des Indes. His career ended in 1720 in personal disgrace and bankruptcy and brought further confusion to the national finances. His system, based on paper money, vouchers and the almost unlimited use of credit, was not wholly detrimental to the French economy since it favoured the development of trade and brought about increased prosperity, at least among certain sections of the community. The adverse result was unprecedented inflation, on which speculators grew rich overnight. Many small-time investors, including artists like Claude Gillot, who caricatured the evils of speculation in a drawing illustrating the reversals of Fortune,[2] lost their entire savings in the eventual crash and died in penury.

This was the period in French history when the gap between rich and poor grew still greater and which saw the rise of the financiers, men like Samuel Bernard and Pierre Crozat, who were to become the most lavish and influential art patrons of the age. Their names crop up repeatedly in connection with Watteau, Boucher and Fragonard. In the middle of the seventeenth century, only a small handful of men had managed to build up their own personal fortunes by the tax-farming system (*fermiers-généraux*). But by about 1690 they had established such a strong position in French society that, as La Bruyère complained in his *Caractères*, they had easily outstripped the members of the old aristocracy, who were only too ready to swallow their pride and marry off their daughters to them. The process was continued throughout the eighteenth century as governments were forced to resort to private loans in order to meet the ever-growing deficits of the Treasury. Thus the financiers made themselves indispensible to the State and increased their stranglehold over the national wealth, which they diverted shamelessly to their own ends. They were the main source of the vast sums spent on building sumptuous châteaux like Champs-sur-Marne (with painted interior decorations in the Chinese taste by Huet), built between 1703 and 1707

by Bullet de Chamblain for a financier called Poisson de Bourvalais. His career was typical of the spectacular rise of this class of men in the early eighteenth century; the son of a poor Breton peasant, he began life as a lackey, made an enormous fortune through selling provisions to the army and finally added the *particule* 'de Bourvalais' to his own name. Bourvalais's fall was equally spectacular when he was arrested in 1716 on a charge of peculation and sent to the Bastille. A year later he was released, but was fined the sum of over four million francs and forced to sell Champs-sur-Marne and his town house on the place Vendôme. Such were the extraordinary reversals of fortune in this period, which Montesquieu noted in one of the *Lettres Persanes*: 'Il arrive tous les dix ans des révolutions qui précipitent le riche dans la misère et enlèvent le pauvre, avec des ailes rapides, au comble des richesses. Celui-ci est etonné de sa pauvreté; celui-là est de son abondance. Le nouveau riche admire la sagesse de la Providence; le pauvre, l'aveugle fatalité du Destin.'[3]

The result of this new private opulence was a general spirit of epicureanism and the quest for pleasure. Money, it was felt, could buy everything, from titles and political power to works of art and the love of women. In violent reaction against the previous régime, morals were suddenly relaxed and Paris acquired its reputation as the capital of debauchery. In this the Regent set the tone with his incessant orgies at the Palais Royal. Every *grand seigneur* and *nouveau riche* felt obliged to follow suit, giving grand receptions in their newly constructed mansions, like the event celebrated in J. F. de Troy's *Oyster Dinner* [*Déjeuner d'Huîtres*] (Chantilly), in which masters and servants mingle in a riot of hearty gluttony. Nothing captures the spirit of the first quarter of the century better than Prévost's short novel *Manon Lescaut* (1734), based on the author's own adventurous life. In their frenzied quest for pleasure the hero, Des Grieux, and his mistress Manon, indulge in fraud, card-sharping and every kind of deceit in their insatiable desire for the life of ease and luxury. They regard every gullible dotard who comes their way as fair game and yet, despite their total lack of moral scruple, are somehow redeemed by their youthful charm and genuine love for each other.

Watteau is conventionally, and perhaps misleadingly, often described as the typical painter of the Regency. Nothing could seem more dissimilar than the smart, epicurean society of Philippe d'Orléans and the shy provincial artist from Valenciennes, who arrived in Paris in 1702 in the hope of making a living by copying popular favourites. Their existences were poles apart: and yet, within a remarkably short time, Watteau was taken up and lionized by the richest patron, Pierre Crozat, and the most discerning connoisseur of the age, Jean de Julienne. This success may partly be due to the fact that Watteau, like the Parisian society which adopted him, made a clean break with the previous tradition of Louis XIV and Lebrun—a break neatly symbolized in the panel *Gersaint's Shop* [*L'enseigne de Gersaint*] (1721), painted as a shop sign for his friend, the dealer Gersaint. In this the King's portrait is unceremoniously packed away into a crate by the porters on the left, while an elegantly dressed young woman casts no more than a cursory glance at such a significant event. This act of casual disrespect for the Grand Siècle is fundamental to Watteau's originality and provides the common link between himself and his contemporaries. He had the benefits—and the disadvantages—of being a complete outsider, hardly even a Frenchman, since his native Valenciennes had until recently been part of the Spanish Netherlands and closer to Flemish than to French traditions. This unfamiliarity with seventeenth-century art was to be his great strength. It enabled him to dispense with the elaborate mythological conventions which still lingered on in the work of Coypel and Charles de la Fosse, and to create a new genre, the *fête galante*, more in tune with his own spiritual needs. At the same time he was free to approach the art of the Old Masters, especially Rubens and the Venetians whom he most admired, with fresh eyes and a mind uncluttered by the conflicting exhortations of academicians and critics. The result was the first truly original artist of the eighteenth century.

A great deal, in fact too much, has already been written about Watteau as the poet of love and pleasure, but since the Goncourt brothers were among the first to say it in their chapter on the painter in *L'Art du dix-huitième siècle* (1856), they deserve to be quoted: 'Love is the light of this world. Love permeates and fills it, is its youth and its serenity. Cross its rivers and its mountains, its paths and its gardens, its lakes and its fountains, and Watteau's paradise opens out before your eyes: Cythera.' They went on to write about Watteau's 'eyes without hunger, embraces without impatience, desire without lust, pleasure without desire . . . an indolence of passion at which the stone satyrs in the green walks laugh their goat's laugh.' These were the words which finally crystallized the view of the artist as a precocious sufferer from '*le mal du siècle*', a persistent view which runs throughout nineteenth-century French literature, from the stories of Gérard de Nerval through the poems of Verlaine, and is closely echoed by the early essays of Marcel Proust.[4] The single important fact which gave rise to this legend was Watteau's early death from consumption in 1721. Whether or not he suffered from this kind of impotent melancholy in the face of the harsh real world—as his nineteenth-century critics liked to suppose[5]—must be open to doubt. We have only the evidence of the pictures themselves and the written testimony of his early biographers, Jean de Julienne, Gersaint and Caylus. These,

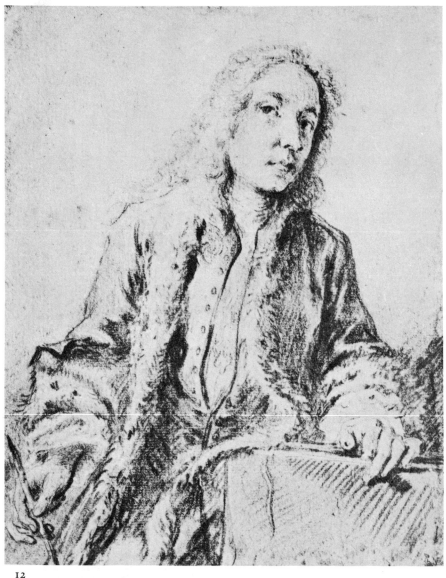

12

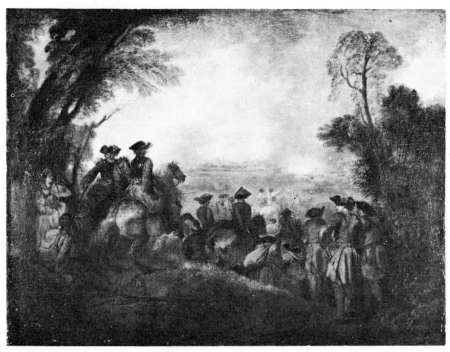

13

it is true, agree on Watteau's gauche behaviour in society and his cranky, often petulant treatment of well-intentioned friends and patrons, but there is little in their accounts to suggest a Romantic dreamer and dallier à la Musset. It seems more likely, in fact, that paintings like the *Embarkation for the Isle of Cythera*, the *Pleasures of the Ball*, at Dulwich, or *The Champs Elysées* in the Wallace Collection, to take three of the most perfect *fêtes galantes*, were created partly to satisfy the needs of Watteau's own imagination, but also in response to the demands of the pleasure-loving society of his time. They embody the ideals and fantasies of the more refined members of that society, for whom love and pleasure were serious pursuits in a leisured civilisation.

The origins and ingredients of this startlingly novel style have to be sought in Watteau's obscure Flemish background. He was born in 1684 of a humble family in Valenciennes (which had only become part of France in 1678 under the terms of the Treaty of Nijmegen), and in 1700 was apprenticed first to a local painter called Gérin, of whom practically nothing is known, and then to an equally obscure painter, Métayer. We can only surmise what he may have learnt from these men, but there is a distinct trace of his early Northern training in the numerous drawings of beggars, street musicians, soldiers and battle scenes such as *Le Défilé* of around 1709, in York, All of these display a strong vein of realistic observation and an ability to capture people in natural, unrehearsed poses, quite alien to the French academic tradition, which underlines all Watteau's work and is never entirely absent even in the most ethereal *fêtes galantes*. *Le Défilé*, in particular, painted during a military campaign near Valenciennes, obviously recalls the battle scenes of Van der Meulen and Parrocel but concentrates with much greater attention on the participants; the sombre colouring relieved by the occasional shot of red emphasises their state of expectant tension.

The most important ingredient, however, in the formation of Watteau's style was the theatre. He arrived in Paris in 1702, where he was soon abandoned by his former master and left to eke out a miserable living by making copies after popular favourites, like Gerard Dou's *Old Woman Reading*. It was through this humble activity that Watteau made the acquaintance of many engravers, collectors and dealers, notably Edmé Gersaint, who were to be of great help to him later in his career. About a year after his arrival in Paris, he had the good luck to come into contact with Claude Gillot (1673–1722), a now almost forgotten artist, but one gifted with a talent for sharp, satirical observation who has sometimes been compared with Jacques Callot. Gillot seems to have had a natural sympathy for the popular undercurrents of French life, the burlesque and satirical elements which the official court style never entirely managed to stifle. Hence, no doubt,

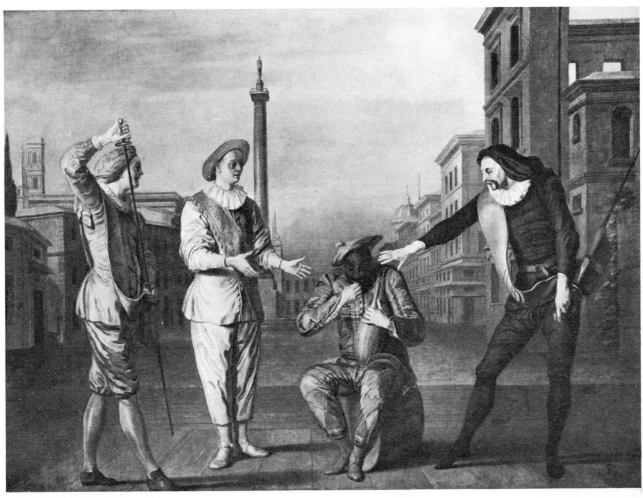

12. Boucher,
Watteau: Self-Portrait,
copy of lost drawing by Watteau.
21.5 × 25.3 cm.
Musée du Louvre.
Photo: Courtauld Institute, London

13. Watteau,
Le Défilé,
32 × 43 cm.
York City Art Gallery

14. Gillot,
Italian Comedians,
Musée du Louvre.
Photo: Musées Nationaux, Paris

15. Gillot,
Italian Comedians,
Musée du Louvre.
Photo: Giraudon

came his unbounded passion for the Italian Commedia dell'Arte, a passion which Watteau was to inherit. The Italian Comedy was already firmly established in France during the second half of the seventeenth century under Louis XIV, and even enjoyed royal protection and the privilege of its own theatre, the Hôtel de Bourgogne. This state of affairs lasted until 1697, when the comedians mounted a play entitled *La Fausse Prude*, a thinly veiled satire on Madame de Maintenon, which gave offence to the King. Their theatre was then closed and the players banished. Only in 1716, thanks to the Regent's personal initiative, were the Italian players recalled to France under the direction of the actor-manager, Luigi Riccoboni.[6] With its stock characters of the Doctor and the Merchant, the pair of lovers Isabella and Orazio, Arlecchino the acrobatic servant in his diamond-patterned costume,

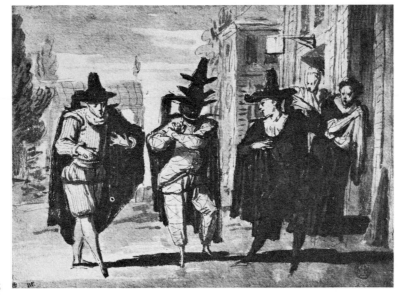

15

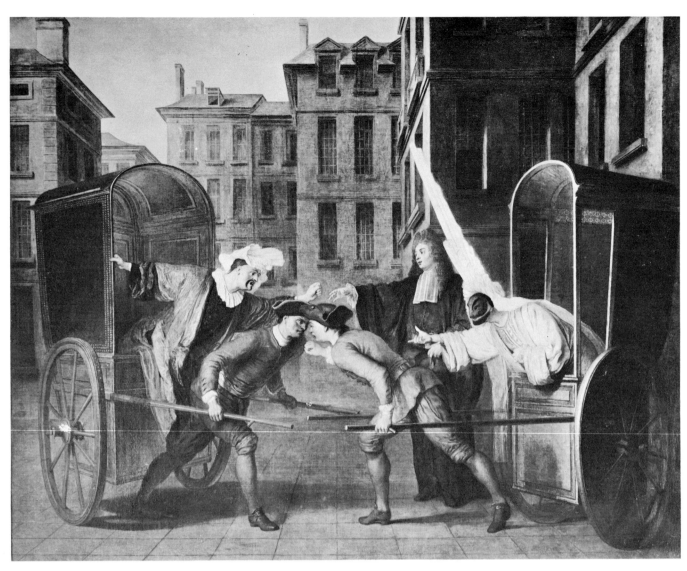

16. Gillot,
The Two Carriages,
127 × 160 cm.
Musée du Louvre.
Photo: Giraudon

Mezzetino the musician, and the most poignant of all, Pierrot the clown (who re-appears in Watteau's picture as *Gilles*), the Italian Comedy has retained a permanent hold over the French imagination and exerted a dominant influence both on art and on the theatre. Its lineage can be traced from the early farces of Molière, such as *Les Fourberies de Scapin*, through the paintings of Watteau and J. F. de Troy, the theatre of Marivaux down to the poems of Laforgue and Marcel Carné's *Les Enfants du Paradis*. This is to provide only one instance of the close relationship between painting and the theatre in the eighteenth century, and beyond.

The first painter to see the potential visual attraction of the Italian Comedy was undoubtedly Claude Gillot, and he can fairly take the credit for having drawn Watteau's attention to this fertile theme. One of the very few oil paintings by Gillot to survive is *The Two Carriages*. The episode depicted by this scene was an improvised addition to a pantomime originally performed by the Italian players in 1695, and proved so popular with the public that it was retained in their repertory. In a deliberately perfunctory,

flat manner reminiscent of Hogarth, Gillot has depicted this quarrel of two street porters whose carriages have met headlong in a narrow street, while a magistrate tries to restore the peace. At first sight it may be hard to see what Watteau's world has in common with this matter-of-fact, slightly harsh little scene, for Gillot, it should be remembered, was working as a contemporary of the Italian players. When Watteau arrived on the stage, the Italian Comedy was already a thing of the past; its theatre had been closed, its players dispersed. But the memory of the Commedia dell'Arte lingered on in the popular imagination, and many of its characters and stock comic scenes survived in that other alternative to the official theatre, the Théâtre de la Foire, which performed on various fairgrounds on the outskirts of Paris. Watteau, therefore, had no direct knowledge of the Italian Comedy, only the legend and the memory. This may explain why, unlike Gillot, he seems to view these scenes through a poetic haze and to lend them a distant enchantment. The subjects of Watteau's paintings, so enigmatic to modern viewers and irritating to his own contemporaries, were probably quite

[26]

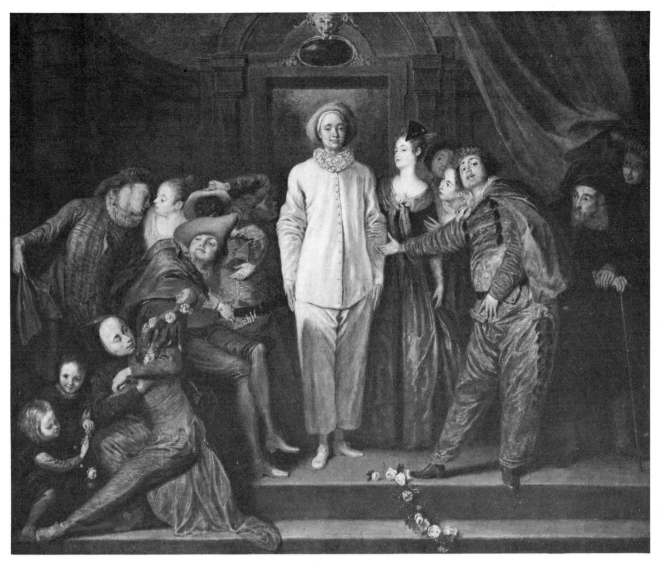

17. Watteau,
The Italian Players,
9.89 × 11.8 cm.
Samuel H. Kress Collection, National
Gallery of Art, Washington

intentionally vague and ill-defined, as the familiar figures from the Italian Comedy spill over and merge imperceptibly into the *fête galante*.

Watteau's attitude to the theatre was not one of sentimental nostalgia, however. In the two pendants, *The French Players* and *The Italian Players*, both painted in 1720, Watteau takes up a clearly defined position on the war of the two conflicting styles which then divided the allegiance of the French public. Even the arch-classicist Boileau came out firmly on the side of the Italians when he wrote: '*Je plains ces pauvres Italiens; il valait mieux chasser les Français.*'[7] Watteau leaves little doubt as to where his own sympathies lie, and his satirical intention in *The French Players* is obvious. This is a typical last-act scene from a Racinian tragedy as conventionally performed by the Comédie Française, in a colonnaded antechamber with the despondent heroine (Phèdre or Berenice?), her weeping *confidante*, and the cold, disdainful *jeune premier* decked out with padded hips, richly embroidered lace and plumed hat. The characters of the actors too can be readily identified: Mademoiselle Duclos, heroine and leading

tragédienne of her day, M. Beaubourg as the hero; and, on the right, M. Poisson, the comic, slightly Molièresque figure in a Spanish costume, and the only intruder in this scene of high tragedy. The pendant to this scene, on the other hand, *The Italian Players*, is obviously treated by Watteau with far more warmth and affection. It shows the entire assembled troup of Riccoboni's players, Lelio himself, his wife Flaminia and their young cousin Silvia Benozzi, all grouped round the central figure of Pierrot, who finds himself thrust into reluctant prominence. The breadth and variety of their gestures, and the effective mingling of love with comedy, make a pointed contrast to the stiff formality of *The French Players*.

Before Watteau achieved this final mastery towards the end of his short life he first had to undergo further apprenticeship, this time to Claude Audran (1658–1734), who took him on as an assistant in 1707–8. Audran was the last of a family of decorative artists and designers who worked on many of the royal palaces, including Marly and La Muette (both now destroyed), around the turn of the century, and he was largely re-

sponsible for inaugurating the decorative style later known as the Rococo. This was a reflection of the new taste for light, elegant rooms in contrast to the heavy colonnades and long galleries favoured by Louis XIV. Double curves, arabesques and scrolls were the features of this style, drawn in a light, calligraphic hand, with sketchy little figures of *singeries* and *chinoiseries* filling in the blank spaces. Watteau himself probably contributed many such figures to Audran's decorative schemes, but few of them have survived. This training was to be of great

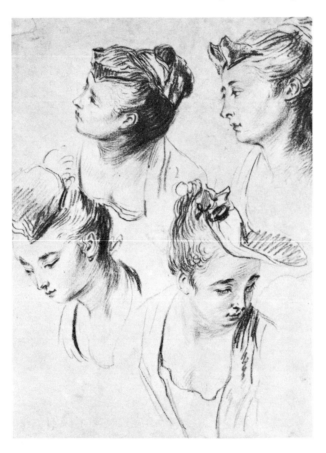

18. Watteau,
Page of studies of women's
faces,
chalk drawing.
British Museum (courtesy of the Trustees).

help to Watteau, particularly in his drawings and sketches after a single motif, where ease and spontaneity were paramount. Even his most finished paintings retain much of this somewhat improvised quality. Audran performed his most useful service to Watteau, however, when he gave the artist access to Rubens' *Marie de' Medici* cycle in the Luxembourg Palace, of which he was the curator. This contact with the great Flemish Baroque painter of the seventeenth century opened up for Watteau a whole new range of colour and movement; it gave his work a more full-blooded, earthy quality, and saved him from the danger of falling into the minor decorative genres he had known until then. Moreover, the beauty of the Luxembourg Gardens obviously exerted its charm on Watteau, who was particularly sensitive to landscape of all kinds. Their features and architectural motifs reappear in the backgrounds of several paintings. Thus Roger de

Piles's wishes were unconsciously fulfilled by Watteau, whose painting provides the first and most illustrious example of '*Le Rubénisme*' in eighteenth-century France.

One of the most persistent characteristics of Watteau, both as a man and as an artist, was his restless dissatisfaction. He was never content to sit back and enjoy his own achievement, or simply to repeat a successful formula as his followers were to do. This is why within the fifteen-odd years of his active career his style evolves with such incredible speed. He also had a remarkable capacity for easy assimilation, which enabled him to absorb nearly all the major strands of European art and, in his own mature works, to recreate these in such a way that it is virtually impossible to point to specific influences. The only other comparable eighteenth-century artist of this kind was Fragonard, who resembles Watteau in this and so many other ways.

The next few years of Watteau's life are thinly documented. In 1709 he entered for the Prix de Rome with a painting, now lost, of *David and Nabal*, and won second prize. Two years later, with the help of some money advanced to him by the dealer Sirois, he was back in Valenciennes where he made the many sketches of soldiers and military subjects. In 1710 he returned to Paris and took up lodgings with Sirois and his family on the Pont Notre Dame. There he stayed for the next two years until 1712, when, in unexplained circumstances and for no apparent reason, he was accepted as an associate member ('*agréé*') of the Academy; under the elaborate regulations of that institution this enabled him to apply for full membership on the strength of a '*morceau de réception*', which in Watteau's case was to be the *Embarkation for the Isle of Cythera*, the one painting which least resembles an academic exercise and was only completed in 1717. Watteau's sudden and unexpected academic success can only be explained by the support given by his fellow painters, Coypel and La Fosse, who quickly spotted his talent, however different from their own.

Meanwhile his fame, chiefly on the strength of his drawings, had begun to spread through the circle of Parisian dealers, collectors and connoisseurs, like Jean de Julienne, and he soon became one of the most sought-after artists of the day. It was in 1712 – or at the latest 1715 – that he met the most influential patron of the early eighteenth century, Pierre Crozat (1665–1740), who commissioned Watteau to paint a series of *Seasons* to decorate the dining room of his town house in Paris. The introduction was probably brought about by their mutual friend Charles de la Fosse, and it was perhaps the single most important event in Watteau's life. For Crozat[8] was not only a generous patron and friend to Watteau, giving the artist free use of his various country houses at Montmorency and Nogent-sur-Marne, he also possessed one of the finest collections of Old Master drawings and paintings, second

only to those of the Regent. Crozat, known as 'Crozat le Pauvre' on account of his vast wealth, was a banker by profession and a native of Toulouse, where his father, Antoine Crozat held the post of *Capitoul* in the regional administration. He was not, therefore, strictly a parvenu, since the family's position had been built up gradually; they had risen through the legal ranks to a status somewhere between that of *grande bourgeoisie* and *noblesse de robe*, whose confines became increasingly blurred throughout the eighteenth century. Pierre Crozat arrived in Paris around 1700 and was quick to penetrate the artistic circles of the capital. He frequented the exhibitions, possibly the Salon of 1699 and almost certainly that of 1704, and made friends of many artists including the Boullogne brothers, Coypel, Jouvenet and, especially, Charles de la Fosse, who painted a *Birth of Minerva* (a sketch of which is in the Musée des Arts Décoratifs) as the ceiling for Crozat's art gallery. Most of Crozat's incredible collection was formed during his travels in Italy between 1714 and 1715, when he was entrusted by the Regent with a mission to buy the entire collection of Queen Christina of Sweden. It was then, on visits to Rome, Naples, Bologna, Parma and Venice, that Crozat bought most of his Italian paintings and drawings, including 154 by Correggio (his favourite artist), 400 by Parmigianino, 123 by Campagnola, 103

by Titian, nearly 100 by Giorgione and about the same number by Veronese. To these he later added many distinguished works by Flemish artists, Rubens, Jordaens, Van Dyck and Rembrandt. The effect of this collection on Watteau was that of a sudden revelation; its impact was all the greater since he had never been to Italy to see works by these masters in the original. It is neither possible nor desirable to work out the exact part played by each of these artists on Watteau's stylistic development, but their overall effect is clear. This direct contact with the greatest Masters of the past taught Watteau to amplify his style, to fill out his figures and to give his compositions much greater breadth and dignity than they would otherwise have had. Watteau's colouring owes much to the Venetians, perhaps still more than to Rubens, and clear traces of Titian can be found in nearly all the distant, fleeting landscapes which form the background to such paintings as, for example, the *Elysian Fields*, in the Wallace Collection.

The painting most obviously inspired by Titian is his *Jupiter and Antiope* (Louvre), with its typically Venetian colouring in Jupiter's ruddy flesh and the streaky orange-blue sky. Veronese, on the other hand, is the dominant influence in the smoky grey-blue tonality of *Love Disarmed* (Chantilly), and, on a much grander scale,

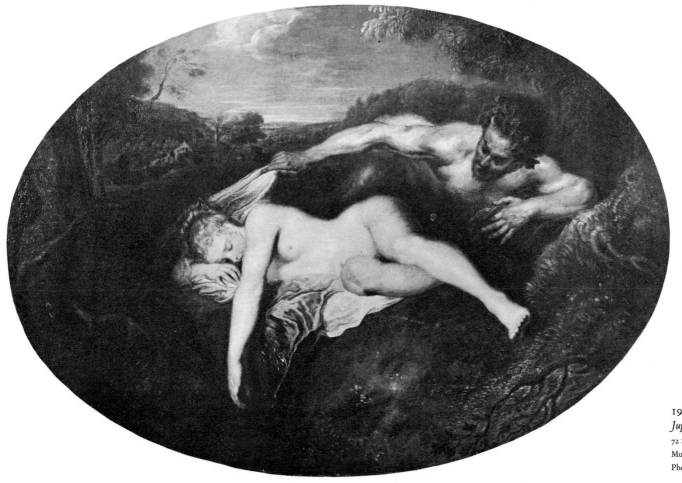

19. Watteau,
Jupiter and Antiope,
72 × 110 cm.
Musée du Louvre.
Photo: Giraudon

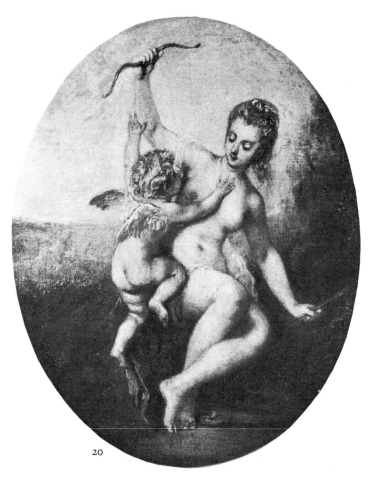

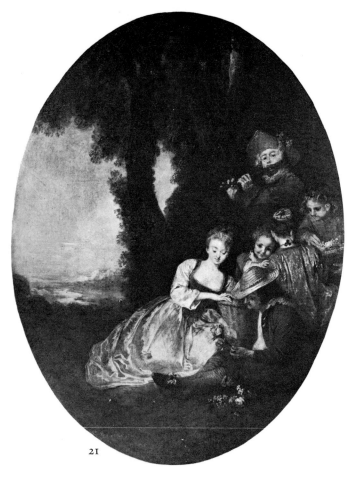

20

21

20. Watteau,
Love Disarmed,
47 × 38 cm.
Musée Condé, Chantilly.
Photo: Lauros-Giraudon

21. Watteau,
L'amour paisible,
67 × 51 cm.
Musée Beaux-Arts, Angers.
Photo: J. Evers

22. Watteau,
The Music Party,
64 × 92 cm.
The Wallace Collection, London

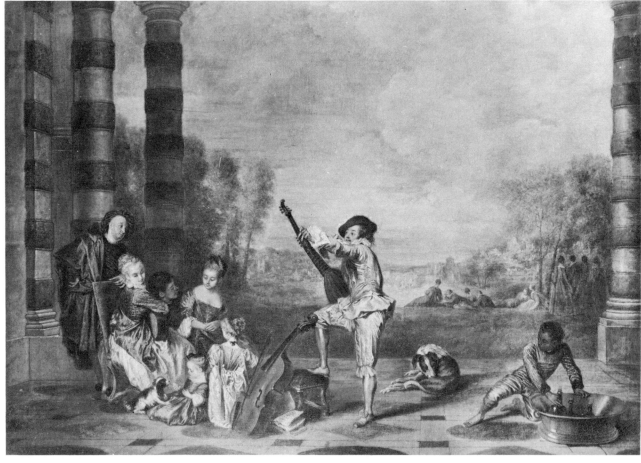

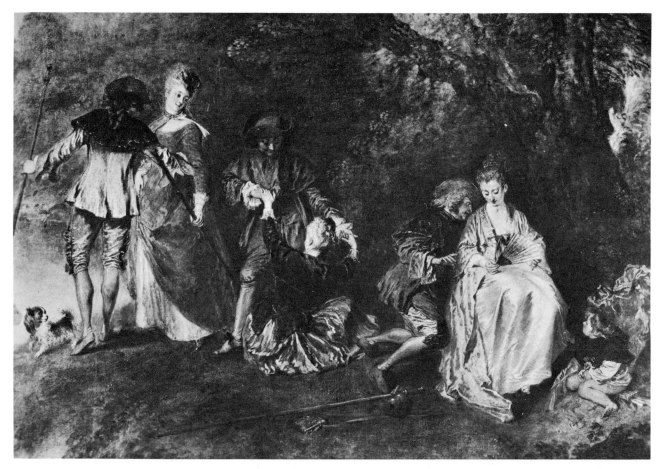

23. Watteau,
*Embarkation for the Isle
of Cythera* (detail).
Musée du Louvre.
Photo: Giraudon

in *The Music Party* (Wallace Collection), a fine, broad and balanced composition which closely reflects Veronese's *Marriage at Cana*.

The benefits of Crozat's patronage were not confined to Watteau. The magnificent mansion designed by the architect Cartaud, which Crozat had built for himself in 1704 at the end of the rue de Richelieu, became the centre of attraction for the intellectual and artistic élite of Paris. The main focus of the house was the art gallery on the first floor, where the majority of his collection was displayed. Crozat regularly opened his house to artists, connoisseurs and collectors, who mingled freely with a constant stream of visitors from home and abroad. The Venetian artist Rosalba Carriera (1675–1757) was a guest in 1720–21, and Pellegrini and Sebastiano Ricci stayed there during their visits to Paris. It was at Crozat's house that the artistic avant-garde in early eighteenth-century France discussed its ideas and helped to fashion the taste, both of its own and the next generation. Significantly, the writings of Roger de Piles figured prominently in Crozat's library, for the two men shared much in common in their passionate devotion to the Italian masters. Crozat also combined a love of music with his interest in the arts, and held frequent musical parties, like the one depicted in Lancret's picture *Le Concert* (New York, private collection), both in his Paris house and in his château at Montmorency. These gatherings, attended by high

Parisian society and sometimes the Regent himself, must have seemed to Watteau to be the living re-enactment of those Venetian concert pieces which, in an outdoor setting, he was soon to transpose into the *fête galante*.

After a two-year stay in Crozat's house, Watteau's old restlessness (or, in Gersaint's words, his '*amour de la liberté et de l'indépendance*') got the better of him and he decided to move on, probably for a brief sojourn with his friend Sirois. On 28 August 1717, he was finally accepted as a full member of the Academy on the strength of his completed picture of the *Embarkation for the Isle of Cythera* and was enrolled as a '*peintre de fêtes galantes*'. This painting marks the true climax of Watteau's career and summarizes the essence of his art, in which everyday reality and theatrical fantasy are finally blended in a unique, original creation. The supreme poetic beauty of this work has, inevitably, given rise to many attempts to rival its beauty in words and, more recently, to much learned commentary. What has perplexed nearly everybody is its subject. Who are the mysterious figures in fancy dress, paired off in couples, and where are they going? Does the picture represent some kind of theatrical charade, or is it the commemoration of a real or imaginary event? The most convincing answer to these questions has been given recently by Michael Levey, who has suggested that the subject is not the departure for Cythera but the return from the Island of Love.[9] The evidence for this conjecture

Plate 4 faces page 32

[31]

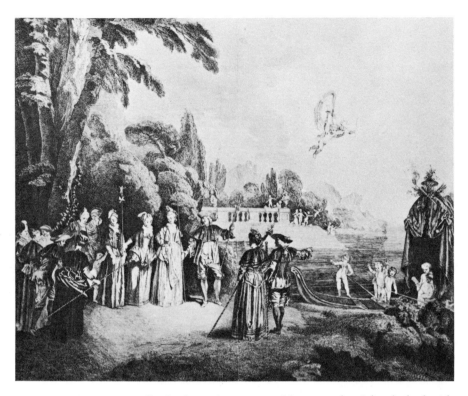

24. Watteau,
Engraving by P. Mercier
after first version of
the *Embarkation for the Isle of
Cythera*.
The Courtauld Institute, London

This, in fact, is the real departure scene and not the later, infinitely more refined and complex picture of 1717. We can see from a comparison of these two paintings how far Watteau travelled within the short time of nine years, from the minor illustrative genre of Gillot and Audran to the creation of a new world of the imagination. It is hardly surprising, in view of this enigmatic quality, that the final *Embarkation for the Isle of Cythera* haunted the imagination of so many nineteenth-century poets from Baudelaire to Verlaine, and seemed to invite them to read their own fantasies into the picture. For the hazy, mountainous distance, reminiscent of Leonardo, suggests the same kind of ill-defined never-never land which the Romantics loved to associate with their ideals of love and womanhood, none of them more so than Gérard de Nerval, who fancifully supposed that Watteau's picture was set in the Ile de France inhabited by his own Sylvie: '*Le* Voyage à Cythère *de Watteau a été conçu dans les brumes transparentes et colorées de ce pays* [le Valois]. *C'est une Cythère calquée sur quelque îlot de ces étangs par les débordements de l'Oise et de l'Aisne*'.[10]

In the *Embarkation for the Isle of Cythera* Watteau emerges clearly as the last true exponent of the courtly conception of love, which, as Madame Adhémar observed,[11] makes him a distant successor to a long tradition reaching from the mediaeval romance to the interminable novels of Mademoiselle de Scudéry and Honoré d'Urfé. He shares with this tradition a semi-Platonic belief in ideal love, often embodied in the form of a pilgrimage to some inaccessible island, and the notion that expectation and desire are to be more highly valued than sensual satisfaction. Is it a mere coincidence that so many of Watteau's figures, viewed from behind as they move silently and gracefully through enchanted gardens, seem to recall the courtly miniaturist qualities of late mediaeval Books of Hours? This ability to portray disembodied states of mind—freed of any corporeal weight or volume—irritated those contemporaries, like the comte de Caylus, who complained that the artist's pictures lacked 'action' and the 'expression of passion', the two essential ingredients of any classically trained painter. They simply could not understand how he could make paintings with no apparent subject. But it was this same elusiveness which fascinated the Romantic generation, whose writers once again raised love and womanhood to a semi-mystical plane. Few of these came to a more perceptive understanding of Watteau than the historian Jules Michelet, who assigned to the painter a central place in the chapter on the Regency in his *Histoire de France*: '*Watteau, fort sensuel d'idées, ne l'est guère en peinture. Il fuit l'obscénité. Elle alourdirait son pinceau. Aux sujets charnels, il élude. Dans son* Voyage de Cythère *que ces gentilles pèlerines, si jeunes, font pour la première fois, il reste au depart même. Il n'en peint que l'espoir, le rêve. Il van les embarquer, et il ne quitte pas le rivage*'.[12] Michelet

lies in the votive statue to Venus on the right, decked with flowers, the fading evening light, and the fact that one of the women in the foreground is turning to take a last lingering look at the scene, while the man next to her is helping his companion to her feet. There seems little doubt that this is not the beginning but the end of the festivity, and the sadness of the occasion is underlined by the slow, undulating rhythm of the figures descending the hill to the boat waiting to take them home.

The source of this picture is again in the theatre, for this same theme of the pilgrims of love occurs in an obscure musical comedy by Dancourt entitled *Les Trois Cousines*, first performed in Paris in 1700 and again in 1709. The third intermezzo contains a scene showing villagers disguised as pilgrims who make the journey to the Temple of Love, and one of the cast steps forward to make the following invocation:

> *Venez à l'île de Cythère*
> *En pèlerinage avec nous.*
> *Jeune fille n'en revient guère*
> *Ou sans amant ou sans époux.*

This is the happy dénouement shown in Watteau's picture, in which all the couples are neatly paired off as in the last act of a play. But as soon as we turn to the first, preliminary version painted in 1709, soon after the performance of Dancourt's play, a vast difference is immediately perceptible. In the earlier picture the figures are disposed in line against a flat two-dimensional background, which closely recalls a stage set. The pilgrims, obviously not yet lovers, stand timidly and awkwardly, waiting to be ferried off to Cythera by the cupids with their oars at the ready.

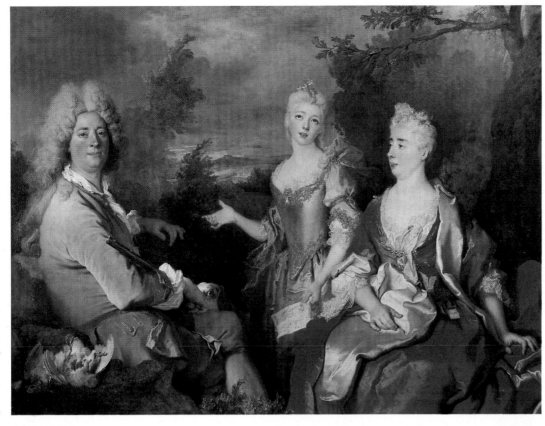

Plate 3
Largillierre,
*The Artist,
his Wife
and Daughter,*
149 × 200 cm.
Musée du Louvre.
Photo: Lauros-Giraudon

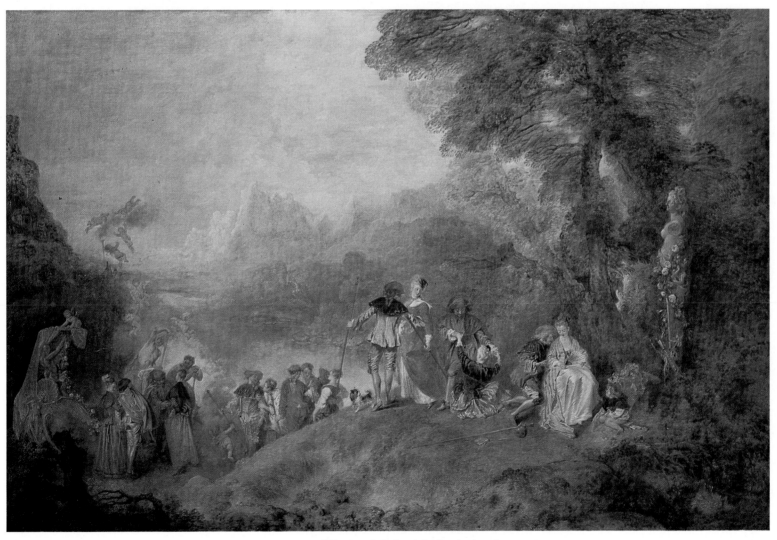

PLATE 4. Watteau, *Embarkation for the Isle of Cythera,*
127 × 192 cm. Musée du Louvre. Photo: Bridgeman Art Library

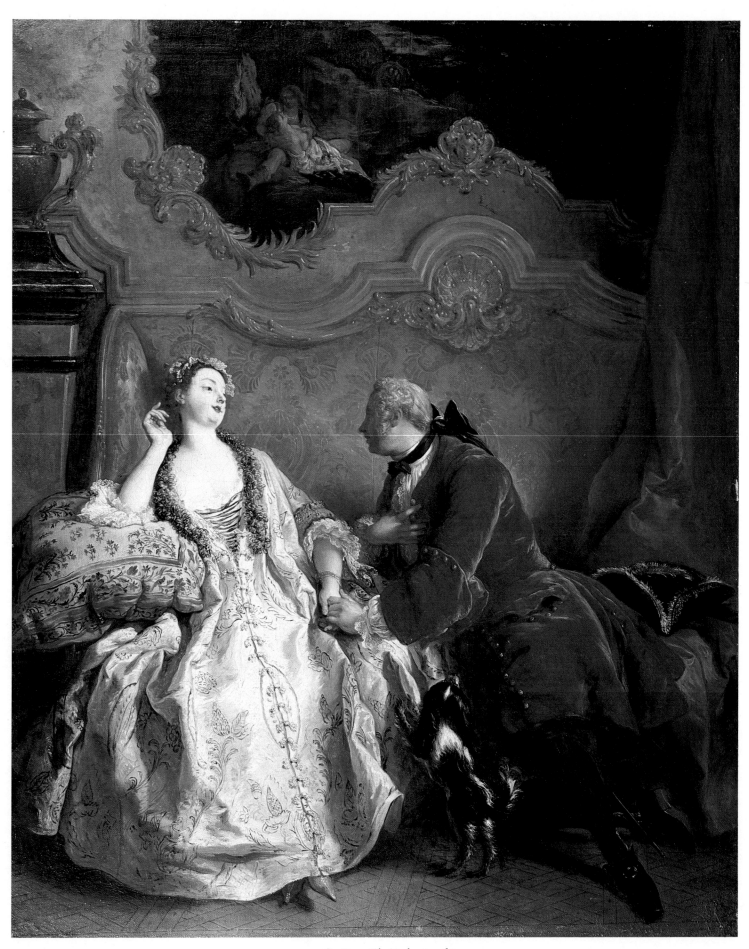

PLATE 5. De Troy, *The Declaration of Love*,

64.8 × 63.7 cm. Private Collection, New York

went on to dissociate Watteau's ideal of woman from the more down-to-earth, pleasure-loving heroine of Prévost's novel, Manon Lescaut, and to describe the former in terms of line and undulating movement, with hardly any suggestion of physical presence. In all Watteau's most accomplished paintings—the *Elysian Fields* in the Wallace Collection, for example—there is the same conspicuous lack of energy, an almost voluptuous sense of inactivity and languor in the small group of people chatting nonchalantly under the trees. And it is no accident that music and love are so closely associated in *The Music Lesson* [*La gamme d'amour*] (London, National Gallery), as in many paintings of the same kind inspired by the Venetian concert piece.

With the *Embarkation for the Isle of Cythera*, Watteau's talent had reached full maturity and, like so many artists who died young, he produced a handful of masterpieces in the last few years of his life. He quickly outgrew the odd, quirky figures of Gillot, the *singeries* of Audran and, in contact with the Old Masters, developed a new, more broadly conceived, almost epic style. But Watteau never

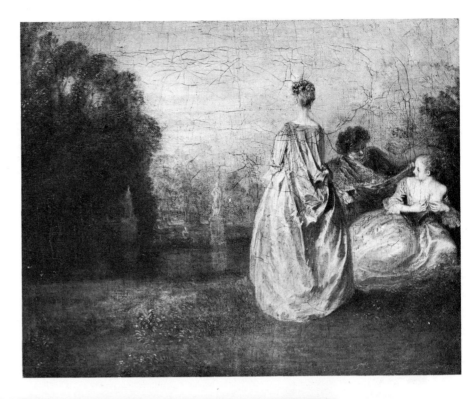

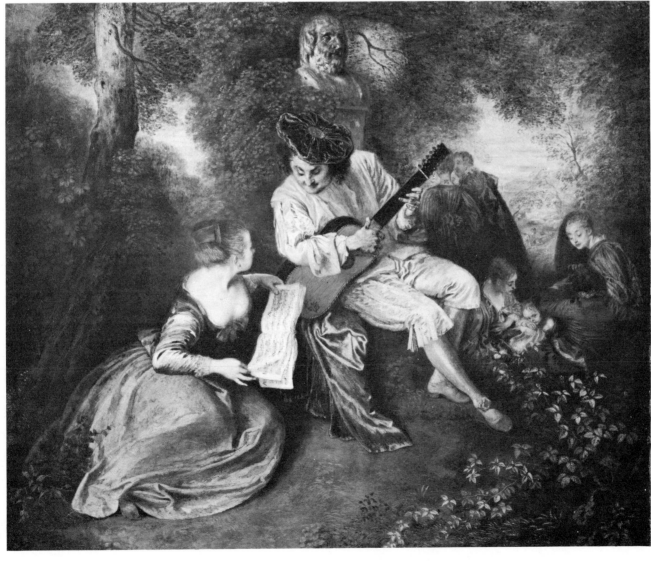

25. Watteau,
The Two Cousins,
29 × 35 cm.
Collection de Ganay.
Photo: Giraudon

26. Watteau,
The Music Lesson
La gamme d'amour,
51 × 58 cm.
National Gallery, London

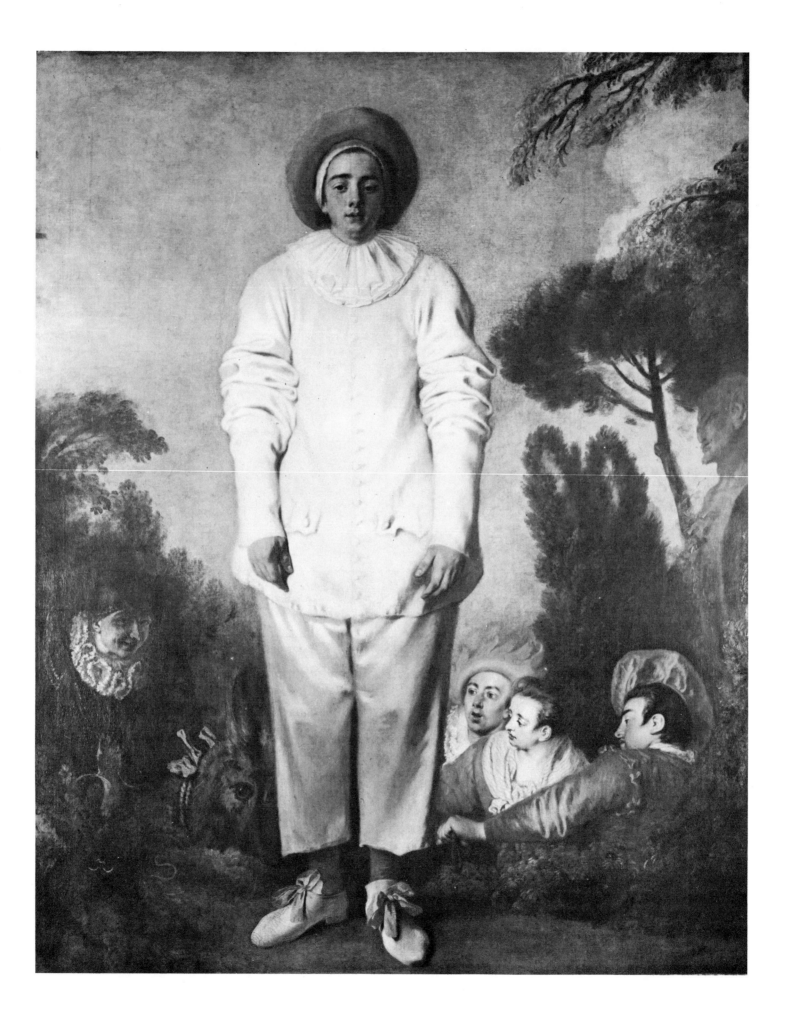

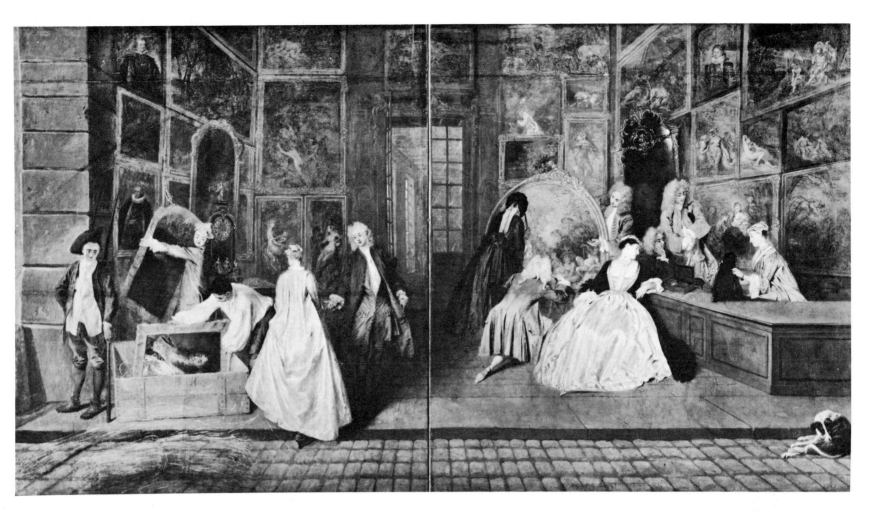

lost contact with everyday reality. The satirical and bur-
lesque elements in his art came once again into the
foreground in his later works, as in the famous painting of
Gilles (*c.* 1721) in the Louvre, surrounded by the familiar
figures from the Italian Comedy, probably painted as a
bill-board for a theatre. This is the classic portrait of the
clown, the original prototype of the *pierrot lunaire* of
Laforgue's poetry. From being a mere figure of fun, and
the butt of all the rest of the troup on account of his
stupidity (alluded to by the donkey on the left), Watteau
has raised the clown to semi-heroic status and invested
him with an ineffable, ambiguous expression which has
baffled all critics who expect paintings to yield a clear-cut
message. Detached from his background, in his baggy
sleeves and short trousers, Gilles stands there gazing
awkwardly at us, so that we are not sure whether to
laugh—as his contemporaries would have done—or to
sympathize with him. Only Molière can be compared
with Watteau in this ability to call forth mixed responses,
half-way between comedy and tragedy.

In 1720, either to sort out his financial affairs or to
consult his physician Dr Mead about his chest, Watteau
travelled to London. It was there that he painted the
Italian Players, in payment, it seems, for his medical
treatment. In 1721, shortly after this journey, which can

hardly have done his health much good, he painted his
last great masterpiece, *Gersaint's Shop* [*L'enseigne de
Gersaint*]. Like the portrait of *Gilles*, this work too was
originally designed as a simple advertisement, in this case
a sign-board for Watteau's friend, the art dealer Gersaint,
who had a well-known gallery called 'A l'enseigne du
Grand Monarque' on the Pont Notre Dame. On a simple
level this vast canvas, which was doubtless exhibited in a
prominent position in the window of Gersaint's shop, is
merely a factual display of the goods for sale inside. It is
not certain whether the paintings on the walls correspond
to Gersaint's actual stock, or whether they are the product
of Watteau's imagination, but there is no doubt that they
provide a representative sample of the kind of art in vogue
with the fashionable world around 1720. Apart from
some Dutch or Spanish-style portraits of men in black
with white ruffs, we can easily discern the mythological
nudes and Bacchic figures associated with Coypel and
Charles de la Fosse and a few poetic landscapes in the
manner of Watteau himself. The painting also provides
an accurate and witty portrayal of the Parisian art world of
the day, so accurate that many of its types, with their
characteristic gestures and slightly bored expressions, re-
appear today on Bond Street or the rue du Faubourg St
Honoré, almost unchanged after two centuries. On the

28. Watteau,
Gersaint's Shop,
(*L'enseigne de Gersaint*).
182 × 307 cm.
Schloss Charlottenburg, Berlin.
Photo: Bildarchiv
Preussischer Kulturbesitz

27. Watteau,
Gilles,
184.5 × 149.5 cm.
Musée du Louvre.
Photo: Lauros-Giraudon

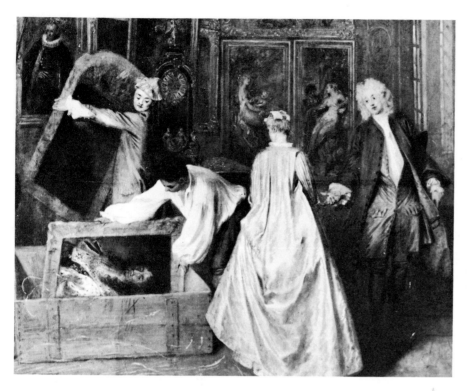

left, three porters are busy packing a portrait of Louis XIV into a crate, while an elegant young woman, seen from behind, is helped into the shop by her doting cavalier. On the right is another couple, an elderly woman in black and her connoisseur husband, examining a large oval canvas in minute detail. Another young woman (who may be their daughter) facing the spectator seems indifferent to the paintings all around her and prefers the sight of her own face in the looking-glass held for her by an assistant; a toilet set open on the counter provides a small touch of feminine vanity. It is possible to read *Gersaint's Shop* as a double allegory on youth and old age, on the pleasures of love and the pleasures of art, with the additional contrast of work on the left and refined luxury on the right. But not too much significance should be attached to any moral or political overtones, which are certainly not explicit on the artist's part. Watteau has simply created a broad and extremely detailed portrayal of a cross-section of fashionable French society in the early eighteenth century, seen from the outside by a humorous and slightly sardonic observer.

It is appropriate that Watteau should have unconsciously chosen *Gersaint's Shop*, a masterpiece of realistic observation, to make his last artistic testament. For this realistic strain constantly re-appears in later French art, notably in Courbet's *The Painter's Studio*, that other self-conscious, though far more elaborate depiction of the contemporary art world by a practising painter. But it was typical of Watteau and his generation that he wished to be remembered neither as a realist, nor as a painter of *fêtes galantes*, but as a religious artist. On his death bed at Nogent sur Marne, where he retired for some rest, hoping

to be able to return to Valenciennes, one of his last acts was to order the destruction of his nude paintings, which he feared would offend the local priest. As a final mark of penance, he undertook to paint a *Christ on the Cross*, which vanished from Nogent church during the Revolution. He died in 1721, at the age of thirty-seven, in the arms of his friend and biographer, Edmé Gersaint. In his account of the artist's last days, Gersaint relates that Watteau's pupil Jean-Baptiste Pater (1695–1736), also from Valenciennes, was the last to watch the master at work and to profit from his lessons. The generation of Watteau's pupils and close followers,[13] including Pater, Lancret, Octavien, de Bar, Pesne and Mercier, continued the master's manner and subjects but hardly ever rose to his level of poetry. While they deserve a better fate than to be dismissed as mere *pasticheurs*, and all have their own distinctive flavour, not one of them has a truly creative imagination. They were simply content to repeat the successful formula of the *fête galante*, usually in a somewhat coarser vein, in order to meet the growing demand for decorative panels to fill the many new palaces under construction throughout Europe. The *fête galante*, in fact, became the first international mass-produced form of art in the eighteenth century. It is no coincidence that one of the most cosmopolitan-minded of European monarchs, Frederick the Great of Prussia, was an avid collector of the genre and commissioned many examples by Lancret for the château of Sans-Souci and the other royal palaces.

As Watteau's closest pupil and follower, Pater inevitably suffers from the comparison. He was quick to exploit the genre invented by his master, and was so successful in this that he simply could not keep pace with the demand for his work and died from physical exhaustion at the age of forty. Pater had none of Watteau's genius for improvisation; as a result, his work is like a theme with few variations. His favourite subject, which became his speciality, was women bathing, usually in an outdoor setting, with a pool and some architectural motif in the foreground and mountains receding into the distance. This formula was so successful that Pater is thought to have executed some fifty different versions of it. The best of these have an undeniable charm, like the painting in Angers (of which almost identical replicas exist in Edinburgh and Stockholm), with its group of semi-naked Rubensian women disporting themselves in a pool against a background of luxuriant foliage framing a silvery mountainous landscape. Another similar painting in the museum of Grenoble may be the one which Stendhal referred to in his *Vie de Henry Brulard* as 'un mélange de volupté et de tendresse' and which triggered off his visual imagination as a boy. Pater's usual preference is for obviously attractive colours of white, lilac, mauve and pink against a pale silvery blue ground, lightly scumbled to create a delicate, gauzy effect. His chief weakness,

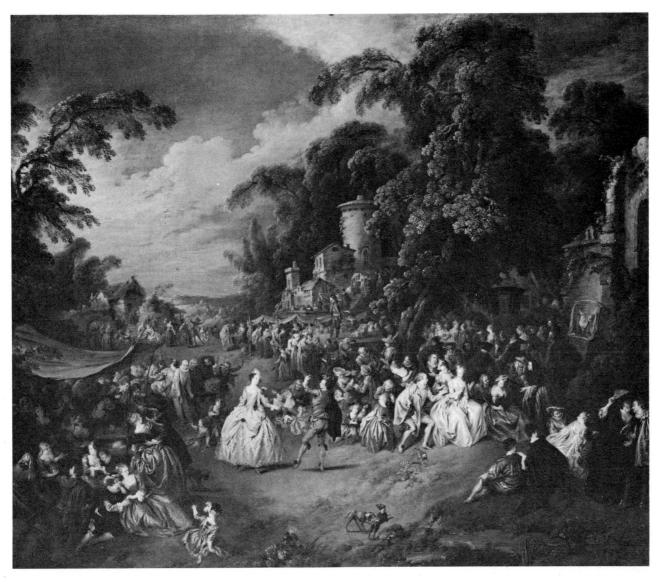

30. Pater,
The Fair at Bezons,
106.7 × 142.2 cm.
Jules S. Bache Collection,
Metropolitan Museum of Art, New York

however, lies in his draftsmanship, which is distinctly feeble. Unlike Watteau, who could create lifelike figures out of a heavily loaded brush, Pater merely succeeds in making his characters look smudgy and formless, with small doll-like heads set on bodies which are proportionately too large. Nor did he always have the ability to make them fuse harmoniously with their background, so that they often look like small appendages stuck on to the canvas. All these were the faults of overproduction, not of basic training, and perhaps of the wrong application of his talents. Temperamentally Pater was even closer to his Flemish origins than was Watteau, with a more pedestrian, earth-bound imagination. He was clearly at home in large village scenes of rustic festivities like the *Fair at Bezons* (Metropolitan, New York) of around 1733, in which peasants dance and enjoy themselves much as they do in Breughel's canvases. Though Pater's picture represents the annual fair at the village of Bezons, on the Seine not far from Paris, it seems to be very much a country affair; there are a few well-dressed people mingling with

the crowd and a carriage can be seen under the trees, but there is hardly any trace of Parisian refinement or the well-groomed avenues of country parks which Watteau preferred for his outdoor settings. Pater, in fact, was perfectly at ease with simple realistic subjects like the *Encampment* scene in the Wallace Collection. He also had a natural if rather heavy-handed talent for comic narrative, as we can see from such paintings as his scene from Molière's comedy *Monsieur de Pourceaugnac* (Royal Collection: H.M. The Queen) and a series of fourteen paintings (Neues Schloss, Potsdam) illustrating Scarron's *Roman Comique*, the seventeenth-century burlesque novel which attracted several eighteenth-century artists, including Oudry.[14] These early somewhat crude efforts mark the beginning of a distinguished line of literary illustrators for which the eighteenth century was to be famous.

Nicolas Lancret (1690–1743), by contrast, was a more gifted artist who began as a *pasticheur* of Watteau but soon developed a distinctive style of his own which, in some respects, has more affinities with de Troy and Boucher.

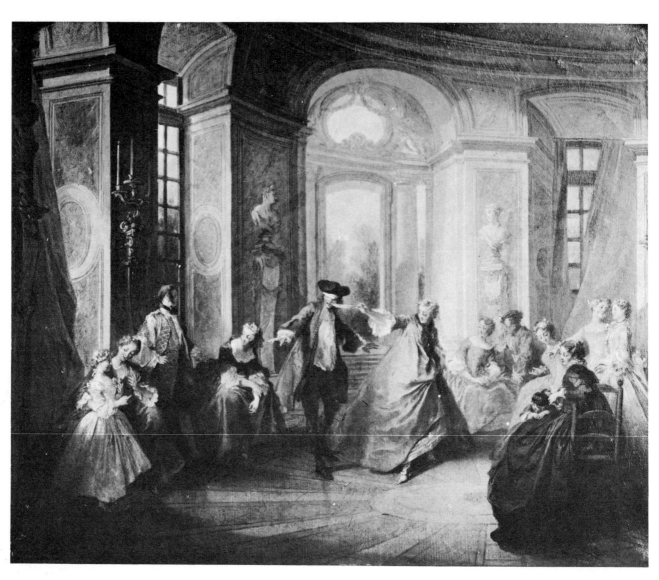

31. Lancret,
*Blind Man's Bluff
Colin-Maillard,*
37 × 47 cm.
Nationalmuseum, Stockholm

After a brief spell with Gillot, from whom he also learnt to love the theatre, Lancret left, on Watteau's advice, to study 'd'après nature'. Instinctively he began to follow in Watteau's footsteps, so closely that the older artist resented the fact that Lancret had poached his own subject matter and was doing so well out of it. Lancret was virtually consecrated Watteau's official successor when in 1719 he was received by the Academy as *'peintre de fêtes galantes'*. The confusion between the master and his follower was such that they were regarded as almost identical by their own contemporaries, and until quite recently several Lancrets were masquerading under Watteau's name. This state of affairs was partly due to the greedy but not always very discerning passion for this type of art of Frederick II of Prussia, who wrote to his sister Wilhelmina: *'La plupart de mes tableaux sont de Watteau ou de Lancret, tous deux peintres français de l'école de Brabant.'*[15] He seems to have cared little about the artist, so long as the work was in the pastoral Rococo style he liked and provided a pleasant accompaniment to his own amateur music-making. As a result, by far the largest single

collection of Lancret's art is still in Berlin, at Sans-Souci and the Neues Schloss, Potsdam. These include some of his most important pieces (the *Country Dance* [*Bal Champêtre*] of 1739, *The Magic Lantern Show* [*Le Montreur de Lanterne magique*], *The Bird-catcher* [*L'Oiseleur*], *The Little Mill* [*Le Moulinet*], *The Pleasures of the Country* [*Les Agréments de la Campagne*], among others), mostly on a broad ambitious scale. Several other similar works by Lancret—including a version of the *Blind Man's Buff* [*Colin-Maillard*]—were bought by that distinguished Swedish collector, the comte de Tessin, for the Royal Collection at Stockholm. Lancret may therefore claim to have been the chief agent in the dissemination of the Watteau manner throughout Europe, even though the style underwent considerable modification in the process as it was adapted to the decorative purpose of Rococo architecture.

It is, however, in his smaller pictures that Lancret displays his own special charm, and a close examination of these will make any confusion between himself and Watteau impossible. Lancret has a direct simplicity and

[38]

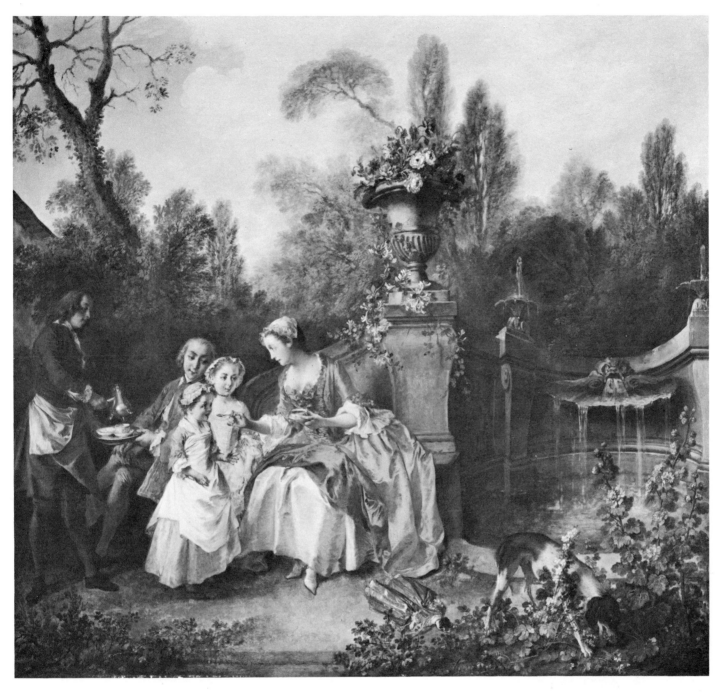

32. Lancret,
The Cup of Chocolate,
89 × 98 cm.
National Gallery, London

paints fully bodied-out figures, but this does not preclude considerable delicacy of colour and modelling. He can be seen at his best in paintings like *The Cup of Chocolate* (Salon of 1742), a delightful evocation of French domestic life around 1740 in which a family is shown taking coffee or chocolate out in the garden. This scene can be regarded as the direct precursor of similar paintings by Boucher like the *Déjeuner* in the Louvre and the *Dressmaker*, and is among the earliest examples of intimist genre painting in the eighteenth century, even though the life it portrays is obviously on a higher social plane than the subjects chosen by Chardin around 1750. To show upper-class people at rest or simply enjoying themselves as private individuals, as opposed to their portrayal in public functions, was still something of a novelty in French art. This Lancret did again in his *Ham Dinner* [*Déjeuner au Jambon*] (1735) at Chantilly which, together with de Troy's more famous *Oyster Dinner* [*Déjeuner d'Huîtres*], formed part of a royal commission for the dining-room of Louis xv's private apartments at Versailles. In this depiction of the easy, unconstrained behaviour of the upper classes during the early years of Louis xv's reign, we can again measure the distance between Lancret's robust but unimaginative art and the elusive poetry of Watteau. For Watteau, the physical world was only a springboard for the imagination, whereas Lancret, like the revellers in his picture, likes to feel, eat and touch the things around him. On occasion, however, he could rise to a certain level of

[39]

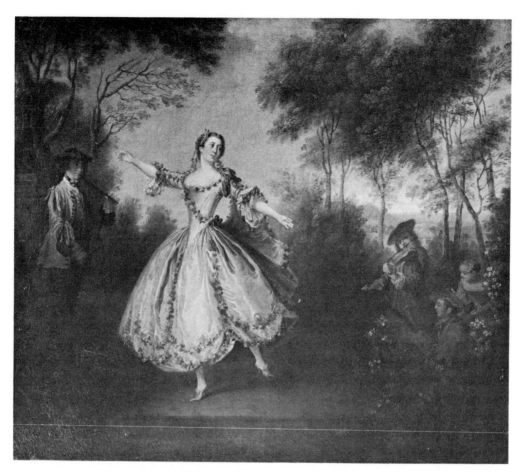

33. Lancret,
Mademoiselle Camargo,
45 × 54 cm.
Musée des Beaux-Arts, Nantes.
Photo: Lauros-Giraudon

36. Mercier,
The Sense of Hearing
from *The Five Senses,*
61 × 74.3 cm.
Paul Mellon Collection,
Yale Center for British Art

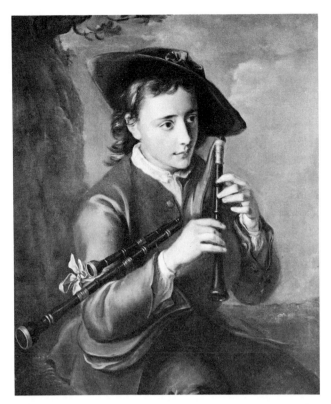

34. Pesne,
Sophie Marie von Voss,
144 × 107.5 cm.
Schloss Charlottenburg,
Berlin

35. Mercier,
The Bagpipe Player,
91 × 71 cm.
Musée de Strasbourg

poetry, as in the charming painting at Nantes of *Mademoiselle Camargo*,[16] the famous dancer from Brussels who charmed the whole of Paris, seen delicately poised in a silvery-blue dress, dancing to the rustic strains of a flute, a fiddler and a bassoon-player.

It would be tedious to list all Watteau's followers in turn, especially since most of them resemble each other closely and add very little to French art, but two of them deserve special mention, both for their intrinsic quality and for their role in the dissemination of the French style abroad. The first is Antoine Pesne (1683–1757), a Parisian artist who, after travelling in Italy, went to Berlin in 1710 and was appointed Court Painter by Frederick I of Prussia. Except for brief visits to Paris and London, Pesne spent the rest of his life at the Prussian court, where he continued to work in a manner loosely derived from Watteau, though closer in actual execution to Lancret. His talent can be judged from paintings like his portrait of *Vleughels* in the Louvre and that of *Jean Mariette* in the Musée Carnavalet. The significance of Pesne's career lies also in the fact that one of his pupils in Berlin was Philippe Mercier (1689–1760). Born in Berlin of French Huguenot parents, Mercier first travelled in Italy and France, before he finally settled in England around 1716 and was appointed Principal Painter to the Prince of Wales in 1729. Both indirectly through Pesne, and during his stay in Paris, Mercier had ample opportunity to study, assimilate and pastiche Watteau's art, from which he made numerous engravings. Mercier also copied a number of Lancret's compositions which he had seen in Berlin, and to this day some of these are still in circulation

under Lancret's name. Mercier was chiefly responsible for importing the *fête galante* into England, where he soon transformed it into the typical eighteenth-century conversation piece. It was in this guise that the French taste penetrated English art, and traces of Rococo elegance can be found in the works of Highmore, Hayman and even Hogarth, but with a greater naturalism and directness as the new generation of English artists found its own feet.[17] Mercier's own style is usually mid-way between the two schools, an agreeable compound of the formal, composed French manner and English simplicity, such as we find in the typical group portrait of *Viscount Tyrconnel with his family* (1705–6, Brownlow Collection), with an exact depiction of Belton House in the background. At other times Mercier comes distinctly closer to the French Rococo style in the charming, if slightly affected rusticity of his young *Bagpipe Player* (c. 1740), at Strasbourg. During his post as Court Painter to the Prince of Wales, Mercier painted several portraits of the English royal family, including the one of the *Prince and his three sisters* of 1733 in the National Portrait Gallery. From 1739 to 1751 Mercier lived in York, where his style of portraiture found considerable favour with the Northern country gentry; many examples of his art are still in their collections today and were recently exhibited in York and London.[18] At his best, notably in the series of *Five Senses*, executed around 1740 (now in the Mellon Collection), Mercier achieves a broadness of treatment and solidity of execution which comes much closer in feeling to the genre scenes of de Troy and even Chardin, far removed from the subtle elegance of Watteau which provided his *point de départ*.

3 : The Decorative Painters of the Rococo

In France, meanwhile, the reinterpretation of Watteau's art by Lancret and others was taken up by a new generation of decorative painters led by Jean François de Troy, which first clashed, then finally merged, with an older tradition continued by Lemoine and Natoire. The two opposite poles from which the new decorative style emerged confronted each other in the intense personal rivalry between de Troy and Lemoine and the famous competition of 1727.[1] The result was a specifically Rococo type of painting designed to complement the architecture of the period, which later culminated in the supreme representatives of decorative art, Boucher and Fragonard. Painting of this sort, often of mythological subjects on a broad scale executed in pastel shades of pink and blue ('la peinture claire'), is usually thought of as the unique contribution of the French eighteenth century. In fact it is really a marriage of two different strains, both of non-French origin: first, the grand-style monumental painting, derived from the Italian Baroque and adopted as the official style by Lebrun and Louis XIV at Versailles; second, the far more lighthearted and colourful Venetian fresco manner imported into France by Sebastiano Ricci and Pellegrini (who in 1720 painted a ceiling for the Banque Royale, now destroyed). These two styles gradually came to merge in most French decorative art from about 1730 onwards. They are clearly perceptible in a lingering preference for the well-defined outlines and expressive attitudes of the Baroque, coupled with a Venetian delight in pure, bright colours and a rejection of the sombre 'soup and gravy' effect associated with much seventeenth-century ceiling decoration.

Nevertheless the tradition of Lebrun and Versailles continued well beyond the first decades of the eighteenth century. Its last representative—and ultimately its victim—was François Lemoine (1688–1737), a man whose heroic but belated ambition to rival and perpetuate Lebrun's prestige led to his suicide in 1737. Born in Paris in 1688, Lemoine began as a pupil of Louis Galloche 1670–1761), a close adherent of the precepts of Roger de Piles and one of the most original teachers of his time. Galloche inspired in his pupils the same eclectic love of the Old Masters, Raphael, Correggio, Titian and, most of all, Rubens, spending many hours in the Luxembourg Palace, studying and making copies of the *Marie de' Medici* cycle. But, according to Caylus, he was not content to teach from previous examples, and urged young painters to go out and study nature in the countryside, to '*puiser les beaux effets que produisent les saisons différentes*'.[2] Such ideas,

which prefigure those of Diderot in the *Essais sur la Peinture* by more than half a century, began to germinate slowly in the minds of French artists but were only to bear recognizable fruit after the decisive turn away from the Rococo after 1750. This influence can have been only partial on Lemoine who, despite his adoption of Rubensian colour, remains one of the last exponents of the grand monumental tradition based on the priority of figure painting.

Lemoine soon fulfilled his high ambitions by winning the Prix de Rome in 1711 with a painting of *Ruth and Booz*. This was the prelude to a whole series of commissions for religious works including a *St Jean dans le Désert* in Nantes cathedral, followed in 1715–17 by a series of paintings devoted to the life of Christ, five of which are now kept in the cathedral at Sens.[3] In 1718 he was received as a full member of the Academy on the strength of his *Hercules and Cacus* in the Ecole des Beaux-Arts. His official training thus complete, Lemoine went on in the 1720s to produce a handful of large impressive works which, to his contemporaries, made him seem the most important painter of his generation. Even if this judgement may appear exaggerated today, some of the paintings are of more than historical interest, notably the *Tancred Surrendering Arms to Clorinda* in Besançon, commissioned in 1722 by Berger, a wealthy tax official for the Dauphiné and a friend of the duc d'Antin. This large and brilliantly coloured composition, with its warm reds and yellows in the Rubens manner and the silvery sheen of the heroine's horse prancing in the middle, can be seen as both an echo of seventeenth-century monumental painting and a step towards the lighter, more playful allegories of the Rococo. It is a typical product of the half-way house which French art had then reached.

Lemoine's supreme ambition was to be the greatest decorative painter of his time, to surpass the work of Antoine Coypel in the chapel of Versailles and to be seen as the true successor to Lebrun. But he had none of the simple-minded conviction of his great predecessor, and he was typical of his generation in his wavering allegiances, first to Rubens and then to the Venetians. Gradually the Italian influence took precedence in his work and, rather than Rubens, he sought inspiration in the crystalline colours of Correggio and the Venetians (especially Titian and Veronese). This gradual evolution was first marked by the visit to Paris of Pellegrini (1675–1741), the Venetian decorative painter, whose ceiling for the Banque Royale (an allegory on the subject of *France sous les traits de*

37. Lemoine, *Tancred Surrendering Arms to Clorinda*, 162 × 275 cm. Musée des Beaux Arts, Besançon

38. Lemoine, *Hercules and Omphale*, 184 × 149 cm. Musée du Louvre. Photo: Musées Nationaux, Paris

[42]

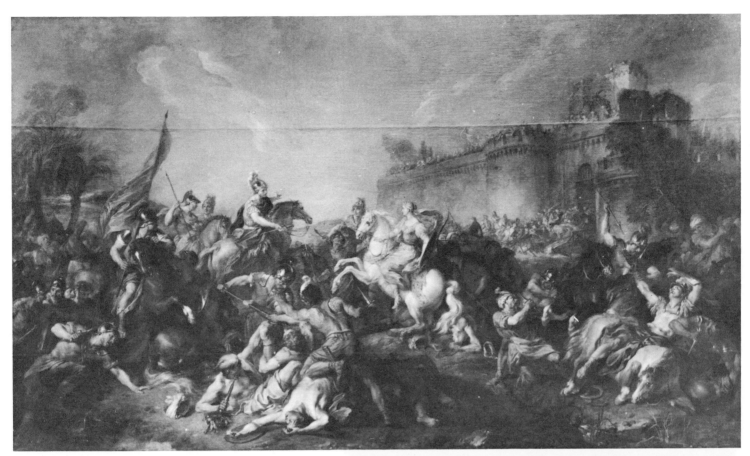

Minerve) so excited Lemoine's jealousy that, determined to outdo his foreign rival, he made plans to paint another version of the same theme.[4] Then, in 1723, Lemoine finally made his long-desired journey to Italy. He travelled to Rome, where he was much impressed by Pietro da Cortona's ceiling in the Palazzo Barberini; then to Bologna and Parma for the obligatory pilgrimage to admire the works of Correggio. But it was Venice and Veronese which made the greatest impact on his imagination. The direct result of this journey was the *Hercules and Omphale* (1724), in the Louvre, a vigorous if not wholly attractive painting which clearly echoes Correggio in its subject matter. The painting, however, has none of Correggio's transparency, and in its rather coarse handling and the strong ruddy brown of Hercules' flesh still feels closer to the Northern tradition of Lebrun and Rubens.

Lemoine finally imposed himself on the Parisian public at the Salon of 1725 where he exhibited a number of important works, including the *Hercules and Omphale* and *Perseus Delivering Andromeda* in the Wallace Collection. These paintings testified to the range and variety of his talent and a complete mastery of the historical and mythological styles. He was well on the way to the uncontested leadership of the French school he so ardently coveted. It is probable that he would have achieved this goal if there had not been another equally ambitious rising star on the horizon, Jean-François de Troy. De Troy was an artist of

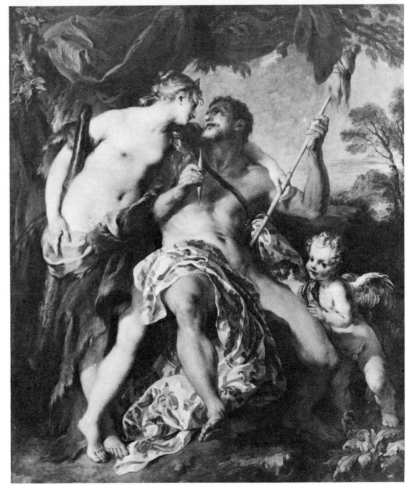

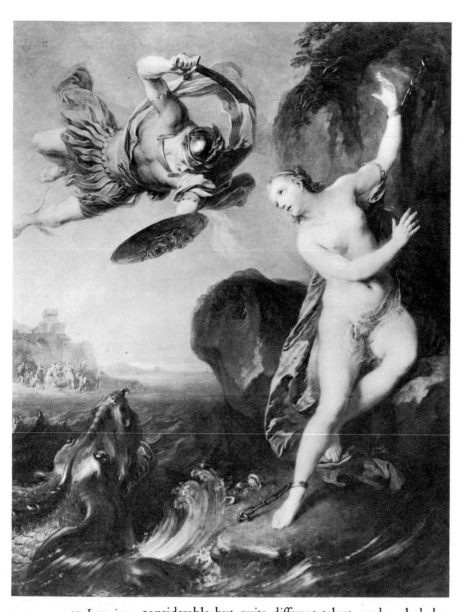

39. Lemoine,
Perseus Delivering Andromeda,
164 × 151 cm.
The Wallace Collection, London

French art which he craved, while de Troy, who had carefully prepared the ground before the exhibition with a good deal of intrigue, felt humiliated by such an affront to his vanity. This confusion was typical of the French academic system and its passion for hierarchies and prizes, which may perhaps have ensured a certain level of technical competence among mediocre artists, but was fatal to those with any spark of creative originality. It is no accident that some of the most gifted artists of the eighteenth century managed largely to by-pass the official system.

Lemoine, spurred on by unsatisfied ambition, embarked on a series of religious and decorative projects. In 1729, he was commissioned to paint a large oval ceiling decoration for the Salon de la Paix at Versailles, representing Louis XV conferring peace on Europe, and between 1731–32 he was occupied in painting a fresco for the Chapelle de la Vierge in Saint-Sulpice.[5] However, these commissions were only a dress rehearsal for what was to be his last and most ambitious project, the ceiling for the Salon d'Hercule at Versailles. He began work on this in 1733 and, after some painstaking efforts, finished it in 1736 when it was officially unveiled to the King, amidst unanimous applause. Lemoine had finally won universal recognition and a place in the pantheon of the great French tradition. Cardinal Fleury remarked that the work would eclipse all the other painting at Versailles,[6] while Voltaire wrote in a much-quoted passage '*Il n'y a guère dans l'Europe de plus vaste ouvrage de peinture que le plafond de Lemoine, et je ne sais s'il y en a de plus beau.*'[7] From Voltaire, the apologist of the Grand Siècle who despised the petty mannerisms of the Rococo, such words were like the official sanctification of his art. To his contemporaries, as well as to the influential mid-eighteenth century critic Lafont de Saint-Yenne, Lemoine came to be seen as the latest link in a chain stretching from Colbert and Lebrun into the new age. His career reached its climax in 1736 when he was appointed *Premier Peintre du Roi.* But he was still dissatisfied, aware that the post no longer carried the same authority and prestige as it had done in the previous century. History painting, moreover, had become something of an anachronism when most of fashionable society had gone over to the more accessible Rococo style. These circumstances, coupled with his own temperamental instability, finally drove him to kill himself with his own sword in 1737. Jean-François de Troy (1679–1752),[8] by contrast, was a brilliant, facile artist, with far more natural ability than his rival. Had it not been for adverse circumstances which deprived him of the occasion to develop his talents to the full, de Troy might have risen to become one of the greatest French painters of the eighteenth century. In an astute judgment, Rigaud said of him that if his capacity for work had equalled his genius, painting would have had no finer representative. As it is, he is certainly one of

considerable but quite different talent, and a clash between the two men became inevitable; they were, moreover, totally opposed in temperament, Lemoine being industrious, painstaking and serious, while de Troy had great natural ability but enjoyed luxury and the pleasures of society. The conflict was brought to a head by a competition organized by 1727 by the *Surintendance des Bâtiments* under the direction of the duc d'Antin. The exhibition was designed to bring together the twelve most famous artists of the day, including amongst others the Coypels, Cazes and Galloche, but primarily to confront the two main rivals, Lemoine who exhibited his *Continence of Scipio*, and de Troy his *Bath of Diana*, both of which now hang side by side in the museum of Nancy. In the event, the jury decided that both works were equal in merit; no first prize was awarded and the sum of five thousand francs was divided between them. But such an indecisive result satisfied neither party. Although Lemoine was subsequently appointed professor at the Academy, he had failed to win the absolute authority over

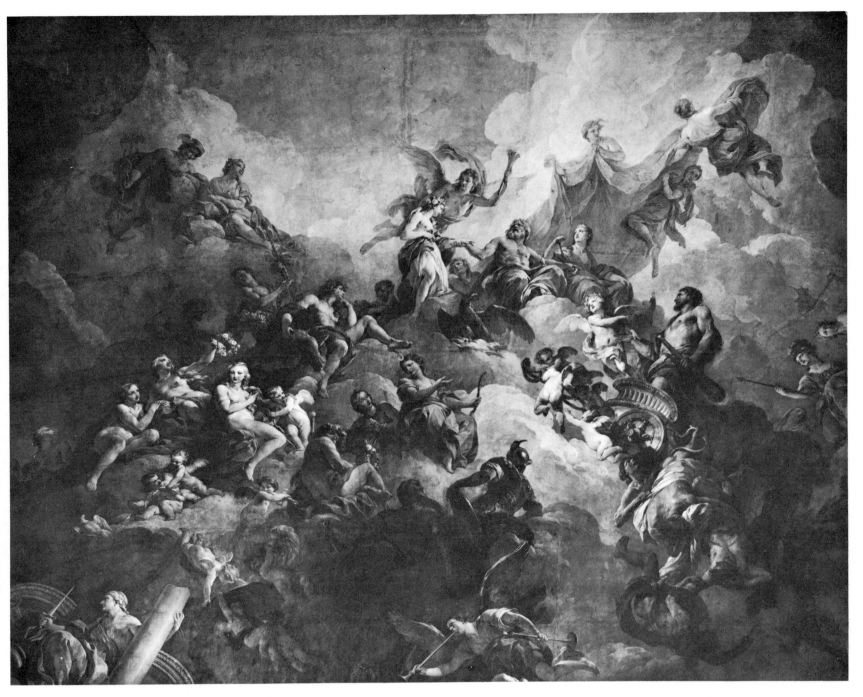

the most interesting and attractive artists, and his scenes of fashionable life like the *Declaration of Love*, the *Surprise*, and the *Reading from Molière*, count among some of the most delightful evocations of French society during the Rococo period. De Troy had all the virtues and the vices of the age he lived in. He was vain, ambitious and as passionate as the cavalier pressing his suit so ardently in the *Declaration of Love*, and he loved money and success without hard work; he led a brilliant social life, gambling, womanising and cultivating the friendships of rich and influential patrons like Samuel Bernard. In the words of his biographer, the Chevalier de Valory: '*Guidé par son penchant vers la volupté, il essaya jusqu'au rôle d'homme à bonnes fortunes.*' This love of pleasure and luxury is the character-

istic of de Troy's art and makes him the most outstanding representative of the early Rococo taste in French painting.

De Troy was born in Paris in 1679, the son of another accomplished artist François de Troy (1645–1730), a portrait painter from Toulouse and friend of Rigaud and Largillierre. As a boy, de Troy already displayed the ease of a natural painter and decorator. Between 1698 and 1706 he visited Italy, where he came strongly under the influence of the Venetians, especially Veronese and Palladio, and for a while he was a pensioner at the French Academy in Rome. On his return to Paris in 1706, de Troy began an orthodox career as a history painter and in 1708 was received as a full member of the Academy on

40. Lemoine,
The Apotheosis of Hercules,
1850 × 1700 cm.
Château de Versailles.
Photo: Alinari-Giraudon

[45]

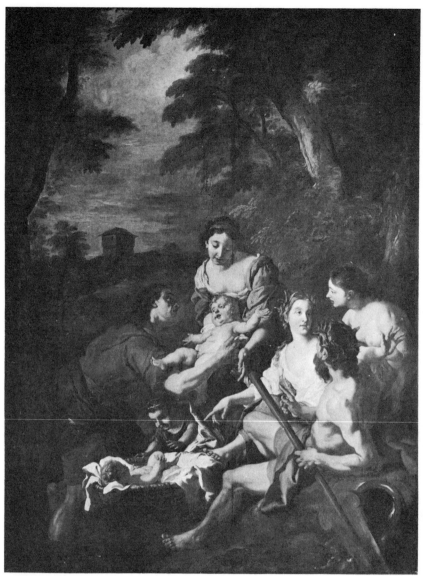

41

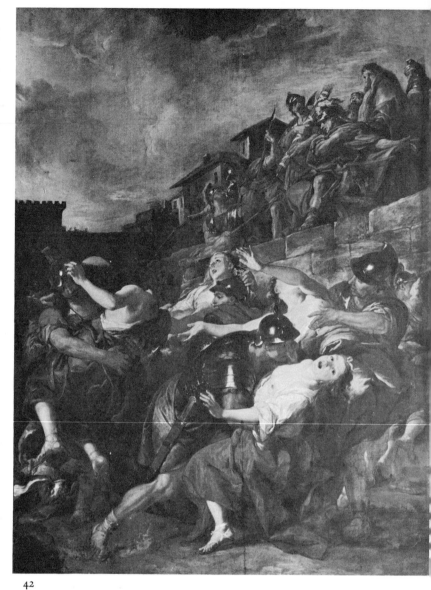

42

41. De Troy,
*The Birth of Romulus
and Remus,*

270 × 204 cm.
Musée d'Art et d'Histoire, Neuchâtel.
Photo: J. M. Breguet

42. De Troy,
The Rape of the Sabines,

270 × 204 cm.
Musée d'Art et d'Histoire, Neuchâtel.
Photo: J. M. Breguet

the presentation of his *Niobe and her Children Wounded by Apollo* (Montpellier). This was followed in 1715 by a painting *Susanna and the Elders* (Hermitage), and in 1722 by a *Plague of Marseilles* (Marseilles). Such historical and biblical subjects were to provide the mainstay of de Troy's career and, according to Mariette, it was on these that he founded his reputation, even though the *tableaux de modes* proved more popular with his Parisian public. On his return from Italy, he soon penetrated the smart society of the Regency and joined whole-heartedly in its hedonistic spirit, gambling, making love and indulging in riotous supper parties. It was in this milieu that he met his two most valuable patrons, Samuel Bernard and François-Christophe de Lalive, a *receveur-général des finances*, whose mansion in the rue Neuve du Luxembourg he decorated in 1726–7 with a series of thirty-five allegorical panels on such well-worn subjects as the Arts and Sciences, the Seasons, and the Four Corners of the World.

In 1723 de Troy executed one of his most important

commissions for Samuel Bernard, another financier who lived on the most lavish scale: a set of four subjects from Roman history, *The Birth of Romulus and Remus, Coriolanus Yields to his Mother's Entreaties, The Rape of the Sabines* and the *Continence of Scipio,* all now in the museum of Neuchâtel, which were to decorate the gallery of his patron's house in the rue Notre-Dame-des-Victoires. This splendid, little-known series of paintings shows the same easy mastery in the historical style that we find in his subjects from contemporary life. There is nothing stiff or pedantic about them, as is so often the case with history paintings of this period. The mood ranges from one of Rubensian fury in *The Rape of the Sabines* to the Arcadian calm and tenderness of *Romulus and Remus.* There is scarcely a hint of the linear rigidity of Jouvenet and the Lebrun school, rather a sense of vibrant undula-ting movement.

After the disastrous competition of 1727, where de Troy exhibited his somewhat feeble picture, *The Bath of*

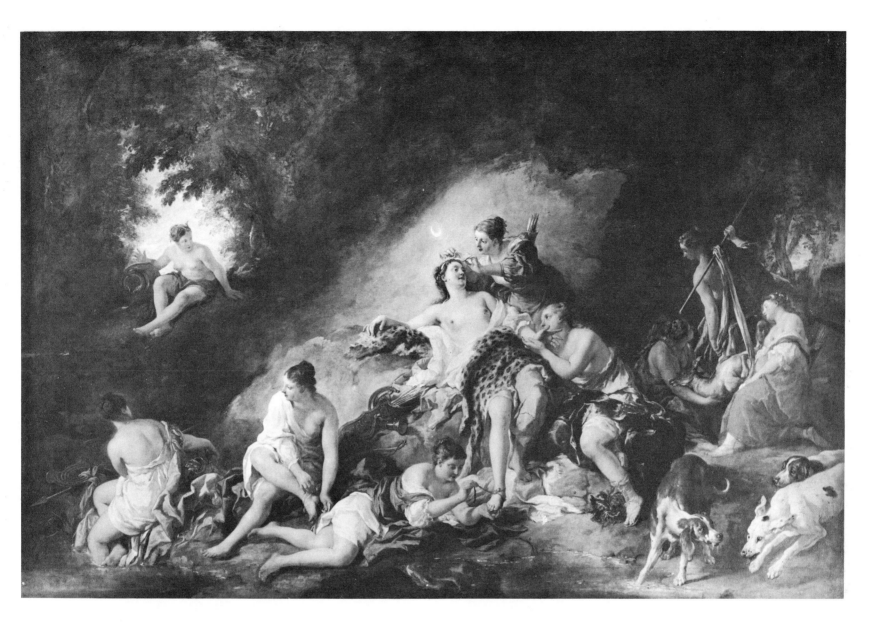

43. De Troy,
The Bath of Diana,
130 × 196 cm.
Musée des Beaux-Arts, Nancy.
Photo: Musées Nationaux, Paris

Diana, and the appointment of Lemoine to the post of *Premier Peintre* in 1736, de Troy retaliated by lowering the price of his work in attempt to undercut his rival. For a while, this ploy was successful and brought him several important commissions from the Church and the Monarchy, including the vast cycle of *The Life of St Vincent de Paul* (1730–32), painted for the Mission of St Lazare in Paris.[9] Finally, in 1734, at the age of fifty-five, he received royal commissions for work at Versailles: the decoration of the new Chambre de la Reine (still *in situ*), in collaboration with Boucher and Natoire. The following year, de Troy contributed his well-known *Oyster Dinner* as part of a decorative project for the dining room in Louis xv's new private apartments on the second floor of the château, where it hung alongside Lancret's *Ham Dinner* (both now at Chantilly) and other panels by Pater, Vanloo, Boucher and Parrocel, all designed to celebrate the pleasures of the table. In 1736, he received an important commission to collaborate on a large decorative

ensemble of six hunting scenes for the Petits Apparte-ments of Louis xv at Versailles. This impressive scheme was dismantled later in the eighteenth century and the separate panels by de Troy, who contributed *The Lion Hunt*, with others by Boucher, Carle Vanloo, Parrocel, Lancret and Pater, were sent in 1801 to decorate the Hôtel de Ville at Amiens to celebrate the Peace of Amiens in that year. In 1874 they were removed to the local museum, where they can all be seen today, a handsome group of paintings which bears lasting witness to Louis xv's passion for hunting, and at the same time reflects the growing taste for exotic subjects during the second quarter of the eighteenth century. In 1737, de Troy painted two panels for the royal dining room at Fontainebleau, a *Hunting Breakfast* and a *Stag at Bay*. These two hunting scenes, painted almost certainly from real life in the surrounding forest of Fontainebleau, have unfortunately vanished but, to judge from two brilliantly improvised sketches (signed 1737) preserved in the Wallace Collec-

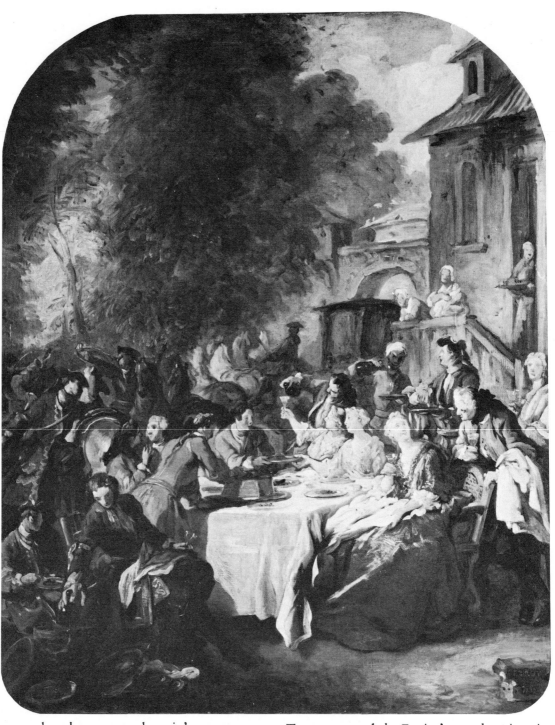

45. De Troy,
The Hunting Breakfast,
56 × 46 cm.
The Wallace Collection, London

44. De Troy,
The Oyster Dinner,
180 × 126 cm.
Musée Condé, Chantilly.
Photo: Giraudon

tion, they must have been among the artist's most success-
ful works and show him to have been an accomplished
recorder of the aristocratic pursuits of contemporary
French society.

All these schemes, however prestigious, failed to satisfy
de Troy's ambition to be first in the field of decorative
painting, for which his natural ability and superb
panache certainly equipped him. He was not content to
be one of a team. Despairing of obtaining enough royal
commissions, he looked for a different outlet by making
models for the Gobelins tapestry factory. In 1736 he began
the sketches for the first set of tapestries based on the story
of Esther. Inspired partly by the Book of Esther in the Old

Testament, partly by Racine's tragedy written in 1689 for
Madame de Maintenon's convent school of Saint-Cyr,
these relate the history of the Jewish princess, Esther, who
married the Persian king Ahasuerus in order to save her
people from destruction.

The initial sketches are handled with all de Troy's
usual brilliance and verve, and have frequently been
compared with Rubens; rapidly improvised in greys and
browns, with a touch of red or yellow, outline is conveyed
in only the sketchiest manner. These preliminary studies
are now scattered throughout various collections, includ-
ing five in the Musée des Arts Décoratifs, Paris, four in the
museum of Beaune and two of the most important, *Esther*

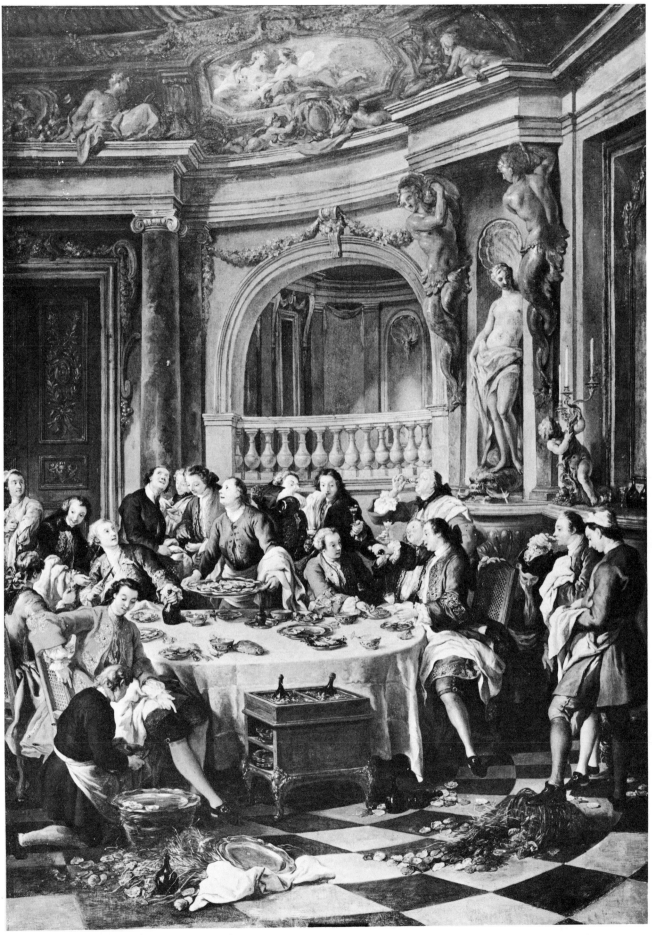

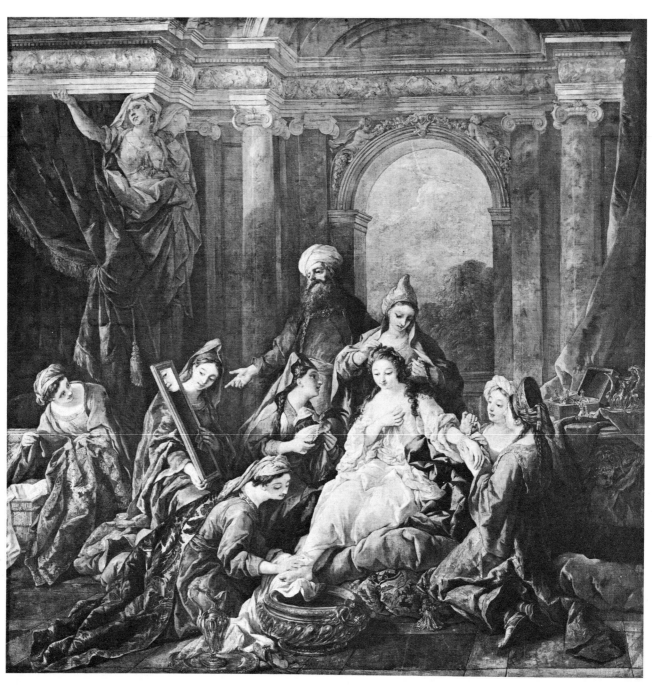

46. De Troy,
Esther at her Toilet,
325 × 320 cm.
Musée du Louvre.
Photo: Giraudon

at her Toilet and *Esther Fainting* [*L'évanouissement d'Esther*] in the Louvre. The last two are the most finished of the sketches and can almost be regarded as paintings in their own right. The first depicts the scene in which the Jewish princess is being dressed by her female attendants in the harem, while the second represents the most dramatic moment in the story – corresponding to the lines, '*Mes filles, soutenez votre reine éperdue*' from Act II, Scene VII of Racine's play – when Esther faints on first being ushered into the terrible presence of Ahasuerus. (De Troy cannot have been unaware that this last subject had also been treated by Veronese in a magnificent painting, now in the Louvre.)

When the sketches were exhibited in 1737 they won wide acclaim and de Troy was finally hailed as the leading painter of his generation. Undoubtedly some of his original panache was lost in the large cartoons which followed in 1737–40 and in the completed tapestries (of which one set is now in the château of Compiègne), but the illustration of *Esther* remains de Troy's great contribution to the decorative, historical style of around 1740.

In 1738, de Troy was given some degree of official recognition when he was appointed Director of the French Academy in Rome. There, according to the Président de Brosses who visited him in 1739, the painter continued to live in some style ('*c'est presque un seigneur*'), entertaining lavishly and neglecting his official duties: '*On s'égosille sur la peinture contre Monsieur Detroy qui ne connaît point de peintre au-dessus de Véronese, si ce n'est lui-même.*'[10] He was, by all accounts, popular with the

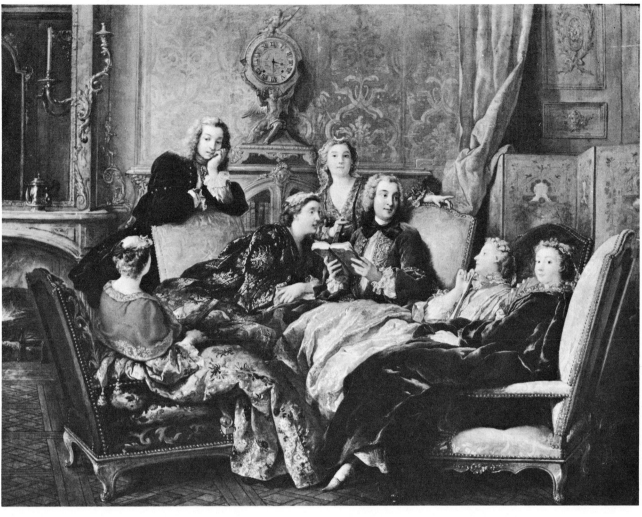

47. De Troy,
A Reading From Molière,
72.4 × 90.8 cm.
Private Collection.
Photo: Sotheby Parke Bernet

young French pensioners under his charge in Rome, generous and tolerant. But this was not enough to satisfy his immediate superior in Paris, the *Directeur-Général des Bátiments*, Orry, a thrifty disciplinarian who looked on de Troy's extravagance with displeasure and accused him of laxity in administration. De Troy managed to hold on to his post until 1750, when he became involved in a personal quarrel over a woman with the marquis de Marigny. He was finally replaced in 1751 by Natoire, and returned to Paris in disgrace.

These last years in Rome were not the most productive of his life, and de Troy felt, not without reason, that he had been unfairly treated by the official French administration which had failed to give him the opportunity to display his talents to the full. One more grand decorative cycle occupied him between 1742 and 1748: the series of illustrations of the story of *Jason and Medea* (from Ovid's *Metamorphoses*), also designed to be reproduced in Gobelins tapestry. As with the *Esther* series, the preliminary sketches, for example the scenes of *Jason Swearing Affection to Medea*, in the National Gallery, London, and *Jason Taming the Bulls* (Birmingham, Barber Institute), are of the highest quality. But when the large completed pictures were exhibited at the Salon of 1748 they were

unenthusiastically received, partly perhaps because the public saw them as a mere repetition of the *Esther* paintings, but primarily because the critical tide had begun to turn against their Rococo theatricality. Thus de Troy became the first of his generation to suffer from the change in taste which later emerged as neo-classicism. He was widely criticized for banality of expression and redundant display. It was true that de Troy had had a mediocre education, that his working habits were desultory and that he was content to treat well-worn themes from history and mythology without much creative originality, but even his opponents found it hard to deny his superb natural gifts. As the comte de Caylus wrote in his official obituary of the artist: '*Les plus grands ouvrages naissaient pour ainsi dire sur la toile et tenaient du prodige.*'[11]

Today de Troy is better known for his scenes of fashionable life, which seem to us to epitomize the Rococo style in painting. They are the direct precursors of Boucher, both in his gallant erotic subjects and in his scenes of French domestic life. One of the most delightful of these '*tableaux de modes*', the *Reading from Molière* (private collection, probably of around 1728) shows a small group of elegant people assembled in a drawing room for a reading party, much as we might imagine an evening in

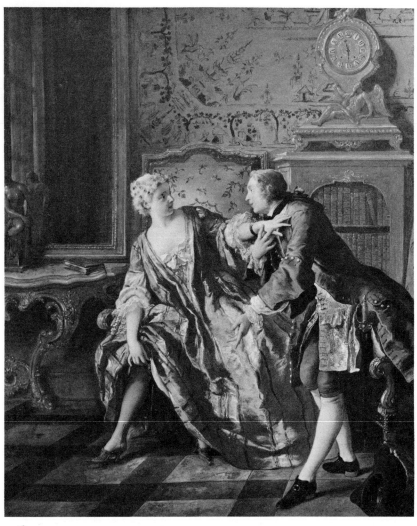

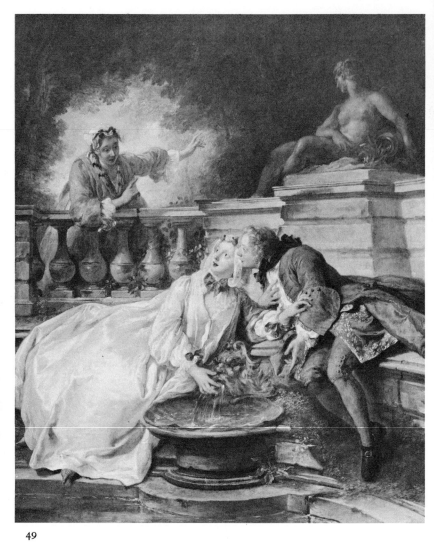

48

49

Plate 5 faces pages 33

48. De Troy,
The Garter,
63.7 × 52.7 cm.
Private Collection,
New York.
Photo: Taylor & Dull

49. De Troy,
The Surprise,
69.5 × 63.8 cm.
Victoria and Albert Museum,
London

the *salon* of Madame de Lambert or Madame du Deffand. The participants are attentive but relaxed and shown in a variety of poses, some casual, some studied; they are obviously aware of a spectator observing them, but have none of the stiff formality of seventeenth-century group portraits. This informality and relaxation of social etiquette was a constant feature of eighteenth-century life and is correspondingly reflected in its art. Love-making was also a favourite subject with de Troy, and is best exemplified by the splendid pair of paintings in the Wrightsman Collection in New York, *The Declaration of Love* and *The Garter* (both exhibited at the Salon of 1725). In the first, a passionate, healthy-looking cavalier presses his suit on a by-no-means reluctant young woman, leaning nonchalantly against a cushion, while above the sofa an explicit rape scene in an elaborate Rococo gilt frame provides the obvious commentary on their behaviour; and yet there is something decorous and courtly about this painting which sets it apart from the more blatant eroticism of Boucher. *The Garter* expresses a similar erotic intention, set against another typical Rococo interior with a tall pier glass over a console table and the background decorated with a delicate Chinese paper; the entire scene

closely prefigures Boucher's *La Toilette* of 1742. Another excellent example of de Troy's *manière galante* can be found in *The Surprise* (1723) in the Victoria and Albert Museum, in which a young woman comes to warn a courting couple in a secluded corner of a park that someone is approaching—a light, deftly-painted scene of considerable technical virtuosity.

Lemoine and de Troy represent the opposite poles in French art of the early eighteenth century but they were perhaps too exceptional as individual artists to be representative of the Rococo phase of taste in general. The evolution of this style has already been traced elsewhere,[12] and its application belongs more strictly to architecture and the decorative arts than to pure painting. But since painters frequently worked in close collaboration with architects, designers, carvers and goldsmiths, and their canvases were often designed to fit into some decorative ensemble, brief mention must be made of some names from a host of minor figures who contributed to the development of this uniquely French creation. The term Rococo is generally understood today to mean the surface type of decoration which flourished in French interiors between around 1710–40. It was a style based on arab-

[52]

esques, curves and double curves, designed to produce effects of filigree lightness and delicacy, in place of the heavy mouldings, cornices and symmetrical compartments of the late seventeenth century. The hôtels which sprung up in the newly fashionable quarters of Paris, especially the Faubourg Saint-Germain, were placed '*entre cour et jardin*' (between the courtyard and the garden) for maximum light, while their interiors were designed with an eye to elegance, convenience, and the intimacy of small social gatherings. This is the setting in which we must imagine the revival of the literary *salon* in the first quarter of the eighteenth century. The Rococo was an aristocratic but not a courtly style, since it came about as a deliberate reaction against the pomp and splendour of Versailles. It was pre-eminently well suited to the social and intellectual pattern of French life which lasted until the outbreak of the Revolution.

It is generally accepted that the origins of the Rococo style can be traced back to the work of French architects and designers such as Jean Bérain (1640–1711) and Pierre le Pautre (*c.* 1648–1716) during the closing years of the seventeenth century, and that painting was only subsequently adapted to decorative schemes devised by them and their successors. Bérain, a pupil of Lebrun, worked at Meudon, and made numerous designs for chimney pieces; but he did not slavishly copy his master, and introduced arabesques and ribbonwork in relief and made other small but significant changes to the prevalent decorative mode. The same process of refinement and lightening of Lebrun's ponderous structures can be observed in the work of Pierre le Pautre, a protégé of Jules Hardouin-Mansart, who executed designs for Marly, Trianon and the *Salon de l'Oeil de Boeuf* (1701) at Versailles. These, however, were basically only amendments to the French classical scheme. The real innovators were to come from outside France.

Gilles-Marie Oppenord (1672–1742), the son of a Dutch cabinet-maker, studied as an architect and draughtsman in Rome, where he was profoundly impressed by the Baroque masterpieces of Bernini and Borromini. On his arrival in Paris in 1699, he became a member of Crozat's circle and was soon adopted by the duc d'Orléans, who was instinctively attracted to the Italianate extravagance of Oppenord's style when more conservative French patrons fought shy of it. In the opening years of the Regency, Oppenord was appointed *Directeur-Général des Bâtiments* to Philippe d'Orléans and worked extensively for him on the Palais-Royal. In addition, he designed many altar-pieces for Paris churches, including one for Saint-Germain-des-Prés (1704), but few of his designs were executed, as they were considered either impractical or too wayward for French taste. It was only later in his career that his designs were accepted and this Baroque strain was gradually assimilated into the

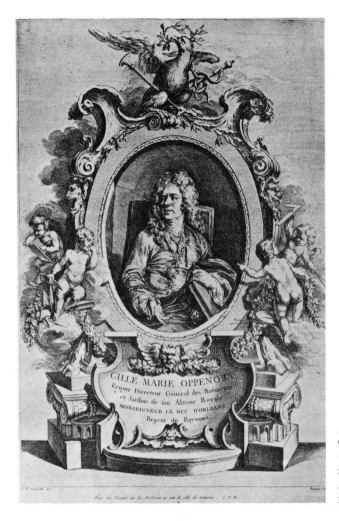

50. Huquier, engraving after *Oppenord: Self-Portrait*, in *L'Art Décoratif Applique à L'Art Industriel*.
Photo: The British Library Board

51. Oppenord, decorative panel, 49.3 × 37.3 cm. Kunstbibliothek Staatliche Museen, Berlin. Photo: Preussischer Kulturbesitz, Berlin

[53]

52. Huquier,
engraving from Meissonnier's
design
for a soup tureen, in *L'Art
Décoratif
Appliqué à L'Art Industriel.*
Bibliotheque Nationale, Paris.
Photo: Giraudon

53. Huquier,
engraving from Meissonnier's
design
for a candlestick, in *L'Art
Décoratif
Appliqué à L'Art Industriel.*
Bibliotheque Nationale, paris.
Photo: Giraudon

54. Huet,
Two Monkeys Smoking,
pencil drawing 14.3 × 19.2 cm.
Courtauld Institute, London

French decorative manner. A typical decorative panel by Oppenord in the Kunstbibliothek, Berlin, gives some idea of his highly capricious, ornate style and shows clearly why Blondel described him as '*un de nos plus grands dessinateurs*'.[13]

Juste-Aurèle Meissonier, born in Turin in 1695, also spent his early years in Italy and was trained in the native Baroque style. He is usually ranked with Oppenord as the other principal creator of the Rococo and his career developed along similar lines. He designed candlesticks, monstrances, altar-pieces and all kinds of ornaments which display a consistently un-French preference for asymmetry, twisted forms and distorted *cartouches* – and for this reason were mostly not executed. Gradually, however, the style attracted increasing interest in France, and in 1726 Meissonier was appointed Dessinateur de la Chambre du Roi. Moreover, like Oppenord, Meissonier exerted his greatest influence on French art and design through the publication of large folio volumes with engravings after his own drawings. The most notable of these was entitled *Livre d'ornements inventés et dessinés* (1734), published by Huquier, containing designs for fountains, cascades, and architectural fantasies, with drawings of shells, figures and animals which, in the words of the *Mercure de France* for March 1734, '*font des effets bizarres, singuliers et pittoresques, par leurs formes piquantes et extraordinaires.*'[14] Books of this kind were to be a major source of inspiration for painters of architectural *caprices* like Jacques de Lajoue (1686–1761), and Meissonier's elaborately curving fountains and colonnades can often be found in the background of pastorals by Boucher and his followers.

These are only a few of the multitude of draughtsmen and artists who contributed to the style, which only reached its full maturity after 1720. Many of the finest Rococo interiors designed for aristocratic *hôtels* in Paris and the châteaux of the Île de France have been dismantled or altered, but enough survive to give us a good idea of their original appearance. What cannot be recreated so easily is the atmosphere of life as it was lived in them; the easy, informal social groups of people reading or discussing the latest news, or the large animated music parties, as in Lancret's painting of Crozat's house. Many of these houses, like the Hôtel de Roquelaure (begun in 1722 by Jean-Baptiste Leroux), in which three of the original rooms survive, are now used for official purposes, while the *salons* at Rambouillet (*c.*1735), designed for the comte de Toulouse, are used for state receptions. It was only after about 1730 that the Rococo style, hitherto confined mainly to architectural effects in the panelling and wainscoting, suddenly burst out into a riot of picturesque little figures and animals, of monkeys in Chinese dress perched on 'double C' scrolls, set against a background of exotic plants and landscapes. The chief expo-

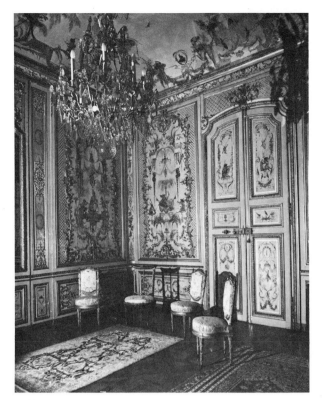

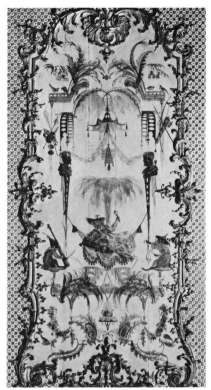

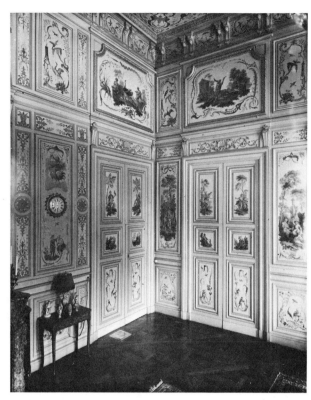

55

56

57

nent of this manner, known as *chinoiserie* or *le Rococo pittoresque*, was Christophe Huet (d. 1759), who made a witty kind of variant on La Fontaine's *Fables* in a series of drawings showing monkeys in oriental costume performing human actions (for example, *Two Monkeys Smoking*, Witt Collection, Courtauld Institute) entitled *Singeries ou différentes actions de la vie Humaine*. Huet was also responsible for the decoration of the two Chinese rooms at Chantilly, painted in 1735 for the duc de Bourbon, and for what is perhaps the most perfect of all Rococo interiors, the exquisite drawing-room at Champs-sur-Marne (painted in 1748, but much restored), where the panels filled with large exotic figures and trees create an almost overwhelming abundance of surface animation.[15]

The greatest masterpiece of this phase of taste, which may perhaps be seen as the last flowering of the Rococo, is undoubtedly the decoration of the Hôtel de Soubise (1735–7). Soon after his marriage in 1732, the prince de Soubise commissioned the architect Germain Boffrand to create new apartments for himself and his bride, the princesse de Rohan; his own were on the ground floor and those of the princesse were on the first floor, culminating in the famous oval saloon. The most prominent artists of the period collaborated on the project, including Boucher (who contributed four mythological scenes and two pastorals), Natoire, Carle Vanloo, Pierre and Trémolières, while the stucco work was carried out by Brunetti. The highlight of the whole scheme, however, is the *Salon de la Princesse*. This is the most elaborate creation of the entire Rococo period, a complex structure of mirrors

and panelling where the gilt scrollwork takes off from the walls and divides the ceiling into separate compartments. In the spandrels, Natoire surpassed himself with a series of eight mythological paintings, executed between 1737 and 1739, on the theme of the story of Psyche. These are certainly among the finest examples of Natoire's early decorative manner, before he took up history painting a decade later, and show great subtlety and refinement, both as compositions in their own right and in the way they are integrated into Boffrand's overall scheme. The soft, voluptuous curves of the figures fit effortlessly into the curvature of the spandrels, and the delicate shades of blue, pink and green provide the perfect complement to the sky-blue ceiling, the gilt frames and the white and gold panelling. The scenes are set against architectural backgrounds of urns and colonnades which create a three-dimensional effect, but any sense of artificiality is banished by the presence of fresh green foliage and limpid water. The eight paintings are taken from La Fontaine's *Les amours de Psyché* (1669), based on the original story in Apuleius' *Metamorphoses*, and represent different episodes from the life of the King's daughter, who aroused Venus's jealousy by her beauty and was seduced by Cupid in her sleep.[16] By the eighteenth century, the legend of Psyche had become synonymous with the joys and sufferings of love, and it is easy to see why it held such a strong appeal for artists of this period, including Boucher and Fragonard. To single out one scene from this fine sequence is difficult but perhaps Natoire's qualities as an illustrator of narrative can be seen at their best in *Nymphs Welcoming*

55. Huet,
Salon des singes (detail).
Musée Condé, Chantilly.
Photo: Lauros Giraudon

56. Huet,
Salon des singes (detail).
Musée Condè, Chantilly.
Photo: Giraudon

57. Huet,
Salon Chinois,
Château de Champs-sur-Marne,
Photo: Caisse Nationale des Monuments
Historiques et des Sites.
© S.P.A.D.E.M.

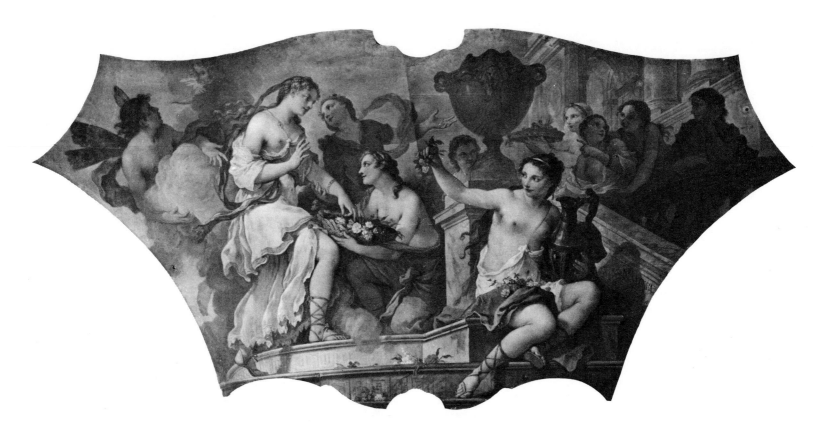

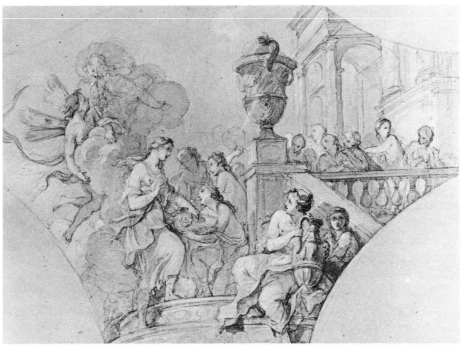

Psyche into the Palace of Love. A comparison with the preliminary drawing in the Cabinet des Dessins at the Louvre shows how carefully Natoire worked out the grouping and attitudes of the figures—especially of the nymph on the right who faces outwards in the finished work—to produce this perfectly balanced and harmonious composition.

The obvious taste for luxury and elegance in the art and decoration of this period found a close parallel in the early writings of Voltaire.[17] Although Voltaire was hostile to certain manifestations of the Rococo, especially the ornamental excesses of its architecture, and in some respects can be seen as a forerunner of Neo-Classicism, it is impossible to dissociate him from the hedonistic temper of this period. He shared its refined epicureanism, its devotion to the pursuit of happiness and pleasure, and its spirit of tolerant moderation. In opposition to Fénelon's cult of the simple life—and forestalling the arguments of

Rousseau – Voltaire believed that civilized society was preferable to the state of nature, and that the arts played a predominant role in the process of raising mankind above the level of barbarism. He was, of course, thinking primarily of literature and the natural sciences, but he also attached considerable importance to the visual arts. Thus, in *Le Siècle de Louis XIV*, in a very selective and biased account of the development of the fine arts in France, he shows how painting was brought by Poussin from total obscurity to the height of classical perfection. The line was then continued by Lebrun, Jouvenet, Lemoine, Rigaud, Largillierre and a whole host of his own contemporaries.

This cursory scheme is interesting not so much for what it reveals of Voltaire's tastes and prejudices, not to mention the glaring gaps in his knowledge, but because he clearly emerges as the champion of the Moderns, his contemporaries. He took the view that the arts both give pleasure to individuals and confer prestige on nations, and were therefore to be encouraged. More important, he clearly perceived that the essential prerequisite for the arts to flourish was a condition of general prosperity; as he wrote in one of his notebooks, the fine arts are 'the children of abundance, of society and of leisure'.[18] This necessary dependence of the arts on private and public affluence is the theme of the famous poem *Le Mondain* (1736), written by Voltaire as a young man at the height of his fame and expressed in the deliberately provocative manner of someone who enjoyed scandalizing the austere moralists and critics of the day:

> *Moi je rends grâce à la nature sage*
> *Qui, pour mon bien, m'a fait naître en cet âge*
> *Tant décrié par nos tristes frondeurs :*
> *Ce temps profane est tout fait pour mes moeurs.*
> *J'aime le luxe, et même la mollesse,*
> *Tous les plaisirs, les arts de toute espèce,*
> *La propreté, le goût, les ornements :*
> *Tout honnête homme a de tels sentiments.*

The notion of good taste based on charm, simplicity and *le naturel* was fundamental to Voltaire's aesthetics. Like Boileau and the seventeenth-century classics he so admired, Voltaire believed that the best judge of literature and the arts was the cultivated amateur, '*l'honnête homme*', not the specialist; he cannot heap enough sarcasm on the pedants, the grammarians and the self-styled dictators of taste. He disliked everything fussy, over-elaborate (like Hardouin-Mansart's chapel at Versailles, dismissed as '*ce colifichet fastueux*') or pretentious, and preferred unaffected elegance and the kind of limpid clarity which marks his own prose. This contrast between good and bad taste is amusingly drawn in the allegory, *Le Temple du Goût* (1732), in which the author takes the reader on a short

60. Largillierre, *Voltaire*, 79 × 64 cm. Musée Carnavalet. Photo: Giraudon

guided tour of French civilization up to his own day. He opens with a sally against the prevalent bad taste of the *nouveau riche* (possibly aimed at certain financiers), who imagines that money alone will buy him the best of everything – architects, painters and sculptors. The result is a vast incommodious mansion with endless corridors and enfilades of columns, and small uncomfortable rooms – all got up to impress the ignorant:

> *Le tout boisé, verni, blanchi, doré,*
> *Et des badauds à coup sûr admiré.*

After this example of bad taste the traveller finally reaches the Temple of Taste. Equally far removed from the crude Gothic style and Rococo extravagance, this building is characterized by simplicity and harmonious proportions which may, perhaps, refer back to the work of François Mansart, but at the same time seems to prefigure the principles of Neo-Classicism. The section concludes with the lines:

> *L'art s'y cachait sous l'air de la nature ;*
> *L'oeil satisfait embrassait sa structure,*
> *Jamais surpris, et toujours enchanté …*

which could well stand as the epitome of Voltaire's personal aesthetics, as well as that of his own generation, for whom art and nature, pleasure and intellect were the prime elements in artistic enjoyment.

[57]

4: The Portrait

French portraiture of the eighteenth century is one of the most accessible and easily enjoyable types of painting from the period. In contrast to the stylized official images of people in the reign of Louis XIV, eighteenth-century portraits usually offer direct and sincere impressions of the sitter, whatever his status. Kings, aristocrats, military commanders, bishops, lawyers, merchants, actors, actresses or simply anonymous beauties, all wished to dispense with the elaborate formal etiquette of the previous régime and to be portrayed in informal guise, in the intimacy of their domestic lives. This new casual elegance, an air of nonchalant good breeding and refinement without any stiffness or pomposity, is the most striking feature of French portraits of this period. The men and women portrayed in them still hold our attention by their direct and natural expressions, their intelligent eyes and finely modelled mouths, often with a hint of irony playing on their lips. At the same time, these portraits bear clear witness to the eighteenth-century passion for psychology, physiognomy and all the external manifestations of character. Everybody in the eighteenth century, from Marivaux in his novels to aphorists such as Duclos and Vauvenargues, believed in the close connection between the inner and the outer man, and that the intricacies of the human heart could be revealed in tangible, physical form. Artists like Tocqué, Aved and, especially, La Tour, took exactly the same view of their own métier and consciously attempted to lay bare the most intimate recesses of a person's character. This emphasis on the individual and the particular is again in direct contrast to the formal seventeenth-century tradition which lingered on in Rigaud and Largillierre, when the sitter's professional status was of greater importance than his individuality.

During the course of the eighteenth century, portraiture took on a variety of guises, from the grand official portrait of the early years, through Nattier's light-hearted mythological subjects and Boucher's decorative images, to the psychological studies of La Tour and the stark, uncompromising portraits of professional men by David. The general tendency was a gradual evolution towards greater simplicity and naturalism, reinforced around the middle years of the century by artists like Aved and Tocqué, who chose to portray middle-class and professional sitters, rather than the nobility. The full-length portraits of Rigaud and Largillierre gave way to three-quarter length studies—like statuettes of the head and shoulders on a pedestal—then, finally with La Tour, to the bare facial mask, stripped of all secondary attributes; draperies, columns and other background 'props' were abandoned as attention focused exclusively on the human face.

Many other categories of portraiture fell between these two extremes. By far the most numerous were the fashionable portraitists headed by Boucher and Nattier during the reign of Louis XV, then by Roslin, Drouais and Vigée-Lebrun under Louis XVI, who were less concerned with the accurate delineation of character than with offering a pleasing image of the sitter. They too, however, reflect the prevailing trend among fashionable people towards simplicity in dress and manners, led by Madame du Barry around 1760, and continued by Marie-Antoinette. Outstanding portraits abound of writers, artists and professional men, for example Greuze's portrait of the bookseller *Babuti*, Nonnotte's portrait of the engraver *Moyreau* (Orléans), Aved's of *Rameau*, Duplessis's of *Glück*, and Vanloo's of *Diderot*, all painted with a striking directness and lack of artificiality in strongest possible contrast to the elaborate conventions favoured by the court and smart society.

French portraiture in the eighteenth century moreover provides an accurate barometer of the social scene, as well as an index of the sitter's character. More than any other genre, it directly reflects the new social mobility of the period, when the rigid class barriers which had marked the seventeenth century—particularly those between the *noblesse de robe* and the *noblesse d'épée*—were gradually effaced by the universal power of money. By this process the sons of rich bourgeois, especially of financiers and bankers, quickly penetrated the ranks of the aristocracy and soon became indistinguishable from them in manners, appearance and taste. Many must have followed the example of the duc de Belleisle, grandson of Nicolas Fouquet, who rose to become the field-marshal and commander of the French armies which invaded Austria in 1741; there is nothing in La Tour's pastel of him to reveal such recent elevation, or to distinguish him from a genuine aristocrat like the marquis de Lücker, a naval commander painted by Tocqué in 1743. Bourgeois aspired to look like aristocrats, but by the same token aristocrats—even royalty—tried to adopt a kind of middle-class simplicity. When Marie Leczinska posed for Nattier in 1748, she expressly stated her wish to appear in ordinary clothes, 'en habit de ville', as a devoted 'mère de famille'.

There are in fact two distinct strains in eighteenth-century portraiture, both of which derive from the earlier traditions of French art. First there is the direct middle-class naturalism chiefly associated with Tocqué, Aved,

La Tour and Chardin—and occasionally foreshadowed by Rigaud and Largillierre in certain portraits of individuals—which echoes the Renaissance portraiture of Corneille de Lyon and Clouet. Then, running simulta- neously, there is a continuous tradition of the portrait convention practised by Nattier, Drouais and Roslin, where artifice, in the shape of mythological garb, the set smile and a certain impersonal ideal of fashion, tends to prevail over the realistic observation. This last type, in- herited from the seventeenth-century prototypes of Beaubrun, Mignard and others, was usually favoured by members of the aristocracy, but by no means consistently, since they too often preferred to be painted in a more casual, off-hand stance. As a result, there is a frequent intermingling of genres and crossing of borders which defies any systematic sociological interpretation. Finally, in a category all on its own, is one of the most persistent and enigmatic types of French portraiture of this period, the so-called '*portrait en travesti*', or sitters in disguise. From Raoux's *Vestal Virgins* half-concealed behind their capes, Grimou's mysterious *Young Pilgrims* (Florence, Uffizi) to the best known examples of all, Fragonard's *Fancy Portraits* of the 1760s, these portraits testify to the eighteenth-century passion for disguise and masquerade, the desire to hide public identities behind a cloak of romantic anonymity.

During the first half of the eighteenth century, French artists showed only an intermittent interest in the deline- ation of individual character. Portraits of such remarkable

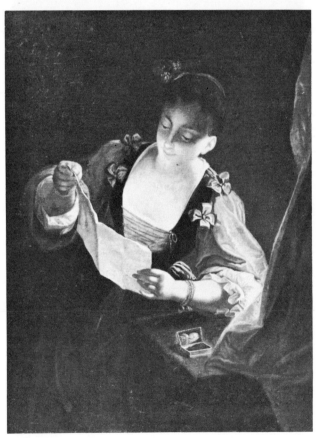

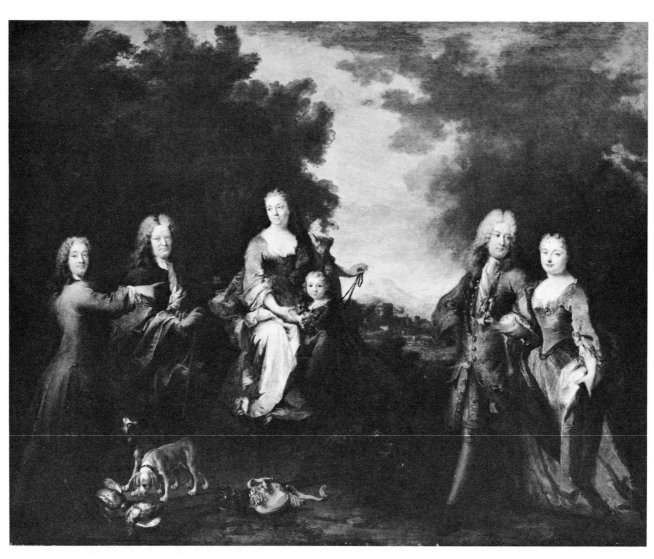

64. Tournières,
Family in a Landscape,
85 × 105 cm.
Musée des Beaux-Arts, Nantes.
Photo: Ville de Nantes

sensitivity as that of *Fontenelle* by Rigaud are an exception. Throughout this period the norm remained the grand historical portrait, continued by such followers of Rigaud and Largillierre as Robert Tournières (1667–1752), an obscure but distinguished painter from Caen. He specialized in consciously archaic group portraits of *grands bourgeois*, magistrates, lawyers and other provincial notables, formally posed with their families against a landscape or architectural background, as in his *Family in a Landscape* 1724, in the Musée de Nantes. But this was still a throwback to an earlier age and can hardly be seen as a specifically eighteenth-century type of portraiture. The first artist to modify the genre and to adapt portraiture to the tastes of his contemporaries was Jean-Marc Nattier (1685–1766), the creator of the 'mythological' portrait, who achieved fame by the simple device of embellishing duchesses and Louis XV's daughters with divine attributes and calling them Hebe, Aurora and Diana. This subtle form of flattery never failed, and from 1730 onwards Nattier was besieged by the court with a constant stream of commissions for similar subjects, still visible today in vast quantities in the palace of Versailles.

Although his output inevitably suffered from overproduction, repetition and a certain bland facility, at his best Nattier is a fine artist with an elegant, refined technique and a lucid transparency of texture obscured by the apparent banality of his subject matter.

Nattier's success was by no means instant. It was only in the middle of his career, around the age of forty, that he devoted himself exclusively to portraits. His early ambition was to become a history painter, and under the guidance of his father, Marc Nattier, who had collaborated with Rigaud, he was brought up to admire the works of Lebrun and Rubens. In 1705, he was engaged in making drawings after Rubens' *Marie de' Medici* cycle in the Luxembourg Palace, and in 1718 he was received as a full member of the Academy on presentation of a conventional but an accomplished mythological subject, *Perseus Turns Phineas to Stone*, now in the Musée de Tours. Nattier must already have enjoyed some measure of success as an academic artist and painter of allegorical portraits, for soon afterwards he was invited to Amsterdam to paint the portraits of the Russian Czar and his wife. The real turn in his career, however, was brought

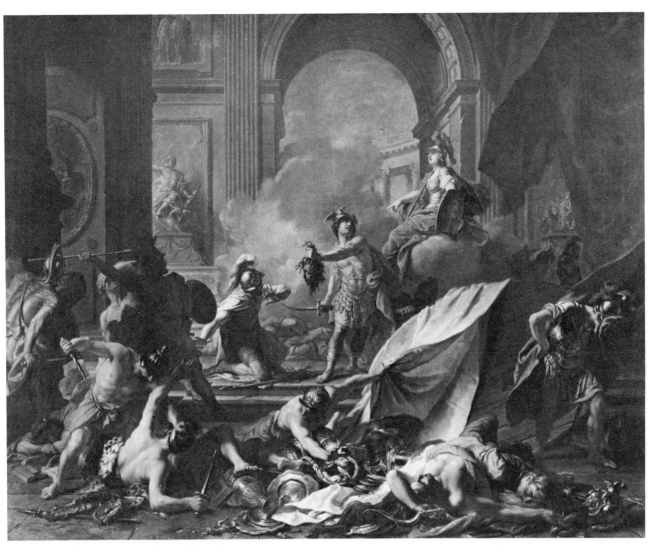

about by the collapse of the Law system. It was the immediate prospect of personal ruin which finally decided Nattier to turn full-time to portraiture, the one genre which guaranteed him a good regular income. Thanks to his family's connections with Versailles, there was no lack of influential patrons.

The origins of Nattier's allegorical and mythological portraits lie in the seventeenth century, particularly in the '*portrait déguisé*'. This type of portrait, showing great ladies dressed as figures from classical history or mythology, was especially favoured around 1650 by the Précieuses and their circle of admirers in the *salon* of Madame de Rambouillet, and its chief exponents were the Beaubrun cousins, Henry (1603–77) and Charles (1604–92), and Claude Deruet (1588–1660). The art as well as the language of Préciosité was a conscious rejection of everything down-to-earth, vulgar and even realistic, and a consistent preference for the subtle and over-refined. Such practices, which began as a mere literary conceit, became a deeply ingrained habit of mind with the French monarchy and the aristocracy during the Grand Siècle, and lasted well into the eighteenth century. Apotheosis

became the standard element in the iconography of the period and also carried into the eighteenth century. When Louis XIV had himself portrayed as Alexander or Apollo in Lebrun's ceilings at Versailles, the metaphor was intended literally. Similarly, when Saint-Simon wrote that a certain duchess occupied '*un rang dans les nues*', he was not conscious of exaggeration, since it was taken for granted that people of elevated rank enjoyed semi-divine status. This was the tradition on which Nattier was nurtured. The allegorical portrait had already been well popularized by artists like Jean Nocret (1617–72) in a painting showing the royal family in Olympus, with Louis XIV in the role of Jupiter (Versailles), and other similar compositions by François de Troy and Pierre Gobert. Women were already accustomed to being portrayed as Diana, Minerva, and sometimes even as Venus. All Nattier had to do was to take over this ready-made iconography and adapt it to the rather more light-hearted temper of the mid-eighteenth century. As a result, he created a kind of stereotype of eighteenth-century woman, bland, charming and unruffled by any visible emotion, poised in an artificial

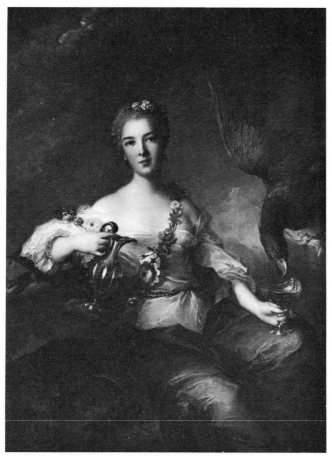

66

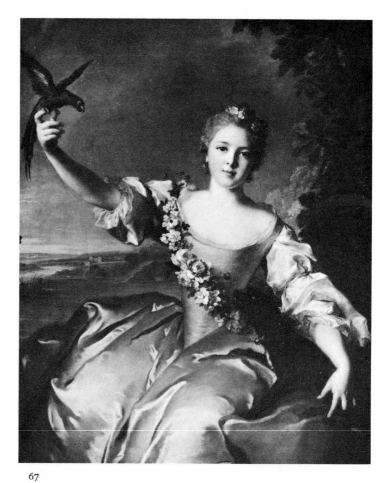

67

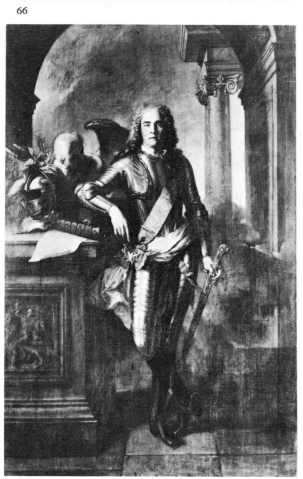

68

69

paradise like *The Duchess of Chartres as Hebe* (Stockholm) or the exquisite *marquise d'Antin* (in the Musée Jacquemart-André, Paris) playing with her parrot.

Nattier first attracted public attention with a magnificently virile portrait of *The Maréchal de Saxe* (Dresden), exhibited in 1725 at one of the open-air exhibitions held on the place Dauphine. Though still cast in the conventional allegorical mould, the figure of Time posing laurels on the warrior's helmet, it shows Maurice de Saxe, one of the greatest French military commanders of the age, in all his youthful vigour, with crossed legs and holding his sword with casual self-confidence. This portrait, as well as that of his son-in-law *Tocqué*, in Copenhagen, demonstrates that Nattier was equally proficient in painting men and women. His next great success was the *Mademoiselle de Clermont taking the Waters of Chantilly* (Chantilly) of 1729 [Plate 6], clearly based on the similar composition by Raoux of *Mademoiselle Carton en Naiade* (1723), Nattier's picture shows Marie-Anne de Bourbon, the sister of the duc de Condé, reclining nonchalantly by an urn in the manner of a river goddess, while a female attendant on the right pours out the celebrated mineral water, *les eaux de Santé*, from a ewer; the Cupid on the left stands not so much for Love as for Health. The topographical accuracy of the painting is shown by the inclusion of the Pavillon des Eaux, constructed around 1725, and the *parterre* in front of it, both of which were subsequently destroyed. The same sitter, Mademoiselle de Clermont, appears, dressed as a sultana, in a later painting, now in the Wallace Collection; the proud, indolent pose of the royal princess clearly illustrates the leisure pastimes of the aristocracy of the day and their passion for exotic charades.

Nattier's reputation as a painter of Louis XV's court dates only from 1740, when the duchesse de Mazarin introduced her two nieces, the duchesses de Châteauroux and de Flavacourt (the youngest daughters of the marquis de Nesle), to Versailles in a bid to launch them in society. She then commissioned Nattier to paint their portraits, one as *Le Silence*, the other as *Point du Jour*. The sitter in the second of these portraits, Madame de la Tournelle, later achieved notoriety as the duchesse de Châteauroux when she became a mistress of Louis XV, and it was no doubt partly due to Nattier's flattering portrayal of her that she owed her good fortune. These two portraits created such a sensation that Nattier was instantly summoned by the royal family to Versailles and commissioned by the Queen—who, in the words of Madame Tocqué, had been struck by their 'perfect resemblance'—to paint her daughter Henriette 'en Flore' (1742, Versailles). The fifteen-year-old princess is shown as a nymph reclining in a meadow, weaving a garland of flowers. This portrait was only the first of a series representing Louis XV's daughters in various guises, both allegorical and naturalistic, as well as the royal mistresses and prominent women of the court.

The portrait of Henriette was immediately followed by that of her sister *Madame Adélaïde dressed as Diana*, painted around 1745 for the Château de Choisy, and in a similar vein the duchesse de Chartres was portrayed as *Hebe* (Stockholm), exhibited at the Salon of 1745. The theme of Hebe, with its stock attributes of the eagle and cup into which the goddess pours the ambrosia of youth, recurs countless times in Nattier's oeuvre.

This had become the standard formula for the '*dames de France*' in Louis XV's reign. But by the middle of the century there were increasing signs of irritation among certain critics, notably Cochin and Bachaumont, who complained of Nattier's endless repetition of the same hackneyed mythological themes. Portraiture in his hands had frozen into a set pattern which had no meaning or relevance to his contemporaries, and made no attempt to portray people in their true character or occupation. Cochin formulated a more realistic definition of the portrait when he wrote: '*Il est naturel de se faire peindre dans l'habit où l'on est le plus ordinairement ou dans celui qui caractérise son état; de tout temps, dans les portraits, on a en vue, en conservant sa ressemblance à sa postérité, de conserver les usages de on siècle . . .*'[2] This more down-to-earth conception of the portrait painter's function was gradually to prevail over Nattier's stereotyped allegories, and was soon adopted by the next generation, especially Aved, Tocqué and Chardin. But even Nattier himself was capable of painting his sitters in a straightforward manner, free of mythological trappings, and it is possible that his naturalistic portraits like those of *Marie Leczinska* (1748) and the superb *Madame Adélaïde Embroidering* of 1756 (Musée de Versailles) are among his finest works. In the portrait of *Marie Leczinska*, in particular, his usual artificiality has given way to genuine perception of character and we are left with a lifelike record of the Queen's simple good nature.

Nattier's son-in-law and pupil, Louis Tocqué (1696–1772), took the art of portraiture much further in the direction of truth and verisimilitude. For this reason he was less popular in his own lifetime, but today his reputation stands considerably higher than Nattier's and he has emerged as a pioneer among French portraitists in the first half of the eighteenth century. His works have a direct simplicity and honesty which strikes an entirely new note in this period, coupled with a technical skill and solidity of execution derived from an intelligent understanding of his great predecessors, Rigaud and Largillierre. Unlike those of Nattier, portraits by Tocqué never lie about the sitter. When commissioned by the Empress Elizabeth I of Russia to paint her portrait in 1758, he was not afraid to show her buxom figure and her famous short nose; what is more, she was pleased with the portrait and obviously valued truth more than flattery. For Tocqué, even old and ugly women like *Madame Dangé* or *Madame*

Plate 6 faces page 64

70

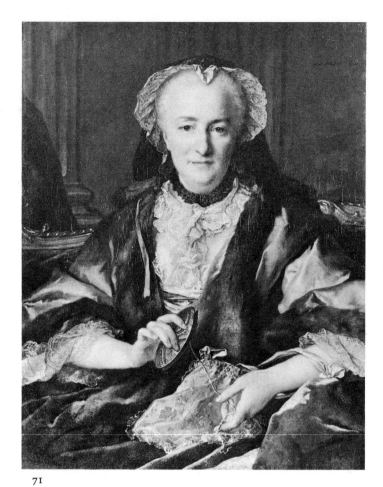

71

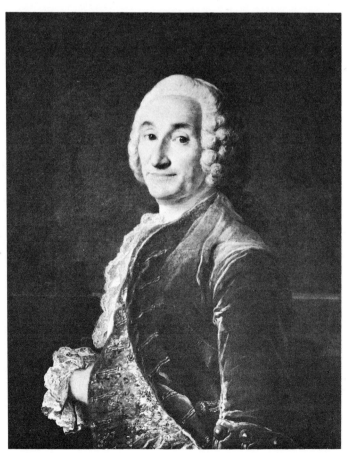

72

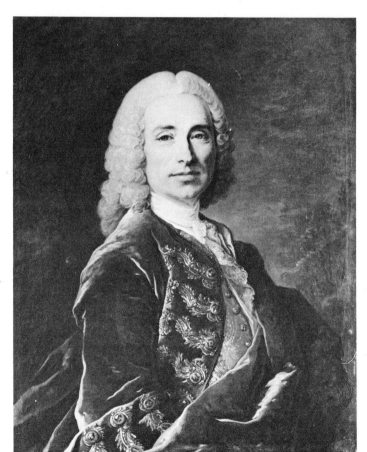

73

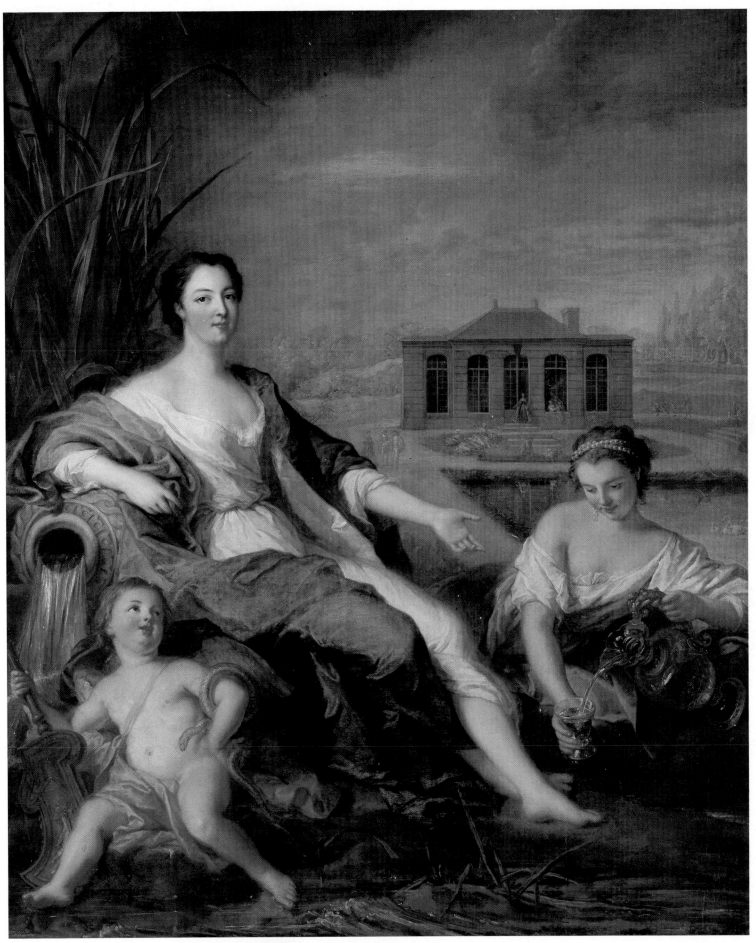

PLATE 6. Nattier, *Mademoiselle de Clermont taking the Waters of Chantilly*,

195 × 161 cm. Musée Conde, Chantilly. Photo: Giraudon

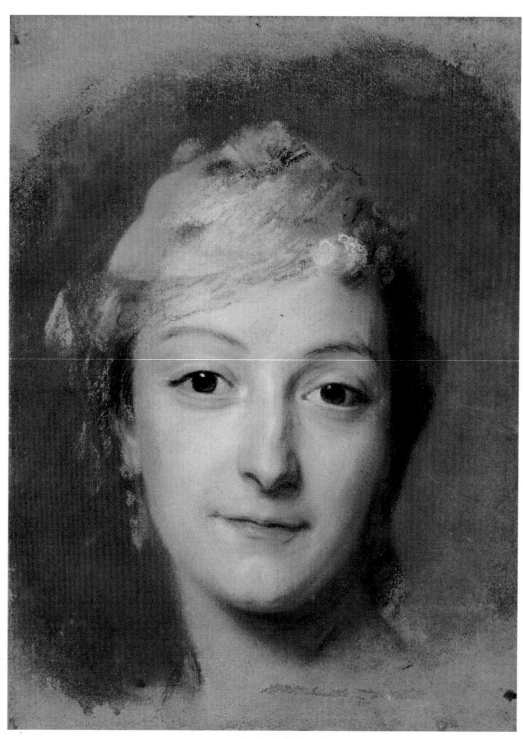

PLATE 7. La Tour, *Mademoiselle Fel*,
pastel, 24 × 32 cm. Musée Antoine Lecuyer de Saint Quentin.
Photo: S.A.E. Tarascou

Harant had an intrinsic interest and dignity which he strove to capture and bring out, not from the most attractive viewpoint, but from the most sympathetic and profoundly human. This shift of interest from the sitter's external appearance and attributes to his underlying character makes Tocqué one of the more radical French eighteenth-century artists and a true pioneer of the psychological portrait. He was, moreover, fully conscious of his innovation when he formulated his views on portraiture in a discourse read to the Academy in 1750: '*Une femme, sans être belle ni jolie, a souvent des moments qui lui sont favorables et le visage perd ou acquiert des grâces selon les diverses situations de l'âme. C'est au peintre à saisir les instants heureux qui semblent l'embellir.*'[3]

In view of Tocqué's espousal of naturalism it was not surprising that he was far more widely patronized than Nattier by the bourgeoisie and professional classes. Among his sitters rank magistrates, politicians, financiers, soldiers (the *Duc de Richelieu*, Tours), artists (*Galloche* and *Lemoyne*, the sculptor), but also great hereditary aristocrats and members of the European nobility and royalty. It would be misleading therefore, to portray Tocqué as the exclusive painter of the bourgeoisie when he was also responsible for the official portraits of the Queen, Marie Leczinska (1740, Louvre), the *Dauphine Marie Thérèse* (1748, Musée de Versailles), among many others. Moreover, the '*bourgeois*' who figure in portraits, such as *Michel de Roissy* (Salon of 1755), a former *receveur-général des finances* at Bordeaux, were men of considerable rank and fortune, and are virtually indistinguishable in dress and appearance from their noble counterparts. All of them share the same alert, intelligent expressions, and a relative lack of pomposity and ostentation in their surroundings which suggests that the social '*beau idéal*' was nearly identical for both classes of society. Everybody above a certain level, it seems, aspired to the kind of discreet, sober elegance of Tocqué's portraits.

Tocqué, like many other eighteenth-century artists, originally took up portraiture as a second best to history painting, for which, he once confessed, he lacked the necessary erudition. He first studied under Nicolas Bertin, then under Nattier, whose daughter he married. He assiduously copied the Old Masters in Paris collections and later helped Watteau and Nattier to make copies of the main works in the royal collections. Although he undoubtedly acquired some of his elegance and refinement from Nattier, Tocqué's art owes more to Rigaud and Largillierre and it was from these that he derived his particular combination of solid workmanship with sumptuous colours, crisp white linen and fine brocade. He never abandoned the old-fashioned formula of the '*portrait d'apparat*' and most of his portraits of royalty are cast in this mould. Even *Marie Leczinska* is shown in full regalia of ermine and *fleurdelysé* cape against the obligatory

columns and draperies in the background, the traditional arrangement which Tocqué repeats in his portraits of the *Dauphine*, the *Empress of Russia* (Leningrad), and those of *King Frederick V of Denmark and his Queen* (Denmark, Amalienborg). Nor did Tocqué spurn the conventional mythological portrait popularized by Nattier, as we can see from his treatment of *Madame Adelaïde de France* or his portrait of the singer *Jéliotte* (1755) disguised as Apollo, which carries allegory to the point of absurdity. But these are not his most typical or original paintings, they are merely concessions to the passing fashion of the day.

The type of portrait which Tocqué made peculiarly his own is the half-length view of the sitter, usually in part profile, against a neutral, uncluttered background. This pattern exemplified in such portraits as that of the *Duc de Richelieu* (Tours), enabled Tocqué to place great emphasis on the face, particularly on the eyes and mouth, which he always modelled with exceptional precision. The duc is dressed in a simple velvet coat, half-open to reveal a waistcoat of elaborate gold brocade and a fine white ruff. His attitude of natural, almost casual ease is that of a man accustomed to authority, with no need to make a display of his rank. The same qualities can be found in most of Tocqué's portraits of male aristocrats, for example the *Marquis de Lücker* or the dashing *Count of Zweibrücken Birkenfeld* in Munich. But perhaps his greatest masterpieces are his portraits of middle-aged and elderly women with no pretensions to beauty or elegance, like *Mademoiselle le Mercier* (Salon of 1745), a wealthy spinster ensconced in her shawl, *Madame Dangé* (Salon of 1753,

74

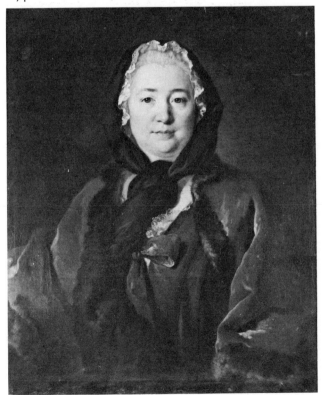

74. Tocqué,
Madame de Graffigny,

81 × 65 cm.

Musée du Louvre.

Photo: Musées Nationaux, Paris

[65]

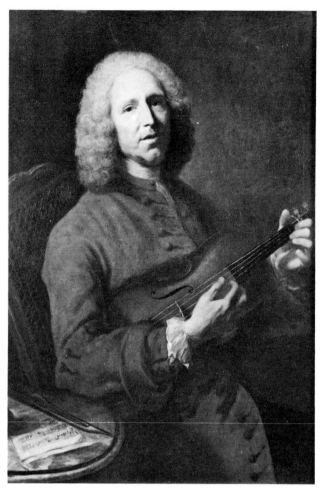

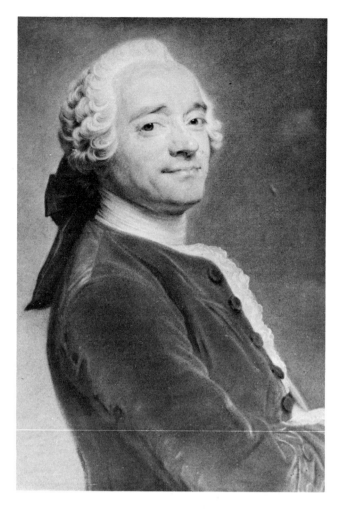

Louvre) with her embroidery in her lap, *Madame de Graffigny* (Louvre) a notable blue-stocking and author of the *Lettres Péruviennes*, and, finally, one of Tocqué's most memorable studies of old age, his portrait of *Madame Harant* (Salon of 1738, Marquis de Jaucourt collection), the mother of the banker and collector, Harant de Presle. In this intensely realistic portrayal of a face disfigured by worn, sagging muscles, Tocqué managed to convey the most profound understanding of character, and it is clear why, despite her ugliness, the sitter left her contemporaries like Marmontel with an overriding sense of her charm and kindness: '*Il est impossible d'imaginer dans la vieillesse d'une femme plus d'amabilité que n'en avait Mme Harenc* [sic] ... *Elle était, au premier aspect, d'une laideur repoussante; mais bientôt tous les charmes de l'esprit et du caractère perçaient à travers cette laideur et la faisaient non pas oublier, mais aimer.*'[4]

French artists in the eighteenth century rarely dared to project human reality in such a stark, unembellished light. Tocqué's real inheritors were not so much his contemporaries as the artists of the Revolution and its aftermath, especially David and Géricault, who finally dispensed with prettiness and charm. But Tocqué did exert a recognizable influence on a handful of his contemporaries, notably Aved, Chardin (in his rare portraits) and, in reverse, on Nattier.

It is undoubtedly J. A. Aved (1702–66) who most resembles Tocqué in his discreet, sober realism, with the same meticulous attention to background detail. A native of Douai, in the north of France, Aved spent his youth in Amsterdam, where he was strongly marked by Rembrandt and the Dutch school. In Paris he studied under Belle and soon became acquainted with the leading artists of the day, particularly Chardin, with whom he was on such close terms that the two painters have sometimes been confused.

Aved's best work has a masculine solidity, as in the portrait of *Jacques du Theil* in the Louvre, for example, and in the *Maréchal de Clermont-Tonnerre* (1759, Château d'Ancy-le-Franc), reminiscent of Gainsborough's male portraits and coupled with a hint of the dark *tenebroso* effects of Rembrandt. His unqualified masterpiece is the portrait of *Rameau* in the museum of Dijon, long attributed to Chardin. This homely portrayal of the elderly composer strumming on his lute could hardly be more true to life, and shows great insight into the real character of the man who wrote the formal, rather pompous music of the *Indes Galantes*. It was perhaps on account of this modest, self-effacing quality that Aved attracted few royal clients in France. Eclipsed by his more brilliant contemporaries, he was forced to seek patrons abroad, notably

the *Stathouder of Holland*, whose portrait he painted in 1751, and *Mahomet Effendi*, the Turkish Ambassador in Paris, whom he also later painted. It was Aved's invitation which decided Chardin to take up portraiture in 1737, beginning with the curious portrait in the Louvre of Aved as an alchemist and culminating in the remarkable series of *Pastels of Himself and His Wife*, also in the Louvre, executed in 1775 at the end of his career. These last works, which exercised such a strong fascination over the young Marcel Proust,[5] have a directness and sincerity rarely found among eighteenth-century self-portraits, when most artists preferred to show themselves in their prime and not in the debility of old age.

Another genre which became increasingly popular in the eighteenth century, though never quite so highly regarded in official circles, was the portrait in pastel. The vogue was imported into France by the Venetian artist Rosalba Carriera (1675–1757), and continued by Frenchmen like Joseph Vivien (1657–1734), known as the 'French Van Dyck' for his technical virtuosity and brilliance. But the best known, if not always the best, exponent of the pastel portrait was Maurice Quentin de La Tour (1704–88), an eccentric, arrogant and gifted artist from Saint-Quentin, in the north of France. La Tour's character, and his limitations, can best be judged from his *Self-portrait* (1751) in the museum at Amiens, a combination of typical Picard guile, jaunty self-assurance and considerable psychological insight. La Tour's problem, however, was that his undeniable talents never quite matched up to his intellectual pretentions, and his art falls somewhat short of his ambition to offer a definitive record of the greatest men and women of his age. In some well-known words recorded by Sebastien Mercier, La Tour boasted: '*Ils (mes modèles) croient que je ne saisis que les traits de leurs visages, mais je descends au fond d'eux-mêmes à leur insu et je les remporte tout entiers.*'[7]

A typical La Tour portrait consists of the bare facial mask, stripped of accessories, with all the emphasis on the eyes and expression. But, with some notable exceptions, what he actually achieves is often no more than a superficial and not always very accurate impression of a person, far removed from the inner truth which he so feverishly sought. In this sense he is inferior to Tocqué and often to his lesser-known rival Perronneau. La Tour was the victim, to some extent, of his own mania for perfection which led him to ruin his portraits by overworking them; the original freshness of the *préparations* is often lost in the final result, marred by too much hatching and unnecessary application of black chalk over the pastel. His work also suffered from his temperamental instability and indiscriminate enthusiasm for all the passing fads of the age—for pantheism, for flying balloons and many other projects dreamt up by eighteenth-century philosophers—all of which finally unhinged his mind. On the

positive side, however, La Tour was sympathetic to the more durable benefits of the Enlightenment. He shared the philosophers' concern for reason, tolerance and humanity, and set a notable example in practical philanthropy when in 1782 he helped to found the Ecole Royale Gratuite de Dessin and other charitable institutions in his native town.

As you enter the Musée Lécuyer in Saint-Quentin today, where most of La Tour's pastels are exhibited, you find the same fascinating range of portraits which confronted the Goncourt brothers. 'All those heads turn as if to see you, all those eyes look at you and you feel as though, in that large room in which all mouths have become silent, you have just disturbed the eighteenth century in conversation.'[8] This is, indeed, a representative sample of prominent eighteenth-century figures: artists and musicians like *Mondonville* with his violin, actresses like *Mademoiselle Fel* and *Madame Favart*, the theatrical manager *Jean Monnet*, writers, including *Duclos* and *Jean-Jacques Rousseau*, the financier *La Pouplinière*, great noblemen and soldiers such as *Maurice de Saxe*, and finally the portrait of the *Abbé Huber* (1742) from Geneva, a noted diplomat, traveller and personal friend of La Tour who was also on close terms with the Encyclopaedists. One of La Tour's most delightful and intimate works, it is a true portrait of an eighteenth-century ecclesiastic, happy among his books, with the benevolent and pleasure-loving expression of a Benedictine monk. As the Goncourt brothers observed, La Tour has almost raised the art of pastel to the level of Rembrandt in the format of a Chardin. The Abbé is shown reading a volume of Montaigne, the light of a single candle casting its gentle

77. La Tour, *Abbé Huber*, pastel, 81 × 102 cm. Musée d'Art et d'Histoire, Geneva

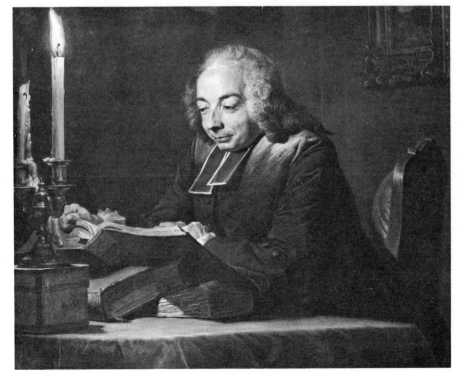

78. La Tour,
Rousseau,
pastel, 46.5 × 38 cm.
Musée d'Art et d'Histoire, Geneva

usually at his best in the impressionistic preparatory studies, where carefully worked out detail was not essential.

Struck by the success of Rosalba Carriera and the increasing popularity of the pastel in France, La Tour soon abandoned oils altogether and devoted himself entirely to this genre. His art received official recognition when, on 25 May 1737, he was received as a temporary member of the Academy. From then on, his success was assured and he continued to exhibit at the Salon from 1737 until 1773, to ever-increasing applause both from the critics and the general public. The work which finally set the seal on his reputation and made him one of the most sought-after portraitists of his time was the portrait of *Gabriel Bernard de Rieux*, president of the Paris Parlement (Edmond de Rothschild Collection). When the portrait was exhibited at the Salon of 1741 it was universally acclaimed as a triumph in the new medium, for La Tour had clearly demonstrated that he could create in pastel a work as impressive and detailed as the portraits of Largillierre. The sitter is a typical member of the *noblesse de robe*, the legal aristocracy which, by the purchase of various offices and sinecures in the official administration, had risen to prominence in the seventeenth century and, by the eighteenth, enjoyed a secure position among the greatest of the land. De Rieux is shown in his scarlet robes, with a large folio volume open in front of him, and all the trappings of legal office on the table. In the following year, 1742, La Tour scored yet another success with his portrait of the President's wife, *Madame de Rieux* (Paris, Musée Cognacq-Jay), shown in a ball-dress and holding a mask. Though smaller than the portrait of her husband, *Madame de Rieux* is highly finished in execution and remarkable for its detail; despite her worldly elegance, the *présidente* is genial and relaxed in the intimacy of her own home. La Tour's more formal mood is shown again in his portrait of *Madame de Pompadour* (Louvre), commissioned by her brother, the marquis de Marigny, in 1751 and finally exhibited at the Salon of 1755 — a work which cost the artist and sitter much in frayed tempers. La Tour, whose fees for his work varied according to whim and his degree of sympathy for the sitter, clearly thought the marquise fair game, with access to a bottomless purse, and duly asked her for 48000 livres: angered by this demand, Madame de Pompadour sent half the sum. The result is an elaborate but somewhat overworked picture showing all the attributes of the royal mistress — her books and folios of drawings — but little of her essential personality.

The real La Tour, the quizzical, enigmatic, impatient and often caustic observer, has to be sought in his numerous preparatory studies, such as those of *Voltaire*, *Mademoiselle Salé* and *Isabelle de Zuylen* (Geneva, Musée d'Art et d'Histoire) which reduce the sitter to a few strokes of chalk but, in the process, capture some fleeting aspect of their character. Tenderness is not usually con-

glow over his face. When, however, La Tour painted a portrait of *Rousseau* around 1752 — shortly after the writer had won fame through the publication of his highly controversial *Discours sur les Sciences et les Arts* of 1750 — he was notably less successful. Instead of the ardent revolutionary philosopher, he showed a neat, well-dressed, urbane-looking gentleman not conspicuously set on overthrowing the social order. This was precisely Diderot's verdict in his *Essai sur la peinture*: 'M. De La Tour si vrai, si sublime d'ailleurs, n'a fait du portrait de M. Rousseau qu'une belle chose, au lieu d'un chef-d'oeuvre qu'il en pouvait faire.'[9]

Born in 1704, La Tour soon showed a precocious talent for drawing. In 1723, a scandal involving him in a liaison with his young cousin, Anne Bougier, forced him to leave for Paris, where he studied under the engraver Tardieu; he subsequently apprenticed with Jean-Jacques Spoëde[10] and Dupouch,[11] and finally under Restout, whose portrait he painted twice, a sketch of which is in Saint-Quentin, with the finished picture in the Louvre. The last two are among La Tour's finest works of a fellow artist and suggests a close sympathy with Restout who, according to La Tour's words quoted in Diderot's *Salon of 1769*, taught him the correct positioning of a head, the technique of allowing air to circulate freely between the face and the background, and the most advantageous disposition of light and shade. Drawing, however, was not La Tour's forte; Louis de Boullogne, the Premier Peintre du Roi, advised him to correct the defect, but La Tour never quite succeeded and his draftsmanship always remained somewhat uncertain; it is for this reason that he is

79

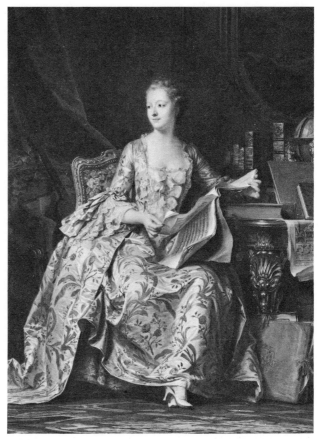

80

79. La Tour,
Madame de Rieux,
pastel, 116 × 90 cm.
Musée Cognac Jay, Paris

80. La Tour,
Madame de Pompadour,
pastel, 175 × 128 cm.
Musée du Louvre.
Photo: Lauros-Giraudon

Plate 7
faces page 65

spicuous in La Tour's work, with one notable exception, in the portrait of *Mademoiselle Fel* [Plate 7]. Marie Fel (1713–78), one of the most famous singers of her day, made her début at the Opera in 1734 and was La Tour's devoted mistress from *c.*1750 until the end of his life. With her oval face, almond eyes and wistful expression, her features became the best known in La Tour's portrait gallery at Saint-Quentin and epitomize the finest qualities of his art. There is little trace here of that '*desséchante ardeur psychologique*' of which the writer Maurice Barrès complained on a therapeutic journey to Saint-Quentin in 1891.[12]

For a long time La Tour was regarded as virtually the only significant pastellist in France during the eighteenth century. So successful was his self-publicity, and so complete his monopoly of all the important clientele, that his rivals in the genre were largely eclipsed. One of the most unjustly neglected of these was Jean-Baptiste Perronneau (1715–83), an artist of great subtlety and refinement who has still not fully emerged from the shade of his obscure career. During his own lifetime, Perronneau was consistently sacrificed to La Tour by Diderot and his contemporaries, and even the Goncourt brothers failed to include him in their *L'Art du dix-huitième siècle*. They apparently made amends for this ommission and even recognized Perronneau's superiority in a paragraph in *La Maison d'un Artiste*, in which they wrote: '*Perronneau est plus naturellement coloriste que La Tour; il est, dans sa peinture*

de poussière colorée, tout plein de tons clairs, frais, presque humides.'[13] They went on to acknowledge La Tour's greater skill in anatomy and physiognomy, but concluded that Perronneau's free, colourist technique had much in common with Reynolds and late eighteenth-century English portraiture. Perronneau's art could hardly be better characterized. It has a clear, limpid transparency, combined with strong, vigorous brushwork, which contrasts pleasantly with La Tour's frequently overworked surfaces. It is neither strained nor mannered, and the sitters are presented in a direct, straightforward light, to be expected from the man who in his *Self-Portrait* (Tours), with his square jaw and strong features, looks the spectator straight in the eye. His art makes no claims to great psychological penetration, but it carries off a resemblance with the greatest of ease, and enabled him to produce a handful of quiet, unspectacular masterpieces.

Unlike his rival, Perronneau never managed to penetrate the court circles in Paris and Versailles and, for this reason, was forced to seek his clientèle elsewhere, among the French provincial nobility and the upper middle-classes in Holland, Spain and Poland. He studied oil painting under the engraver Laurent Cars (whose portrait, now in the Louvre, he painted in 1759) and then under Natoire. By about 1750 he had acquired complete mastery of the medium, as can be seen in the splendid portrait of *Madame de Sorquainville* (1749) in the Louvre. With its slightly broken pattern of beige, olive-green, blue

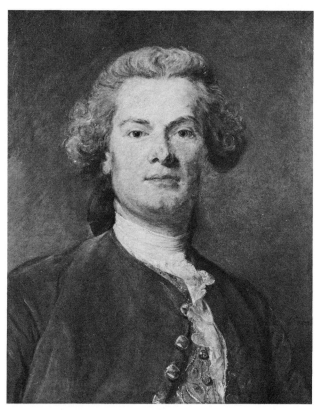

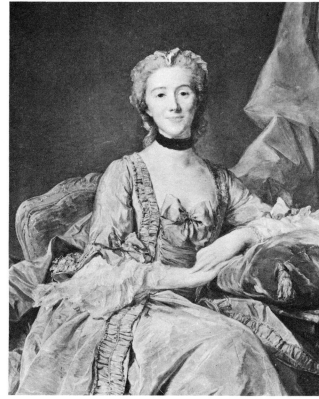

81. Perronneau,
Self-Portrait,
54 × 45.4 cm.
Musée des Beaux-Arts, Tours.
Photo: Lauros-Giraudon

82. Perronneau,
Madame de Sorquainville,
101 × 81 cm.
Musée du Louvre.
Photo: The Mansell Collection/Giraudon

and white against a neutral background, the painting contrasts strongly with the artificial gloss of Nattier, and at the same time foreshadows certain portraits by Gainsborough and Reynolds. It is a classic portrait of a French *grande dame* around the middle of the century. Perronneau again demonstrated his proficiency in oils in his portrait of *J.-B. Oudry* in the Louvre, which he presented as his '*morceau de réception*' to the Academy in 1753. But the artist was soon caught up in the vogue for pastels, and from 1750 onwards this became his favourite mode of expression.

He travelled widely all over Europe and chose his sitters, mostly obscure people, wherever he happened to be. His own character is apparent in his work: diffident, sentimental and vagabond, he usually endows his sitters with intelligent, sensitive and somewhat remote expressions. Something of this nostalgia is present in almost all of his portraits, from the *Boy with the Book* in Leningrad to *Madame de Sorquainville* and *Madame Chevotet*. In the *Jacques Cazotte* (London, National Gallery), the writer from Dijon and author of a short story, *Le Diable Amoureux*, the expression is more that of the subtlety and refinement typical of a minor man of letters. Technically, Perronneau displays an easy, inconspicuous mastery. Using a palette of clear, translucent colours, he proceeds by small touches to create works of perfect harmony. His remarkable ability to convey the moisture of the eyes and lips and the glimmer of subdued light on the face is evident in the portrait of *Madame Chevotet* (1751) in Orléans [Plate 8], one of the most beautiful portraits Perronneau executed.

Plate 8 faces page 80

With the advent of Louis XVI in 1774 and until the outbreak of the Revolution, French portraiture underwent further vicissitudes which reflected the changing state of society during those years. At first, the swing was away from the naturalism of Tocqué and Aved, back towards a new type of formality and convention in the portraits of Drouais, Roslin and many other followers. It seemed, in fact, as if the precepts of Tocqué had been forgotten, only to be revived in the very last years of the century. The only difference between Nattier and Drouais was a change of style and sitters, as Louis XV and his family were replaced by those of their successors; the basic pattern of the elegant society portrait remained constant. Fashion naturally changed and '*le style Pompadour*', typified in the portraits of the marquise by Boucher and La Tour, gave way to the novel, vaguely 'Greek' style adopted by Madame du Barry, the new royal mistress who replaced Madame de Pompadour in Louis XV's favour. Henceforth, all women in smart society aspired to copy Madame du Barry and posed as vestal virgins in simple white tunics, adorned only by a rose in their hair.

This pretence of naiveté and chastity became the new social '*beau idéal*' during the years 1760–70, and its chief representative was Francois-Hubert Drouais (1727–75).[14] He had no serious rival in his own lifetime; as Grimm wrote: '*Toutes nos femmes voudront désormais êtres peintes par Drouais.*' Trained by his father Hubert, who had benefited from the lessons of Natoire, Boucher and de Troy, Drouais first exhibited at the Salon of 1755 and the following year painted the children of the royal family.

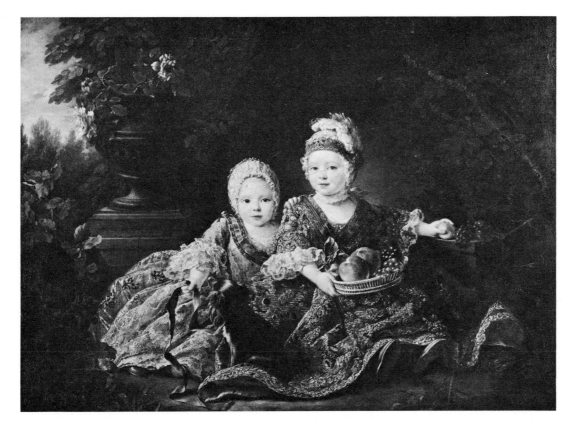

From then on, his success was assured and he became the official court portraitist. He exhibited three double portraits at the Salon of 1757, the first of *The duc de Berry and the comte de Provence as children* (Brazil, Sao Paulo), the second of the *Prince and Princess de Condé*, dressed in gardening clothes, and a third, of the *Prince de Guéménée and Mademoiselle de Soubise* dressed as grape-gatherers at vintage time, the two latter formerly in the collection of Baron Edmond de Rothschild. These three works clearly testify to Drouais' close awareness of fashion and novelty at a time when grand people were already beginning to affect a taste for the simple rustic life.

Drouais continued to maintain his reputation with many portraits of members of the royal family, the Prince d'Elbeuf, Mademoiselle de Lorraine, the comte d'Artois and others; but it was his painting of women and children which found universal favour, such as the *Children of the duc de Bouillon* dressed as Savoyards (1756, private collection).[16] This charming, if somewhat sentimental, work closely anticipates Rousseau in its representation of the mountainous region bordering on Switzerland, which became a focal point for early Romantic sensibilities and whose inhabitants seemed models of uncorrupted humanity. Most of Drouais' portraits are half-length or oval busts of the sitter, but he also painted full-length and highly-detailed portraits in the traditional manner; two of these, the *Comte de Vaudreuil* (1718) and *Madame de Pompadour* are in the National Gallery, London. The portrait of *Madame de Pompadour* was first shown at the Salon of 1763, and only recently re-emerged into the light of day from the

Rothschild collection at Mentmore. The great interest of this picture is that it is the last known portrait of Madame de Pompadour, finished shortly after her death in April 1764, and shows her in old age working at her embroidery, her favourite dog by her side, and surrounded by the furniture and decorative objects she did so much to patronize. The painting is carried out with a minute attention to detail, but with a restraint and conscious lack of sparkle which provides a fitting end to the Rococo era and already suggests the advent of neo-classicism.

The royal mistress usually associated with Drouais, however, was Madame du Barry, variously portrayed by him as Flora, a Vestal Virgin and a Muse (Salon of 1771). Madame du Barry performed the same function for Drouais as Pompadour had done for Boucher: she imposed on him her own stereotype of feminine elegance, oval face, slanting eyes and swept-back hair, usually decorated at the parting with a flower. This new 'neo-Grecian' look invented by Madame du Barry immediately became all the rage in Paris, and was responsible for her success with the King when she was presented at court in 1768. But, as so often in eighteenth-century France, the critics found themselves at odds with the verdict of society. In a review, Bachaumont complained that Drouais always gave the royal mistress a prettified, simpering look untrue to her real character, while Diderot, in his *Salon of 1769*, reproached the artist for monotonous repetition of the same facial types, all painted in the same pasty colours. By about 1770, the tide had already turned against the conventional portrait, and once again, but this time

83. Drouais,
The duc de Berry and the comte de Provence as children,
95 × 127 cm.
Museu de Arte de Sao Paulo, Brazil

irrevocably, artists, critics and the public united in their demand for a more vigorous and positive type of portraiture, showing people in their everyday occupations, as they really were. The changing temper of the times also became strongly apparent at the Salon of 1771, when Madame du Barry chose to have herself portrayed by Drouais as a Muse in the nude. Probably because the model was a well-known public figure, the painting so outraged general opinion that the sitter, to her great anger, was forced to withdraw it from the Salon. The significance of this event and the increasing concern for morality—at least outward decorum—is underlined by a letter read by Marigny, the *Directeur des Bâtiments*, to the Academy on 26 June 1773, urging members to show greater severity towards such blatant lapses from public decency.

The pattern in portraiture set by Drouais was closely followed by Roslin, and many others. Alexandre Roslin (1718–93) was a Swedish artist who, after travelling in Italy, settled in Paris in 1752 and soon found favour with Madame de Pompadour and the court circle. He quickly rose to be one of the most fashionable portraitists of the day, second only to Drouais, and his portraits of *Madame Adélaïde* and *Madame Victoire* from the period 1760–70, as well as those of prominent figures in Parisian intellectual life, such as *Madame d'Alembert*,[16] were immediately successful. To the modern eye, however, Roslin carries the aristocratic formality of Drouais to the point of lifelessness. Portraits like, for example, that of *Isabella, Countess of Hertford* (1765, Glasgow, Hunterian collection), though technically perfect, are closer to carefully made-up dummies than to human beings, with the same frigid smile and inexpressive faces mounted on quantities of minutely-painted embroidery.

As the eighteenth century drew to its close, the number of portrait painters multiplied so rapidly that it is impossible to mention more than a few and indicate briefly their general stylistic tendencies. Duplessis, Vestier, Claude Hoin, Danloux, Ducreux, Mesdames Labille-Guiard, Vigée-Lebrun and Vallayer-Coster: a mere handful of the numerous and highly accomplished portrait painters during the reign of Louis XVI, not to mention the outstanding portraits by Greuze, Fragonard and other artists who deserve separate consideration in their own right. The overall trend in these years was for portraiture to revert to sobriety and simplicity almost as if, in anticipation of the impending Revolution, aristocrats wished to attract as little attention as possible and not to court public envy by parading ostentatiously. The only exception to this generalization was Madame Vigée-Lebrun, whose portraits of Marie-Antoinette, the princesse de Lamballe and other great ladies of the day, invariably show the sitters in extravagant headdresses. On the whole, however, French portraiture of the period 1770–90 makes a

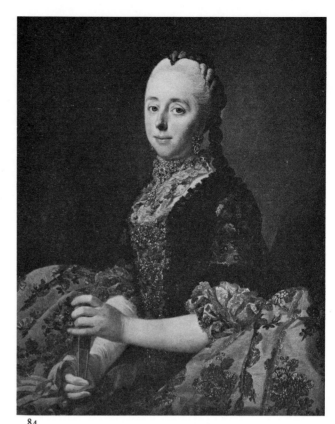

84

decisive turn away from the artificiality of the Pompadour and du Barry eras, and often directly foreshadows the portraits of Prudhon and David painted during or shortly after the Revolution. In their search for purity artists frequently avoided the free colourist technique and the decorative qualities of the Rococo period. Another common feature of these portraits is that many were influenced by sculpture, particularly the busts of Houdon and Pajou, which reinforced the natural tendency among painters towards naturalism and greater concentration on the expressive potential of the human face to the exclusion of the rest of the body. As a result, French portraits of this period—especially the *Fancy Portraits* by Fragonard from the early 1770s—often look like isolated busts of the sitters, detached from their surroundings and shorn of all external trappings.

Many of these qualities can be found in Louis XVI's official portrait painter, Duplessis (1725–1802), widely praised by his contemporaries for his great sincerity and truth in the delineation of character. Duplessis is far from the conventional ideal of the court painter; his work has a robust strength, combined with accuracy, which endows all his sitters with a powerful human presence. This is especially true of his best known masterpiece, the portrait of *Glück* at the harpsichord (1775, Vienna), which, besides Aved's portrait of Rameau, shows the profoundest sympathy by an artist for the act of musical creation. Duplessis' success came only late in his career, after an obscure beginning in Carpentras and a period in Rome studying under Subleyras and Joseph Vernet, neither of

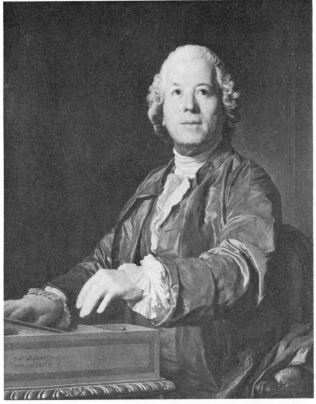

85

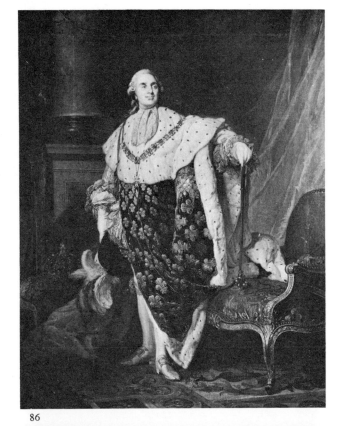

86

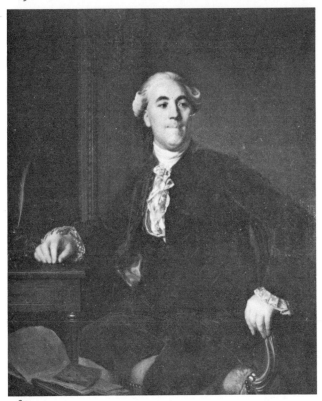

87

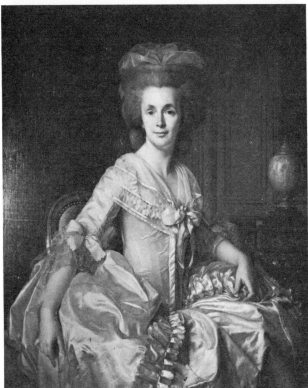

88

whom appear to have left any recognizable imprint on his own work. In 1771 he received his first royal commission, to paint the portrait of the Dauphine Marie-Antoinette on horseback, which he never executed, but the most prolific period of Duplessis' career dates only from the accession of Louis XVI in 1774. Beginning with the portrait of

Louis XVI (Versailles), shown in half-length wearing the Cordon du Saint-Esprit, Duplessis went on to fix the features of many of the most prominent figures from the last years of the century: the *Comte de Provence, Jacques Necker* and *Madame Necker,* and the *Comte d'Angiviller,* among others. The portrait of *d'Angiviller* (c. 1779, Shef-

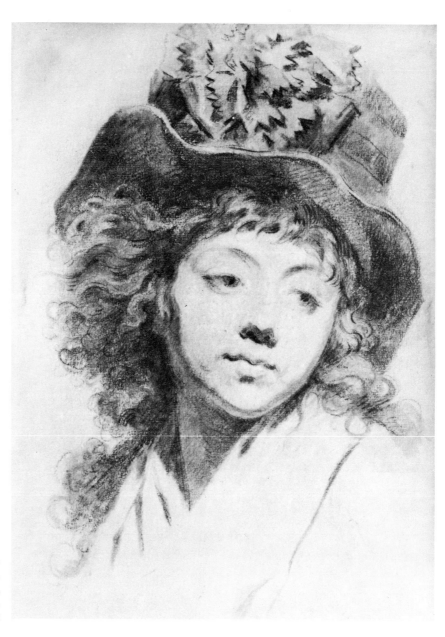

89. Hoin,
Woman in a Black Hat,
chalk drawing,
386 × 272 cm.
Musée des Beaux-Arts, Dijon

field collection), the powerful *Directeur des Bâtiments,* wearing his numerous official decorations and with a plan of the projected new Gallery of the Louvre unrolled on a table, manages to combine the personal and the official aspects of the sitter's personality. The painting clearly conveys his authority but at the same time is relaxed and human, and can be regarded as the late eighteenth-century answer to the formal portraits of Rigaud and Largillierre. The same informality and relative lack of pomp is apparent in Duplessis' portrait of *Jacques Necker* (Château de Coppet),[18] twice minister of finance under Louis XVI who tried unsuccessfully to restore some kind of order to the chaotic state of the royal treasury during the last years of the régime; while in a portrait sometimes thought to represent *Madame de Staël* (San Francisco, Young Museum), Duplessis came closer to the spirit of the new Romantic age which, with its accent on striking directness and honesty, was to sweep away the conventions of

eighteenth-century portraiture once and for all.

From a host of minor but often very talented provincial portrait painters during this period, Claude Hoin (1750–1817) deserves a special mention. Better known for his charming gouaches of gallant and allegorical subjects, often like those of Fragonard on a small scale, he also executed several excellent portraits in oils, and in chalk and pastel. A native of Dijon, he studied with Greuze, another compatriot, in Paris. Greuze was undoubtedly his formative influence and he began by copying his master's studies of young girls' heads and later drew several of his own in this vein. One of his best known portraits is that of the *Woman with a Blue Ribbon,* in a combination of black, brown and red pencil, lightly touched up with blue, red and white—a drawing of perfect delicacy and charm. Another drawing, of the *Woman in a Black Hat,* in soft black pencil, has the same casual, unstudied quality of some of Prudhon's female

studies, and reminds us how much both artists owed to their common teacher François Devosge, who may have been no more than a mediocre painter himself, but who helped to train a whole new generation.

Antoine Vestier (1740–1824) was another provincial artist, also of Burgundian origin, who rose well above the average level and produced two or three memorable portraits. After a spell in Pierre's studio in Paris, Vestier travelled in England and Holland. His portraits, which he first exhibited at the Salon of 1782, testify to the influence of both countries. He comes particularly close to the manner of Reynolds and Gainsborough in works like the superb portrait in Tours of *Jean Theurel* (1788), a veteran campaigner in the Touraine regiment, painted a few years before his retirement at the age of ninety-two. This work has a breadth and vigour rarely found in French eighteenth-century art, which can only be parallelled in English painting of the time. At other times, as in the *Portrait of a Man* (1788) in Avallon, Vestier directly foreshadows the Revolutionary sobriety of J.-L. David, reinforced by the neutral background and the austere simplicity of the sitter's dress. Vestier represents the last moments of the Ancien Régime, when the freedom and spontaneity of eighteenth-century art were still alive, but in a chastened and more sober form. Eventually, however, painters like Vestier, and Duplessis at the end of his career, fell into the very antithesis of Rococo exuberance. In their search for purity and simplicity, they deliberately excluded free brushwork and lively colour from their practice, so that their last works tend to resemble wax images, with little trace of life or movement.

The last phase of the Ancien Régime was marked by a distinguished generation of women portrait painters, Adélaïde Labille-Guiard, Anne Vallayer-Coster and Elisabeth Vigée-Lebrun, who capture these final years of

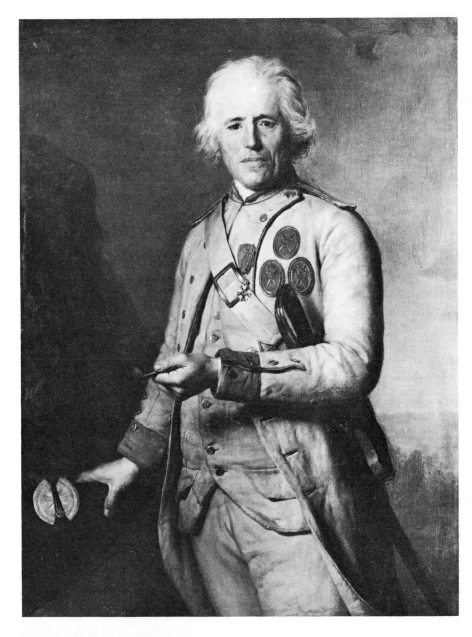

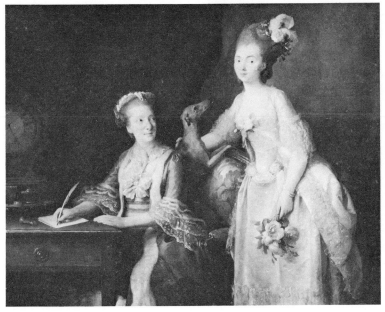

90. Vestier,
Jean Theurel,
122 × 90 cm.
Musée des Beaux-Arts, Tours.
Photo: Musées Nationaux, Paris

91. Vallayer-Coster,
Woman with her Daughter,
128 × 162 cm.
Bowes Museum, Barnard Castle, County Durham

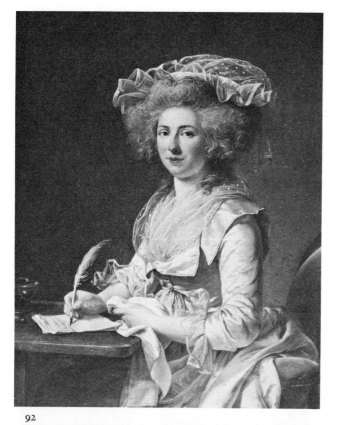

92

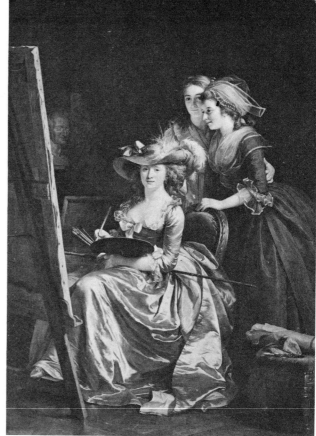

93

92. Labille-Guiard,
Portrait of a Woman,

100 × 81 cm.

Musée des Beaux-Arts, Quimper.

Photo: M. Bocoyran

93. Labille-Guiard,
Self-Portrait with Two Pupils,
Mesdesmoiselles Capet and
Carreaud de Rosemond

32.7 × 23.4 cm.

Metropolitan Museum of Art, New York

94. Vigée-Lebrun,
Duchesse de Polignac,

98.4 × 71.2 cm.

National Trust,

Waddesdon Manor

95. Vigée-Lebrun,
Marie-Antoinette and her
Children,

260 × 205 cm.

Château de Versailles.

Photo: Musées Nationaux, Paris

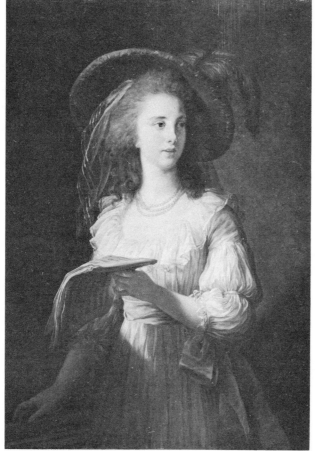

94

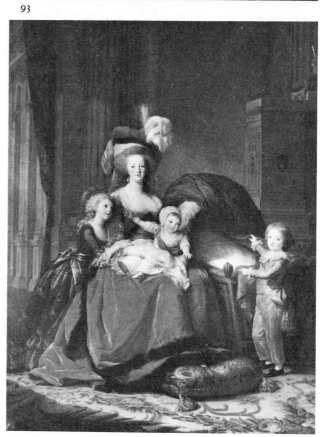

95

the eighteenth century with their own special blend of elegance and precision. Adélaïde Labille-Guiard (1749–1803) has largely been eclipsed by her better-known rival, Madame Vigée-Lebrun, but painted many first-rate portraits of her contemporaries and deserves greater recognition. Her paintings have a simplicity and honesty sometimes lacking from the more florid creations of Madame Vigée-Lebrun. Her technique is meticulous, but not over-emphatic, and suggests a feminine counterpart of Duplessis. Her career began as a miniaturist and pastellist, first taking lessons from La Tour, then from the man she eventually married, François-André Vincent, who taught her the technique of oil painting. After a late start, Madame Labille-Guiard was finally received as a member of the Academy in 1783, and from then onwards she received many important commissions to paint members of the royal family (*Madame Elisabeth* and *Madame Adélaïde*, Versailles), as well as fellow artists (Vien, Suvée, Vincent) and the most distinguished people of her generation. Unlike Madame Vigée-Lebrun, Adélaïde Labille-Guiard was sympathetic to some aspects of the Revolution, at least at its outset; she remained in Paris during those years and even painted portraits of Robespierre and members of the Convention. In composition and format her portraits vary greatly according to the sitters; traditional and formal in the manner of Van Dyck in her portraits of royalty, Madame Labille moves to extreme simplicity in her depiction of single figures. One of the best examples of the latter type is the *Portrait of a Woman* (c. 1787), in Quimper, writing what appears to be a message of farewell to her children. The painting is a masterpiece of understatement, elegant, precise and yet not glossy, with its finely rendered satin, the transparent gauze of her dress and exceptional delicacy of modelling. Madame Labille is also on fine form in portraits of herself and her fellow-artists, notably in the *Self-Portrait with Two Pupils, Mesdesmoiselles Capet and Carreaud de Rosemond* (1785, New York, Metropolitan Museum of Art), showing the sitter comfortably installed at her easel, while the two girls watch with expressions of delight and intense concentration.

There is, however, little trace of this restraint and lack of ostentation in the work of Elisabeth Vigée-Lebrun (1755–1842), who was unashamedly worldly and enjoyed the close friendship of Marie-Antoinette and the royal circle. She was fond of the theatre, musical parties, charades and all the various forms of entertainment practised by smart society during the last years of Louis XVI's reign. This, combined with her personal beauty and

charm (see *Self-Portrait*, Texas, Fort Worth; a full-length portrait in the National Gallery, London) made her the most fashionable portrait painter of the time. The daughter of an obscure painter named Vigée, she showed a precocious talent for drawing and rapidly achieved fame, being only twenty-four when she painted her first portrait of Marie-Antoinette. The secret of her success may be explained in part by the fact that, like the unfortunate Queen, Madame Vigée-Lebrun delighted in fancy-dress and disguises and did not conceal her dislike of modern costume. As she explained in her *Souvenirs*, this was the reason for enveloping her sitters in broad shawls in imitation of the fine draperies of Raphael and Domenichino; hence, too, the wide Rubensian hats in which she liked to deck out her female sitters, such as the beautiful *Duchesse de Polignac* at Waddesdon, with her musical score and open piano beside her. The best idea of Madame Vigée-Lebrun's formal, courtly manner can be gained from her three-quarter-length portrait of Marie Antoinette (1779–83) at Versailles, holding a single rose in her hand, against a background of trees, in which the somewhat affected pose suggests a return to the mannerisms of Mignard and late seventeenth century art.

Madame Vigée-Lebrun is perhaps at her best and most natural in portraits of individual sitters, many of which have such charm, like the ravishing *Mademoiselle Roland*, painted in Rome in 1791, that it is hard not to forgive the artist's persistent sentimentality. Her art was a conscious anachronism, typifying the final attempt by Ancien Régime society to shut its eyes to unwelcome realities, and to take refuge in a world of make-believe and fancy dress. After the storming of the Bastille and the outbreak of the Revolution in 1789, which led to the execution of Marie-Antoinette and the exile of the duchesse de Polignac, Madame Vigée-Lebrun prudently left Paris and made a triumphal tour of Europe. This included a visit to London in 1802, during which she painted the portraits of many prominent figures, the Prince of Wales and Lord Byron among them. But, despite the profound upheavals which finally shattered the 'douceur de vivre' of eighteenth-century society, the art and life style of Madame Elisabeth Vigée-Lebrun changed very little. She retained her affection for the idealized, theatrical pose, and in a well-known though not altogether successful portrait of the priestess of the new age, *Madame de Staël as Corinne* (Château de Coppet, 1802), accompanied by her lyre and dressed in a Greek toga, she made a first step in the depiction of that specifically Romantic theme, inspiration.

5: Boucher and the Reign of Madame de Pompadour

To many critics, including the Goncourt brothers, French civilization in the eighteenth century seemed virtually synonymous with the Rococo style and the rule of Louis XV. Although over-simplified, this view is easily understandable when we consider that this monarch's rule stretched from 1715 to 1774 and thus spanned the major part of the century. Throughout this long reign, marked by a period of almost unbroken internal peace, Louis XV became as closely identified with his own century as his father had been with the previous one. Less autocratic than his predecessor, Louis XV was intelligent, easy-going and popular (christened 'le Bien-Aimé'), though lazy and inclined to leave important affairs of state in the hands of his minister and former tutor, Cardinal Fleury, who virtually ruled the country from 1726 to 1743. Louis nevertheless put his own personal stamp on most French institutions, not least in the realm of the arts. Through his marriage to Marie Leczinska, daughter of the King of Poland, then later through a succession of mistresses, Mesdames de Châteauroux, de Pompadour and du Barry, the King ensured that women exerted a dominant influence on the court and metropolitan life in general. French art of this period was largely created to satisfy the tastes of women—in sharp distinction to the martial, virile quality of much seventeenth-century art—and it was largely for their delight that vast sums were spent on the exquisite products of the Vincennes and Sèvres china factories, the Gobelins tapestries, and the many celebrated goldsmiths, silversmiths and cabinet-makers of the day. It was during the reign of Louis XV, and especially under the patronage of Madame de Pompadour, that the decorative arts reached their peak of perfection, when every French artefact from the most elaborate commode by Jacob down to the humble provincial *armoire* bore the same mark of elegance and refinement. The 'fine arts', moreover, became so closely intertwined with the decorative arts that any lingering distinction between the two was now effaced.

The main reasons for this flowering of French civilization in the middle of the eighteenth century were twofold: the creation of a new social élite, coupled with the general prosperity of the country. The second factor, which Voltaire saw as the necessary condition for the arts to flourish, was primarily made possible by the stabilization of the currency in the early years of Louis XV's reign. The value of money was fixed by Cabinet decree in 1726, and from then on scarcely altered until the Revolution. If this control of the raging inflation of the previous decade

made it more difficult to make a fortune overnight, it did much to favour the commercial interests and expansionist policy inaugurated by Colbert under Louis XIV. The result was the progressive accumulation of wealth by the urban bourgeoisie, who lost no time in buying the offices and sinecures which virtually conferred on them the rank of nobility, disowning their origins, marrying off their daughters to the greatest families of the land, and thereby strengthening rather than weakening that passion for hierarchy and order which characterized France under the Ancien Régime. It was not the very rich, but the middle ranks of professional men, lawyers, doctors and the like, who were to constitute the main opposition to aristocratic privilege and, in the last decades of the century, to clamour for greater political representation through the Third Estate. The élite of French mid-eighteenth-century society was, therefore, a compound of ancient lineage and new money, represented by aristocratic patrons like the duc de Penthièvre, the marquis de Véri, Randon de Boisset and men of more recent wealth, the financiers and *fermiers-généraux*, Samuel Bernard, Bergeret de Grancourt, Grimod de la Reynière, and Lenormant de Tournehem, the guardian of Madame de Pompadour. These men and others like them possessed vast fortunes, the surplus of which they usually devoted to the arts, as patrons and collectors.[2]

The artist most closely associated with the élite based on the court of Louis XV was François Boucher (1703–1770), and largely for this reason his posthumous reputation has suffered more than that of any other eighteenth-century artist. Boucher's art became a by-word for Rococo frivolity and eroticism, synonymous with all the vices—and none of the virtues—of this style. He was attacked during his own lifetime by Diderot, among others, and he continues to be attacked, on the grounds that he pandered to the depraved tastes of a privileged minority of courtiers and rich connoisseurs. Whatever justice there may be in such strictures depends largely on the spectator's point of view; but they are certainly not based on artistic considerations, and it is as an artist that Boucher must be judged. Boucher was first and foremost a professional painter, born 'brush in hand', as his biographer Mariette wrote,[3] the supreme virtuoso of the mid-eighteenth century. He accepted everything which came his way with a zest bordering on creative fervour, equalled only by the great master decorators of Italy. His unfortunate reputation as a 'chocolate box' painter stems from the critics' failure to perceive the immense labour,

constant practice and meticulous draftsmanship which underlies his apparent facility and brilliant improvisation. Although he often undeniably lapsed into imaginative banality and slovenly execution, especially towards the end of his career, at its best his art has a sparkle and vitality which only his pupil, Fragonard, was to surpass.

French civilization of the mid-eighteenth century was an essentially urban phenomenon. It was created to satisfy the desires of town-dwellers who spent most of their spare money and leisure on clothes, furniture and the theatre, as well as the arts; on everything, in fact, which contributed to their domestic well-being and enhanced the elegance and refinement of their lives. Now that the court of Versailles had lost its pre-eminence in French social life, the individual *hôtels* in Paris became the focal point of cultural life in the capital. It was for this urban clientèle that Boucher primarily worked, and he became their typical, most representative artist. Boucher was himself a Parisian, born on the rue de la Verrerie, the son of a minor painter of ornaments who kept a print shop on the place du Vieux Louvre. This family background of artisans and dealers was the main formative influence on Boucher, who regarded himself as a craftsman above all else. He rapidly showed a precocious talent for drawing and, after painting a *Judgement of Susanna* at the age of seventeen, he entered the studio of François Lemoine. Although he later boasted to Mariette that he had learnt very little from Lemoine, his early works, with their crystalline colouring and full, Italianate modelling, reveal a clear debt to the older artist. This affinity between pupil and master is best illustrated by Boucher's two exceptionally fine early compositions in the Wallace Collection, the *Rape of Europa* and *Mercury confiding the Infant Bacchus to the Nymphs*, pendants painted around 1734, both of which were catalogued as late as 1913 as the work of Lemoine.[4]

The first element in Boucher's early training was the grand Italianate monumental tradition, naturalized in France by Lebrun and his pupils. The second, more specifically French element was the small-scale decorative manner associated with the minor Rococo artists and perfected by Watteau. This Boucher learnt from his second master, the engraver Laurent Cars, for whom he drew book illustrations and coats-of-arms. It was to his study of Watteau, however, that Boucher owed his consummate draftsmanship. Early in his career he was commissioned by the connoisseur Jean de Julienne to make a series of engravings after 125 drawings from Watteau's *Figures de différents caractères*. This collection of studies showing individual figures in various actions and postures left a distinct mark on Boucher's own drawings, particularly of women, and taught him how to capture the delicate contours of the female body, the twist in the nape of the neck and the turn of an ankle seen from behind. But whereas Watteau lends to these figures his own nervous diffidence, Boucher gives them a fullness of contour and radiant, fleshly quality in keeping with his more robust temperament.

The next stage in Boucher's formation as a decorative painter came with his travels in Italy between 1727 and 1731. He showed a typical jaunty disrespect towards the Old Masters he studied there, very different from the exaggerated deference expected from the young French pensioners in Rome. He travelled 'more to satisfy his curiosity than for personal profit', as he later put it to Mariette, staying in Genoa, Ferrara and Venice en route for Rome, where he took up residence at the French Academy in May 1728. In Rome Boucher was visibly impressed by the work of the great Baroque decorators, Pietro da Cortona and Luca Giordano. He quickly assimilated their light, airy, broadly-conceived frescoes, which clearly influenced his own later decorative projects; they taught him how to situate bodies in space with the utmost ingenuity and with an eye to the greatest dramatic effect. Despite the flippancy of his own pronouncements, he always remained dependent on the established practice of the Italian Baroque tradition and those elaborate constructional devices which enabled artists to create order out of a mass of incohate figures. The sense of directional purpose and unity is always present in Boucher, particularly in the large, ambitious compositions, such as *The Triumph of Venus* (1740), in Stockholm, and the *Rising* and *Setting of the Sun* (1753), in the Wallace Collection, which owe so much to Italian precept.

In 1731 Boucher returned to Paris, where his early works quickly found favour with connoisseurs and fashionable society. Three years later, in 1734, he presented his *Rinaldo and Armida* as his 'morceau de réception' to the Academy and was received as a full member. This tender, lyrical painting, from Tasso's epic poem *Gerusalemme Liberata*, shows the youthful Rinaldo temporarily seduced by the beautiful witch Armida in her secluded garden; with its gently flowing contours, delicate chiaroscuro and langorous atmosphere, reminiscent of Correggio, *Rinaldo and Armida* represents a synthesis of Boucher's recollections of Italy and of the new enthusiasm for Rubens. At roughly this stage in his career, Boucher came into contact with another formative influence, the Dutch and Flemish school of landscape painters, notably Teniers, Berchem, Ruysdael and Bloemaert, who were to play an important part in his own perception of landscape and the pastoral scene. They taught him to mingle elements from the classical Italian tradition with more down-to-earth rustic scenery, and to create that typical combination of the formal and the picturesque which made him so popular in his own day. The single most important Dutch artist for his subsequent development was undoubtedly the Utrecht painter Abraham Bloemaert (1564–1651).[5] While in Italy, Boucher had already acquired several

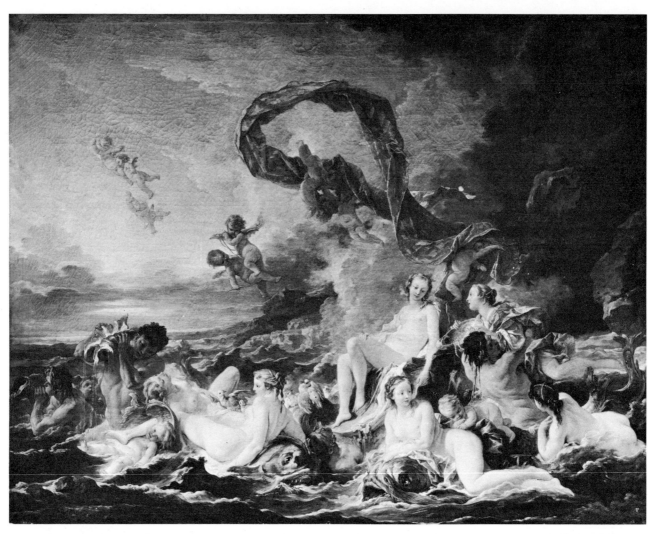

96. Boucher,
The Triumph of Venus,
130 × 162 cm.
Nationalmuseum, Stockholm

97. Boucher,
Rinaldo and Armida,
135.5 × 170.5 cm.
Musée du Louvre.
Photo: Giraudon

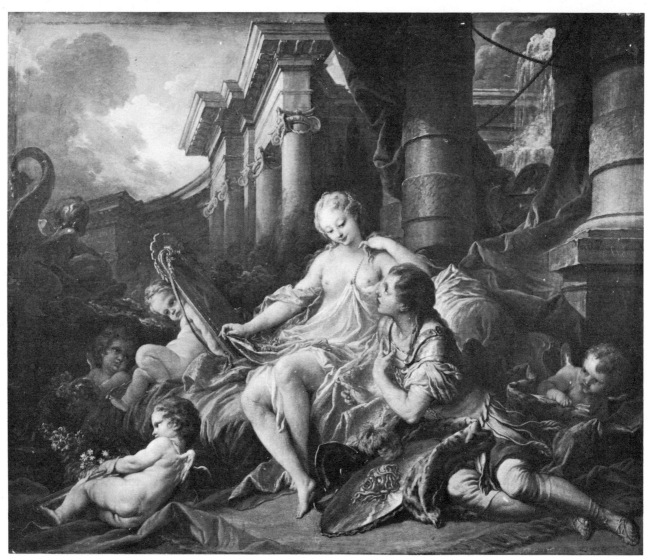

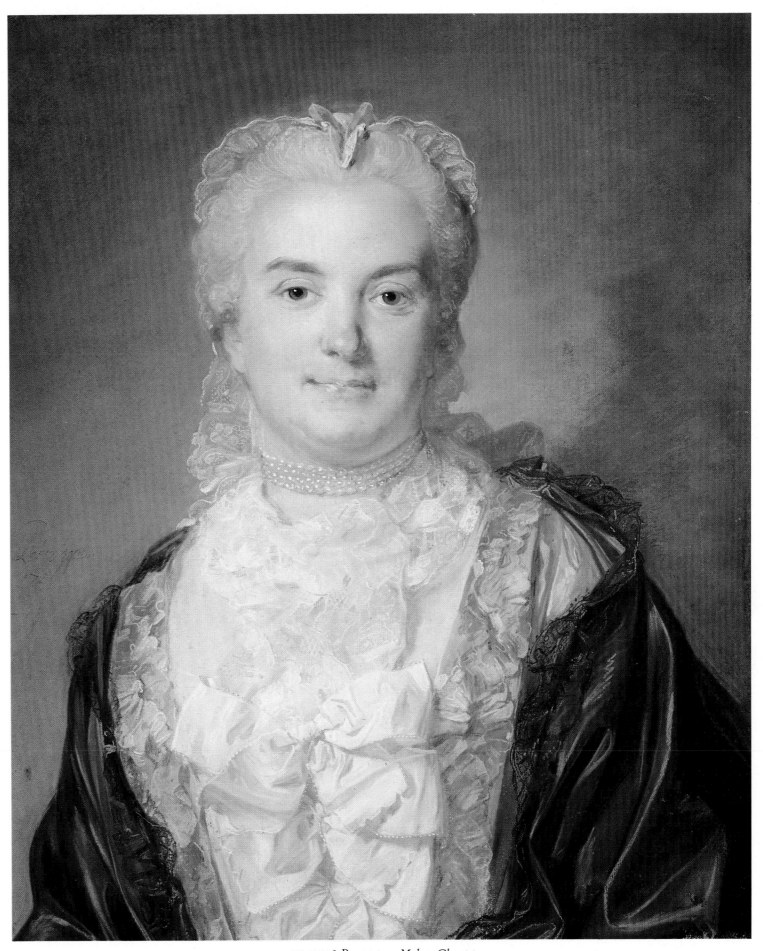

PLATE 8. Perronneau, *Madame Chevotet,*

pastel, 61 × 52 cm. Musée des Beaux-Arts, Orléans. Photo: Lauros-Giraudon

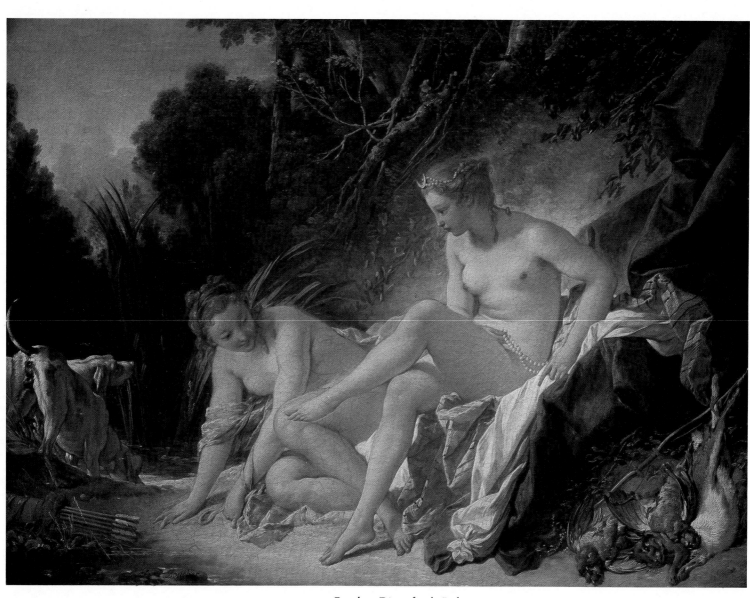

PLATE 9. Boucher, *Diana after the Bath*,
56 × 73 cm. Musée du Louvre. Photo: Bridgeman Art Library

drawings by Bloemaert which he later used to make a series of etchings, published in 1735 as the *Livre d'études d'après les desseins originaux de Blomart*. From these studies it is clear that from Bloemaert he learnt to introduce the familiar figures, the fishermen and washerwomen, into the foreground of his landscapes which help to create a mood of bustle and animation.

His training thus completed, Boucher took a significant step in 1735, when he received his first royal commission from the *Direction des Bâtiments* to decorate the Queen's apartments at Versailles with four allegories in grisaille. This was the first stage in a career which was to make him the greatest decorative painter of his generation. As his fame spread, Boucher was soon besieged with commissions for putti, cupids and nymphs to decorate the panels of French royal and aristocratic châteaux. Moreover, European princelings, determined not to be outshone by Versailles, set out to imitate their French counterpart and if they could not procure the work of Boucher himself, had to make do with one of his numerous pupils, for example Jakob de Wit in Holland or J.C. von Mannlich in Germany. To meet the ever-increasing demand for his decorative panels, Boucher was forced to employ a large army of assistants and, unfortunately for his reputation, he was not above signing studio works or paintings largely untouched by his own hand. The result was a large number of copies, replicas and outright fakes, some of which are still in circulation.

The other factor which militates against a proper understanding of Boucher's art is that many of his paintings are now dispersed in private collections and museums throughout the world, so that it is hard to imagine them in their original setting. A few decorative schemes have survived intact (notably those at Versailles, the Cabinet des Médailles in the Bibliothèque Nationale and the Salle du Conseil at Fontainebleau), but the majority of royal palaces, such as Marly, Choisy, La Muette and Bellevue, were destroyed during or after the Revolution. These decorative panels were always designed for a specific architectural context, usually as overdoors or in positions above the wainscoting, flanked by carved Rococo panelling and tall pier glasses, for the kind of interior evoked in the delightful interior picture of 1739, showing a French family taking breakfast. Throughout his life Boucher was in constant demand for such schemes, and his first commission for the Queen's apartments at Versailles was followed by many others: the six hunting scenes for the King's dining room at Versailles (1736), now at Amiens, the decorations for the Hôtel de Soubise (1738), paintings for the gallery of Madame de Pompadour's château at Bellevue (1750), and the decoration of the Salle du Conseil at Fontainebleau (1735). These are only the principal decorative ensembles, in which Boucher displays a consistent tech-

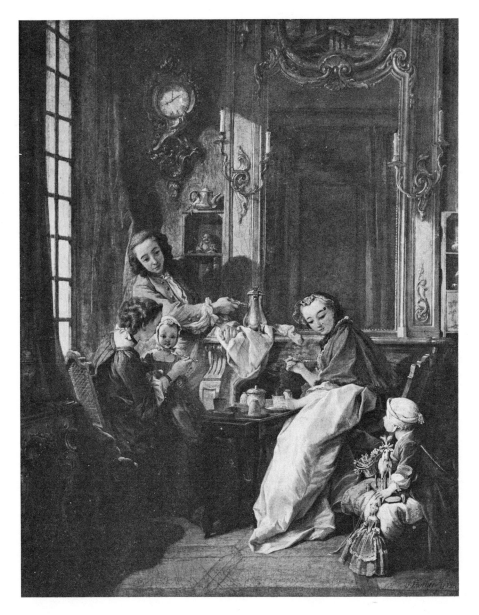

98. Boucher,
Family Taking Breakfast,
81.5 × 65.5 cm.
Musée du Louvre.
Photo: Giraudon

nical mastery in the handling of old, familiar themes from classical mythology.

His executive skill and capacity for rapid improvisation made him ideally suited for the design of theatrical sets, and much of his career was devoted to the theatre and opera. Boucher first worked for the Opéra in 1742, when he took over responsibility for designing the sets from the Italian architect-decorator, Servandoni; from then on until 1748 he produced a series of costume designs and scenery, few of which have survived. One exception, which gives a fair idea of his remarkable talent in this field, is the oil sketch preserved in Amiens, *The Hamlet of Issé* [*Le Hameau d'Issé*] (1742), a brilliant, sparkling piece of improvisation designed as a backdrop for the heroic pastoral *Issé* by Destouches and Lamothe, set to music and performed at the Opéra in the same year. The decorative and theatrical roots of Boucher's approach to landscape are clearly apparent in this sketch, which makes little pretence to 'nature' in its self-conscious,

99. Oudry,
Steps in the Park at Arcueil,
pencil drawing,
30.2 × 51.2 cm.
Musée d l'Ile de France, Sceaux.
Photo: Giraudon

100. Boucher,
Landscape with Watermill,
90.8 × 118 cm.
Bowes Museum,
Barnard Castle, County Durham

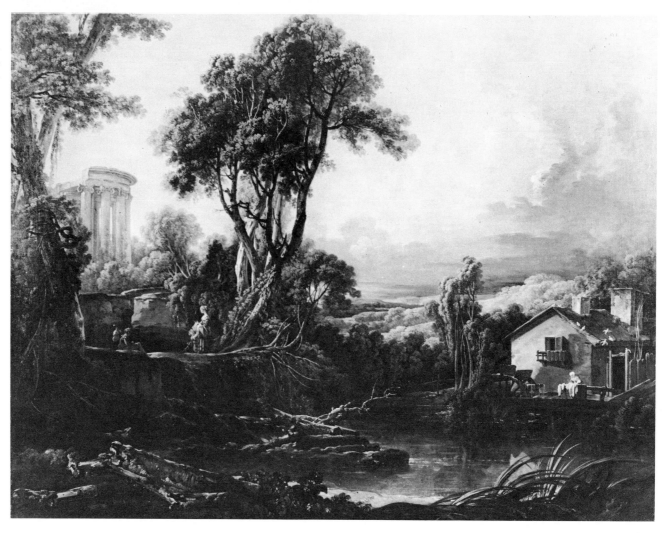

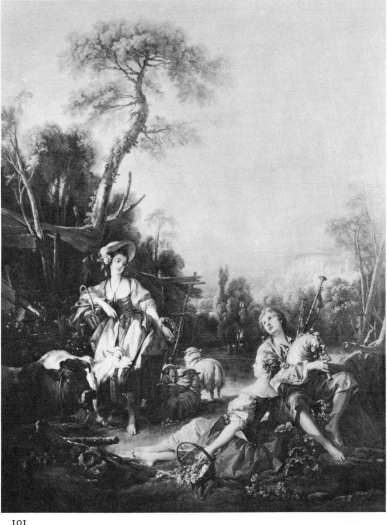

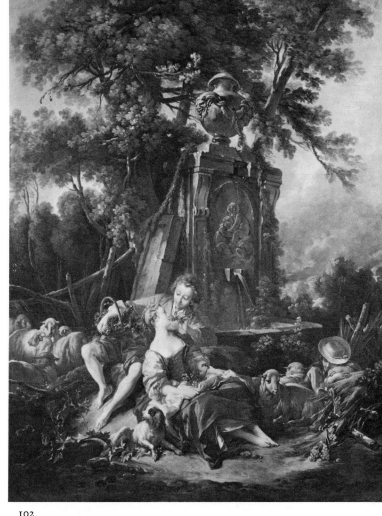

101

102

artificial rusticity; Italian architectural motifs are grafted on to an ordinary French village in the most implausible manner. The whole thing might have remained a figment of Boucher's imagination, if Marie-Antoinette had not translated a very similar idea into reality in the Petit Hameau at Versailles.

Artifice and nature both play their part in Boucher's creative process, especially in his approach to landscape, where the theatrical origins of his art are most conspicuous. Though the critic Watelet reproached the artist for painting landscapes without consulting nature first, Boucher in fact made the most meticulous preparatory drawings on the spot, like that of the steps and bridge at Arcueil. He usually drew these in the company of his friend Oudry (fig. 99), who accompanied him on outings to Charenton on the river Marne and other places in the Île de France. Many of his landscapes were inspired by the Picardy countryside near Beauvais, when the artist was placed in charge of the tapestry factory. With their limpid blue skies reflected in clear water, their fresh streams and vigorous green foliage, landscapes like the one in Orléans (c.1753) capture the essence of the northern French countryside. But there is also an element of truth in Watelet's

criticism. For Boucher, 'nature' was merely a stage set in which the various props could be shifted at will: a dovecot, a rickety bridge, a ruin or a cottage—these are the simple ingredients used and re-used on scores of different occasions. The result is a kind of picturesque bustle, a random assortment of objects and figures for which the Goncourt brothers invented the name 'le fouillis'. Boucher frequently introduces elements quite foreign to his native country, such as an Italian urn or fountain. In the supremely beautiful landscape in the Bowes Museum, for example (fig. 100), a classical temple rises above what might otherwise be an ordinary French river scene. These landscapes usually combine features of topographical accuracy (like the mill at Charenton, which often appears) with elements of pure fantasy, thereby creating a unique blend of Dutch realism and Arcadian idyll.

Closely related to the landscapes are the numerous pastorals, which became Boucher's chief speciality during his lifetime. Paintings of this type, like the pair in the Wallace Collection, *Summer* and *Autumn Pastoral* (1749), usually show elegant young shepherds and shepherdesses, far too clean and fashionably dressed to be authentic rustics, idly tuning their pipes or casting fond glances at

101. Boucher,
Summer Pastoral,
263 × 201 cm.
The Wallace Collection, London

102. Boucher,
Autumn Pastoral,
264 × 201 cm.
The Wallace Collection, London

[83]

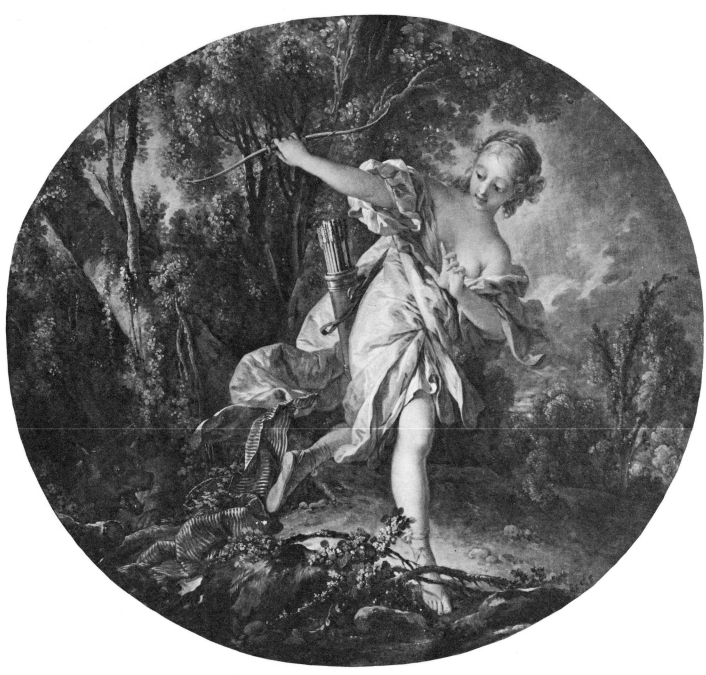

103. Boucher,
Sylvia and the Wolf,
123.5 × 134 cm.
Musée des Beaux-Arts, Tours.
Photo: Lauros-Giraudon

each other, with hardly a thought for the sheep in their charge. Boucher's attitude to nature and the countryside was obviously that of a town-dweller, the Parisian born and bred who saw only the agreeable aspects of country life and none of its hardships. There is no suggestion of the labours involved with agriculture, the need to shear or slaughter the prettily beribboned sheep, whose function is purely decorative. This mode of existence held an obvious appeal for a man of Boucher's langorous temperament. But it also reflects the state of French civilization around 1750, when people from the metropolis began to yearn for the rural idyll. The cult of 'nature' had already begun, but was still confined within the limits of pastoral gentility and had not yet achieved the freedom and elemental force which the writings of Rousseau were soon to unleash.

The pastoral in art was, in one sense, only the extension

of a long literary tradition stretching from the eclogues of Theocritus and Virgil, through the Italian Renaissance up to such recent French writers as Fontenelle and Marmontel. The emphasis here was on subtlety, charm and wit, and emotions were never allowed to go more than skin deep. As Marmontel wrote in his article on the Eclogue for the *Encyclopaedia*: '*La délicatesse du sentiment est essentielle à la poesie pastorale.*'[6] Nature is constantly refined and embellished to provide a decorous backcloth to the incessant trysting and gallantries of the protagonists. One device particularly favoured by Fontenelle in his numerous elegies and eclogues—in close imitation of Ovid's *Metamorphoses*—was that of gods and goddesses disguised as mortals; just as in Boucher's painting *Apollo and Issé*[7] (1750, Musée de Tours), taken from a contemporary opera by Houdar de la Mothe, the sun god takes off his

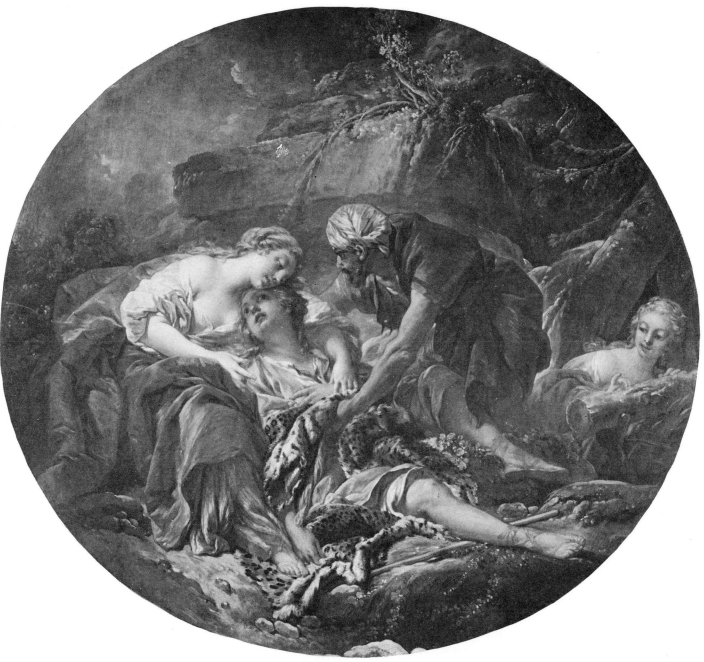

104. Boucher,
*Amintas Comes Back to Life
in Sylvia's Arms*,
122.5 × 139 cm.
Musée des Beaux-Arts, Tours.
Photo: Lauros-Giraudon

disguise and reveals his divinity to the young shepherdess. Boucher was no doubt familiar with the works of Fontenelle, and his name was frequently linked with the writer by contemporary critics like Bachaumont, who complained of his endless '*bergers à la Fontenelle*'.[8] In another delightful set of four paintings, executed in 1756 as overdoors for the duc de Penthièvre's town house in Paris,[9] Boucher took his theme from Tasso's pastoral poem *Aminta* (1573), relating the loves and adventures of Sylvia and a young shepherd, Amintas. Perhaps the most attractive of the series, *Sylvia and the Wolf*, shows the heroine fleeing from a wolf she has just wounded; despite its obvious artificiality, this scene, deftly painted in fresh tones of pink, yellow and green, has a poise and charm which none of Boucher's imitators could ever recapture.

But by around the middle of the century the genre which had won Boucher his fame was beginning to wane in popularity. People were growing tired of his insipid idylls, his marquises dressed up as country girls and their fake rusticity. Though the court circle surrounding Madame de Pompadour still enjoyed the pastoral poems of Cardinal de Bernis and Saint-Lambert, the intelligentsia, led by Diderot, reacted violently against them and demanded something truer to life and more authentic. Thus Boucher and the literary tradition on which he had been nurtured gradually fell out of fashion, clearing the way for a younger generation of artists led by Fragonard and Greuze, with a more representative outlook of the mood of France in the late eighteenth century.

Most of all, however, Boucher is known as the supreme painter of the nude. His relaxed, sensuous temperament equipped him ideally to paint the female body in all its

105. Boucher,
Diana Asleep,
pencil drawing,
23 × 38 cm.
Ecole des Beaux-Arts, Paris.
Photo: Bulloz

poses, and his hand seems literally to caress the curves of a woman's hips and thighs, as in the beautiful drawing of *Diana Asleep* in the École des Beaux-Arts. His mood ranges from the elegantly seductive pose of the central figure in the *Triumph of Venus* (1740), in Stockholm, and the gentle languor of the pretty shepherdesses to the frankly erotic appeal of the naked *Girl on the Couch* (1752, Munich, Alte Pinakothek).[10] The feeling Boucher conveys is one of passive sensuality equally remote from the diffident amorous gestures of Watteau's *fêtes galantes* as from Fragonard's feverish quest for physical satisfaction. The model he used for the early pictures, including the *Triumph of Venus*, was his wife, Marie-Jeanne Buseau, whom he married in 1733, but later in his career he usually drew on Louise O'Murphy, an Irish blonde and well-known courtesan of the day who served in Louis XV's private harem, the Parc aux Cerfs; her well-rounded but rather undistinguished features reappear in many of Boucher's nudes from around 1745 on. Towards the end, Boucher tended to dispense with the living model altogether, a habit deplored by Sir Joshua Reynolds in his *Twelfth Discourse* after a visit in 1752 to the artist's studio in Paris.[11] This undoubtedly led to a lowering of his professional standards, and resulted in the careless, flaccid draftsmanship and uniform turquoise-blues and pinks of the later works. But, at his best, Boucher ranks among the finest painters of women in the history of Western art—a

fact clearly recognized by Renoir, when he paid tribute to Boucher as 'the man who best understood the female body'. Both artists shared the same epicurean delight in physical beauty, in gentle curves and fully modelled forms, and in the translucent quality of flesh in strong sunlight. All these qualities are best exemplified by what is perhaps Boucher's finest single painting, *Diana after the Bath* (1742), in the Louvre [Plate 9]. Plate 9 faces page 81

It was entirely appropriate that the height of Boucher's career should have coincided with the rule of the greatest female patron of the age, Madame de Pompadour (1721–64). The most famous and the most gifted of Louis XV's mistresses, she began life modestly as Jeanne Poisson but, thanks to her guardian, Lenormant de Tournehem, a former director of the Compagnie des Indes, she soon came into contact with eminent people in Parisian artistic and intellectual circles. She acquired all the accomplishments of a well-bred young woman, learning to draw, embroider and play the harpsichord with some skill. At an early age, she married a Monsieur Lenormant d'Etioles and in 1746 became official mistress to the King, who soon afterwards gave her the title 'marquise'. From then until her death in 1764 Madame de Pompadour became the most influential patron of the arts in mid-eighteenth-century France. She was not only lavish in her spending of the Treasury's funds—already severely depleted by a series of wars abroad culminating in the Seven Years'

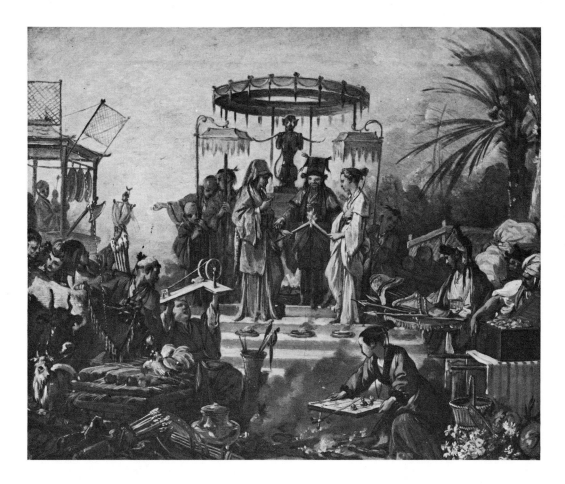

106. Boucher,
The Chinese Wedding,
41 × 48.3 cm.
Musée des Beaux Arts, Besançon

War (1756–63)—she was also discriminating, and consistently exercised her patronage on behalf of art of the highest quality. With her support, the Sèvres china factory (transferred from Vincennes in 1756), the Gobelins and Beauvais tapestries and the many famous cabinetmakers, silversmiths and other craftsmen, achieved a height which has rarely been equalled, before or since. Moreover, her hold over the arts was strengthened by the appointment in 1751 of her brother, Abel Poisson (later marquis de Marigny), to the crucial post of *Directeur des Bâtiments*, which gave him virtual control over official patronage.

Madame de Pompadour was, therefore, well placed to exercise her influence on behalf of her favourite artists, especially Boucher. His encounter with Madame de Pompadour in 1745 marked the climax of his career, and placed the final stamp of elegant luxury on his art. There has rarely been a closer correspondence of taste between artist and patron. Henceforward Boucher executed numerous projects for the marquise and her many châteaux in the neighbourhood of Paris, including Choisy, Bellevue and La Muette. He painted *chinoiseries*, overdoors, pastorals, decorative ensembles of all kinds—most of which are now dispersed in museums throughout the world—as well as designs to be executed in *biscuit* by the china factory at Sèvres. It was also thanks to Madame de Pompadour that Boucher obtained so many

royal commissions during this period, among them the decoration of the King's dining-room at Fontainebleau in 1748.

Of the numerous works painted specially for Madame de Pompadour's various residences, a few deserve particular mention and can be enjoyed as individual works of art, regardless of their original setting. The *Nativity* (Musée de Lyon), for instance, painted in 1750 for the high altar in the chapel of the Château de Bellevue, is a fine example of Boucher's religious style and, with its central source of light streaming down on the infant Christ, suggests a strong affinity with Correggio's *Notte*, which the artist may well have seen in Italy. Then there are the two splendid allegories in the Wallace Collection, the *Rising* and the *Setting of the Sun* (1753), a pair originally designed to be executed in Gobelins tapestry, which Madame de Pompadour subsequently bought for Bellevue. These are two of the most accomplished pieces in Boucher's full-blown mythological style, broad in treatment and yet meticulous in preparation and detail, as one can see from a preparatory drawing of the triton in the lower right-hand corner of the *Rising of the Sun*. Their subjects are taken from that perennial favourite among Rococo artists, Ovid's *Metamorphoses*, and show, first, Apollo rising from Thetis' couch in a blaze of sunlight before an assembly of nymphs and tritons; second, Apollo returning to Thetis' couch at dusk, while in the

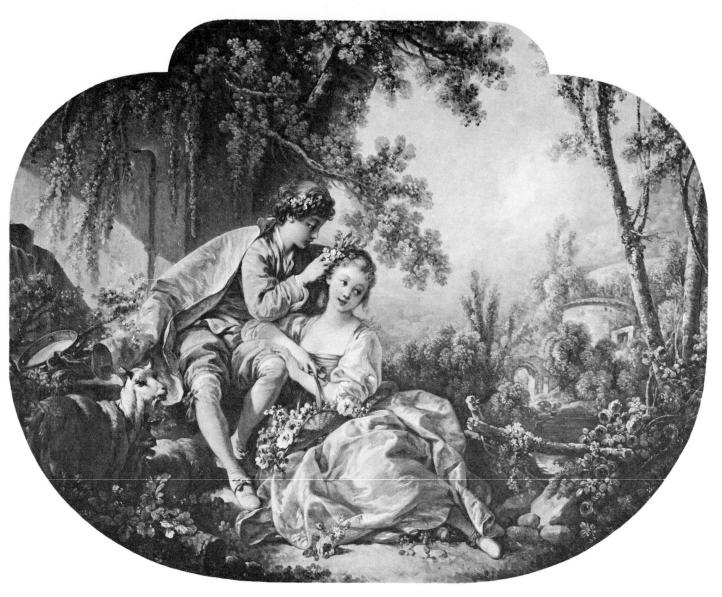

107. Boucher,
Spring,
55 × 71 cm.
The Frick Collection,
New York

sky a pair of cupids carry an awning which symbolizes night. But the most beautiful of all the decorative schemes executed for Madame de Pompadour is undoubtedly the series of *Four Seasons* in the Frick Collection, painted in 1755 and probably intended for use as overdoors in one of her châteaux. These four delightful compositions combine the traditional theme of the seasons with Boucher's favourite genre, the pastoral idyll. There is no suggestion of the labours normally associated with the different times of the year, only one of agreeable leisure and amusing pastimes. In *Spring*, for example, the young lover wreaths a garland of flowers for his sweetheart's head; *Summer* is simply depicted by three half-naked women cooling themselves by a fountain; in *Autumn*, the two young lovers are seen gathering grapes at vintage time, while in *Winter* – perhaps the most ingenious of the series – a young woman who strongly resembles Madame de Pompadour in her youth is shown on an ornamental sledge in a frozen, wintry landscape. These four subjects, which, as a recent scholar has shown,[12] derive from similar compositions by Watteau, represent the peak of elegance, refinement and imaginative fantasy, the epitome of the kind of art favoured by Madame de Pompadour.

There are, finally, Boucher's portraits of Madame de Pompadour herself [see Plate 10]. Surprisingly, perhaps, these are not among the artist's most intimate or personal creations, for all of them, whether set indoors or outdoors, tend towards a somewhat generalized image of the sitter which betrays little or nothing of her true character. They are not 'psychological' portraits in the mould of La Tour or Perronneau, nor mythological portraits after Nattier; if a parallel has to be sought, they are closer to the official portraits of Rigaud and Largillierre, only translated into the more casual idiom of the mid-eighteenth century and stripped of their elaborate trappings. Boucher's interest in his sitter was more in her capacity as royal mistress and patron of the arts than in her private individuality. This role is most fully apparent in the largest and most elaborate *Portrait of the Marquise*, (dated 1756, in Munich) which emphasizes her status by the conscious choice of attributes surrounding her; the rosewood secretaire and gilt pendule in the background allude to her interest in furniture and the decorative arts, the drawings and etchings (possibly by her own hand) scattered at her feet show her as a lover and amateur of the arts, while her interest in literature is denoted by the open book in her lap and the handsome

Plate 10
faces page 104

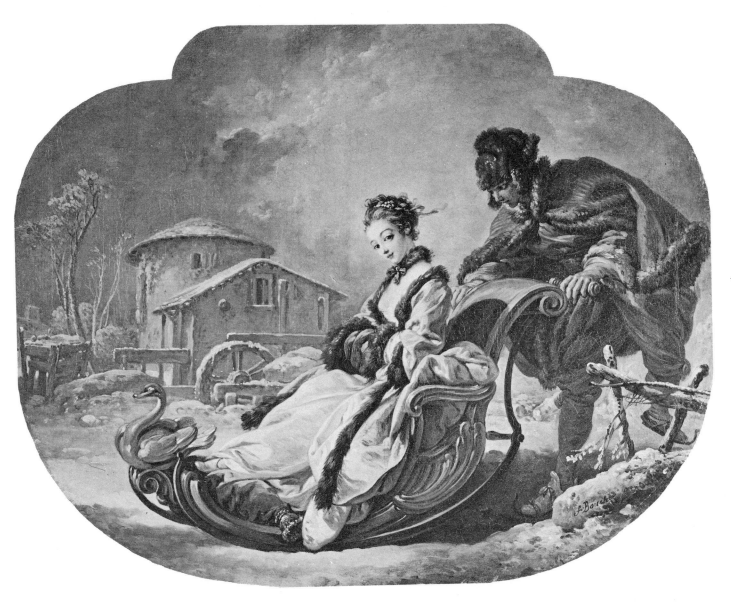

folio volumes placed conspicuously to the right.

But the two fine smaller portraits of Madame de Pompadour in London, in the Wallace Collection (1757) and the Victoria and Albert Museum (1759), have much greater charm. Both show her dressed in the height of fashion, sitting out of doors in a small enclosed shrubbery. In the Wallace portrait she wears a rose-beige dress, adorned with small ornaments known as *parfaits contentements*, with her favourite pet lapdog close by. The statue in the background is generally recognized to be Pigalle's *L'Amour et l'Amitié* of 1758, alluding to the fact that Madame de Pompadour's relationship with the King had recently changed from that of mistress to friend; by the frequent repetition of this imagery in the art commissioned by her, Madame de Pompadour also wished to show that despite her loss of the King's affections she still retained his support and a powerful hold over royal patronage.[13] The other enchanting portrait of her in a similar format and setting, in the Victoria and Albert Museum, shows the marquise reclining in a wooded garden with a book (possibly a copy of Cardinal de Bernis' pastoral poetry, her favourite reading matter) resting in her lap. Here she wears a grey satin dress, against a wooded background of silvery green-grey shrubs dotted with pink flowers. This charming sylvan setting was no doubt chosen to reflect her love of the pastoral poetry then in vogue. This is not 'nature' as Rousseau was soon to interpret the word, merely vegetation strictly confined within the limits of the formal garden. From a psychological point of view, these two portraits exhibit a similar constraint. They reveal almost nothing of the true character of the sitter; in the Wallace painting she looks out directly towards the spectator, open-eyed but cool and without any marked expression, while in the second she appears to gaze abstractedly over her open book into the middle distance.

The next most important patron in Boucher's life was the comte de Tessin,[14] Swedish Ambassador to the French court from 1739 to 1742, who bought several of the artist's major works, including the *Triumph of Venus* and the *Dressmaker* in Stockholm, and collected many of his finest drawings. Tessin was a noted Francophile and connoisseur, the author of a short story, *Faunillane*, and the friend of several French artists, including Desportes, Oudry and Chardin. His entire efforts were directed towards the importation of French art and taste into

108. Boucher, *Winter*, 55 × 71 cm. The Frick Collection, New York

[89]

Sweden. With this in view, he helped to found the Swedish Royal Academy of Painting and Sculpture in 1735 in direct imitation of the French model, and was thus largely instrumental in the diffusion of French civilization in northern Europe. He became self-appointed mentor to the young King Gustavus III, and in a series of didactic letters entitled *Lettres à un jeune prince* set out to enlighten his charge on the need to cultivate and encourage the arts in Sweden. He left no doubt as to which type of art he wished Swedish painters to emulate: 'The works of the French school are in perfect harmony with the genius of that nation and bear the imprint of their vivacity.' It is clear that what attracted the Count to French art, and to Boucher especially, when he commissioned paintings like the *Dressmaker* of 1746, were the eminently Rococo qualities of lightness of touch, charm and brilliant colouring. Thus, by around 1740, Boucher came to be regarded in cosmopolitan circles as the foremost French artist, almost as the country's cultural ambassador, just as Voltaire was seen by European royalty as the typical representative of literary France. Boucher was a prime agent in the maintenance of the hegemony of French culture throughout Europe in the eighteenth century.

Boucher was at the peak of his fame between 1750 and 1760, the favourite of the royal mistress, and fêted by elegant Parisian society. But even at the moment of his greatest triumph critical opinion had already turned against him. While he could still count on the unfailing eulogies of friends like the Abbé Leblanc, others, including Bachaumont, Grimm and La Font de Saint-Yenne, made severe criticisms, taxing him with false, artificial colouring and the endless repetition of a few hackneyed themes. The most vociferous of these prominent writers and intellectuals was Diderot. Tired and irritated by the banality of the Rococo style, Diderot wanted to purge art of Boucher's pink-bottomed nudes and beribboned shepherds and to lead it back to a severe classical taste, '*un goût sévère et antique*',[15] in keeping with his admiration for the ethos of Stoicism. The style now recognized as Neo-Classicism began, therefore, as a moral and aesthetic rejection of the kind of decorative painting which had dominated French art until the mid-century. It was inevitable that Boucher, the idol of a small clique based at the court, should have borne the brunt of the attack. After some mildly favourable comments on a *Nativity* by Boucher in his *Salon de 1759*, Diderot hardened progressively in his attitude towards the artist, even though he never failed to acknowledge Boucher's superb pictorial qualities. Hence the critic's famous quip in the *Salon de 1761*: '*Cet homme a tout excepté la vérité*'. By 'truth' Diderot meant not only truth of colour, but truth of feeling, which he found so conspicuously absent from the artist's work. Boucher so patently lacked sincerity or any deep emo-

tional involvement with his subject; even his Madonnas, Diderot wrote, were like worldly creatures in disguise. This emphasis on the subjective element in art, and the call for painters to make a personal statement, was a new criterion in French art-criticism and one which was later to contribute largely to the ideology of the Romantic movement. It was, of course, quite foreign to an artist of Boucher's outlook and training. He took a strictly craftsman-like, professional view of his art and had no time for theory; for him, speed and executive skill were paramount. By the Salon of 1763, Diderot's earlier criticisms had given way to violent abuse, and he accused Boucher of being 'the ruin of all young painters'. The last and most significant charge which Diderot levelled at the artist was that of immorality, and in a famous diatribe in his *Salon de 1765* he wrote: 'The degradation of taste, colour, composition, figures, expression and draftsmanship has closely followed the degradation of morals. ... What sort of imagination can a man have who spends his life with prostitutes of the lowest kind?' It was this kind of outrageous and frequently libellous attack which Boucher and many other artists had to face from critics carried away by their reforming zeal. In their eyes, Boucher's crime was that he refused to be reformed. He continued to pander to the tastes of a small group of aristocratic connoisseurs and to practise a kind of art devoid of any social message, at a time when Diderot and the *philosophes* were actively trying to promote ideas of education and progress.

Boucher was, in fact, singularly resistant to the new currents in art and ideas which began to emerge in the last years of Louis XV's reign. This was apparent in 1764, when he received from Marigny the commission to contribute two of the four subjects from Roman history for the royal château of Choisy, alongside Deshayes, Vanloo and Vien.[16] Boucher evidently felt ill at ease with these severe historical subjects and abandoned the project; he was then given permission to paint other more congenial themes, probably mythologies or the Seasons, but he never carried them out and the commission was handed on to Pierre. Despite such setbacks, and deteriorating eyesight, Boucher never lost his zest for creation, and when he exhibited for the last time at the Salon of 1769, with two large, confused but still very impressive canvases 'in the style of Castiglione', *Setting out to Market* [*Départ pour le marché*] and *Gypsy Market* [*Marché de Bohemiens*] (Boston, Museum of Fine Arts), even Diderot felt compelled to admire the courage and unabated energy of the 'old athlete' who refused to give up. Boucher died in his studio in the Louvre on 30 May 1770 and was buried with considerable pomp in the parish of Saint-Germain-l'Auxerrois. Only a decade after his death, however, his art, once sought by princes all over Europe, underwent a total eclipse, and the price of his pictures fell dramatically. The *Four Seasons*, which had fetched 1402 livres at the

Marigny sale in 1782, made little more than half that figure when they were re-sold in 1787. The reason for this sudden reversal was the profound change of taste and aesthetic attitudes brought about by the revival of history painting in the second half of the eighteenth century. The new mood was clearly defined by the sculptor Falconet when he wrote: 'For all too long we have seen false artificial colouring obscure the colours of nature, and a feeble pink emasculate all our artists' pictures. When Boucher imagined that he was conforming to the taste of his century, he ruined it.' Falconet concluded with the confident prediction: '*Le goût du beau commence à renaître.*'[17] Thus Boucher came to be spurned for what the avant-garde of artists and critics regarded as the frivolous, aristocratic style of the Rococo period. He had been too closely associated with the historical moment of Louis XV's reign to escape the general opprobrium heaped on that period shortly before and during the Revolution. Even as late as the 1820s, at the height of the Romantic movement, his name was a byword for the outmoded mannerisms of the *dix-huitième* style and used by critics as a term of abuse to designate the Rococo revival which, in their eyes, threatened to undo the work of the artistic Revolution performed by J.-L. David. It was only in the middle of the nineteenth century that Boucher, together with Fragonard, came back into fashion, largely under the impetus of the studies of the Goncourt brothers.[18] But this revival of interest in Boucher and the Rococo style proved short-lived; even today the artist's name is strangely tainted and hardly considered worthy of serious study. The aura of expensive luxury surrounding his art, his cheerful, amoral outlook and lack of psychological depth have not found favour in contemporary eyes, except with a handful of connoisseurs. The time is ripe, perhaps, for a fresh look at this underrated artist and for due recognition of his superb pictorial qualities, which no amount of accumulated prejudice can obscure.

6: The Revival of History Painting

It is no accident of history that, shortly before 1750, at the very peak of Boucher's career and the height of Madame de Pompadour's influence on the arts, a movement was already well under way which was seriously to undermine the hegemony of the Rococo style, and finally to sweep it away without trace. Although this movement took various forms—the revival of history and serious religious painting, the return to classical antiquity, the passion for archaeology, the summons to virtue and a state of 'nature'—these were in fact only different aspects of a single phenomenon.[1] This was, basically, the desire for a return to a tradition of art expressing order, idealism and nobility of purpose, as it had been practised in seventeenth-century France under Lebrun and 'le grand Colbert'. It was, needless to say, the exact antithesis of Boucher's art, and conceived in direct opposition to the frivolity of the Rococo, which the protagonists of the serious style, '*le genre noble*', accused of perverting public taste and pandering to the whims of a small clique of courtiers and aristocratic connoisseurs. This does not mean that in mid-eighteenth-century France history painting needed complete resurrection. Indeed, as we can see from the examples of Lemoine, the Coypels and Charles de la Fosse, the great tradition of history and religious painting survived well through the first half of the century. But, if not extinct, the tradition had remained dormant, and lacked both the vitality given by fashionable approval and the prestige of official support. Consequently the vacuum left in French art by the death of Lebrun and the temporary eclipse of history painting cleared the way for Watteau, Boucher and a type of art created for personal rather than for public taste.

The key to this new development was the role of the Académie des Beaux-Arts, an offshoot of the original French Academy, founded in 1635 by Richelieu. The Academy was designed to raise the level of the arts in France and to give young artists a thorough training in the theory and practice of their métier. Great emphasis was placed on strict draftsmanship and the pre-eminence of classical sculpture as a source of inspiration; form was deemed of higher value than colour and history painting regarded as the highest form of artistic activity. Such ideas, partly derived from Nicolas Poussin and codified by his disciple Félibien, were constantly and unremittingly expounded to the Academy by the *Premier Peintre*, Lebrun. They soon acquired the status of official doctrine, a corpus of academic teaching, with all the rigid pedantry which that implies. Towards the end of the seventeenth

century, however, the attacks of critics like Perrault and Roger de Piles, coupled with artists' growing impatience with formal constraints, combined to undermine the prestige of the Academy and severely curtail its role in the lives of French artists. The Academy's position had, moreover, been dependent on a strong monarchy, which regarded the arts, literature and sciences as merely a means of the extension of royal power. When this disappeared with the Regency in 1715, fragmentation of French artistic life inevitably followed; patronage passed from the State into private hands, and authority slipped away from the Academy. Consequently, for the first half of the eighteenth century, the French Academy was in a state of decline, its funds severely reduced and its influence on the arts minimal.

The main reasons for the reversal of this decline and the systematic attempt to restore history painting to its former prestige were, briefly: a succession of able and determined *Directeurs des Bâtiments*, notably Lenormant de Tournehem (who held office from 1745 to 1751), the marquis de Marigny (1751–73), the comte d'Angiviller (1774–91); growing public weariness of Boucher and the insipidity of the Rococo and, finally, an increasingly vociferous band of critics, mostly intellectuals of radical views, who lent their wholehearted support to the movement for reform. The crucial year in this development was 1747, the date of publication of La Font de Saint-Yenne's *Réflexions sur quelques causes de l'état présent de la peinture en France*, in which the critic firmly stated the new creed: '*De tous les genres de la Peinture le premier, sans difficulté, est celui de l'Histoire. Le Peintre-historien est seul le peintre de l'âme, les autres ne peignent que pour les yeux . . .*'[2] This belief in the dignity of history painting and its supremacy over all other genres was to be the single unifying theme, voiced by critics, artists and administrators during the second half of the eighteenth century. The aim of all the *Directeurs Généraux*, beginning with Lenormant de Tournehem in 1745, was a return to the simple and efficient administration of Colbert and Lebrun, which they believed, with the protection of Louis XIV, had provided the right conditions for the great flowering of French art in the seventeenth century. Time and again we come across this nostalgia for the Grand Siècle in the writings of the critics, notably in La Font de Saint Yenne's *l'Ombre du grand Colbert* (1752), and in that persistent refrain from Diderot's *Salon of 1761*: '*O le Poussin, ô Le Sueur. Où est Le Testament d'Eudamidas?*'

The first of the new administrators to put such ideas

into practice was Lenormant de Tournehem, Madame de Pompadour's uncle, a conscientious, methodical man who took his official duties very seriously. His first task was to raise the status of the Academy from the decline into which it had fallen under previous directors. He therefore increased the budget accorded to the Academy and raised the fees paid to history painters for royal commissions (both of which had been severely reduced by his predecessor, Orry). More importantly, with the help of his *Premier Peintre*, Charles Coypel, Tournehem set about the work of improving the teaching standards given by the Academy. He insisted on strict discipline, regular lectures and constant practice in draftsmanship by copying from antique sculpture. Moreover, he was determined to raise the general intellectual and cultural level of young artists, and to this end he introduced formal lessons in classical history, literature and mythology. A casual acquaintance with Ovid and the more picturesque fables of antiquity was no longer enough for a young art student; he was also expected to have a well-furnished mind and to be able to hold his own in any learned conversation. This again can be seen as a revival of the seventeenth-century notion of the 'painter-poet', typified by Poussin, and was to exert an increasingly powerful influence on French art from 1750 onwards.

These and other reforms were pursued by Tournehem's successor, the marquis de Marigny. Marigny, who began life as simple Abel Poisson, was an eager, ambitious young man who quickly rose to be the most important single figure in French patronage of the mid-eighteenth century and a pioneer of the new taste. He started his career as a conventional lover of the prevalent Rococo, but during the course of an educational journey in Italy, made in 1749 to 1751 in the company of Cochin, the architect Soufflot and the Abbé Leblanc, his eyes were opened to the merits of the Old Masters, especially the Bolognese, and the virtues of purity and simplicity. Unlike later converts to the classical style, however, Marigny was never doctrinaire in his tastes. He sought a happy mean between Rococo frippery, on the one hand, and classical austerity on the other—a typically French compound of idealism with charm and wit: '*Je ne veux point de la chicorée moderne, je ne veux point de l'austère ancien. Mezzo l'uno, mezzo l'altro,*'[3] Marigny wrote in a letter to Soufflot on 18 March 1760. In practical terms, Marigny continued his predecessor's policy of improving payments for large history paintings and reducing those for portraits. He was responsible for the distribution of numerous commissions to decorate the royal palaces, and for several large compositions designed for the Gobelins tapestry works, including Natoire's *Histoire de Marc-Antoine* (1756) and the series *The Love of Gods* [*Les Amours des Dieux*] by Vanloo, Boucher, Pierre and Vien. Marigny can also take the credit for ordering one of the finest series

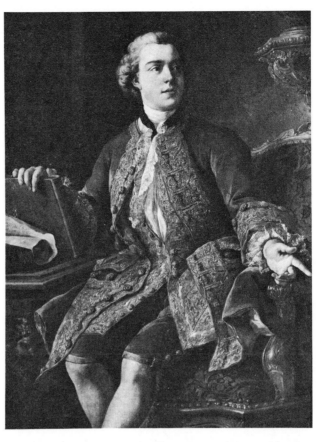

109. De Troy,
The Marquis de Marigny,
132 × 96 cm.
Château de Versailles.
Photo: Musées Nationaux, Paris

of large canvases, Vernet's fifteen *Ports of France* (the first four of which were exhibited at the Salon of 1755), which, by virtue of their epic scale, deservedly earned the title of history paintings and rank among the single most important act of patronage during Louis XV's reign.

The accession of Louis XVI in 1774 coincided with the appointment of the comte d'Angiviller, the last of the great *Directeurs des Bâtiments* under the Ancien Régime, who held office until 1791. Although unpopular with many artists—except for his favourite protégés, Pierre and Vien—who found him brusque and authoritarian, d'Angiviller did more than anyone else to improve the material condition of painters; under his protection, the budget allocated for royal commissions was far in excess of those of other periods. D'Angiviller was a man of deep conviction and a firm believer in the social and didactic function of art. Like Turgot, Louis XVI's Finance Minister, whom d'Angiviller resembles in many respects, he pursued enlightened policies with a cool rationalism accompanied by strong authoritarian overtones. Artistic patronage in his hands became another department of State and a direct extension of the royal principle which both he and the King were anxious to strengthen. Increased financial assistance for artists went hand in hand with greater regimentation. In return for better fees they were expected to conform more closely to the Director's wishes, and to paint subjects expressly designed to improve public taste and to glorify the French national past, notably those aspects which showed the monarchy

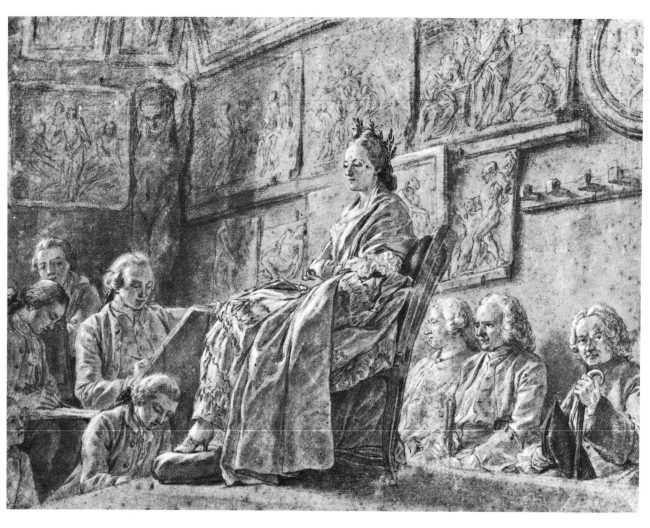

in the most favourable light. These measures were aided by ever more rigid control by the Director over the activities and teaching methods of the Academy, which towards the end of the eighteenth century became virtually a closed corporation. Members of the Academy formed a kind of moral élite and enjoyed many privileges, such as exemption from military service. Its monopolistic nature was further emphasised in 1777, when d'Angiviller conferred on the Academy the sole privilege of teaching painting and sculpture. This decree was soon followed by the suppression of rival academies and exhibitions, like the Salon du Colisée and the Salon de la Correspondance (founded in 1778 by Pahin de la Blancherie and suppressed in 1783), at which non-members of the Academy had the opportunity of showing their work. D'Angiviller was also a strict disciplinarian who did his utmost to quell any sign of rebellious independence in his pupils. He insisted on a strict diet of copying from the Old Masters and drawing from antique sculpture, only allowing students to pass on to the living model once they had mastered these preliminary disciplines. Study of the human body was reduced to an anatomical science, and the portrayal of feeling codified into a number of set gestures and expressions inherited from Lebrun's *Theory of the Passions*. It

is hardly surprising that many critics broadly sympathetic towards d'Angiviller's aims, like Falconet, Watelet and, most of all, Diderot in his *Essais sur la Peinture* (1765), repeatedly attacked the Academy's teaching methods, accusing them of spurning 'nature' and of reducing artistic creation to a mindless routine.

By a succession of policies pursued from around the middle of the century until the outbreak of the Revolution, French art was thus subjected to a continuous process of institutionalisation and exposure to political influence. A pattern of artistic dependence on the State was firmly established which survived successive governments, through the Revolution, the Empire, and well into the Restoration. It can be seen that, despite his violent hostility to the Academy and the Ancien Régime, Jacques-Louis David directly inherited many of the ideals promulgated by d'Angiviller and the previous generation of history painters, notably the belief in the public educational role of art as a means of promoting the civic virtues. In fact, in the artistic life of France as in politics and administration (as Tocqueville showed in his pioneering study of the Ancien Régime), many institutions founded by the Monarchy were simply taken over and modified by Napoleon and his successors, but the under-

lying structures remained basically unaltered.

The Academy formed the central core of the Academic system, but there were many ramifications, like the *Ecole des Elèves Protégés*, the *Ecole de Rome*, the post of *Premier Peintre*, a host of prizes and, finally, the Salon. All these combined to provide a natural career structure for any ambitious young artist and, if they did little to kindle the spark of genius, at least ensured a moderate level of proficiency in not particularly gifted painters. Once a young artist had enrolled as a pupil at the Academy and attended the classes for a certain time, he was invited to compete for the Rome prize, usually on a historical or biblical subject of the Director's choosing. If he was lucky enough to win a prize, he was sent to the Ecole de Rome for a further period of training and study of the Old Masters. In the first half of the century, the Ecole de Rome was in a state of considerable neglect and pupils were left largely to their own devices under a series of easy-going Directors like J.F. de Troy, whose notorious laxity became the cause of his dismissal in 1752. But, with the appointment of Marigny in 1751, the school was subjected to much greater discipline and control. Under Marigny's influence, the Ecole de Rome became something like an English boarding school and finishing school combined, where the students were expected to improve their culture and acquire the social graces. De Troy was replaced as Director by Natoire, who at that time had just renounced his earlier Rococo sympathies to become a wholehearted supporter of the movement for reform. Natoire set an example to his pupils—of whom the ablest but most refractory was Fragonard—by his fervent adoption of the classical taste and in his many admirable drawings of Rome and its surrounding countryside. The same ideas were pursued, with still greater zeal and much less tolerant eclecticism, by Natoire's successors in the post, Hallé, Vien and Lagrenée l'Aîné. It was, finally, under Vien's Directorship (1775–81) that the Ecole de Rome became the focal point for the Neo-Classical movement, when the passion for archaeology stirred by the discoveries of Herculaneum and Pompei drew hordes of foreign scholars (notably Winckelmann), travellers and connoisseurs to the city as if to the shrine of a new religion. There the seeds were sown for a totally original and revolutionary art inaugurated by J.-L. David, a former pupil of Vien, whose early paintings, such as *Antiochus and Stratonice* (1774), in the Ecole des Beaux-Arts, Paris, still show a certain lingering Rococo mannerism, but who was soon to break away from his predecessors without trace.

The last and perhaps most important constituent in the official system of patronage was the Salon. Only the possibilities of a regular exhibition enabled the authorities to kindle the competitive spirit in artists, to compare their respective works and to reward them accordingly.

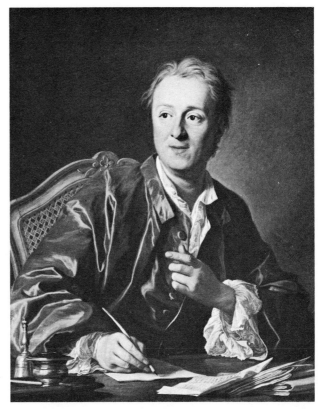

111. Louis-Michel Vanloo,
Diderot,
81 × 65 cm.
Musée du Louvre.
Photo: Giraudon

Sporadic exhibitions had been held in the Louvre from the late seventeenth century onwards, as well as special competitions like those of 1727 and 1747 organised by the *Direction des Bâtiments* to confront certain prominent artists; but it was only in 1737 that the Salon (so called because it took place in the 'Salon Carré' of the Louvre) became a regular event. The Salon, usually held every two or three years, was to be the key factor in the subsequent evolution of French art. It had the effect of opening up contemporary painting to a far wider public than previously, when art was largely confined to a small circle of wealthy connoisseurs with access to the main private galleries. Henceforward art became the object of general public comment, and both influenced and was influenced by public taste. A parallel of these exhibitions was the emergence of art criticism as a literary genre, and the growth of journalism in the form of reviews like the *Mercure de France*, Fréron's *l'Année Littéraire* and Grimm's *Correspondance Littéraire*, which provided the critics with their chief organ. Diderot's famous *Salons*, published between 1759 and 1781, mark the high point of this new medium. Reviews such as these did more than anything else to form the public's taste and to keep it abreast of artistic matters. Until around the middle of the eighteenth century art criticism had amounted to little more than a series of disconnected judgments on works of art, usually from a purely technical or qualitative viewpoint. But the first really professional critics—La Font de Saint-Yenne, Saint-Yves, the Abbé Leblanc—began to adopt a more systematic approach to the subject and to relate the art in

[95]

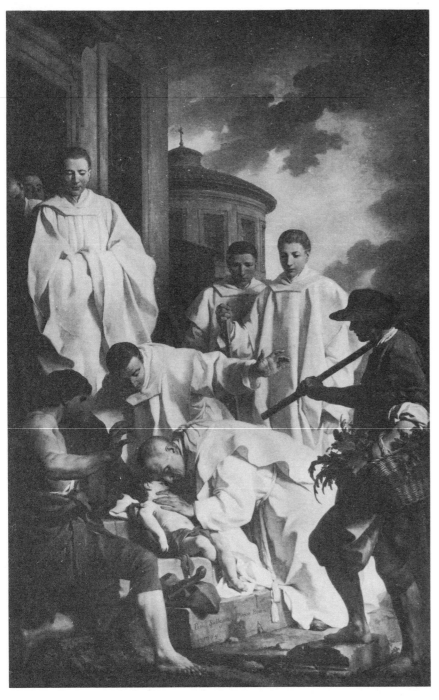

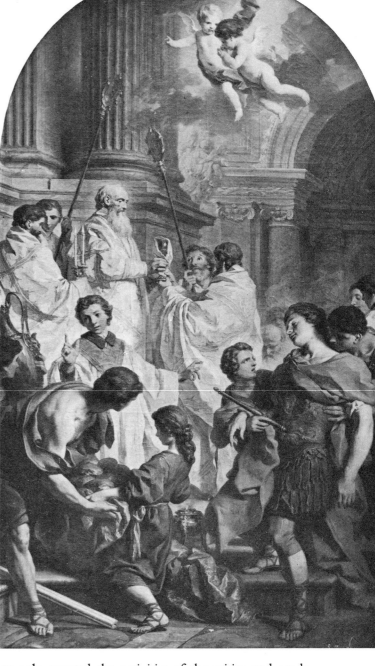

112. Subleyras,
The Miracle of St Benedict,
325 × 215 cm.
St Francesca Romana.
Photo: Alinari

113. Subleyras,
The Mass of St Basil,
134 × 77 cm.
Musée du Louvre.
Photo: Giraudon

question to broader moral, social and philosphical issues. They saw their task not merely as the dispensation of value judgments, but the attempt to provide some comprehensive analysis of the state of the arts in France at the time. Most agreed that French painting was in serious decline and in need of urgent regeneration, which could only be achieved by a return to the traditions of history painting.

One immediate result of this new-found freedom of comment—which frequently took the form of extremely violent attacks on established reputations (Boucher, Natoire and Vanloo being their favourite butts)—was a growing hostility between the critics and artists. Seeing their reputations damaged by adverse criticism, painters, championed by the *Premier Peintre*, Charles Coypel,

strongly resented the activities of the critics and made several unsuccessful attempts to silence them. They charged the critics with ignorance of the métier of painting and mocked their lack of professional qualification to hold forth on a subject which they knew nothing about. In the artists' eyes, the critics were mere *littérateurs* with no brief to pronounce judgment on the arts. The critics, for their part, replied with the argument that painting requires no special initiation; its beauties were obvious to any '*honnête homme*' guided by his own instincts and good taste. They stood firmly for the amateur's right to express his opinion and claimed merely to be speaking in the name of the ordinary intelligent spectator. This point of view was most explicitly stated by La Font de Saint-

Yenne when he defined his own critical ideal as: '*La critique d'un spectateur désintéressé et éclairé qui, sans manier le pinceau, juge par un goût naturel et sans une attention servile aux règles.*'[4] It was in this climate that the interaction developed between artists and writers so characteristic of French art in the late eighteenth century. The result, on the whole, was a beneficial one, for it helped to stretch the intelligence of French artists and to open their minds to a whole range of literary and philosophical influences. One final and still more far-reaching result for the growth of criticism was the gradual democratization of art, for the critics, mostly professional men of radical views, saw to it that painting should no longer remain the exclusive preserve of a small minority but should reflect the aspirations of a broader public.

These various factors combined around the middle of the century to re-direct French art towards greater idealism and nobility of purpose. But these qualities, inherited from the seventeenth century, had never entirely disappeared in France. They had merely gone underground, temporarily eclipsed by the essentially Parisian vogue for the Rococo, but they survived in many obscure provincial painters and their local academies. As in the first decade of the eighteenth century, this continuity of purpose is most evident in religious painting, which preserved its identity largely unchanged by the vicissitudes of fashion. By its very nature, religious art—except for some sentimental effusions by Boucher and Natoire—was preserved from the mannerisms of the Rococo, and retained much of the sobriety and clarity of its seventeenth-century predecessors, Poussin and Le Sueur. These qualities are admirably illustrated in the painter Pierre Subleyras (1699-1749), an obscure provincial from Uzès, who found his true spiritual home in Rome rather than in Paris. Although almost Boucher's contemporary, Subleyras's art and the

world of fashion are poles apart. He began his career in Toulouse where he studied under two forgotten painters, Chalette and Rivalz; in 1724 he came to Paris and was momentarily attracted by Lancret's *fêtes galantes*. Subleyras soon realised, however, that his vocation did not lie in the playful style then in vogue and, after winning the *prix de Rome* in 1727, he went to the city where he was to spend the best part of his creative life. The seriousness of his temperament and a very un-Parisian dislike of ostentation equipped him admirably for his career in Rome. Protected by the duc de Saint-Aignan, Subleyras was quickly adopted by the Roman aristocracy and the highest ecclesiastical circles, including the Pope Benedict XIV. He was the only French artist apart from Poussin ever to receive a commission for St Peter's, and nearly all his finest religious paintings of saints, and scenes from the Old and New Testaments, date from his Roman period. These are all characterised by a sobriety and simplicity of mood, reinforced by a good, solid technique totally devoid of gimmicks. In *The Miracle of St Benedict* (1744), originally painted for St Peter's, Rome (now in S. Francesco Romana), for example, showing the saint reviving a dead child, Subleyras creates a clear and powerful image by the simple effect of contrasted masses, relieved by the brilliant white of the clerics' robes. The restrained expression of deep emotion is always present in Subleyras' art, notably in *The Mass of St Basil* in the Louvre, which, by the gravity of its subject and powerful but reticent gestures, suggests a close affinity with Domenichino's *Communion of St Jerome*. In all Subleyras's portraits of saints and clerics like the young *Deacons* in Orléans, studies for *The Mass of St Basil*, there is the same quiet intensity of religious fervour, a kind of spiritual inwardness corresponding to the Quietist movement during the eighteenth century. The most extreme form of mystical emotion can

114. Subleyras, *Deacon*, study for *The Mass of St Basil*, 47.5 × 37.5 cm. (Deacon with chandelier). Musée des Beaux-Arts, Orléans. Photo: Giraudon

115. Subleyras, *Deacon*, study for *The Mass of St Basil*, 46.5 × 36 cm. (Deacon with Chalice). Musée des Beaux-Arts, Orléans. Photo: Giraudon

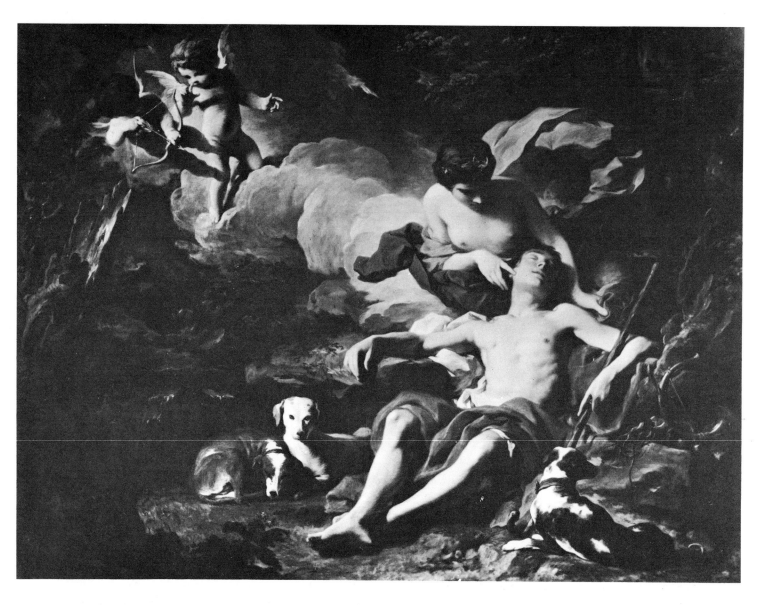

116. Subleyras,
Diana and Endymion,
73.7 × 99 cm.
Mr Brinsley Ford

be found in one of Subleyras's most remarkable portraits, that of the *Blessed John of Avila* (City Art Gallery, Birmingham), the spiritual adviser of St Teresa. At the other end of the scale, Subleyras was capable of a quiet, tender lyricism, as we can see from his still lifes and mythological works, like the beautiful *Diana and Endymion*.

Another religious painter from the first half of the century, but of very different character, was Jean Restout (1692–1768). Even less familiar than Subleyras, most of Restout's large religious compositions hang in dark corners of remote provincial churches, mouldering and neglected. To the average spectator, they may seem like so many acres of dingy canvas, but in his own time Restout was considered the leading religious painter of his generation, the natural successor to his uncle and teacher, Jean Jouvenet. The artist's contemporary reputation may be judged by the fact that, according to Grimm's *Correspondance Littéraire* (Letter of October 1757), Restout was chosen by Frederick the Great of Prussia as one of the

three leading French painters of the day. If this judgement has not been ratified by posterity, perhaps Bachaumont's appraisal of the artist may seem nearer the mark: '*M. Restout, élève de Jouvenet, peint dans le goût de son maître, mais moins grand. Il est propre aux grands sujets, surtout ceux de Dévotion, il compose bien, son dessin n'est pas extrêmement correct, mais de grande manière.*'[5] This is an accurate description of Restout's style, marked above all by vigour, breadth of handling, and a strong imagination, creating strange, elongated bodies which perform acts of devotion in contorted, rhythmic motion. Nothing could be further from Subleyras's simple, almost two-dimensional enactment of rituals and saintly miracles. Two of the earliest and justly famous examples of Restout's art are the pair of swooning saints in the museum of Tours, *The Ecstasy of St Benedict* and *The Death of St Scholastica* (both 1730). No two paintings could better refute the fallacious notion of the eighteenth century as a period of incredulity, for they portray a pitch of religious fervour bordering on hysteria. Their sweeping diagonal gestures and overall theatricality

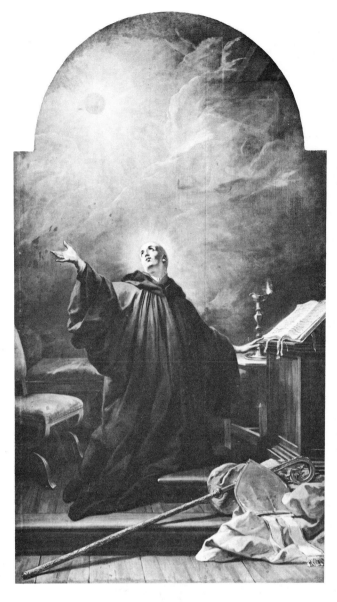
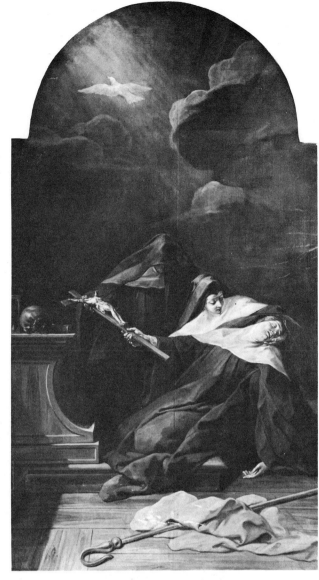

117. Restout,
The Ecstasy of St Benedict,
338 × 190 cm.
Musée des Beaux-Arts, Tours.
Photo: Musées Nationaux, Paris

118. Restout,
The Death of St Scholastica,
338 × 190 cm.
Musée des Beaux-Arts, Tours.
Photo: Musées Nationaux, Paris

suggest a closer affinity with the Baroque and the Counter-Reformation than with the classical tradition of Poussin and Le Sueur. There can be no doubt about Restout's personal religious conviction, but he was not bound by an particular sect and, apart from the *St Benedict* (painted for the Benedictine congregation of St Maur, near Tours), he also painted for Jansenists, Oratorians, Sulpiciens, Cistercians and other orders. He had the typical versatility of the eighteenth-century artist, which also enabled him to turn to subjects from classical mythology and fable – like the pair in Versailles illustrating the story of Psyche and Venus (*Psyche fleeing Venus' anger, Psyche imploring Venus' pardon,* 1748) – with the same verve and intense feeling.

While religious painting at this time was in many respects a throwback to the previous century and earlier, the real initiative in the revival of history painting came not so much from these artists as from a new generation of converts, or '*ralliés*', as they were christened by Locquin. These younger painters, notably Natoire and Carle Vanloo, were either pupils or followers of Boucher who began their careers in the Rococo manner but gradually saw the error of their ways and changed course. Natoire (1700–77) provides the clearest example of this change of direction around the middle of the century. By virtue of his outstanding gifts as an artist and teacher, Natoire played a pivotal role in the re-orientation of French painting. He was an almost exact contemporary of Boucher and their careers ran almost parallel until about 1750, when they sharply diverged. A native of Nîmes, Natoire won the *prix de Rome* in 1721, and from 1723 until 1729 studied at the French School under the directorship of Nicolas Vleughels, who quickly spotted the young artist's talents and encouraged him to produce those beautiful drawings of the classical remains at Tivoli and Frascati. This period in Rome was the most fruitful in Natoire's life. It made a deep and lasting impression on his art, but was only to bear fruit some twenty years later. On his return to Paris in 1730, Natoire found himself obliged to comply, somewhat reluctantly, with the preva-

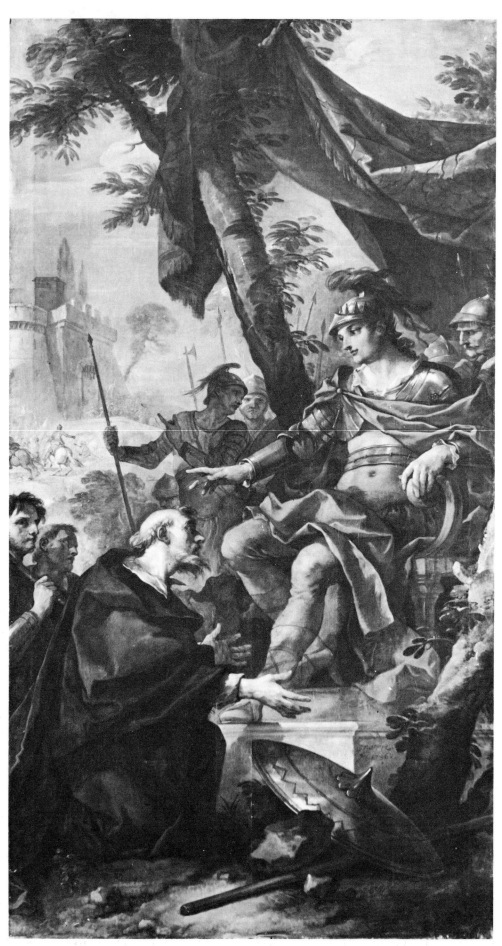

119. Natoire,
*St Remy Offering the Surrender
of Reims to Clovis,*

234 × 124 cm.

Musée de Troyes.

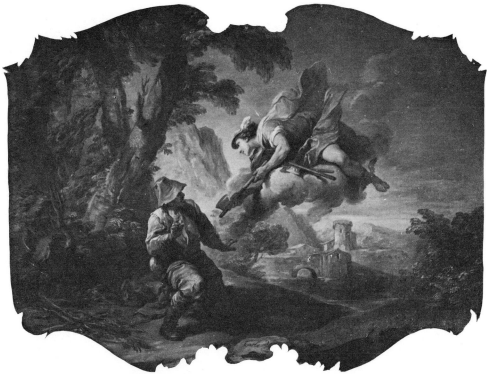

lent Rococo fashion for decorative painting and to produce endless series of allegorical panels for Versailles (*Youth and Virtue*, painted for the Chambre de la Reine in 1734), and the Parisian mansions of the leading members of the aristocracy. The most accomplished of Natoire's decorative ensembles, the *Story of Psyche* in the Hôtel de Soubise (1737–9), reveals consummate skill in adapting his style to the architectural requirements of the overall plan. But there is evidence that Natoire was already beginning to chafe under this enforced submission of painting to architecture. He complained that painting had been reduced to mere furniture (*'une sorte de meuble'*), and in a letter of 7 April, 1747 to his friend Duchesne he wrote: '... *Les peintres ne travaillent presque jamais pour eux-mêmes ... Le public nous demande des sujets agréables, et depuis que je suis à Paris on ne m'a jamais demandé autre chose.*' Nevertheless, even Natoire's early works have a nobility and breadth of conception, in striking contrast to the usual banality of this period. In his choice of subject matter, too, Natoire was by no means conventional. In his celebrated series of six scenes from the *Life of Clovis* (executed in 1735–8 for Philibert Orry's Château of La Chapelle-Godefroy), he made a pioneering venture into the French national past before such subjects became common currency at the end of the century. One of these, *St Remy Offering the Surrender of Reims to Clovis*, shows the early Christian saint in an attitude of supplication before the King of the Franks, a moving and entirely convincing enactment of a particular historical moment. And yet, despite his sympathies with history painting and his attempts to raise his own style to *'le genre noble'*, Natoire remained attached to the old mythological nude. There is a certain irony in the fact that his best known and most

beautiful painting, *The Triumph of Bacchus* [Plate 11] in the Louvre (painted in 1747 for the competition organised by Lenormant de Tournehem to improve the standard of history painting), is hardly a piece of history painting at all, but an outright reversion to the manner of Boucher. In fact, as a painter of the female nude, Natoire has beaten Boucher on his own ground. *The Triumph of Bacchus* and such works as *Dorothea Surprised in her Bath* [Plate 12] (Compiègne, Musée du Château), have a pearly quality, and a cool, slightly acid colouring which sometimes makes his rival look coarse by comparison.

This same indeterminate stage, midway between the Rococo and the new style, was also reached by Carle Vanloo (1705–1765). The most famous and widely praised artist of his day, hailed by Grimm as the 'foremost painter in Europe', Vanloo's name—except to a few art historians—is now merely a convenient label much used by the salerooms to describe any French eighteenth-century painting of doubtful quality and authorship. The trouble with Vanloo is that he has no distinct personal style, or rather he hovers between many different styles and lacks consistency. But, to his own contemporaries, it was this very eclecticism which ensured his success. To them, he seemed to possess complete mastery of the entire repertory, ranging from the Flemish style, via the Bolognese and the seventeenth-century French, to the Rococo then in fashion. It is nevertheless possible to discern a clear development in his style. In the 1730s, at the outset of his career, he began in the current Rococo vogue and worked alongside Boucher and Natoire on the Hôtel de Soubise. There he painted one of his most appealing early works, *Mercury and the Woodcutter*, illustrating one of La Fontaine's fables about a poor forester who appeals to

120. Carle Vanloo, *Mercury and the Woodcutter*, 103 × 142 cm. Hôtel de Soubise, Paris. Photo: Musées Nationaux, Paris

Plate 11 falls between pages 104 and 105

Plate 12 falls between pages 104 and 105

Mercury to return him the axe he has lost; the god is seen descending on the right, bringing not only the forester's wooden axe, but also two others in gold and silver, as presents. This tale is delightfully evoked against a landscape of great beauty and depth. But Vanloo quickly realised that this light, decorative style was not the way to satisfy his considerable ambition. He therefore began to simplify his style and to adopt the broad, well-rounded contours better suited to the large official and religious commissions. This new move towards simplicity can best be seen in such religious paintings as the *Virgin and Child* (1738) in Rouen, and *St Clotilda Praying at the Tomb of St Martin* (1752, Musée de Brest), but there is nothing austere about this healthy, cheerful-looking saint and her three attendant putti hovering above the tomb. As one critic, Laugier, wrote of this second picture at the Salon of 1752: '*La figure de la sainte est tout-à-fait agréable, je dirais volontiers qu'elle l'est trop.*'[6] ('The saint's expression is quite charming, I would even say too charming.') Vanloo, in fact, rarely strays far beyond the range of Rococo sentiment and even his most ambitious compositions, like the *Theseus Overpowering the Marathon Bull* (1745, Nice, Musée Chéret), have a dash and theatricality closer in feeling to De Troy than to the severity of Vien and the Davidian school. The nearest approach Vanloo ever made to true neo-classical simplicity was in one of his last and most impressive cycles of religious painting, the *Life of St Augustine*, executed between 1746 and 1755 for the church of Notre Dame des Victoires in Paris. There they can still be seen in the choir, calm and eloquent scenes from the life of the saint, unchanged since the year 1802, when they were restored to the church after the upheaval of the Revolution.

The same lingering Rococo mannerisms can be found in two more half-hearted converts to the new style, Pierre and Hallé. J. B. M. Pierre (1713–1789), a pupil of Natoire and de Troy, won the first *prix de Rome* in 1734 and rapidly climbed the path to official success and fame. He soon won the favour of Madame de Pompadour, for whose Château of Bellevue he painted conventional allegories, as well as mythological scenes for the Salle du Conseil at Fontainebleau, and elsewhere. He was elected professor of the Academy in 1748 and finished his career as *Premier Peintre du Roi* in 1770, in succession to Boucher. Pierre was the typical successful artist-courtier of the mid-eighteenth century, who loved playing the *grand seigneur*. With the backing of Marigny and the benefit of his position in the Academy, Pierre consistently used his influence to his own advantage and alienated most of his colleagues in the process. He was, in fact, universally disliked, both by his fellow-artists for his patronising, arrogant treatment of them, and by the critics for his slapdash execution and his undeserved reputation. Diderot dismissed him as '*le plus vain et le plus plat de nos*

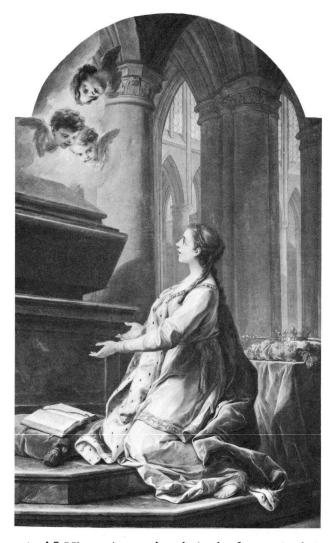

121. Carle Vanloo,
*St Clotilda Praying
at the Tomb of St Martin*,
278 × 173 cm.
Musée de Brest.
Photo: Musées Nationaux, Paris

artistes'.[7] His art, it must be admitted, often merits their strictures; it is frequently coarse, flashy and sometimes – as in the large *Bacchanal* in Le Puy – faintly decadent, reminiscent of late nineteenth-century painters like Bouguereau. Pierre rose to fame on his early mythological works and attracted attention with a painting of *Medea* stabbing her children, at the Salon of 1746. But, prompted by his overweening ambition, he became convinced that he had a historic role to play in the regeneration of French art. He therefore turned his attention to prominent official commissions of history and religious art and abandoned his erotic frivolities. The outcome was numerous frescoes executed for the churches of Saint-Roch[8] (*Assumption of the Virgin*, 1756), Saint-Sulpice, Notre Dame des Champs, and the *Descent from the Cross* (1761) in Versailles Cathedral, all of them painted in a broad but undistinguished manner. But Pierre was an artist of undeniable talent, and when he took the trouble, he was capable of painting very fine works, like *The Adoration of the Shepherds* (Salon of 1745) in Detroit [Plate 13], full of Italianate panache and close in feeling to the religious pictures of Boucher and Natoire. His best-known picture, and one which exemplifies his virtues and his faults, is *Mercury Changing Aglaura into Stone* (Salon of 1763) in the

Plate 13
faces page 105

[102]

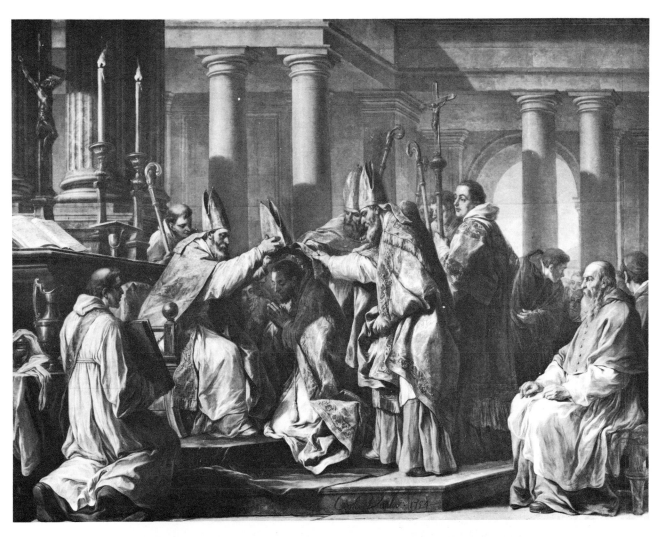

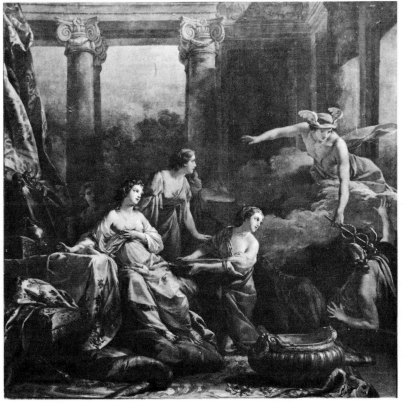

122. Carle Vanloo,
The Coronation of St Augustine,
400 × 550 cm.
Eglise de Notre Dame des Victoires,
Paris.
Photo: Caisse Nationale des
Monuments Historiques et des Sites.
© S.P.A.D.E.M.

123. Pierre,
*Mercury Changing Aglaura into
Stone,*
320 × 320 cm.
Musée du Louvre.
Photo: Musées Nationaux, Paris

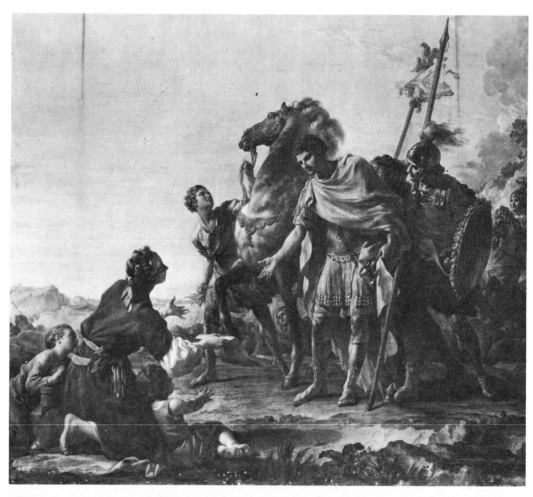

124. Hallé,
The Justice of Trajan,
265 × 302 cm.
Musée des Beaux-Arts, Marseilles

125. Hallé,
Cornelia, Mother of the Gracchi,
76 × 96 cm.
Musée Fabre, Montpellier.
Photo: Musées Nationaux, Paris

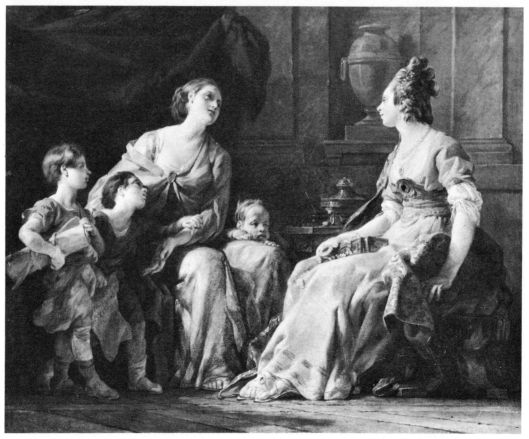

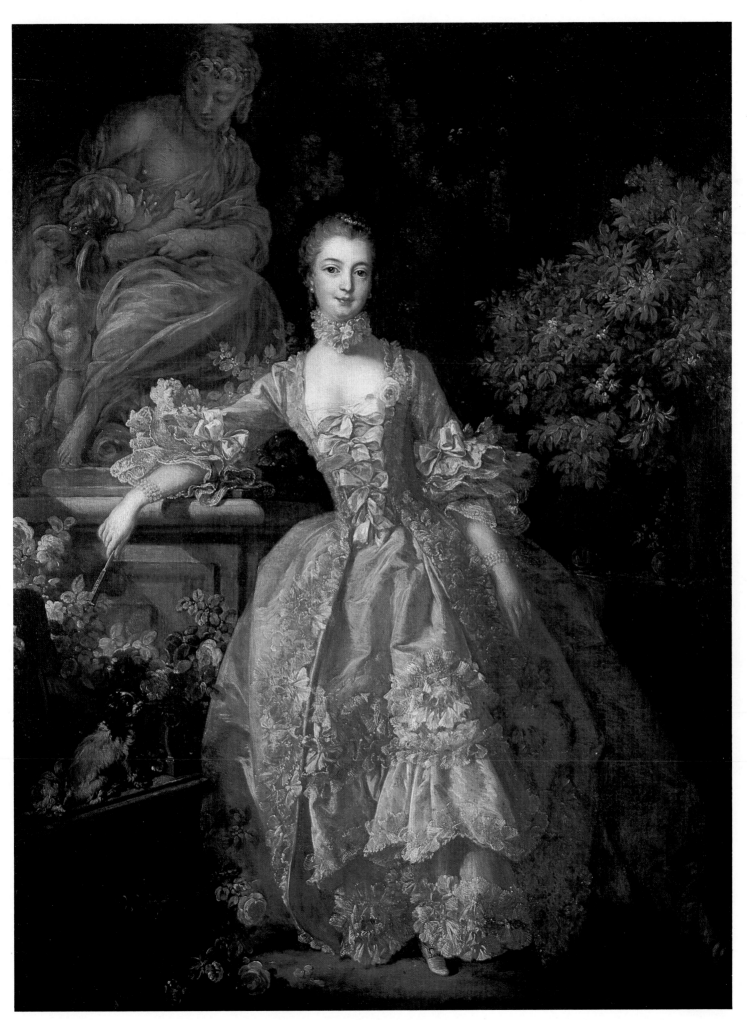

PLATE IO. Boucher, *Marquise de Pompadour*,

210 × 157 cm. The Wallace Collection, London

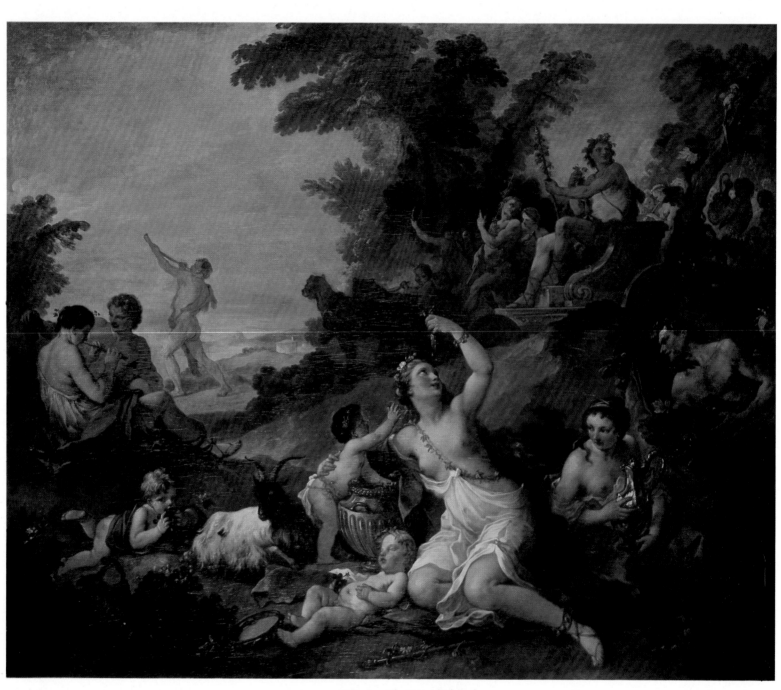

PLATE II. Natoire, *The Triumph of Bacchus,*

162 × 195 cm. Musée du Louvre. Photo: Musées Nationaux, Paris

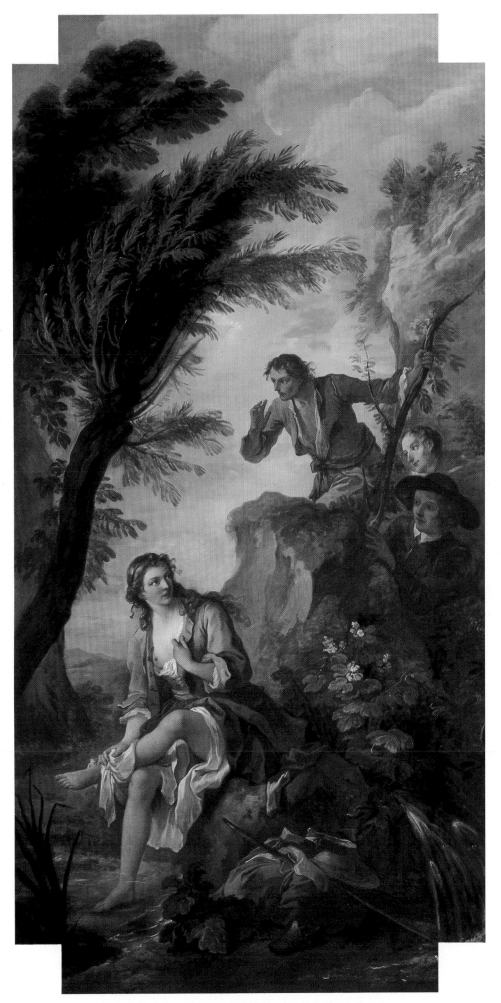

PLATE 12. Natoire, *Dorothea Surprised in her Bath*,

330 × 165 cm. Château de Compiègne.

Photo: Musées Nationaux, Paris

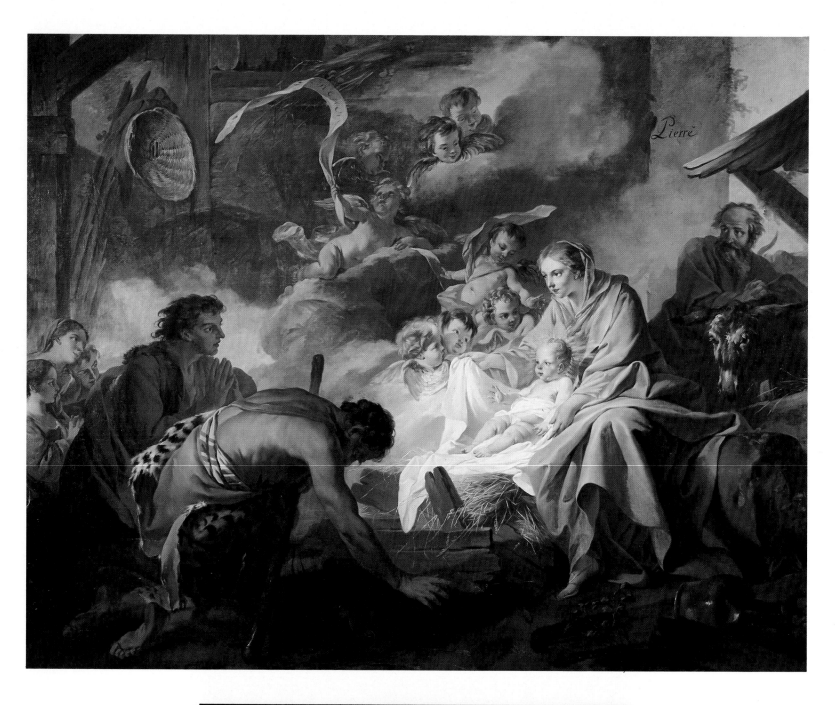

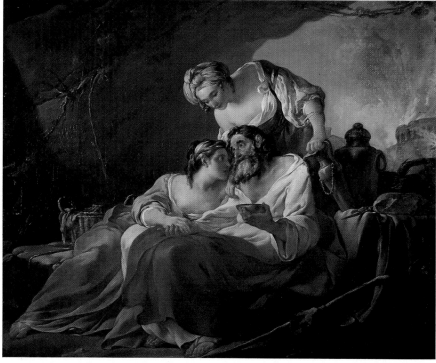

Plate 13
Pierre,
The Adoration of the Shepherds,
280 × 356 cm.
Detroit Institute of Arts.
Photo: Nemo Warr

Plate 14
Vien,
Lot and his Daughters,
64 × 80 cm.
Musée des Beaux-Arts,
Le Havre.
Photo: Photorama

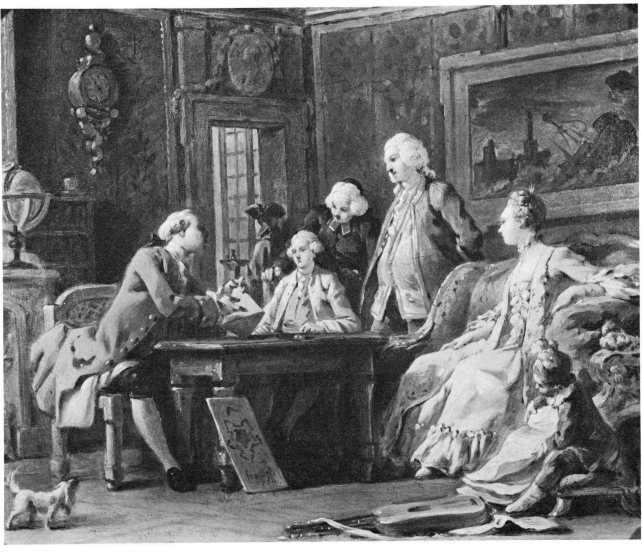

126. Hallé,
The Education of the Rich,
33 × 44 cm.
Formerly Cailleux, Paris

Louvre, a brilliant and mannered piece of allegory, set in the most sumptuous surroundings.[9]

His contemporary, Noël Hallé (1711–1781), is a far more engaging artist, though he fared no better at the hands of the critics. Another convert to the historical style, Hallé never managed to conceal his preference for Rococo prettiness and charm, and even his most ambitious compositions like *The Justice of Trajan* (Marseilles) have an elegant, courtly flourish not quite in keeping with the seriousness of the subject. He seems most at home with young women and children, easily recognisable by their snub noses, oval faces and swept-back foreheads. Hallé was born into a family of painters, the son of Claude Guy and grandson of Daniel Hallé; after studying in Rome between 1737 and 1744, he was received as a full member of the Academy on the strength of his *Dispute Between Minerva and Neptune* (1748) in the Louvre. From there he went on to enjoy all the usual official honours and finished his career as *Surinspecteur des Gobelins* in 1770. One of the most important commissions Hallé received as history painter was to paint *The Justice of Trajan* as part of a series of humanitarian themes from Roman history proposed by

Cochin for the Royal Château of Choisy.[10] Exhibited at the Salon of 1765, where it was derided by Diderot,[11] the painting is still very much in the Rococo vignettist tradition of Eisen and Moreau le Jeune, only translated on to a broader scale. Hallé was incapable of neo-classical severity. His love of colour, movement and dramatic gestures is constantly apparent, for instance in the recently discovered *Antiochus Falling from his Chariot* (formerly Heim Gallery). A typical example of Hallé's style, in which a classical subject is treated with a very unclassical charm is the painting *Cornelia, Mother of the Gracchi* (Salon of 1779), illustrating the story from Valerius Maximus of the poor Roman widow whose only wealth is her three children, and the richly dressed woman from Campania in all her finery and jewels. Despite its stoical theme, designed to celebrated poverty and the pride of motherhood, the painting is still much closer to the domestic genre of Greuze and Lépicié than to the classicism of Vien and David. This same love of children and handsome women is evident in Hallé's excellent genre pictures, *The Education of the Rich* (1764, Cailleux, Paris) and *The Education of the Poor* (private collection), in which

[105]

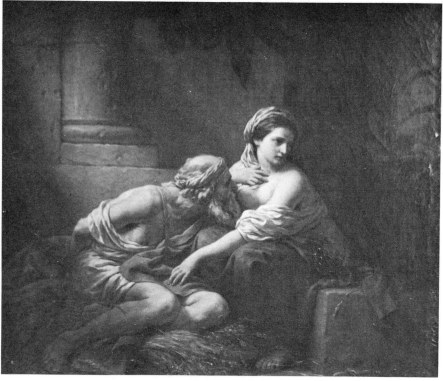

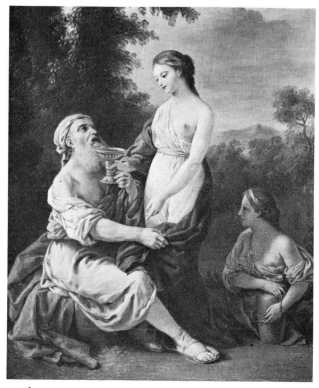

127

128

127. Lagrenée,
Roman Charity,
40 × 60 cm.
Musée des Augustins, Toulouse.
Photo: Courtauld Institute, London

128. Lagrenée,
Lot and his Daughters,
40.6 × 33 cm.
National Trust, Stourhead.
Photo: Courtauld Institute, London

all the details of a late eighteenth-century interior are conveyed in the manner of brilliantly improvised sketches.

Also hovering indecisively between the Rococo and a graceful decorative form of classicism is Lagrenée the Elder (1724–1805). A pupil of Carle Vanloo, Lagrenée continued to follow in the footsteps of Boucher and Natoire and was known during his lifetime as the 'Albano of France' on account of his graceful allegories. His polished charm and suave, undemanding variety of classicism made him popular with all the leading collectors of the day, including Caylus, La Live de Jully and Madame Geoffrin. As his '*morceau de réception*', Lagrenée painted *The Rape of Deiantra* (1755), in the Louvre, a work which clearly shows his indebtedness to Guido Reni's picture of the same title. The moment of Lagrenée's greatest success, however, came at the Salon of 1765, where he exhibited several paintings, including *Saint Ambrose Presenting Theodosius's Letter to God* (Eglise Sainte-Marguerite, Paris), a series of history paintings (now lost), two charming overdoors for the château of Choisy, *Justice and Mercy* (Musée d'Autun) and *Kindness and Generosity* (Musée de Fontainebleau), and *Roman Charity* (Musée de Toulouse). This impressive display earned the following accolade from Diderot: '*C'est un peintre que celui-ci … Il a le dessin, la couleur, la chair, l'expression, les plus belles draperies, les plus beaux caractères de tête, tout, excepté la verve.*' It is all too fine and polished, as in *Roman Charity*, intended to portray a young woman's act of kindness towards an old man condemned to starvation in a cell. The artist has completely missed the pathos

of the scene; this inability to rise to the occasion and to portray noble suffering finally led Diderot to condemn the artist in his *Salon de 1771* as '*le plus beau pinceau et la tête la plus vide d'imagination que je connaisse*'. Nevertheless, failure to satisfy the critic by no means impaired Lagrenée's popularity. His combination of a smooth, brilliant execution, elegantly draped figures and choice of edifying themes from the best Roman authors ensured for him a numerous fashionable clientèle, both in France and in the rest of Europe. These qualities are exemplified in the important series of six paintings at Stourhead,[12] dated 1770 and 1771, and probably bought in France by Sir Henry Hoare: *Chastity of Susanna, Lot and his Daughters, Happy Old Age, The Obliging Mother, Telemachus Encounters Termosiris* and the *Lacedaemonian Woman Instructing her Son*. The scenes, taken from the Old Testament, Plutarch and Fénelon, all illustrate different lessons in virtue, but in a gently seductive guise. Stylistically, in their clearly articulated forms and subtle transitions from light to shade, they clearly refer back to the Italian masters, especially Guido Reni and Domenichino, whom Lagrenée greatly admired during his stay in Rome. Lagrenée was a mild, eclectic artist and one who deserves to be remembered for his courageous stand in favour of artistic independence and freedom, at a time when d'Angiviller and the Academy were doing their best to enforce conformity among French painters. In a famous letter to d'Angiviller, written in 1781 from Rome, shortly after Lagrenée's appointment as Director of the French Academy, he wrote: '*On ne commande point au talent, vous le*

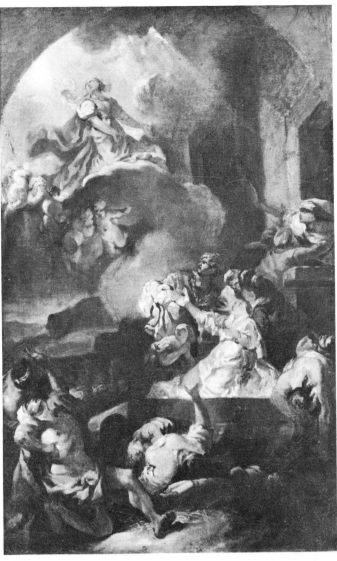

129

130

savez mieux que moi ... On est né peintre, comme on est né poete ... Les arts ont toujours été et seront toujours enfants de la liberté.'[13]

Towards the end of the eighteenth century, history painting in France began to adopt many styles other than the purely classical one favoured by Vien and David. After the accession of Louis XVI in 1774, French painting underwent rapid and major transformations, all of which directly reflected the preoccupations of a society in the process of profound upheaval, culminating in the outbreak of Revolution in 1789. Artists were, for the first time, deeply immersed in the intellectual and political currents of the age, and many of them responded sympathetically to the new humanitarian and ethical ideals propagated by Rousseau and the Enlightenment. This is not to say that French painters before David harboured consciously revolutionary intentions; indeed, most of the important commissions of the 1770s and 1780s came directly from the King himself, via d'Angiviller, and were designed specifically to reinforce the authority of the Monarchy. The change was, initially at any rate, confined to style and technique, corresponding to the demand for a

more virile and dramatic form of art than the effete allegories of Boucher, Pierre and Vanloo. Certain painters of this period, notably Doyen, Deshays, Ménageot and Vincent, seem almost like pre-Romantics in retrospect, for they injected a new passion into French art which was to have profound repercussions in the early nineteenth century. At the same time they opened up an entire new range of historical subject-matter which artists were to exploit for the next half century and beyond. The most spectacular example of this new *élan* came from the painter Doyen (1726–1806), whose *Miracle of the Ardents* (Eglise Saint-Roch, Paris) created a sensation when it was exhibited at the Salon of 1767. This vast and (originally) strongly coloured work, full of pathos and extremes of emotion, hangs in a dark corner of the transept of Saint-Roch, opposite Vien's *St Denis Preaching*. No greater contrast could be imagined than between the Baroque turbulence of Doyen's picture and the totally static quality of the other. The *Miracle of the Ardents* commemorates an event which took place in 1129, when fire fell from Heaven on to Paris and people died in agony from a

129. Doyen,
Miracle of the Ardents,
80 × 50 cm.
Musée du Louvre.
Photo: Musées Nationaux, Paris

130. Vien,
St Denis Preaching,
665 × 400 cm.
Eglise St Roch, Paris.
Photo: Caisse Nationale des Monuments
Historiques et des Sites.
© S.P.A.D.E.M.

[107]

violent sensation of burning in the stomach; only with the miraculous intercession of St Geneviève, the patron saint of Paris, seen in the upper left-hand corner of the picture, was the scourge halted. This was a subject ideally suited to a man of Doyen's ardent temperament. He has extracted every last ounce of pathos from the event, reinforced by a heavy use of chiaroscuro around the agonised, contorted figures. The inspiration behind this highly dramatic scene is a combination of the Bolognese (particularly Guercino) and Rubens, whose work Doyen went specially to study in Flanders before painting this picture. Of all the paintings of this period, the *Miracle of the Ardents* is the most original in conception and directly foreshadows those masochistic horrors of the early nineteenth century, Gros's *Plague-stricken at Jaffa* and Delacroix's *Massacre at Chios*, both of which include the same prostrate, dying men in the foregound. In the *Miracle*, and in many other paintings from classical history and literature (*The Death of Virginia*, 1759, Parma, *Mars Defeated by Minerva*, 1781, Poitiers, etc.), Doyen revealed an imaginative power and a sense of epic poetry and drama rare in artists of his time. He can fairly claim to be one of the precursors of modern Romanticism.

J.B. Deshays (1729–1765) was another artist whose love of pathos and dramatic effects led him to seek inspiration in Bolognese religious painting. During his short lifetime, Deshays rose to fame with his paintings of the early Christian saints and martyrs, many of them shown in acute physical suffering and subjected to torture of the most appalling kind; among them are *The Martyrdom of Saint Andrew*, (Salon of 1761, St Louis, Versailles) and *Saint Jerome Writing of Death* (Salon of 1765, St Louis, Versailles). In all these works, intensity of expression and the reality of suffering is taken to its furthest extreme. This effect is accentuated by tumultuous Baroque compositions of diagonals and pyramidal forms suggestive of great physical effort, combined with violent oppositions of light and shade which accentuate every straining muscle and sinew. Deshays' taste for energetic themes was already apparent in his '*morceau de réception*', *Hector Displayed on the Banks of the Scamandra* (Musée Fabre, Montpellier), shown at the Salon of 1759. This was a remarkable work for a young man who began his career in the studio of Boucher (whose daughter he married in 1759) and shows how rapidly the older man's style was transformed in the hands of his pupils – despite a lingering prettiness in the figure of Venus descending from the clouds with a garland of flowers. It was at the following Salon, however, in 1761, that Deshays really came into prominence, with his series of saints, when he was acclaimed by Diderot as '*le premier peintre de la nation.*' The most powerful of all these works is *The Martydom of St Andrew* (Rouen), showing the early Christian saint being flayed alive while the Roman praetor observes this

131

grisly scene from a stand on the left. In Diderot's words: *'Sa scène vous attache et vous touche; elle est grande, pathétique et violente.'*[14] This painting is perhaps the most complete expression of the Baroque tendency in eighteenth-century France, and stands in marked contrast to the opposite style, which in the hands of Vien and his followers was to emerge as neo-classicism.

Another important aspect of art after the accession of Louis XVI was the revival of interest in French national history, especially the Middle Ages and the reign of Henri IV. Painters were actively encouraged by d'Angiviller to celebrate the French past and the Monarchy in its moments of greatest heroism and glory. This movement, which coincided with Rousseau's cult of antique virtue and the new vogue for Plutarch, was given added impetus by the publication of Villaret's *Histoire de France* (1763) and the comte de Tressan's *Amadis des Gaules* (1779). Henceforward, tales of mediaeval chivalry became legion. Artists vied with each other to display the virtues of St Louis, the chevalier Bayard and du Guesclin, who seemed the natural successors to Scipio and the heroes of Roman antiquity. This was the motive behind one of the most important acts of patronage of the new reign when, in 1775, d'Angiviller conceived a plan to illustrate the history of France[15] in a series of paintings, of which three—Durameau's *Continence of Bayard*, Brenet's *Honours Restored to du Guesclin, High Constable* and Suvée's *The Death of Admiral de Coligny* were exhibited in Paris;[16] a fourth scene, Vincent's *Arrest of President Molé*, first appeared at the Salon of 1779 and now hangs in the Palais Bourbon. All these works were consciously designed to inculcate a love of chivalry, heroism and patriotic virtue in the French public.

Durameau's *The Continence of Bayard* (Salon of 1777, Grenoble) shows the mediaeval hero gallantly refusing to take advantage of a pretty young girl whose favours he had procured for the night. He is seen here in the act of returning her to her grateful mother, with a small dowry into the bargain, to enable her to make a good match. Few of the critics of the day missed the unconscious humour of this picture, and they ridiculed Bayard's mercenary gesture as he appears to dangle this small purse in a manner more appropriate to a grocer or money-lender than a chivalrous knight. But from a historical viewpoint, this is a highly significant picture. Although painted in the superficially colourful and attractive style of Boucher, the setting of a Gothic interior is conveyed with historical accuracy. This is the direct ancestor of the so-called Troubadour style which was to flourish in the early years of the nineteenth century in the hands of artists like Fleury Richard, Révoil, Mallet and Bergeret.

Brenet's *The Death of du Guesclin* (Salon of 1777, Château de Versailles), by contrast, is a vigorous and dramatic painting portraying the death of a national hero.

The account of du Guesclin's death in 1380, after the siege of Châteauneuf-de-Randon, is taken from Villaret's *Histoire de France* (1763) and relates how his enemies, the English, came to pay a last homage to the dead warrior; in the centre two of du Guesclin's faithful soldiers, Olivier Clisson and the maréchal de Sancerre, point to their former commander prostrate on his deathbed. Although the painting still has a certain flourish and theatricality reminiscent of Boucher and his school, in treatment as well as in the choice of a noble, uplifting subject, it marks a significant step towards full-blown neo-classicism. Brenet, in fact, played a major part in the official programme for the revival of history painting and, by the mid-1770s, stood high in favour with the authorities. On 12 December, 1779, d'Angiviller commended the artist's progress, saying that he was one of the most distinguished

132. Durameau,
The Continence of Bayard,
320 × 152 cm.
Musée de Grenoble.
Photo: Maison Ifot

131. Deshays,
The Martyrdom of St Andrew,
420 × 220 cm.
Musée des Beaux-Arts, Rouen.
Photo: Ellebé

135

133

134

painters working in the King's service. Brenet's style marks a distinct break with the turbulent Baroque compositions of Doyen and Deshays, towards a clear and restrained form of classicism inspired by Raphael, the Carracci and Domenichino. This evolution is clearly illustrated by two majestic paintings of the late 1770s, *Caius Furius Cressinus accused of Sorcery* [*L'agriculteur romain*] (Salon of 1777, Musée des Augustins, Toulouse) and *Metellus condemned to death by Augustus* (Salon of 1779, Musée de Nîmes). *L'agriculteur romain* illustrates the story of a successful Roman farmer who seeks to prove his innocence of sorcery simply by pointing to his oxen and ploughshare; there is no pathos or melodrama here, but clearly articulated forms and calm, eloquent gestures. This painting is typical of Brenet's search for clarity and simplicity, in the tradition of Poussin and Le Sueur.

Two more painters, Vincent and Ménageot, were actively, though briefly, involved in the revival of historical subjects and each of them left one memorable painting. François-André Vincent (1746–1809) was the son of a Genevan miniaturist established in Paris and a pupil of Vien who made a promising start to his career when he won the *prix de Rome* in 1768 with his *Germanicus Quelling the Uprising* (Ecole des Beaux-Arts). During his stay in Rome, from 1771 until 1775, Vincent made a number of brilliant caricatures of his fellow students, Suvée, César Vanloo, Peyron, Renard and others. Many of them are remarkably close to the style of draftsmanship of Fragonard, who was in Italy at this time in the company of the financier, Bergeret de Grancourt. Bergeret had a particularly high opinion of Vincent's talent and was painted in 1774 by the artist in a curious portrait showing him in a silk turban and dressing-gown, surrounded by folios of drawings and pieces of sculpture (Musée de Besançon). Vincent was, in fact, a remarkable portraitist and later in his career painted many excellent ones, like that of the actor *Dazincourt* (1792) in Marseille. But the artist's reputation today rests on a single painting, *The Arrest of President Molé during the Fronde* in the Chambre des Députés. Exhibited at the Salon of 1777, where it was an enormous popular success, this work is the first outstanding example of a theme from French national history. The artist has chosen the highly dramatic moment when the President of the Paris Parlement, Molé, a loyal subject of the crown, is confronted by a group of rebellious *frondeurs* (the anti-Monarchist faction during the minority of Louis XIV) in the rue de l'Arbre-Sec and ordered by their leader Raguenet, at the point of a sword, to return to the Palais-Royal in order to reclaim the parliamentarians held captive by the Queen. The entire scene is a masterpeice of historical realism: the setting of the Paris street, with its gabled mediaeval houses, and the series of portraits of the chief protagonists are all painted with the accuracy we might expect of a Romantic artist of around 1830. Indeed,

this picture is the direct forerunner of Delacroix's *Liberty on the Barricades* and similar expressions of popular sentiment in the nineteenth century. Vincent's *Molé* also possessed a topical significance which few of the artist's contemporaries would have missed, since the theme had been specially chosen by d'Angiviller in 1775 to illustrate the loyalty of the Paris Parlement to the Crown. For most of the eighteenth century the Parlement – a hereditary oligarchy of patrician magistrates and lawyers – had been a thorn in the Monarchy's flesh until its members were exiled by Louis XV's Minister Maupeou in 1771. One of Louis XVI's first acts on his accession in 1774 was to retore the Parlement and its privileges in an attempt to win its allegiance back to the cause of the Crown, then already heavily under attack from other quarters.[17] The event was widely seen as a concession by the King to democracy, or, in the deliberately ambivalent words of Voltaire: 'Louis XVI in his wisdom re-established the Parlements that Louis XV with justice had destroyed. The people witnessed their return with transports of joy.'[18] The painting is therefore a piece of propaganda in favour not so much of popular liberty as of unity and reconciliation. This work was Vincent's one great triumph and though he painted several others with similar historical themes, including the series from the *Life of Henri IV* (1783–7, at Fontainebleau and the Louvre), he was unable to repeat his initial success. He then reverted to his earlier classical manner, but by the mid 1780s his reputation was already eclipsed by that rising star, J-L. David, whose far more forceful style rapidly dominated the rest of his generation.

The career of Vincent's counterpart and near-contemporary, François-Guillaume Ménageot (1744–1816), follows in almost parallel lines. Born in London, he returned to Paris as a child and studied under Deshays, then under Boucher, winning the *prix de Rome* in 1766 with the painting *Thomyris Plunging Cyrus' Head into a Pool of Blood* (Ecole des Beaux-Arts). On his return from Rome in 1774, Ménageot soon built up a good reputation for himself, with paintings of classical and religious subjects, typified by a work like *Time Halting Study* [*Le Temps qui arrête l'Etude*]. He was in particular demand as a painter of religious commissions, most of which still survive in Paris and French provincial churches. But, like Vincent, Ménageot is known today on the strength of a single work, *The Death of Leonardo da Vinci* (1781), in the Hôtel de Ville at Amboise. The painting forms a kind of pendant to Vincent's *Molé*, first because it is executed in the same lively, colourful but realistic manner, and second because it exploits a similar historical vein of subject matter, even though the episode of Leonardo dying in the King's arms is almost certainly apocryphal. This is also a subtle piece of propaganda, for Ménageot clearly wished to pay homage not only to the great Italian artist but also to the King, whose enlightened patronage brought him and

133. Brenet,
Caius Furius Cressinus accused of Sorcery,
324 × 326 cm.
Musée des Augustins, Toulouse.
Photo: Jean Dieuzaide

134. Brenet,
The Continence of Scipio,
129 × 179 cm.
Musée de Strasbourg.
Photo: Courtauld Institute, London

135. Vincent,
The Arrest of President Molé during the Fronde,
305 × 305 cm.
Chambre des Députés, Paris.
Photo: Caisse Nationale des Monuments Historiques et des Sites.
© S.P.A.D.E.M.

largely done by artists, amateurs and *dilettanti*. The cause of classical antiquity was soon espoused by Winckelmann, the itinerant German scholar and former librarian to the Duke of Brunswick at Wolfenbüttel, who professed to find his true spiritual home in the city-state of Sparta and in its healthy, athletic *moeurs*. He was a devoted admirer of early Greek sculpture and in his first important publication, *Gedanken über die Nachahmung der Griechischen Werke in der Malerei und Bildhauerkunst* of 1755, fixed the seal of critical approval on the incipient classical movement and, with his lyrical descriptions of the Apollo Belvedere and other famous statuary, defined the standards of truth and timeless beauty which became the new artistic norm. The book was, moreover, enthusiastically reviewed in Fréron's *Le Journal Etranger* and, with the help of copious extracts, ensured the rapid circulation of Winckelmann's ideas in France.

The first visible result of Winckelmann's doctrines was Anton Raphael Mengs' *Parnassus* (1761) in the Villa Albani, a frigid, lifeless caricature of Raphael's famous composition in the Vatican but one which crystallised the aspirations of the new movement and was to produce many offspring in the late eighteenth and nineteenth centuries. With the presence of Winckelmann, Rome soon became the shrine for young artists from all over Europe, including Angelica Kauffmann, Benjamin West, Gavin Hamilton and many more who made the pilgrimage as if to the source of a new religion. Prints after the main compositions by Benjamin West and Gavin Hamilton quickly reached Paris, where they were eagerly studied and copied by French artists. (David, for example, made a copy after Gavin Hamilton's head and bust of Hector.) The French Academy in Rome was also in the vanguard of the new enthusiasm for classical antiquity, and several of its Directors took a personal lead, like Natoire, who made detailed sketches of Trajan's column and other Roman ruins. This was the atmosphere of ferment when Joseph-Marie Vien (1716–1809), a young student from Montpellier who had worked under Natoire in Paris, arrived in Rome in 1744. Vien was to become one of the most ardent converts to classical antiquity. His work, though innocuous in appearance in its Etruscan purity and charm, was to exercise far-reaching consequences on French art, and actively determined the development of David, his most outstanding pupil. Vien's originality was not immediately apparent, for during his spell at the Ecole de Rome he was still very much under the sway of the Bolognese artists, the Carracci and Domenichino, especially, who in the eyes of mid-eighteenth-century connoisseurs represented one of the peaks of artistic achievement. This influence is clearly paramount in his early paintings, for example in the extremely beautiful *Lot and his Daughters* (1748), in Le Havre [Plate 14], as well as the series representing the *Life*

many others to France. Ménageot's *Death of Leonardo* was also destined to have numerous progeny in the early nineteenth century, when painters like Bergeret, Granet and Gigoux showed a special predilection for touching episodes from the lives of their illustrious predecessors.

The predominant direction French painting was to follow from about 1760 until the collapse of the Empire in 1815 was that of neo-classicism. This was more than a revival of the doctrines of Poussin, Lebrun and the seventeenth-century classical painters. It was a self-conscious exercise in the archaeology of classical antiquity, first of the Roman, then of the Greek periods, which gradually took hold of an entire generation of French painters, beginning with artists like Vien, Peyron and Suvée and culminating in David's great masterpieces, painted immediately before the Revolution. The movement is usually thought to have begun with the first excavations for Roman ruins near Vesuvius in 1738, followed by the rediscovery of Herculaneum and of the site of Pompeii in 1748. This archeological work was backed up by a spate of scholarly publications, Piranesi's *Vedute di Roma* of 1750, the *Magnificenze di Roma* of 1751, Caylus' *Recueil d'antiquités égyptiennes, étrusques, romaines et gauloises* (1752 onwards), all of them amply provided with illustrations which artists were to exploit for the next half century and beyond. The preliminary groundwork was

Plate 14

faces page 105

[112]

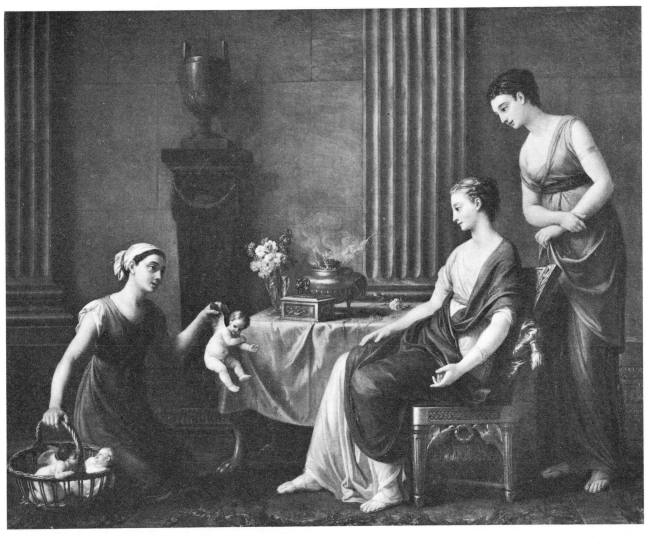

137. Vien,
The Cupid Seller,
95 × 119 cm.
Château de Fontainebleau.
Photo: Lauros-Giraudon

of Saint Martha in the Eglise Sainte-Marthe at Tarascon; but there is no trace of Vien's distinctive brand of classicism. On his return to Paris in 1750, he was finally admitted to the Academy in 1754—after considerable difficulties—on the strength of his *Daedalus and Icarus* in the Ecole des Beaux-Arts. It was about this time that everything that Vien had seen and heard in Rome about the rediscovery of classical antiquity rose to the surface in his mind and began to set his own art on that course. At this crucial juncture one of the most influential of mid-eighteenth-century patrons came into the artist's life: the comte de Caylus,[19] a prominent amateur, classical scholar and archaeologist, who further helped to wean Vien away from the Bolognese and Roman Baroque and re-orientate him towards the 'pure' art of classical Greece and Herculaneum. Though hated by professional writers and critics like Diderot (who described him as '*le plus cruel des amateurs*'),[20] Voltaire and Marmontel on account of his arrogance and vanity, Caylus was capable of real generosity towards those artists he felt could be moulded to his own wishes. Moreover, he provided artists with an ample store of raw material in his numerous publications, especially his treatise on the technique of painting on

encaustic wax as described by Pliny, and his series of subjects from Homer, the *Tableaux tirés de l'Iliade*. Vien's best known essay in the new Greek style is his *The Cupid Seller* [*La Marchande d'Amours*] (Salon of 1763) at Fontainebleau, consciously designed to imitate the simple frieze-like pattern of an antique painting at Herculaneum. But, as Diderot commented, this work has none of the grandeur or severity of classical antiquity. It is simply a pretty little idyll in the style of an Anacreontic ode, with mildly erotic overtones, not very different from the Rococo of Boucher except in its two-dimensional form and fluted columns in the background. The same could be said of Vien's eight other exhibits at the Salon of 1763, including *La Vertueuse Athénienne* and the *Four Seasons*, painted for Madame Geoffrin, which appeared under the following titles: *The Flower-seller, Proserpine Decorates the Bust of Ceres, An Offering in the Temple of Venus* and *The Priestess Burning Incense on a Tripod*.[21] It is a rather curious irony that such innocent-looking works were soon to evolve into full-blooded neo-classicism and the revolutionary paintings of David. For neo-classicism grew out of distinctly worldly origins. As Grimm reported of Paris at the time: '*Tout est à la Grecque*'. At the outset, this was

[113]

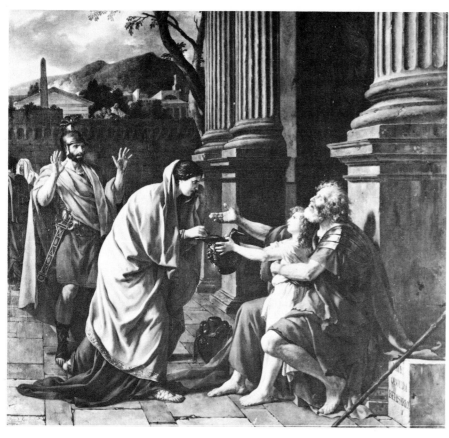

138. David,
Belisarius Begging Alms,
288 × 312 cm.
Musée des Beaux-Arts, Lille.
Photo: Muse'es Nationaux, Paris

these works go far beyond their precursors in power, simplicity and concentration. Where other artists, like Vincent, treated the theme of Belisarius,[22] Justininian's former general, reduced to begging in his old age, they seem to be painting no more than an historical anecdote. David, on the other hand, achieves in his magnificent painting a finality which makes this the only *possible* way to portray the scene; his gigantic figures impose themselves on the spectator with unprecedented clarity and force. This, at last, was the kind of austere grandeur Diderot had so long awaited, and he instinctively recognized it when it appeared: '*Ce jeune homme a de l'âme.*'[23] Indeed, after 1780 it is hard to think of David as an eighteenth-century artist at all, for within a few years he had broken so far beyond the range of *dixhuitième* sensibility that in intensity of feeling and power of expression he already belongs to the Revolutionary generation and its aftermath.

David's roots were none the less firmly fixed in his own times. His early works, the *Battle of Mars and Minerva* (1771, Louvre) and *Antiochus and Stratonice* (prix de Rome 1774, Ecole des Beaux-Arts) are still well within the current Rococo idiom, and in their lingering prettiness and charm show distinct traces of Boucher's mannerisms. David was by no means hostile to Boucher; even after he had broken radically with the latter's manner and rejected his sentiment as insincere and outmoded, he never lost his respect for Boucher's great natural ability: '*N'est pas Boucher qui veut*' [Not everyone can be a Boucher], he is reported to have said. Moreover, it was Boucher who introduced David to Vien, procuring him an entry into the older man's studio but adding a word of warning that he might find Vien rather cold for his taste. Vien, though not an inspiring artist, was an excellent teacher and can fairly claim to have revealed to David his true vocation. This lay in the gradual adaptation of the early classical manner of Vien, Mengs and Winckelmann, current in Rome, to noble, heroic themes inspired by the great examples of antiquity. On his arrival at the French Academy of Rome in 1775 David was firmly on his guard against the craze for antiquity: '*L'antique ne me séduira pas, il manque d'action et ne remue pas.*' Within a year or two, however, he had soon worked out his own relationship to antiquity, which was not the literal-minded, pedantic copying of his colleagues but a full-blooded enthusiasm for something capable of completely transforming French art.

These years of training and assimilation came to fruition in *The Oath of the Horatii* (Louvre) painted in Rome, displayed first in David's studio on the Piazza del Popolo and at the Paris Salon of 1785, where it caused a tremendous sensation. The painting is the ultimate statement of David's revolutionary artistic principles and a crucial event for the later development of French art, for this work, more than any other, dealt the final death blow to

scarcely more than an elegant Greek variant on the Rococo, a change of fashion corresponding to the taste of the new royal mistress, Madame du Barry, who, according to contemporary accounts, returned Fragonard's panels for her new pavilion at Louveciennes and commissioned others by Vien to replace them. These were in the light Etruscan style then in vogue and were well suited to the neo-classical exterior of Louveciennes by Ledoux. Vien, in fact, soon attracted an international clientèle with paintings like the *Mars and Venus* (1768, Leningrad), conceived by Diderot on behalf of Catherine the Great, a pretty, sentimentalised view of classical antiquity; the artist cannot resist the Greuze-like anecdotal touch of the pigeons nesting in the warrior's helmet. Vien's main importance today, however, lies not so much in his output as in his teaching, for it was during his own term as Director of the French Academy in Rome from 1775 to 1781 that Vien exerted a strong influence on a whole generation of young artists and imbued them with his own passion for antiquity. David spoke for all of them when, on the occasion of Vien's burial in the Panthéon in 1809, he pronounced: '*Notre père a cessé de vivre.*'

The art of J.-L. David (1748–1825) marks the logical outcome and climax of the evolution of history painting through the eighteenth century. Everything that preceded him was, in a sense, merely the preparation, or '*coup d'essai*', for those great masterpieces of David's late thirties, *Belisarius Begging Alms* (Salon of 1781, Musée de Lille) and the *Oath of the Horatii* (Salon of 1785, Louvre). But

[114]

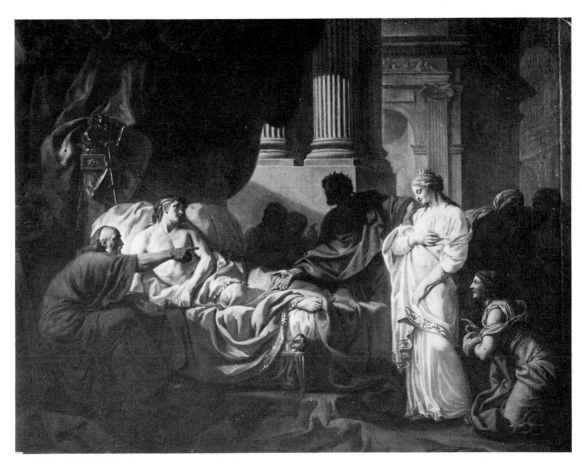

139. David,
Antiochus and Stratonice,
120 × 155 cm.
Ecole des Beaux-Arts, Paris.
The Mansell Collection. Photo: Bulloz

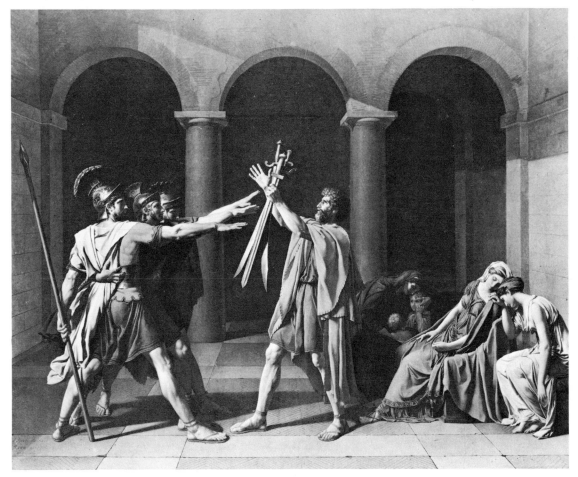

140. David,
The Oath of the Horatii,
330 × 425 cm.
Musée du Louvre.
Photo: Lauros-Giraudon

the eighteenth-century tradition. Its originality lies first of all in the extreme tautness of its construction, corresponding to a strict observance of the unities of time and action. The setting is one of stark simplicity: a dimly-lit antechamber divided by two Doric columns, with a bare marble floor. Our entire attention is focused on the central action, three Romans, standing with taut muscles and in strict alignment, swearing an oath of allegiance to their aged father, Horace. Everything about the figures suggests manly virtue, courage and patriotic pride; on the right, and in complete contrast in their soft, slumped forms, the womenfolk abandon themselves to pity and weeping. The subject of the *Horatii* has been much debated but still not entirely resolved.[24] It used to be thought that the painting was a straightforward depiction of the last act of Corneille's play *Horace*, but there are significant differences. First, there is no oath-taking in Corneille: second, and perhaps more important, the whole emphasis in seventeenth-century tragedy is on patrician valour and the pre-eminence of kings and nobles. This Cornelian concept of heroism, an aristocratic vestige from the Fronde, was the exact antithesis of David's fervent belief in democracy and republicanism. The more likely source, therefore, seems to be a ballet version of *Horace* by Jean

Georges Noverre, performed in Paris in 1777 with important modifications to Corneille's original play.

But this was only the immediate event which helped David to crystallize his final image, a painting which by its tremendous impact compelled artists, critics and the public to recognise that the old conventions had been swept away once and for all. An artistic revolution had taken place a mere four years before the storming of the Bastille in 1789. Though there was nothing explicitly revolutionary about the painting, which was commissioned by d'Angiviller under the auspices of the Ancien Régime, the *Horatii* seemed to herald the new mood of popular sentiment in France immediately before the outbreak of Revolution. The artistic revolution was destined to outlast the political one, for the reforms carried out by David and his followers set a new standard for French painting until into the 1820s and, in the exceptional figure of Ingres, well beyond the mid-nineteenth century. Only when these had frozen into a new orthodoxy were they called into question and finally rejected by the Romantics, who once again began to cast their eyes back to an earlier generation of eighteenth-century artists in the name of freedom, colour and spontaneous expression.

7: The Still Life and Genre Painting

Two of the most widely practised, but least highly regarded types of painting in eighteenth-century France were still life and genre. These were very much the poor relations among contemporary art forms: they neither enjoyed the respect accorded to history painting, nor could they command the high prices of portraiture. The reason for this official disparagement of the *nature morte*—despite considerable private patronage of it—must be sought in the doctrines of the Academy, which refused to accept that a painting of flowers, fruit or dead game called for the same degree of intelligence and creative imagination as a work inspired by classical history or mythology. Today, especially in the face of Chardin's supreme masterpieces, we may dismiss this view as patently absurd. But in the eighteenth century the prejudice against 'low' subject-matter died hard, and a still life painter was virtually debarred from the full honours of the academic system. There was, moreover, a lingering suspicion in the academic mind of the democratic bias inherent in still life and genre painting. Many French still life painters, including Chardin, following the pattern of their predecessors in seventeenth-century Holland, had learnt their métier in a guild system, like the Academy of St Luke, which offered the artists a training outside the Academy, but on an altogether more humble plane. They were therefore regarded by their grander rivals as mere artisans or craftsmen, but not true artists in the full social and intellectual sense. In the socially-conscious eyes of eighteenth-century France, an artisan was inferior, being only one step higher than an ordinary labourer, but it was from precisely this class that so many artists of the period emerged.

The critics, dealers and amateurs of the day, however, were less blinded in their tastes by official dogma, and had already begun to perceive the merits of still-life painting. The genre was very much in demand as a form of decoration in the early eighteenth century. This change of attitude coincided with a new enthusiasm in eighteenth-century France for Dutch seventeenth-century art, notably the easily collectable cabinet pictures of both Teniers, Gerard Dou and Metsu. Distinct traces of these Dutch artists can be found throughout French art of this period, in the paintings of domestic interiors by Chardin, Boucher and Lépicié, and especially in the favourite motif, derived from Dou, of the figure standing at an open window. Rembrandt, in particular, exerted a strong influence on many artists, including Raoux, Grimou, Santerre, Fragonard and Greuze. Louis XIV's well-known contempt for Dutch painting was soon disregarded by artists and collectors, whose attitude later in the eighteenth century was neatly summarized by Diderot's famous quip: 'I prefer country manners to coquetry and I would given ten Watteaus for a Teniers.'[1] This new appreciation of Dutch art helped to redirect the eyes of French artists towards a closer observation of the realities of everyday life—hitherto despised by the grand style—and taught them to pay greater attention to technique, the rendering of light and shade and the actual texture of objects. For the first time in their history, perhaps, French artists were content simply to be painters, without the semi-literary or philosophical pretensions of their academic colleagues.

Like nearly all other genres, the still life in eighteenth-century France derived closely from prototypes of the previous century.[2] The seventeenth century had produced a great resurgence of the still life in France, exemplified in one mood by Philippe de Champaigne's sombre reflections on mortality and human vanity, and in another by the great flower painters of the period, notably J.-B. Monnoyer (1634–99) and Blain de Fontenay (1653–1715). The best known of these still life painters is Monnoyer, who painted large, opulent flower pieces like the *Still Life with Flowers*, in Versailles, with a draped column in the background, damask curtains and a classical bust on the left, and a porcelain vase in the centre

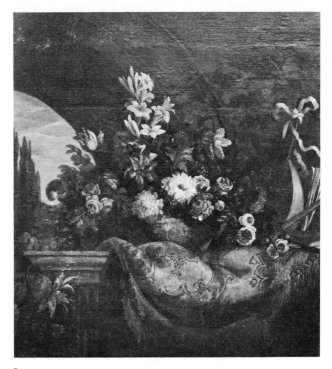

141. Monnoyer,
Still Life with Flowers,
148 × 160 cm.
Château de Versailles.
Photo: Musées Nationaux, Paris

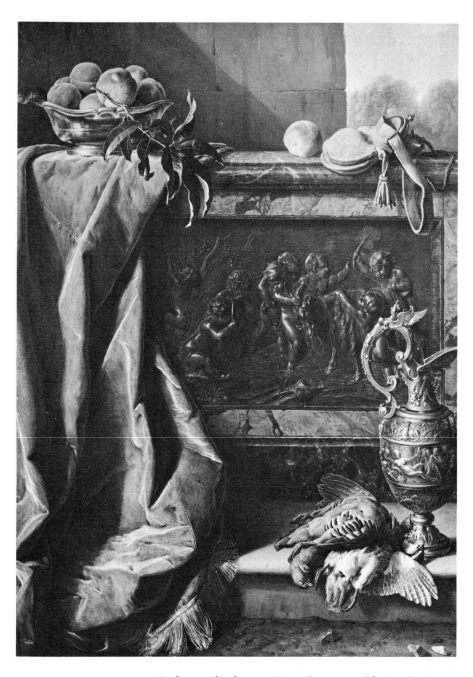

Plate 15
faces page 128

142. Desportes,
Still Life with Bas-Relief,
127 × 97 cm.
Cailleux, Paris

Chardin's picture. Gradually objects were deprived of their symbolic and allegorical significance, treated with less regard for their dignity and more for their purely pictorial value.

The formula set by Monnoyer was followed in the early years of the eighteenth century, with a few modifications, by François Desportes (1661–1743) and Largillierre. Nearly all Desportes' compositions suggest an invisible human presence, even though they rarely include figures. His great accumulations of flowers, bowls of fruit, game, hounds and guns (*Still Life*, 1719, Cailleux Collection) are fragments of the way of life adopted in the late seventeenth century by every *grand seigneur* whose profession was war and whose recreation was hunting. They were the supreme embodiment of the aristocratic ideal of the age which, like its memorialist Saint-Simon, prized military valour and sporting prowess above all else. Technically, they are brilliant and create an overall impression of great splendour and richness, like the *Still Life with Bas-Relief* (1741) in the Cailleux Collection, with its crimson red damask curtain on the left and gilt ewer in the foreground. Desportes made a speciality of beautiful, finely-veined marble, as in the *Still Life* of 1706 (Le Havre) [Plate 15], in which fruit and game are displayed on a plinth against an oval niche. He also had a rare gift for conveying the translucent quality of objects; unlike Chardin's opaque textures, his fruit seems chosen specially to reflect a cool pearly-grey light. He is little concerned with the intrinsic interest of objects. In the splendid *Still Life with a Peacock* in Lyon, for example, we are never far away from the familiar décor of history painting, with its traditional props of columns and portico. It was this kind of Baroque paraphernalia which was to be so conspicuously absent from the work of Chardin.

By contrast with the work of his predecessors, in Chardin's hands the still life gradually changed into something quite different. The objects he so lovingly portrayed – a copper cauldron, a pewter jug or a half-eaten meal – became paintings in themselves, with no need of columns and draperies to support them. No other French artist has ever come so close to the reality in front of him – usually the everyday, humble reality of the Parisian *petite bourgeoisie* from which Chardin himself came. This ability to portray the actual physical presence of things, in all their volume and consistency of texture, was to many eminent French writers from Diderot to Proust, and is still to us today, Chardin's supreme virtue as a painter.[3] At the sight of *The Jar of Olives* (Louvre) at the Salon of 1763, Diderot exclaimed: 'Here is Nature herself.'[4] How Chardin's art, laborious and painstaking as a coachbuilder's method of working layer by layer, produced something so magical and yet so true to life, is one of the mysteries of artistic creation which has puzzled his spectators from the eighteenth century onwards. To some of

raised on a plinth containing flowers and fruit. This is not just an ordinary flower picture, but a highly structured and elaborate composition in which the artist has raised the still life to the dignity of history painting. The plants have been specially chosen for their beauty, rarity and splendour, while the attributes are those of the traditional classical allegory. The seventeenth-century still life was designed as decoration of the most prestigious kind, fit to adorn a nobleman's palace or château. Hence the strict selection and hierarchy of its ingredients; only a limited range of objects, plants and animals had the right to representation in painting. It was only later in the eighteenth century that this range was extended to include commonplace flowers of the hedgerow, objects of pewter instead of the elaborately engraved ewers of gold and silver, a slice of pâté or an inelegant fish like the skate in

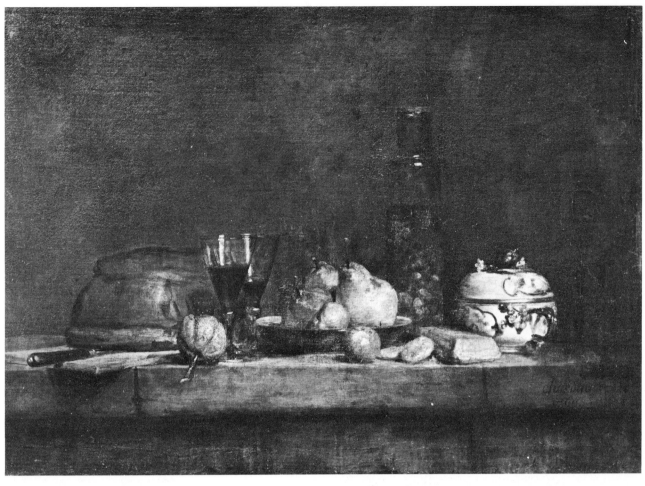

143. Chardin,
The Jar of Olives,
71 × 98 cm.
Musée du Louvre.
Photo: Giraudon

his contemporaries, like Mariette, this extreme concen‑
tration of vision on a tiny fragment of the visible world
seemed to indicate mere lack of imagination, the narrow
dependence of the copyist. Even the Goncourt brothers,
who wrote so perceptively about his technique and the
creamy texture of his paint, imply a certain limitation in
the artist's outlook when they state that he 'searched for
nothing beyond himself, for nothing higher than his
immediate vision'. Chardin's world is totally devoid of
flights of fancy; he deliberately avoided the hackneyed
mythologies and compositional devices favoured by his
contemporaries. He had the uncanny ability to create a
picture from almost nothing – a few pots and pans chosen
at random – but to re‑create them in a pattern of ordered
harmony so that they impose their presence on the spec‑
tator with much greater force than they would in ordinary
life. By the sheer intensity of his gaze, Chardin teaches us
to *see* the things we usually notice at a casual glance. Like
all great visionary artists, he exerts an unrivalled power of
revelation on the spectator who readily accepts the
painter's vision as his own. .This, at any rate, was the
experience of Marcel Proust, who devoted one of his most
sensitive essays to Chardin in the *Nouveaux Mélanges*,
stating that the true hierarchy of art is not in grandiose and
spectacular themes, but '*la noble hiérarchie des couleurs pré‑
cieuses, l'ordre des lois de la beauté*'. The true artist like

Chardin, or Vermeer, extracts poetry from within him‑
self; his only rules are the internal laws of beauty. In a
letter of 1918 to his friend Walter Berry, Proust described
the effect Chardin had had on him as an adolescent,
revealing beauty where he had least suspected it: '*Avant
d'avoir vu des Chardin, je ne m'étais jamais rendu compte de ce
qu'avait de beau, chez mes parents, la table desservie, un coin de
nappe relevé, un couteau contre une huître vide.*'[6]

The novelty of Chardin's technique and subject matter
was by no means apparent at the start of his career. His
originality only came to light gradually, and his working
methods always remained slow and painstaking. The son
of a carpenter and maker of billiard tables, Chardin was
born in Paris in 1699, into a typical artisan's family. His
background was comfortable but not affluent, and incul‑
cated respect for the values of hard work and integrity. To
this extent, Chardin was and remained the typical repre‑
sentative of the Parisian *petite bourgeoisie* – as the Goncourt
brothers christened him – who portrayed through the eyes
of a sympathetic observer the members of his own world
such as scullery maids and modestly dressed housewives.
Though his origins were only a shade lower on the social
scale than those of Boucher, Chardin was never tempted
by the gloss and glamour of the fashionable world and he
remained a craftsman at heart.

The first stage of Chardin's career is relatively obscure.

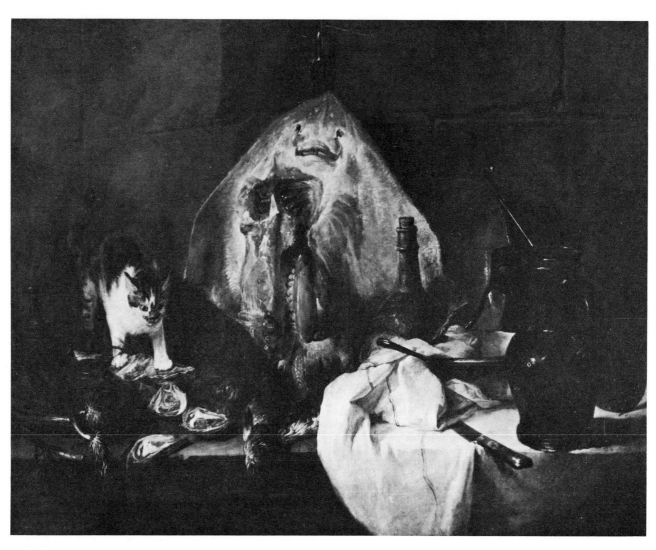

144. Chardin,
The Skate,
114.5 × 146 cm.
Musée du Louvre.
Photo: The Mansell Collection

After learning the elements of drawing in the studio of P. J. Cazes (1676–1754), he entered the Academy of St Luke (an old-fashioned artist's guild and independent corporation) in 1724 to study to become a painter. Very few of his early works have survived, a notable exception being the *Game of Billiards* in the Musée Carnavalet, a precise, matter-of-fact piece of realistic observation in which the artist has presumably drawn on the experience of his father's craft. Soon afterwards, Chardin went to study under Noël-Nicolas Coypel (1690–1734) and it was during this period, in the mid-1720s, that he began those close researches into the properties of colour and the effect of light on surrounding objects which later made him the supreme master of the *nature morte*. He was determined above all to be true to what he could see in front of him. The result was a series of paintings of game, rabbits, hares, partridges and pheasants (see, for example, *Dead Rabbit with a Red Partridge*, *c.* 1728, Paris, Musée de la Chasse) characterized by a broad touch and absence of fuss over detail which clearly anticipate the still lifes of the artist's maturity. But these early works are still not distinctive of Chardin; they lack the absolute clarity and purity of his real masterpieces. The painter had succeeded in break-

ing with the formalized creations of Oudry and Desportes, but he was still bound by his Dutch and Flemish predecessors of the seventeenth century. Chardin learned much of his technique and subject matter from these, but his method was ultimately the reverse of theirs, sacrificing detail to the overall mass in his search for unity of composition.

In June 1728, Chardin first showed *The Skate* (Louvre) at an outdoor exhibition on the place Dauphine. The painting was noticed and greatly admired by Largillierre, who immediately put him up as a candidate for the Academy. Three months later he was admitted to full membership as a painter of *natures mortes*—a rare privilege for a genre reckoned lowest in the official hierarchy and one which shows that the Academy was occasionally prepared to bend the rules on behalf of an artist of exceptional talent. Later in life Chardin showed his respect for the Academy by taking his official duties seriously as treasurer (1755) and as the person responsible for hanging paintings at the Salon. *The Skate*, Chardin's '*morceau de réception*', is an elaborate work, still very close to its Flemish seventeenth-century antecedents in its polished, shiny surfaces and accumulation of in-

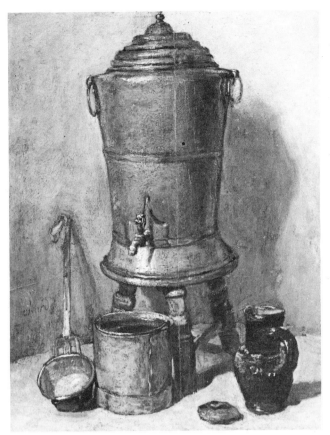

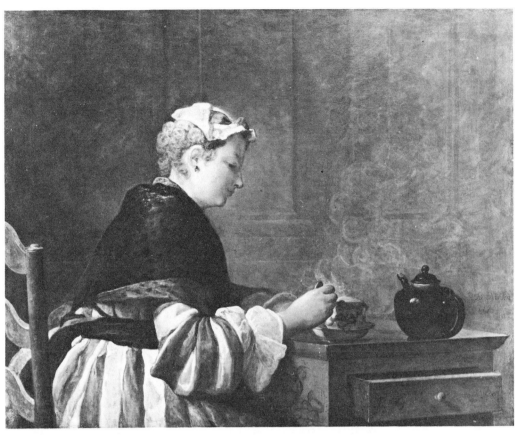

tricate detail. The grotesque-looking fish in the centre of the composition reminded Marcel Proust of an 'enormous marine monster', while a ferocious cat on the left stands poised ready to devour some oysters on the shelf. During the early 1730s Chardin followed up this gastronomic theme with similar paintings devoted to the kitchen and household objects, for example, the *Still Life with Cutlets* (1732) in the Musée Jacquemart-André, the superb *Copper Urn* in the Louvre, and the *Copper Cauldron*, *c.* 1732, in the Musée Cognacq-Jay. In these works, for the first time, Chardin's authentic character begins to emerge, as his brushwork takes on a gritty, gnarled quality, like the bark of a mature tree. At the same time his compositions tend to become simplified, reduced to a few significantly-placed objects. He deliberately avoids the accumulation of minute detail so beloved of his Flemish prototypes. *The Copper Urn*, especially, is a masterpiece of ordered simplicity, with the urn in the centre flanked by the ladle and jug, but any impression of rigid symmetry is broken by the careful placing of the bucket slightly off-centre. This infallible sense of pattern and form has led some modern critics to compare Chardin with Cézanne and even with abstract artists like Braque. The parallel is not unmeaningful, but there is a danger in reading art history backwards, for Chardin's attitude to the world around him was very different from theirs. Even when there are no figures, there is a strong suggestion of human presence in his paintings, unlike the void at the centre of abstract art. In his technique and choice of objects,

Chardin cannot help betraying his sympathy for the domestic middle-class virtues and a peaceful, well-ordered life.

Chardin's calm sympathy with the people of his own Parisian background is further evident in the series of genre paintings begun around 1733. These range from scullery maids (*L'Ecureuse*, 1738), middle-class housewives (*La Pourvoyeuse*, 1739) and mothers (*La Toilette du Matin* in Stockholm, *Le Bénédicité* in the Louvre) to more elegantly-dressed women like the *Lady Sealing a Letter* (1733, Berlin), all shown in a variety of everyday actions and gestures, as if caught in a moment of temporary immobility. There is a certain timeless quality about these ordinary people and their humdrum occupations which no artist has ever surpassed. They are deservedly among Chardin's most popular paintings and were widely diffused during his own lifetime by numerous engravings. The first in the series of genre pictures, the *Lady Sealing a Letter*, is somewhat uncharacteristic of Chardin and has more of the elegance and sparkle of de Troy's conversation pieces; its rich furnishing and heavy velvet drapery make the painting an exception in the artist's *oeuvre*. But in his next essay in the same vein, the *Lady Taking Tea* (1736) in Glasgow, Chardin has reduced the accessories to the bare minimum: a grey-green scumbled background, a ladder-back chair and a solid, red-painted table. As usual with Chardin, the figure is shown in profile, and by his rigorous exclusion of redundant detail the artist concentrates all his attention on this simple, everyday act.

145. Chardin,
The Copper Urn,
32.5 × 40 cm.
Musée du Louvre.
Photo: Giraudon

146. Chardin,
Lady Taking Tea,
81 × 99 cm.
Hunterian Art Gallery, Glasgow.
Photo: University of Glasgow

[121]

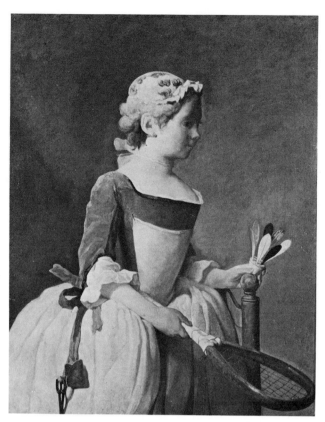

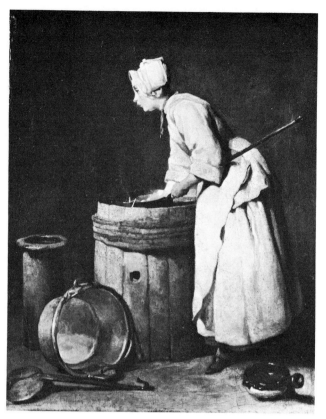

148. Chardin,
Girl with a Shuttlecock,
81 × 65 cm.
Galleria degli Uffizi.
Photo: The Mansell Collection/Alinari

147. Chardin,
The Scullery Maid,
45.7 × 36.9 cm.
Hunterian Art Gallery, Glasgow.
Photo: University of Glasgow

Chardin is evidently most at ease with the typical French *mère de famille*, seen shopping, looking after her children or enjoying a quiet moment to herself. To this day, this type of Frenchwoman has changed very little, and in the average Paris shop or outdoor market we can still see real-life Chardins, like the healthy-looking young woman in *The Housewife* [*La pourvoyeuse*], carrying a large chicken home to an already well-stocked kitchen.

Plate 16 faces page 129

Such paintings soon established Chardin as the ideal painter of family life and domestic happiness. After his marriage in 1731 to Marguerite Saintard and the birth of a son soon afterwards, it was natural that he turned to the world of childhood. His paintings of children are, if anything, still better loved than all his others. They seem to recapture a lost world of innocence, purity and intense absorption. One of the most delightful of the series, [Plate

Plate 17 faces page 129

17] from the late 1730s, is *The Young Artist*[7] (1737, Louvre), showing a neatly dressed boy in a tricorne hat, sharpening his pencil over a large drawing folio. With its perfect poise and subdued harmony of colour, the painting has all the silent tranquillity of the still lifes. But the figure of the boy is more than a simple pretext for Chardin to display his mastery of form. He is the living embodiment of Chardin's artistic ideal, combining deep concentration, patience, meticulous preparation of his tools, and a cheerful disposition. This is surely the meaning of the painting, which so vividly illustrates the delights of the artist's vocation and closely recalls some remarks by Chardin reported in Diderot's *Salon of 1765*: 'Il faut apprendre à l'oeil à regarder la nature ; et combien ne l'ont jamais

vue et ne la verront jamais!' Very close to the *Artist* in style and context is the *Child with a Top* (Salon of 1738, Louvre); unlike the former picture, however, this is an actual portrait of the young son of Monsieur Godefroy, a prosperous banker and jeweller. Here the emphasis is on play rather than work, as the boy obviously prefers the innocent amusement of watching a top spinning on his desk to his closed books, pen and paper. In this picture Chardin uses a limited range of buff colours, brown and olive-green, but the effect is the same ordered harmony. Another painting devoted purely to play and fantasy is the enchanting *Girl with a Shuttlecock* (1737, Paris, private collection). Of all Chardin's paintings of children, this is the furthest removed from the world of adults and work. The little girl, secure in the hermetic realm of childhood, needs nothing else for her happiness but her racket and shuttlecock. Chardin conveyed his instinctive sympathy for children in these paintings, and expressed a nostalgia for their serene innocence in images as potent as the pages of Marcel Proust.

Chardin's career consists of sudden breaks and about-turns, resulting in the most unexpected transformations of his entire repertory and style. The second great change in his art occurred shortly after his second marriage to a wealthy widow, in 1744. His new financial independence must be the chief reason why he suddenly abandoned the highly popular genre paintings and devoted himself almost exclusively to still lifes for the next twenty years. This second series of still lifes contains some of the artist's most amazing creations, including the *Jar of Olives, The*

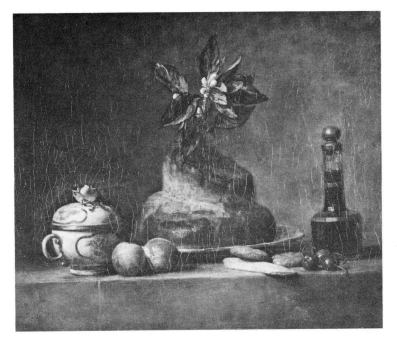

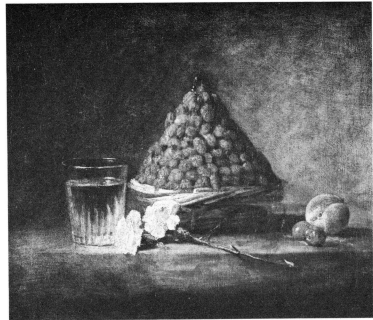

Brioche, the *Bouquet of Flowers* (in Edinburgh) and *Wild Strawberries*. Although reproduced time and again, the paintings never lose their pristine freshness, and their fascination can never entirely be explained. It is clear that, in the intervening twenty years or more since Chardin's first still lifes, his art has undergone a profound change. He is no longer interested in the detailed texture of a dead bird or a fruit, but in the surrounding atmosphere and the complex play of reflections which make up the overall harmony of a picture. This is what Diderot so clearly expressed in his *Salon of 1763: 'C'est celui-ci qui entend l'harmonie des couleurs et des reflets. Ô Chardin! Ce n'est pas du blanc, du rouge, du noir que tu broies sur ta palette: c'est la substance même des objets, c'est l'air et la lumière que tu prends à la pointe de ton pinceau et que tu attaches sur la toile.'*

Among the paintings at the Salon which inspired Diderot's poetic description was the *Jar of Olives* (Louvre), painted in 1760. It is remarkable not only for its veiled, gauzy transparency, but also for its choice of objects – pâté, fruit, half-emptied glasses, a Meissen bowl and the jar of olives – which becomes far more varied in Chardin's later pictures. The touch of luxury and a preference for rare and more unusual things indicates, as some critics have pointed out, the greater affluence of the artist's own domestic setting. The same Meissen sugar bowl reappears in *The Brioche* (1763, Louvre), together with some peaches, a carafe of liqueur and the loaf crowned with a sprig of orange blossom, creating one of the most perfect ensembles ever devised by Chardin.

Towards the end of his life the artist appears to seek after ever greater purity and simplicity. This total and exclusive concentration of vision is admirably illustrated by two more late pictures, the *Bouquet of Flowers* and *Wild Strawberries*. The *Bouquet of Flowers* (c.1760) in Edin-

burgh is no more than an assortment of carnations, tuberoses and sweet peas in a long-necked vase of either Japanese china or Delftware, but arranged simply and with perfect taste. Last and most miraculous of all is the *Wild Strawberries* (Paris, private collection), a simple pyramid of wild strawberries, flanked by a glass of water, two cherries and a peach, with a pair of white carnations in the foreground. Here the forms seem to dissolve into the surrounding atmosphere, creating one of Chardin's most delicate and rarified works of art. This last pair of paintings are his most 'modern', for no other French artist achieved such extreme purity and concentration until the time of Manet and Cézanne. The last word on Chardin should, once again, be left to the Goncourt brothers, whose ability to re-create paint in words has rarely been equalled: *'Et c'est là le miracle des choses que peint Chardin: modelées dans la masse et l'entour de leurs contours, dessinées avec leur lumière, faites pour ainsi dire de l'âme de leur couleur, elles semblent se détacher de la toile et s'animer, par je ne sais quelle merveilleuse opération d'optique entre la toile et le spectateur dans l'espace.'*[8]

During his own lifetime and after, Chardin had many followers and imitators, none of remotely comparable stature. But, in the context of eighteenth-century painting, two excellent provincial artists deserve special mention for a charming pair of pictures which come very close to Chardin's portrayal of domestic contentment, although neither studied under him. The first, from Besançon, is Donat Nonnotte (1708–85), a pupil of Lemoine and protégé of the duc d'Antin. Nonnotte made a promising debut as a history painter (*La Surprise de Besançon*), but his fortune sank after the successive deaths of his patron and former master, Lemoine, who had employed him on several important religious commissions in Paris. The

149. Chardin,
The Brioche,
47 × 56 cm.
Musée du Louvre.
Photo: Lauros-Giraudon

150. Chardin,
Wild Strawberries,
38 × 146 cm.
Private Collection, Paris.
Photo: Lauros-Giraudon

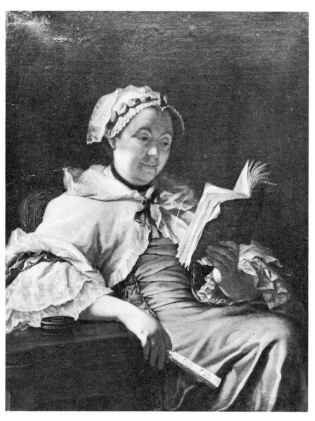

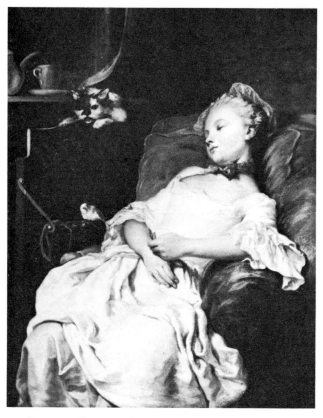

151. Nonotte,
Madame Nonotte,
93 × 73 cm.
Musée des Beaux-Arts,
Besançon

152. Colson,
Girl Asleep,
93 × 73 cm.
Musée des Beaux-Arts,
Dijon

153. Oudry,
*Stag Hunt in the Forest
of Fontainebleau,*
357 × 661 cm.
Château de Fontainebleau.
Photo: Giraudon

artist then turned his attention to portraiture, including that of his wife, Marie-Elisabeth, a rich widow ten years his senior, seen comfortably ensconced in an armchair reading a book (*Madame Nonnotte,* 1758, Besançon). The second artist is Jean-François Gilles Colson (1733–1803), a native of Dijon who studied under his father and achieved proficiency as an architect and sculptor as well as painting. For a time he served as architect to the duc de Bouillon. He was a prominent member of the Academy of Dijon and many other learned societies in Paris, a typical eighteenth-century dilettante and polymath with many varied interests. There is nothing, however, in the rest of his output to explain how he came to paint his unique masterpiece, *Girl Asleep,* in the museum of Dijon, a delightful portrait of a young girl overtaken by sleep in a large, comfortable armchair. These are only two of the many modest intimist paintings showing people reading, sleeping, musing or doing nothing in particular which eighteenth-century artists made their own speciality.

Chardin brought the *nature morte* to a peak of perfection, but several other eighteenth-century artists developed forms of their own in which the still life and genre overlap. Chief of these was Jean-Baptiste Oudry (1686–1755), best known as a painter of hunting scenes and animals, but who also ranks as one of the most accomplished draftsmen and landscape painters of the period. Oudry exemplifies the triumph of Dutch naturalism over Poussinesque tradition in the second quarter of the century. Trained first by Michel Serre, he was adopted at an early

age by Largillierre, whose own Flemish training made him quick to spot a kindred spirit, and was given valuable advice on the importance of light and shade in painting. Elected to the Academy in 1719, Oudry first attracted public attention with a painting of a *Boar Hunt* exhibited in 1722. This was the prelude to a series of royal hunting pictures, *Les Chasses de Louis xv,* which have never been surpassed for the accuracy with which they depict the king's favourite pastime. Most of them were commissioned between 1733 and 1736 by the *Direction des Bâtiments,* first painted in oils then translated into tapestry. Oudry was well placed to organise the execution of his designs, for in 1726 he was appointed official designer and in 1734 he became the overall director of the Beauvais tapestry factory. His importance can be gauged by Voltaire's reference to Beauvais in a letter of 1736 to the Abbé Moussinot as 'le royaume d'Oudry'. In the decorative arts, Oudry's chief originality lay in his adoption of small, light-hearted motifs—especially flowers and fables—for use on pieces of furniture, screens, footstools and so on, in place of the large scale battle scenes and mythologies favoured by Lebrun and his followers.

To modern taste, however, Oudry's hunting tapestries cannot recapture the sparkle and vitality of the original paintings. Many of the *Chasses de Louis xv* can still be seen *in situ* in the royal palaces of Versailles, Fontainebleau and Compiègne for which they were intended. One of the first in the series is the *Stag Hunt in the Forest of Fontainebleau* (the tapestry was executed in 1738), a magnificent panoramic view of the hunting field, with the King on his

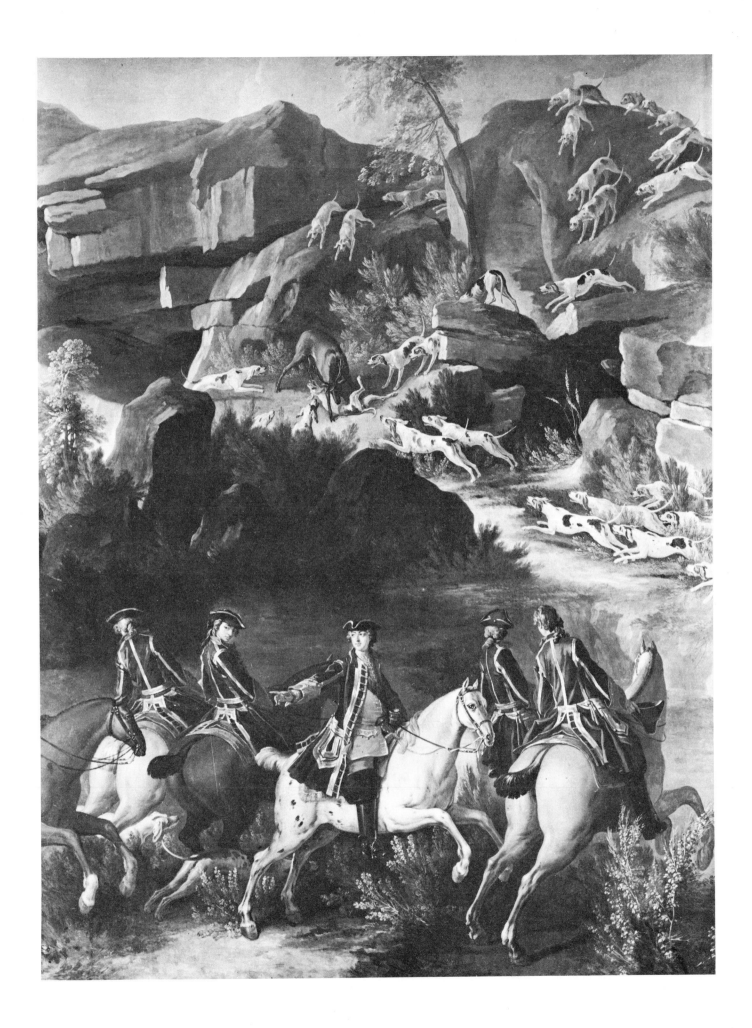

grey horse in the centre, followed by a group of aristocratic young officers; in the background, hounds sweep down from all directions on the wounded stag, trapped between rocks. The painting is remarkable not only for its strong, vigorous colouring in the blues and reds of the hunters' tunics and the tawny brown of the rocks, but also as an accurate piece of landscape painting. It is known that Oudry made several visits to Fontainebleau and took great pains to get the formation of the rocks exactly right. Similarly, in paintings set in the forest of Compiègne such as *The King's Rendezvous at the Well* [*Le Rendez-vous au puits du Roi*] (1735, Fontainebleau), Oudry first made a detailed plan of the forest. This concern for the accurate and truthful observation of landscape makes him—together with Desportes—a pioneer in the naturalistic landscape which was only to come to fruition in the last years of the eighteenth and the early years of the nineteenth centuries. But the hunting scenes are primarily genre paintings of contemporary life, and they preserve an invaluable record of the favourite pursuit of aristocratic French society of the day. Hunting was a form of relaxation for the King and an escape from official duties; but every detail and movement in the scenes show the same concern for hierarchy as all the other activities of the court: it is more the enactment of a ritual or ballet than an outdoor sport. The sense of hierarchy is clearly illustrated in the second of these paintings, *Le Rendez-vous*, in which the comte de Toulouse, the natural son of Louis XIV, respectfully salutes Louis XV with bared head, while the King in the centre is helped into his riding boots by three officers of the royal household.

Apart from the royal hunts, Oudry achieved fame as a painter of animals, both living and dead. These range from gentle and placid creatures, storks, herons and lambs, to ferocious predators like wolves, foxes, vultures and other birds of prey. His art covers almost the entire animal realm and can be seen as the pictorial equivalent of Buffon's *Histoire Naturelle*. But where Buffon treated his animals with a scientific approach, Oudry shows them interlocked in combat, their muscles straining after the elusive prey. As his biographer d'Argenville[9] wrote, Oudry's portrayal of animals shows more skill and intelligence than sentiment. Examples of the predatory type are legion in his work: the pair in the Wallace Collection of a *Dog and Pheasants* (1748) and a *Hawk attacking Partridges*, to name only two, both painted for the château of Montigny-Lencoup (Seine-et-Marne). It is no accident that Oudry made some of the most beautiful illustrations for an edition of La Fontaine's *Fables*.[10] The painter is in close sympathy with the poet's view of the animal kingdom as a microcosm of human behaviour and a direct reflection of the cruelty, folly and vices of mankind. This lyrical but quite unsentimental poet often presents nature red in tooth and claw, but occasionally his pessimism

gives him a moment of respite, and a glimpse is caught of pure, tanquil beauty, as in his version of *The Wolves and the Sheep*[11] (Château-Thierry, Musée La Fontaine) or the *Stag Admiring its own Reflection in a Pond* (Versailles), with its tall, graceful trees and the aqueduct of Arcueil in the background.

Chardin's art is that of a pure painter, with virtually no ideological content and free of all explicit moral or philosophical ideas. Towards the middle of the eighteenth century, however, simultaneously with the return to history painting, this situation changed as content took priority over considerations of style. The French public, swayed by the arguments of writers and satirists, gradually opened its eyes to the abuses of contemporary society and began to expect art to reflect the movement for social reform. Boucher's pastorals and erotic fantasies were rejected not simply as the products of an out-dated style but as emblems of the apparently futile pursuit of leisure and happiness by the aristocracy and court. They represented an immoral way of life, in which love and the marital virtues were sacrificed to pleasure, the rich amused themselves while the poor were oppressed or ignored. Henceforward the middle classes and the provinces were invested with all the virtues which the nobility and the metropolis lacked. One of the curious aspects of this universal change of heart is that, although the impetus came mainly from writers of bourgeois origin like Diderot and Rousseau, the nobility were among the first to espouse the movement for social reform. As a result, philanthropy, conjugal happiness and all the other newly-discovered virtues were adopted with the same fervour which might otherwise have been reserved for some novel fashion. It is a comment on the times that Greuze's most 'middle-class' pictures were most keenly sought by aristocratic collectors.

The intellectual tide on which Greuze and the other eighteenth-century genre painters—notably Jeaurat, Aubry and Lépicié—rose to prominence has already been fully outlined elsewhere,[13] and only the essential need briefly be repeated. The crucial factor was the phenomenon known as '*sensibilité*', a quasi-religious attitude of mind which stressed feeling at the expense of reason, valued goodness of heart more highly than noble deeds and, in general, attempted to substitute a subjective ethos in place of the objective code of behaviour laid down by religion. The movement has its origins in late seventeenth-century France, in Fénelon's gentle brand of mysticism and the doctrines of Quietism. But it gradually lost its religious overtones during the eighteenth century and became associated with the purely secular philosophy of materialism. The chief exponent of '*sensibilité*' was Jean-Jacques Rousseau, perhaps the most influential writer France ever produced, who determined not only the future course of society, but of literature, the arts and much else. The focal point of Rousseau's philosophy is himself:

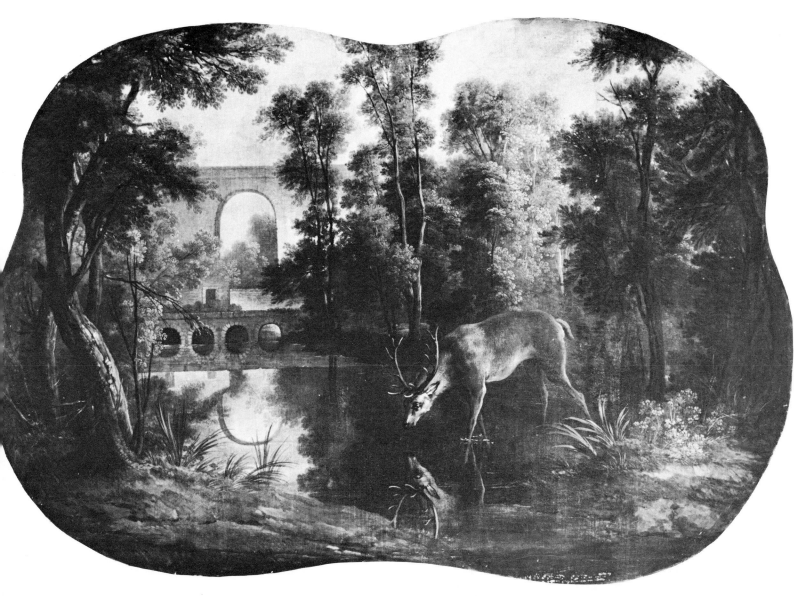

the sanctity of his own ego. On the opening page of his *Confessions* he firmly states his belief in his own unique-ness: '*Je sens mon coeur je connais les hommes. Je ne suis fait comme aucun de ceux que j'ai vus; j'ose croire n'être fait comme aucun de ceux qui existent.*' From this premise all the rest follows. His sentimental effusions over innocent young children, his ecstatic delight in natural scenery in *La Nouvelle Héloise*, and the primitive customs of uncor-rupted humanity, were all so many manifestations of his unique individual personality. In comparison with these virtues, Rousseau's crimes, his perversity and rank ingrat-itude were of little account, for in his own eyes, good intentions and noble enthusiasms outweighed evil actions.

More relevant to the present context is the fact that in his many tracts, from the *Social Contract* to *Emile*, Rous-seau appointed himself chief educator and mentor to his own age. He believed that eighteenth-century society was rotten to the core, rotten because it was based on evil institutions which had corrupted the fundamental good-ness of humanity. The arts, too, had been corrupted by the hedonistic ethos of an over-ripe state of civilization. In his epoch-making *Discours sur les Sciences et les Arts* (1750) Rousseau declaimed: 'Our gardens are adorned with statues and our galleries with paintings. What do you imagine these masterpieces of art represent, exposed to public admiration? The defenders of the nation? Or those even greater men who have enriched it by their virtues? No. They are images of all the vagaries of the heart and reason, carefully extracted from classical mythology and offered at an early age to the curiosity of our children, no doubt so that they should have before their eyes models of bad behaviour even before they can read!' Only by making a clean sweep of social conventions, by the 'return to nature' in place of the sophistication and artificial pleasures of society, could men hope to redeem themselves in the late eighteenth century. This is precisely what many of them did, from Marie-Antoinette and her courtiers downwards. Under Rousseau's influence, and especially following the publication of his didactic novel *Emile* (1762) on the education of children, nobles and great ladies began to disavow their own class and to adopt the

154. Oudry,
Stag Admiring its own Reflection in a Pond,
98 × 140 cm.
Château de Versailles.
Photo: Musées Nationaux, Paris

[127]

trappings of a simpler life, retreating to the country from the evils of the metropolis, breast-feeding their children, behaving kindly towards their servants and even practising conjugal fidelity. Simplicity had once again become fashionable, in the inevitable reaction against the over-civilized over-sophisticated phase of the Rococo. To this extent, Rousseau can claim to be the chief agent in the rehabilitation of those middle-class virtues which were to be so self-consciously present in the next generation of genre painters.

The other chief factor in this development was the revival of the theatre in the form known as the '*drame bourgeois*', or '*comédie larmoyante*'. As its title implies, this was a deliberately middle-class type of theatre aimed at a middle-class audience, democratic in style and content and with themes chosen from ordinary family life to illustrate the domestic virtues.

It was a conscious rejection of the high-flown classical tragedy (based on the Aristotelian unities and written in Alexandrine verse) still practised in the eighteenth century by Voltaire. Instead of heroic deeds performed by kings and queens in remote or exotic countries, the *drame bourgeois* attempted to portray the situations of everyday life in a declamatory but prosaic diction considered more accessible to the general public. At the same time the theatre became the pretext for copious weeping and tears, and for many writers like Greuze's friend, the radical playwright L. S. Mercier, the degree of emotion aroused in the spectator became the sole criterion of a play: 'What is dramatic art?' he asks rhetorically. 'It is the art which, above all others, exercises our *sensibilité* . . . teaches us to be decent and virtuous . . . no appeal to the soul of man by impressions of pity and compassion can be too strong.'[14] The theory underlying this new school of drama was given its most explicit formulation by the chief instigator of the great dictionary, *L'Encyclopédie*, Denis Diderot, who also played an active part in the evolution of French painting at this time with his famous *Salons*. In three lengthy tracts, *Entretiens sur le Fils Naturel* (1757), *De la Poésie Dramatique* (1758) and the *Paradoxe sur le Comédien* (1773) Diderot argued his case for the domestic bourgeois drama, in which the tragic element was to consist in such commonplace misfortunes as sons' ingratitude towards their parents, fathers' rejection of their children, and the fatal results of drunkenness, vice and passion of all kinds. The theatre was to become a 'school of morals', designed to move, edify and instruct the spectator. From this rather unpromising recipe, Diderot constructed his own attempts at drama, *Le Fils Naturel* (1757) and *Le Père de Famille* (1758), and it is hardly surprising that they had very little success.

This formula, which was virtually impossible to re-enact on the stage, proved an immense asset to painting, for when translated into the form of '*tableaux vivants*', it offered a clear, comprehensible image which the public could take in at a glance. Thus the close alliance between painting and the theatre which Watteau had already established early in the century was cemented and deliberately fostered by Diderot, Greuze and their direct descendant, Jacques-Louis David. Henceforward painting became consciously dramatic and theatrical in effect, and can frequently only be understood by reference to some obscure play. This interdependence of the two arts—which was also responsible for the exaggerated declamatory nature of French painting of the later years—would certainly have been applauded by Diderot; in fact it was very largely his personal creation: '*O quel bien il en reviendrait aux hommes, si tous les arts d'imitation se proposaient un objet commun, et encouraient un jour avec les lois pour nous faire aimer la vertu et hair le vice!*'[15]

Jean-Baptiste Greuze (1725–1805) was the painter who put these doctrines into practice, and often literally took his cue from Diderot. Partly for this reason his reputation has suffered more than any other single eighteenth-century painter, with the exception of Boucher. If he is known to the general public at all, it is on the strength of his notoriously ambivalent female figures with titles like *Virtue Stumbling* [*La Vertu chancelante*] (Munich, Alte Pinakothek), intended to pay tribute to virtue but whose demeanour is anything but virtuous. These are the kind of pictures which nineteenth-century collectors most avidly sought and which are still well represented in English private collections, like those at Waddesdon Manor and the Wallace Collection. In stuffy Second-Empire apartments in Paris it was common to find dubious Greuzes of scantily-dressed vestal virgins, whose voluptuous charms fitted in well with the sybaritic atmosphere of the 1850s. But in his own lifetime Greuze was treated with the utmost respect, bordering on veneration. His contemporaries regarded him as a serious moralist with a profound understanding of the human heart and its passions. Uncritical as they were, carried along on the tide of *sensibilité*, they took Greuze's pictures at face value as illustrations of the new morality in action.

Greuze's modest provincial background equipped him well for his chosen role. Born in 1725 in the small Burgundian town of Tournus, he first studied under a little-known painter, Charles Grandon, in Lyon. It was during his stay in Grandon's studio that Greuze conceived of and painted *The Bible Reading* [*La Lecture de la Bible*] (private collection), the picture which won him instant fame when it was shown in Paris at the Salon of 1755. He had hit on the formula, a mixture of homely virtue and sentimental piety, which he was able to repeat time and again throughout his career without tiring his public. This was exactly what the Parisians were looking for: an authentic provincial setting, based on Greuze's home country, combined with a serious, edifying theme,

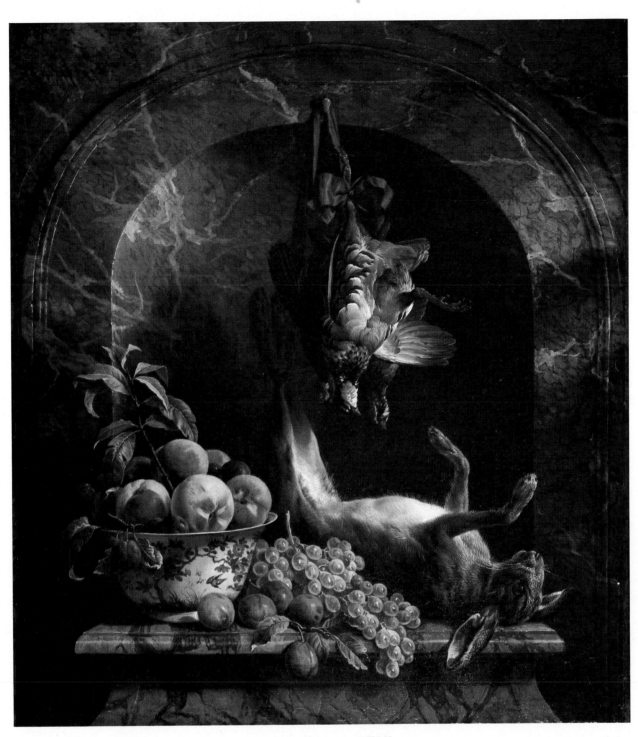

PLATE 15. Desportes, *Still Life*,

109 × 96 cm. Musée des Beaux-Arts, Le Havre. Photo: Photorama

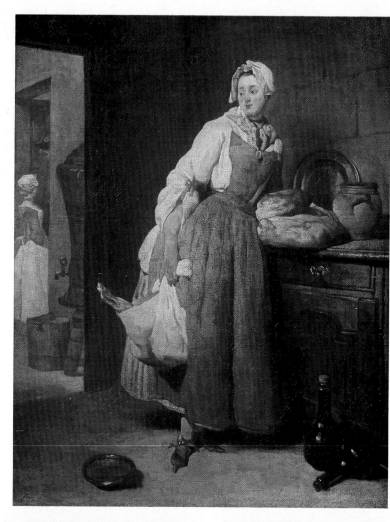

Plate 16
Chardin,
The Housewife,
47 × 38 cm.
Musée du Louvre.
Photo: Musées Nationaux, Paris

Plate 17
Chardin,
The Young Artist,
80 × 65 cm.
Musée du Louvre.
Photo: Musées Nationaux, Paris

Plate 18
Greuze,
The Schoolboy,
62 × 48 cm.
National Gallery of Scotland,
Edinburgh

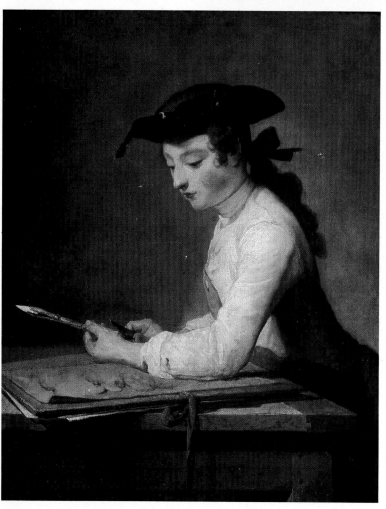

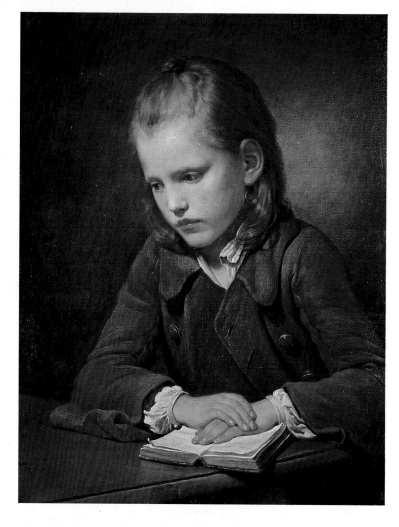

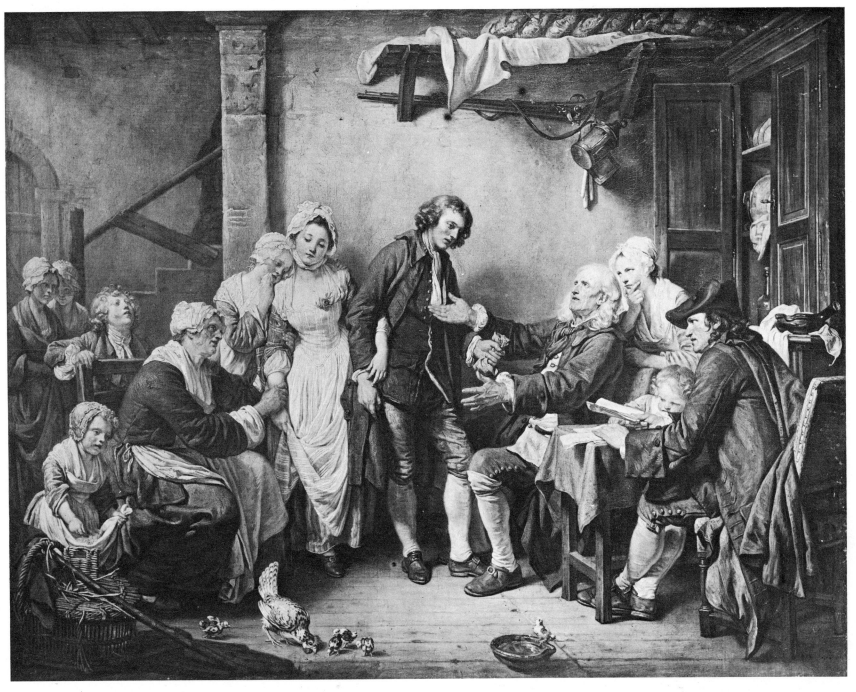

in complete contrast to Boucher's fake shepherds and pastorals. In the early 1750s, he went to Paris and enrolled as a student at the Academy, where he appears to have had little success. His path to fame was opened up, not by the Academy, but by the influential collector La Live de Jully (who bought *The Bible Reading*), and another amateur and patron, the Abbé Gougenot, who at his own expense took Greuze on a long trip to Italy in 1755 and gave him the opportunity to study the Old Masters. But, apart from Correggio and Guido Reni, Greuze seems to have been unimpressed by what he saw in Italy. He remained loyal to the Dutch genre painters, notably Teniers and Wouwermans, who usually provided the models for his own genre scenes.

It was only at the Salon of 1761 that Greuze began to attract real public attention with the exhibition of his *The Village Bride*. The painting shows a venerable white-haired old man blessing his daughter and son-in-law before a notary and the assembled family; in the foreground, a hen and her young brood provide another illustration of the family theme. The background, compared with the picturesque jumble in *The Bible Reading*, is neat and spruce, and suggests a slight rise in the social scale, from the peasant family of the first picture to the provincial *petite bourgeoisie* in which Greuze was most at home. As many critics noted, Greuze surpassed himself in the pretty figure of the bride (and in the even more attractive preparatory drawing in the museum of Châlon-

155. Greuze, *The Village Bride*,

92 × 117 cm.
Musée de Louvre
The Mansell Collection, London

[129]

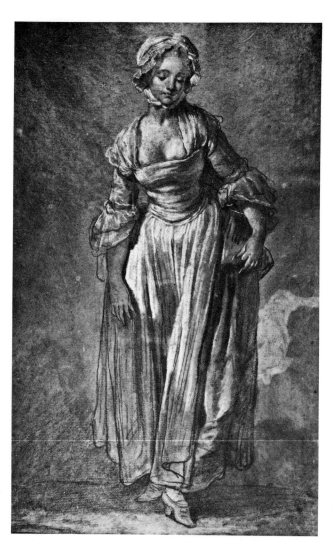

almost have been conceived as an illustration for one of Diderot's bourgeois tragedies. Diderot, as was to be expected, was among the first to welcome the picture. He hailed the artist with the words: '*C'est vraiment là mon homme que ce Greuze ... D'abord le genre me plaît; c'est la peinture morale.*'[16] Pursuing this vein, Greuze's career as a moral painter reached its climax at the Salon of 1765 where, apart from several first-class portraits (those of Wille and Watelet in particular) and his usual girls mourning dead birds, he exhibited the preliminary sketches for *The Father's Malediction* and *The Punished Son* (both now in Lille), two of his most important compositions, completed in 1777 and 1778 respectively. This last pair of paintings (in the Louvre) can be read as the final tragic chapter in Greuze's family chronicle; unlike their predecessor, *The Village Bride*, they illustrate the evil results of family strife. At the same time they provide a clear measure of the evolution in the artist's style. The figures have been stiffened and straightened out into a two-dimensional plane; the colours have become matt and lifeless; and the gestures and expressions are still more theatrical than before. Moreover, in the misguided attempt to raise domestic genre to the dignity of history painting, Greuze has deliberately adopted Poussinesque compositions, in which the figures, clothed in classical drapery, declaim and gesticulate according to the rules of classical tragedy.

Despite the success of these and similar paintings, Greuze was still unsatisfied in his overriding ambition, which was to be a serious history painter. This ambition was to be the cause of the one great fiasco in his career, which he never managed to live down. He had been admitted to the Academy in 1755, but only as a temporary member. He had still to produce his '*morceau de réception*' to entitle him to full membership. The subject he chose to offer in 1769 was *Septimus Severus and Caracalla*, a self-conscious and exaggerated piece in the neo-Poussinesque style which he had recently espoused, showing the Roman emperor reproaching his son with an attempt to assassinate him. The work is composed in the most rigid, linear manner against an austere classical background of drapery and fluted columns. The effect is undeniably lifeless and the characters' faces and expressions weak in the extreme; and there is a fatal lack of drama in what is supposed to be a highly dramatic scene; contemporary critics could not resist making jocular references to the Paralytic rising from his bed to reprimand his miscreant of a son. When submitted to the Academy for its approval, the painting was a total failure. Greuze was admitted to full membership but, according to Diderot's account of the event, only as a genre painter.[17] He had thus failed in his lifelong ambition to be recognized as a history painter. As a result, he bore the Academy a lasting grudge, refusing to exhibit at the

sur-Saône), with her slender waist and modest demeanour. Diderot was delighted when he saw the painting at the Salon of 1761, as it provided the exact equivalent in painting to his own dramatic theory. He accordingly awarded Greuze full marks for *sensibilité* and good conduct. It was shortly before the appearance of this picture, probably in 1759, that Diderot met Greuze through Madame Geoffrin. This encounter was to be crucial in the artist's career, for with the support of Diderot's prolix and inflammatory prose, Greuze began to take himself more seriously. He was not content to be a simple painter with a taste for homely subjects, but determined to become a public moralist, with all the dour lack of humour which that task implies.

From 1761 until 1765 Greuze continued in this new direction, to the ever-increasing applause of the public and the critics. His *Paralytic Man tended by his Children* (Leningrad, Hermitage), exhibited in 1763, echoes *The Village Bride* in setting, overall composition, and especially the aged father figure on his sick-bed surrounded by his devoted family. But there is already a strong suggestion of self-conscious pathos in the strained gestures and expressions of the actors—for this is pure theatre and might

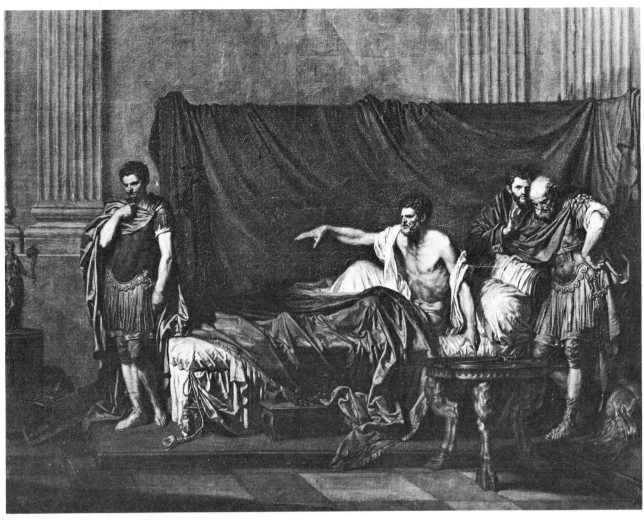

157. Greuze,
Septimus Severus and Caracalla,
124 × 160 cm.
Musée du Louvre.
Photo: Giraudon

official Salon and preferring to show his paintings in his own studio or at the rival exhibitons organized by Pahin de la Blancherie. He increasingly turned to private patrons, especially the Russian nobility, for whom he painted many works in his favourite vein, young girls, vestal virgins and the occasional superb portrait, like *The Schoolboy* in Edinburgh [Plate 18]. But he rapidly found himself overtaken by a younger generation of genre paint٭ ers and, through his refusal to exhibit at the Salon, he cut himself off from his former public. The last years of his life, which stretched beyond the Revolution until 1805, were lonely and unhappy, spent in obscurity and penury. This end to Greuze's career is sadly ironic. For though his *Severus and Caracalla* was an artistic failure, it marked a pioneering step in the evolution of neo٭classicism which was soon to be carried to its logical conclusion by J.٭ L. David in such works as the *Oath of the Horatii* (1785) and the *Lictors bringing Brutus the Bodies of his Sons* (1789), both of which owe so much to Greuze's example.

To consign Greuze's portraits to a brief postscript is to do them an injustice, for, while they stand apart from his official career, they are among his most attractive paint٭ ings. Moreover, it needs no effort of the historical imagi٭ nation to enjoy them, as they are generally simple, direct

Plate 18
faces page 129

and sincere. This is especially true of that marvellously rugged portrait of the artist's father٭in٭law, *Babuti* (Paris, private collection), shown at the Salon of 1759, closely inspired by Rembrandt's effigies of old men; and of its twin, the portrait of Greuze's friend, the engraver *J.٭G. Wille* (1765, Paris, Musée Jacquemart٭André). Both convey the pride and integrity of professional men, with٭ out pretensions or frills. His portraits of women are more decorative and often equivocal in intent, as he specialized in pictures of nubile adolescent girls who appeared to have recently lost, or were about to lose, their virginity. This is the plain meaning of a painting like *The Broken Vessel* (1773) in the Louvre, an allegory of lost innocence. But many of Greuze's female portraits have no such *double entente*. With great delicacy and softness of touch, they simply portray pretty women like the *Madame de Porcin* in Angers, with her little lap dog and bouquet of flowers, or the actress *Sophie Arnould* in the Wallace Collection, nonchalantly posed in a broad٭brimmed hat *à l'anglaise*. *The Milkmaid*, in the Louvre, from the 1780s, is painted in a rather bright, glossy style reminiscent of Madame Vigée٭ Lebrun, exactly the type of girl who might have served in Marie٭Antoinette's model dairy at Versailles.

Greuze had many imitators in France and in England,

[131]

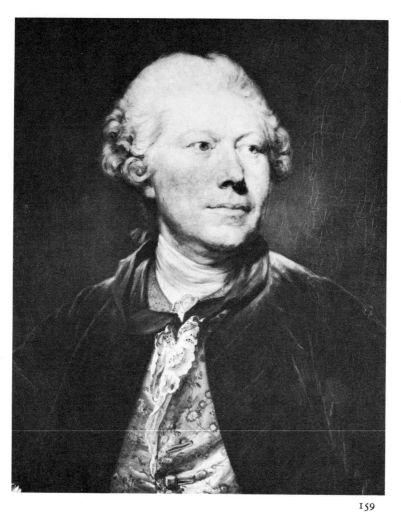

159

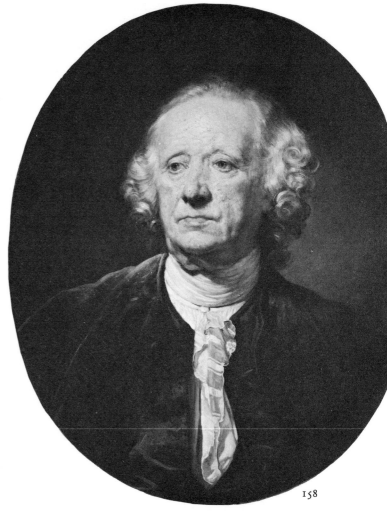

158

where his influence rapidly spread through the medium of engravings and was soon reflected in the paintings of Francis Wheatley. In France, a handful of genre painters rose with their own distinctive talent. The eldest of these was Etienne Jeaurat[18] (1699–1789), who began his career as a pupil of Nicolas Vleughels in Rome and painted historical and mythological subjects. Jeaurat is chiefly known today, however, for his street scenes of popular subjects which go back directly to the genre inaugurated by Gillot and Watteau. After painting some delightful illustrations to La Fontaine (for example *Brother Philip's Geese*, 1739, formerly Revd. H. A. Keates Collection) and modest genre scenes like *Fortune and the Baby* (formerly Doucet collection) on the theme of rich young parents leaving their baby at a peasant cottage, Jeaurat turned in the late 1740s to the depiction of contemporary social reality on a broad scale. He already belonged to a circle of satirical writers and actors, men like Piron, Collé and Vadé, whose realistic and frequently salacious stories clearly influenced his own portrayal of the Parisian populace. He was no doubt further prompted in this direction by the example of Hogarth, who visited Paris in 1743, and the rapid diffusion of the *Rake's*

Progress, Marriage à la Mode and the rest of the series in numerous prints. Hogarth's popularity, in fact, coincided with the growing clamour for social reform in France. The public showed increasing concern over the degradation of the urban population, with beggary, theft and prostitution rampant in the streets of Paris. This was the background to Jeaurat's best known street scenes, painted in the 1750s, such as *The Removal of Prostitutes to Prison* (Salon of 1757, Musée Carnavalet), showing a waggonload of prostitutes being carried off the streets to prison, taunting and shouting at bystanders on their way. Other paintings of street scenes include the *Marché des Innocents*, the *Place Maubert*, a *Paris Street Scene* (1754) *The Arrest of Disorderly Persons* and *The Painter's Removal* (all in the collection of Earl Beauchamp). The *Street Scene*, a quarrel between two women, is strongly reminiscent of Gillot's *Two Carriages* with its background of tall houses and narrow streets. These scenes portray in a starkly realistic style the seamier side of Parisian life, the world of actors, charlatans, prostitutes and stall-holders, who until this time figured very rarely in French art of the period. They form the most valuable pictorial record of urban life in mid-eighteenth-century France, and set an example

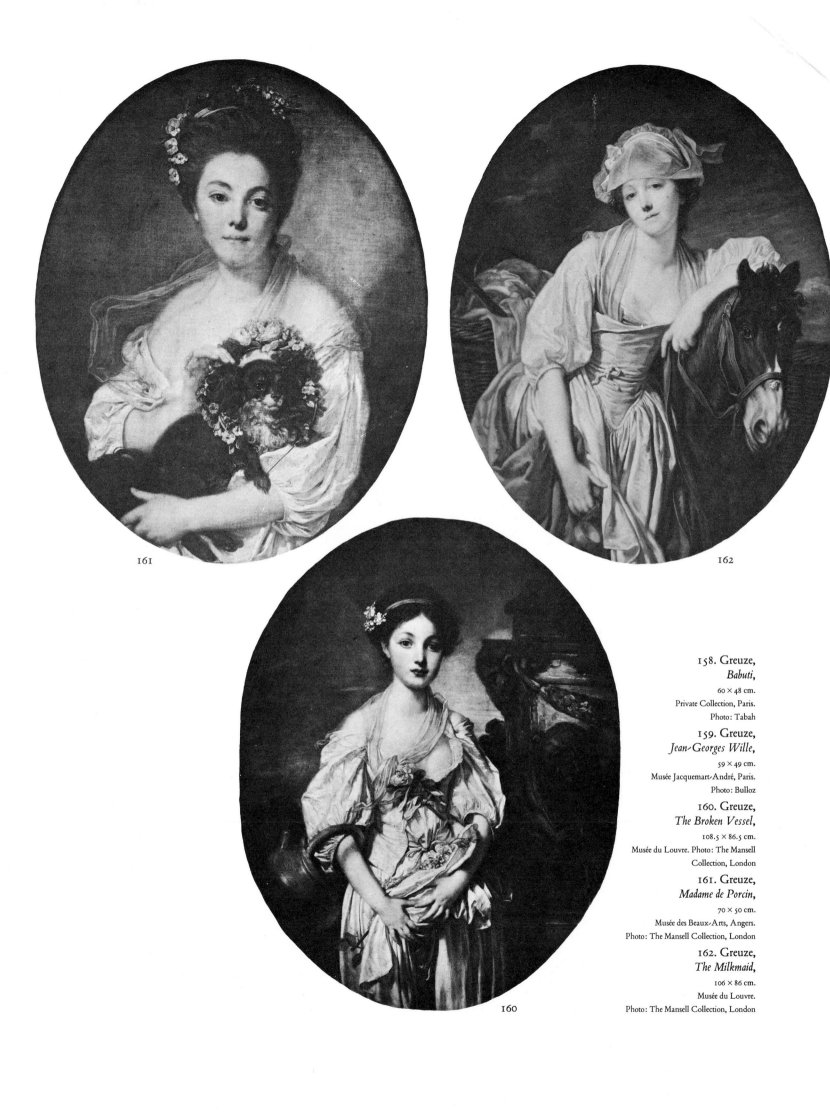

158. Greuze,
Babuti,
60 × 48 cm.
Private Collection, Paris.
Photo: Tabah

159. Greuze,
Jean-Georges Wille,
59 × 49 cm.
Musée Jacquemart-André, Paris.
Photo: Bulloz

160. Greuze,
The Broken Vessel,
108.5 × 86.5 cm.
Musée du Louvre. Photo: The Mansell
Collection, London

161. Greuze,
Madame de Porcin,
70 × 50 cm.
Musée des Beaux-Arts, Angers.
Photo: The Mansell Collection, London

162. Greuze,
The Milkmaid,
106 × 86 cm.
Musée du Louvre.
Photo: The Mansell Collection, London

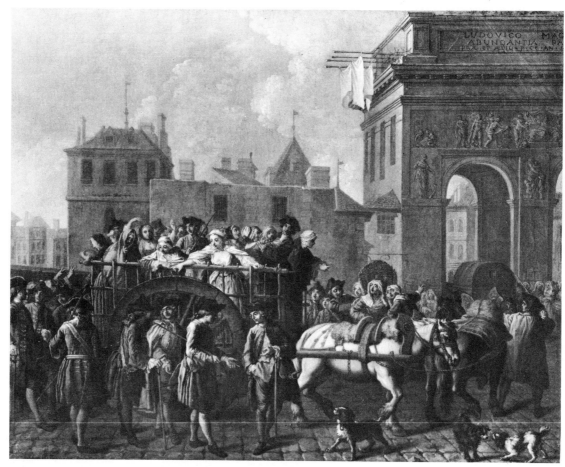

163. Jeaurat,
*The Removal of Prostitutes
to Prison,*
65 × 82 cm.
Musée Carnavalet, Paris.
Photo: Lauros-Giraudon

164. Lépicié,
Fanchon Rising in the Morning,
72 × 92 cm.
Hôtel Sandelin, St Omer.
Photo: The Mansell Collection

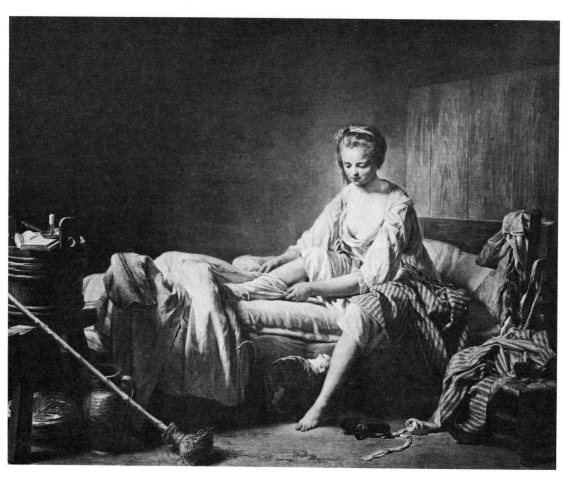

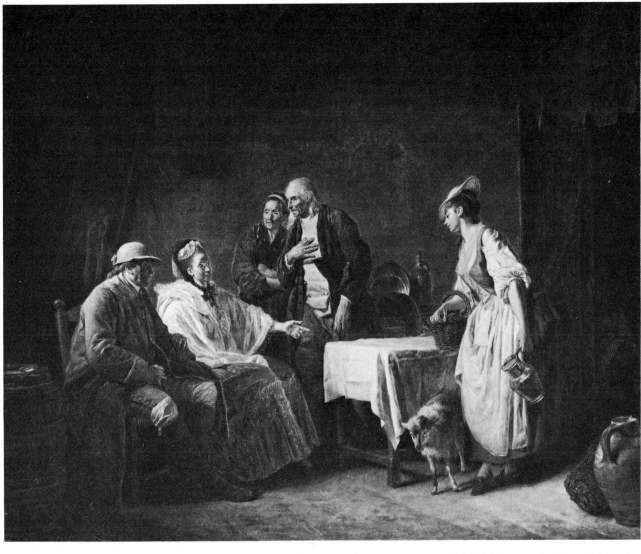

165. Aubry,
The Shepherdess of the Alps,
9.6 × 11.6 cm.
Gift of Mr & Mrs Whitcom,
Detroit Institute of Arts

which was soon to be followed up by Demachy, Debucourt and, later, by Boilly in his scenes of Paris during the Revolution.

Two further artists who followed closely in the wake of Greuze's popularity were Lépicié and Aubry, and both produced works of great charm. Nicolas-Bernard Lépicié (1735–1784) is chiefly known today for his scenes of poachers, peasants' kitchens, market scenes and especially his most ambitious paintings, the *Customs-House Interior* (Salon of 1775) and the *Market-hall Interior* (Salon of 1779). During his own lifetime he was frequently compared with Teniers, and was one of the most highly praised genre painters of the day. He began his career as an engraver in the steps of his father, then turned to painting under the guidance of Carle Vanloo, with whose help he became an academician in 1764 on the presentation of his *William the Conqueror* (Caen, Abbaye aux Hommes). Like Greuze and so many others of his generation, Lépicié's supreme ambition was to be recognised as a history painter and, perhaps unfortunately, he devoted a great deal of time and effort to this aim. Critics were on the whole well-disposed towards him, but several, including Bachaumont, regretted his higher aspirations: '*Lépicié se fait toujours goûter quand il ne veut pas s'élever au genre de l'histoire.*'[19] This verdict has been ratified by posterity, for Lépicié is appreciated today not for his history paintings but for his genre scenes of domestic interiors, such as the *Carpenter's Family* and the *Peasant Family* (1777, formerly at Mentmore). These scenes from the daily lives of peasants and artisans are close enough to recall Chardin and Greuze, but they are treated with a very different kind of casual elegance and picturesque disarray. Their tone is generally subdued, painted in soft browns and greys and with a slightly flickering touch. Lépicié is perhaps even more attractive in his paintings of young girls, like the *Fanchon Rising in the Morning* (Musée de Saint-Omer) and the *Young Girl Reading*, revealing the artist's gentle vein of sensibility which made him popular in his own time but which caused him such personal suffering. Lépicié was a complex character, typical of the unsettled mood of late eighteenth-century France. Of a gentle, philanthropic nature, he gave most of his money to the poor and ended his life in a fever of devotional piety and spirit of mortification.

[135]

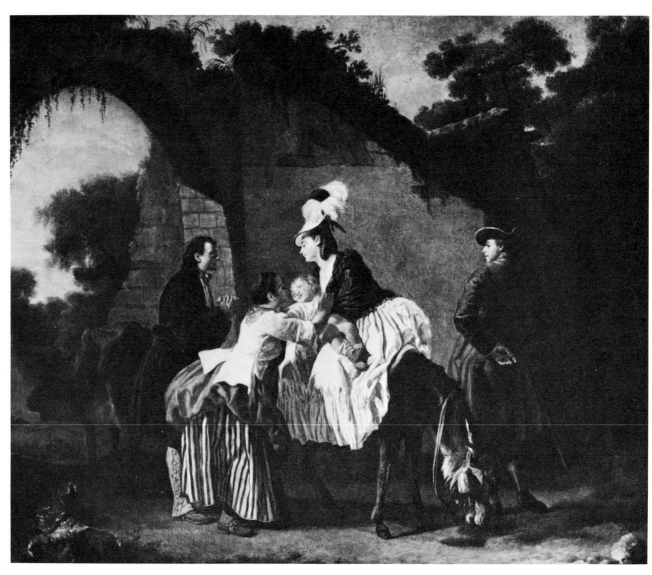

Etienne Aubry (1745–1781) also worked in the vein of Greuzian sensibility and domestic virtue. He is one of the more talented minor masters of the late eighteenth century and his career certainly repays closer study. A pupil of Sylvestre and Vien, like Lépicié, he had high hopes of becoming a well-known history painter. With the strong support of d'Angiviller, he went to study in Rome in 1777, but left suddenly in 1780, realizing that his real gifts lay elsewhere. From then on, he devoted himself to genre pictures which he exhibited regularly at the Salon between 1775 and 1779. The best known of these is *The Shepherdess of the Alps* (Salon of 1775, Detroit),[20] the scene from Marmontel's short story in which the shepherdess, a disguised young noblewoman, is introduced to an Italian count and his wife, who are so struck by the girl's beauty that when they tell their son of their encounter, he falls in love with her instantly. The episode is treated by Aubry with charm, refinement and discreet realism; the figures speak and act clearly, but without undue emphasis. The same message of homely virtue and kindheartedness is conveyed in several other paintings from the 1770s, all with the same modest understatement, as, for example, in *Paternal Love* (1775) in the Barber Institute, Birmingham, and in the *First Lesson in Brotherly Love* (Kansas City), where a new-born is introduced to his little brother in the presence of his parents and grandparents. In contrast to this last work is *Farewell to the Nurse* (Salon of 1777, Williamstown, Mass., Clark Institute), which makes an explicit condemnation of the practice of farming out children to foster parents. A rich young woman and her husband come to reclaim their child from a peasant couple, who have obviously shown the baby more affection than its real parents; the father, meanwhile, stands back impatiently. The painting is the visible equivalent of the theories propounded by Rousseau's *Émile* and provides a fitting conclusion to the theme of parents, children and family life in eighteenth-century France.

8 : From the Pastoral to the Sublime

'Il y a de l'idylle dans la brise et de l'utopie dans le vent.'[1]

❦

Throughout the eighteenth century the attitude of Frenchmen towards landscape and nature underwent a gradual but profound change. For an understanding of the development of landscape painting, therefore, we must first look briefly at the background of social and literary currents which, as so often in France, find an accurate reflection in the visual arts of the time. In their increasing awareness of nature and the beauties of the countryside, painters were often merely following the cue of writers and social commentators, who were the first to record such changes of public attitude.[2] The seventeenth century had largely been a metropolitan and urban civilization, based on Versailles and the court. Its ideal 'landscape' was the Le Nôtre park, a rectilinear pattern of canals, fountains, *parterres* and statuary. This was a complex and highly organised creation in which nothing was left to chance, and it represented the triumph of art over nature. Seventeenthcentury writers were primarily interested in mankind and the operations of the human heart; if they showed any interest in natural scenery, as they occasionally did (as, for example, when Madame de Sévigné, author of letters to her daughter and others, writes about her favourite avenue of trees at Les Rochers) this was usually only a brief, passing allusion. Nature was firmly relegated to the role of backcloth and enjoyed virtually no independent existence. Similarly, the great painters of the century, Poussin and Claude Lorrain, were not 'pure' landscape artists—except perhaps in some of their drawings—but painters in the classical tradition, who looked to nature (usually idealized and carefully chosen views of Italy) to provide a suitably dignified background for their noble and heroic themes from ancient mythology.

Alongside the humanistic tradition in seventeenthcentury art and literature, there also ran a persistent strain of nostalgia for the pastoral idyll. This strand, typified by the pastoral poetry of Racan and the interminable novel *L'Astrée*, by Honoré d'Urfé, about the loves of shepherds and shepherdesses, carried on well into the eighteenth century and may well have contributed to the evolution of landscape art. With its emphasis on peace and rural solitude, this literary form corresponded closely to the mood of Watteau's *fêtes galantes*; they shared the same longing for some longlost golden age, a world of innocence and beauty. The parallel between Watteau and the pastoral romance was made explicitly by Horace Walpole: 'The genius of Watteau resembled that of his countryman d'Urfé; the one drew and the other wrote of imaginary nymphs and swains, and described a kind of

impossible pastoral, a rural life led by those opposites of rural simplicity, people of fashion and rank.'[3] Walpole clearly perceived the element of makebelieve in this tradition. Nature, in the shape of gracefullydrawn avenues of trees and welltended swards of grass, was merely a convenient haven, a retreat for weary courtiers and their bored mistresses. This same pastoral theme was continued in the early eighteenth century by Fontenelle, the prolific author of eclogues and pastoral romances, and it survived with very little change in the paintings of Boucher and his many followers. But by the 1750s, when Boucher was still actively turning out his amorous shepherds and shepherdesses, the genre was definitely under attack and considered outmoded. The time was overripe for a change. The public demanded a more authentic rusticity in painting and literature, one which expressed a genuine sympathy with the countryside and countrymen.

The change, however, was slow and imperceptible. The French had been so deeply conditioned by their own cultural tradition that it took them a long time before they could look at nature with fresh eyes and discover beauty in a stretch of river, a clump of trees or a group of cottages. Urban life, with the attractions of society and the arts, had always seemed to them preferable to the arid wastes of the countryside, without company or amusement. As a result, the French rural economy was in a deplorable state and agriculture largely neglected, with landowners preferring to live in Paris or Versailles. Shortly after 1750, however, there were signs of a change of heart, as people tired of the metropolis and began to yearn for the rural retreat. Once again, rustic simplicity returned to fashion, at about the same time as did family life and domestic virtue. Under the impetus of Quesnay, Turgot and the physiocrats, agriculture became a topical subject, hotly debated from Paris to the remotest provincial towns. The movement away from urban life had reached such proportions that in October 1750 the Abbé Raynal commented: '*Tout le monde est maintenant à la campagne.*'[4] This new passion for the countryside was not confined to the upper classes of society as before. Whereas Watteau's paintings and the literary tradition from which they sprang had depended largely on the existence of a leisured aristocracy, the new cult of nature was far more democratic in its appeal. Nobles and financiers spent long periods on their country estates from choice, not necessity, and devoted themselves to agriculture; bourgeois from Paris and the cities bought villas in the surrounding countryside, poets retreated to their *ermitages*, and even the work

ing population flocked to the more accessible corners of the Ile de France. The journals of contemporary writers are full of rhapsodic descriptions of walks in the countryside, delightful views of rivers and fields, and the joys of nature. The pastoral descriptive poetry of Saint-Lambert and Delille never failed to delight its public, despite its stilted phraseology and monotonous rhythms. Painters too were caught up in this contemporary craze. Boucher and Oudry made some of their most sensitive sketches in the park of Arcueil, on the Marne; Hubert Robert, Fragonard and Demarne delighted in a day's excursion to the countryside just outside Paris; while artists like Moreau l'Aîné, Noël and Houël depicted the broad horizons and gentle luminous atmosphere of the Île de France with all the charm and the freshness of a new discovery.

The new cult of nature was, of course, only another aspect of the profound change in attitudes caused by

167 Gravelot, *Love's First Kiss*, illustration from Rousseau, *La Nouvelle Heloise*. 1764 edition, Paris. Photo: The British Library Board

sensibilité. The countryside became associated in people's minds with goodness and virtue, just as the town became synonymous with the vices of corrupt civilisation. The author chiefly responsible for this misleading but highly influential equation was again Jean-Jacques Rousseau, who perhaps did more than anyone else to unleash the passion for nature among his countrymen with the publication in 1761 of his great book *La Nouvelle Héloïse*. With

his ecstatic descriptions of the mountainous Swiss scenery in the pays de Vaud on Lake Geneva, the setting of the second half of the novel, Rousseau set out to demonstrate his belief in the harmony of man and nature. The good life, in his view, was only possible on the basis of a strict, frugal rural economy and in peaceful conditions far removed from the corrosive influence of towns. The most influential section of the entire book, and one which almost certainly affected the course of landscape painting, is the part in which Rousseau defines his ideal garden, the Élisée, in Book IV, Letter XI, as a kind of cultivated wilderness, in which all sorts of herbs and wild flowers are allowed to grow in random profusion. The garden is self-contained and private, cut off from the rest of the world by high walls, and designed to induce '*la rêverie agréable*'. Urns, statuary, straight lines and artefacts of any kind are deliberately excluded in the attempt to create the impression of spontaneity and freedom – in striking contrast to Voltaire's more old-fashioned garden layout at Ferney, with its formal *parterres* and avenues.[5] For Rousseau, the garden and landscape in general was merely the extension of his ideas on the relationship between man and society. It was designed to reflect his own deep spiritual need for a place of calm, solitary meditation, where the imagination was free to roam at will, unconstrained by social obligations. Many of these and similar ideas found direct expression in the picturesque French gardens of the time[6] – notably Ermenonville, Méréville and Watelet's Moulin-Joli – and in the practice of the leading landscape artists of the late eighteenth century.

The one artist who most closely reflects this new mood of spontaneity and freedom was Jean-Honoré Fragonard (1732–1806). Though trained in the Rococo style by Boucher, Fragonard's art has an exuberance, vitality and imaginative scope which make him unique among eighteenth-century painters. He is, as the Goncourt brothers wrote, the only true poet of the century apart from Watteau, with a lyrical and often epic imagination which broke far beyond the confines of his early Rococo training. Fragonard was Watteau's true spiritual heir, for in his great decorative park scenes of the 1770s, such as *The Fête at Saint Cloud*, he took the *fête galante* and translated it into a more modern contemporary idiom. Like his Flemish predecessor, Fragonard's art is a compound of poetic fantasy and realistic observation. He is also one of the most elusive of artists and the most difficult to define, as much of his genius consists of a Protean adaptability, which enabled him to switch styles and subjects almost at will, with a blithe disregard for consistency or the rules. Unlike many eighteenth-century artists, he also possessed a technique equal to his imaginative fervour. This is reflected in an incredible virtuosity of handling, ranging from the cool transparent pastels of the early works, the vibrant shreds of pure colour in the *Fancy Portraits*, to the glossy

sheen of the late allegorical pictures. In this range of style, as well as the variety of subjects encompassed by his art, Fragonard can claim to be one of the most creative and original artists of his time and, in certain respects, a forerunner of the Romantic movement.

Fragonard was born in Grasse, a small town in Provence, set among lavender, olive groves and cypresses. This Mediterranean background was undoubtedly a key factor in his visual imagination and contributed to his love of strong, bright colours and sense of movement. From there he inherited 'an almost Italian temperament and a French mind',[7] in the words of the Goncourts, which placed him in close sympathy with the Italian poets, Tasso and Ariosto, who were to inspire some of his finest works. In 1738, however, he moved with his family to Paris. He first began his art studies under Boucher, whose studio he entered in 1747. But Boucher, apparently too preoccupied with his own reputation, had no time for an untrained novice and sent him on to Chardin. He appears to have had little luck there either, as Chardin's slow laborious teaching methods were not well suited to his restless nature. Sometime around 1748 Boucher took Fragonard back into his studio and from that moment on his career began in earnest. He rapidly assimilated his master's style, as can be seen from the charming pair of early paintings, the See-Saw (Amsterdam, Thyssen-Bornemisza Collection) and Blind Man's Buff (Toledo, Ohio), both of c. 1750–52, which so accurately reproduce Boucher's light palette and smoky-grey colours that they were mistaken by the Goncourt brothers as pastiches after Boucher. But there is already a significant difference between pupil and master, a greater liveliness and zest in the handling, a springy elasticity in the bough of the tree in the See-Saw. All these characteristics soon became more marked as Fragonard quickly outstripped Boucher, making him appear staid and old-fashioned by comparison. Moveover, he was not slow to see that the French public was already tired of Boucher's genteel pastorals and fake shepherdesses. He was almost ready to step into the breach and to offer something more exciting, novel and dramatic.

Fragonard submitted to the usual process of academic training. In 1752, at Boucher's instigation, he entered the competition for the prix de Rome, offering the Biblical subject of Jeroboam Sacrificing to the Golden Calf (Ecole des Beaux-Arts) and, with remarkable ease, carried off first prize. This was Fragonard's first essay in the grand historical manner, which though uncongenial to him set him well on the path to success. Before going to Rome, however, he had to spend four years in preparation at the École Royale des Elèves Protégés and it was there that he painted the recently-discovered Psyche Showing her Sisters Presents from Cupid (1753–4, London National Gallery). In 1756 he finally set out for the Ecole de Rome, which was under the directorship of Natoire. Although he could

hardly have wished for a more enlightened and easy-going tutor, and one who almost certainly encouraged him to sketch from nature in the countryside surrounding Rome, Fragonard was restless under the academic routine imposed on the School by Marigny and the French authorities in Paris. In 1758, Fragonard was making good progress on a copy after Pietro da Cortona's St Paul recovering his sight in the Capuchin church. But most of what he saw in Rome – Raphael, Michelangelo and the High Renaissance – left him cold, as he sensed that their austerity and preoccupation with formal design went counter to his own instinctive love of movement and colour. It was with relief that, on a journey two years later to Naples,[8] he discovered the works of Solimena and Luca Giordano, both fa presto artists whose bravura held far more appeal for a man of his ardent, impetuous temperament.

The real turning-point in his career came in November 1759, when the Abbé de Saint-Non arrived in Rome. Richard de Saint-Non,[9] a man of cheerful, hedonistic temper, was a typical eighteenth-century cleric with a comfortable ecclesiastical sinecure enabling him to devote most of his time to travel and the arts. A talented amateur artist in his own right, he made (in addition to engravings after Rembrandt) numerous etchings after Fragonard's drawings, many of which he later incorporated into two handsome folio volumes, Fragments des peintures et tableaux les plus intéressants des palais et églises d'Italie (1770–73) and the Voyage de Naples et de la Sicile (1781–6). Saint-Non also became Fragonard's most valuable friend and patron. Just as the Abbé Gougenot had done previously for Greuze, Saint-Non enabled Fragonard to travel in Italy at his expense without any set programme. Thus liberated from the academic routine of the École de Rome and its pedantic insistence on classical antiquity and the Old Masters, Fragonard found himself able to develop his natural gifts for the first time. Some time early in 1760 he was introduced by Saint-Non to Hubert Robert; the two artists became firm friends and influenced each other's work, which is sometimes so close as to be indistinguishable. In the summer of that year, at Saint-Non's invitation, the three set off on a journey from Rome to Venice. Their first port of call was the Villa d'Este at Tivoli, where they spent several months sketching in the grandiose, decaying park, with its fountains, avenues, cascades and the dark, overhanging boughs of its famous cypresses. This sojourn was a revelation to Fragonard, for it opened his eyes to the beauty of the Italian landscape and architecture, the configuration of its trees and the strongly contrasted masses of light and shade created by a clear, luminous atmosphere.

The Italian journey, and Tivoli especially, left a permanent trace on the rest of Fragonard's oeuvre. It bore instant fruit in the many red chalk drawings he made in

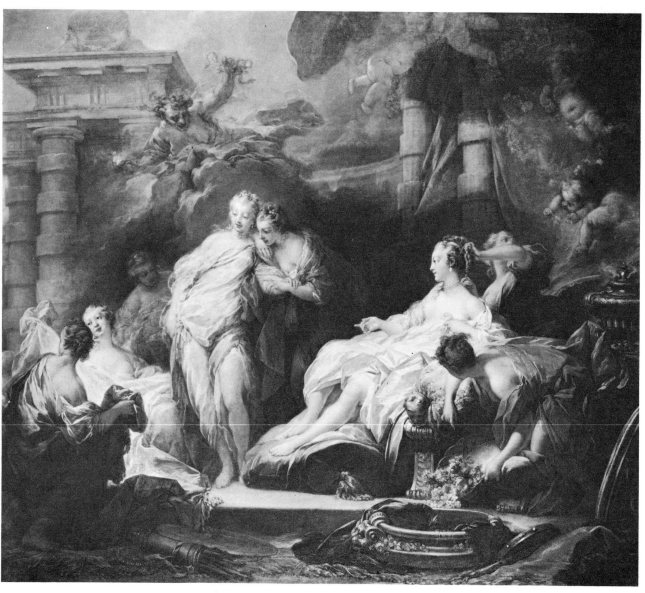

1760 and shortly afterwards, showing a clear, synthetic vision of nature. Soon after his return to Paris in 1761, Fragonard embarked on a series of Italian landscapes based on his sketches and drawings made on the spot, with the vision of Tivoli fresh in his memory. The best of these are the *Gardens of the Villa d'Este (c.* 1762, Wallace Collection), the *Waterfall at Tivoli* (Louvre) and *The Washerwomen*, in Amiens [Plate 19], all more or less contemporary, and all remarkable for their complete technical mastery which enabled Fragonard to translate his fresh, spontaneous vision of nature into works of great compositional rigour. In the *Washerwomen*, Italian women string out their washing between statues in the kind of park Fragonard knew from his stay in Italy, showing scant regard for the ruins of classical antiquity; as in Hubert Robert, archaeology is merely the background for a picturesque episode from everyday life. This picture is one of the most perfect Fragonard painted, with its chalky white impasto rendering of the stiff clean linen and its subdued palette of grey, white and a touch of yellow.

He had an innate sense of the form and underlying structure of landscape which can also be seen in the very different series of northern landscapes, executed probably in the mid-1760s under the direct or indirect influence of the Dutch landscape painters. Whether Fragonard had visited Holland at this stage of his career seems doubtful, but in paintings like *The Three Trees* (formerly in the Cailleux Collection), the *Landscape with a Large Stretch of Greensward* (Grasse, Musée Fragonard) and *Annette et Lubin* (Worcester, Mass.), with their dark, melancholy trees and brooding skies, the presence of Ruisdael is unmistakable.[10] This last group of paintings shows how easily Fragonard could switch from his bright, extrovert Italianate manner to a mood of introspective northern melancholy.

In 1765 Fragonard made a successful bid for official recognition when he presented his *Coresus Sacrificing Himself to Save Callirhoë* (Louvre) as his 'morceau de réception' to the Academy. He was received as a full member of that body, and the painting was exhibited later that year at the

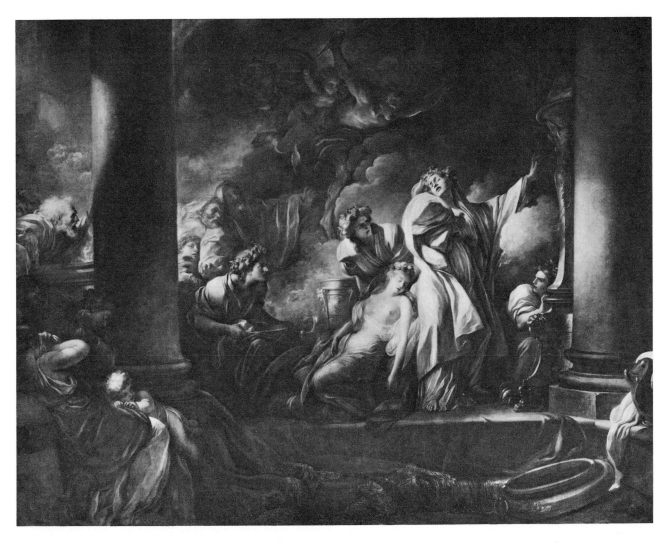

Salon, where it received rapturous applause from jury, artists and critics alike. Diderot hailed the work as a brilliant example of the new historical style he was attempting to promote. In his *Salon de 1765* he allowed his imagination to re-create the painting in an extraordinary passage of imaginative fantasy entitled 'Plato's Cave', doing more than justice to the macabre elements in Fragonard's work. This vast canvas, highly melodramatic and operatic in its effect—derived possibly from a contemporary opera, *Callirhoë*, by Le Roy, and partly from a drawing by Natoire[11]—concentrates on the climactic moment when Coresus, the high priest of Bacchus, is about to stab himself to spare his beloved princess Callirhoë from the same fate. The choice of such a theme of heroic sacrifice, coupled with the artist's highly original treatment of the subject, won Fragonard universal acclaim and, for a moment, he appeared to become the leader of the revival of history painting. But this type of work was not lucrative; despite Marigny's promise to have the painting reproduced by the Gobelins tapestry works, the Royal Treasury was slow to part with the artist's fees. Largely as a result of his frustration in dealing with the authorities, combined with the feeling that his

170. Fragonard,
Coresus Sacrificing Himself to Save Callirhoë,
309 × 406 cm.
Musée du Louvre.
Photo: Alinari-Giraudon

169. Fragonard,
The Gardens of the Villa d'Este,
red chalk drawing,
48.8 × 36.1 cm.

[141]

171. Fragonard,
*Abbé de Saint-Non
in Spanish Costume*,
94 × 74 cm.
Coleccian Cambo,
Palacio de la Virreina,
Barcelona

172. Fragonard,
The Lover Crowned,
318 × 243 cm.
The Frick Collection,
New York

in an inscription on the reverse, were painted in no more than an hour, a remarkable feat of improvisation by any standards. Some of the figures, for example the *Portrait of Monsieur de la Bretèche* (1769, Louvre) and that of the *Abbé de Saint-Non in Spanish Costume* (Barcelona, Museum of Modern Art), are obviously Fragonard's patrons in fancy dress; in the second picture Saint-Non, dressed in a red tunic, plumed hat and holding a sword with a horse tethered behind him, seems to be playing the part of Don Quixote, one of Fragonard's favourite literary heroes. But the meaning of some of the *Fancy Portraits* is by no means clear, and they retain a strong aura of mystery as if anxious to conceal their true identity. This is particularly true of the unidentified *Warrior* in Williamstown (Clark Art Institute), which once belonged to Stanislas Poniatowski, King of Poland—a hard-bitten desperado who thrusts his fist forward in a gesture of heroic defiance. These portraits are at the opposite pole from the discreet, sober realism of Tocqué and Aved, and strike a note of aristocratic eccentricity and extravagance unfamiliar in the art of the period.

The 1770s were the period of Fragonard's highest creative activity and witnessed some of his most ambitious and original decorative schemes. The first of these was *Pursuit of Love*, a series of panels commissioned in 1770 by Madame du Barry for her new pavilion at Louveciennes. In the same year, she had the original château transformed by the architect Ledoux into an entirely new Neo-Classical structure, with a severe façade and recessed Ionic columns. Fragonard's panels on the theme of the pursuit and conquest of love were to have decorated a discreetly elegant interior, with fittings by Pierra Gouthière and other leading craftsmen of the day. They show the artist's imagination at its most exuberant and lyrical, suggesting a lightly veiled form of eroticism which expresses its meaning through allegory and oblique allusion rather than explicit statement. The outward meaning of the sequence is easy to read. In the first panel, *Storming the Citadel*, an eager lover clambers over the wall of a small, enclosed shrubbery; the girl is evidently startled by the intrusion, while the provocative stance of the statue of Venus directly echoes the man's aggressive intentions. Next, in *The Pursuit*, the young man adopts a more conventional form of wooing his sweetheart by offering her a posy of flowers. The girl trips coquettishly away but is obviously flattered by his attentions. In the third panel, *The Declaration of Love* [Plate 20], the couple have arrived at a stage of tender intimacy and dwell lovingly on a *billet-doux*. In the last scene, *The Lover Crowned*, the young man is crowned by his sweetheart with a garland of flowers; her musical instruments lie scattered on the ground, Cupid has fallen asleep on his pedestal, and an eager young artist on the right busily sketches the scene. The *Pursuit of Love* has been read, quite plausibly, as an allegory on the loves of Louis XV and Madame du Barry

Plate 20
faces page 145

real gifts lay elsewhere, Fragonard abandoned history painting and instead turned his attention to private collectors. Henceforward, his patrons were to be leading connoisseurs, financiers and actresses of the day. They were not in the same financial embarrassment as the Treasury, nor did they attempt to impose uncongenial subjects on him. Randon de Boisset, the marquis de Véri, Bergeret de Grancourt and Sophie Guimard, the actress in Fragonard's portrait, were the most prominent of the wealthy private individuals who from now on provided the mainstay of Fragonard's career. It was for them that Fragonard painted his notorious erotic pieces like the *Longed-for Moment* (Paris, Weil-Picard Collection) and the *Stolen Shirt* (Louvre), rapidly dashed off with a minimum of effort but with an incredible *brio* corresponding to their expression of feverish desire. In Fragonard's picture of love, all is action and violent movement, in complete contrast to the becalmed languor of Watteau's *fêtes galantes* or Boucher's drowsily voluptuous pastorals.

Private patronage was also responsible for what is perhaps today Fragonard's most celebrated series of paintings, the so-called Fancy Portraits. These are some of the most extraordinary virtuoso pieces in French art, in which the paint surface is virtually reduced to a few shreds of vibrant colour. They represent the supreme triumph of *Rubénisme* in eighteenth-century France, and the final justification of rapid execution at the expense of careful draftsmanship. Two of the portraits, Fragonard boasted

173. Fragonard,
The Fête at Saint-Cloud,
216 × 335 cm.
Banque de France, Paris.
Photo: The Mansell Collection/Giraudon

and critics have claimed to discover the King's features in the young man. There are also allusions to an earlier iconography of love and friendship created by Madame de Pompadour and the sculptor Pigalle,[12] when the King terminated his relationship with his former mistress. The significance of the *Pursuit of Love* is partly revealed by the behaviour of the statues, which echo and complement the lovers' actions below, notably in the *Declaration* scene, in which the woman clutches her heart to her breast, uncertain whether to yield to the temptation of love.[13] Unlike the imagery associated with Madame de Pompadour, however, Fragonard's paintings have nothing to do with platonic love, but are a gently seductive invitation to gallantry and erotic pleasure. Despite their beauty, the panels failed to satisfy Madame du Barry who, for no stated reason, returned them to the artist in 1773 and ordered new ones in the Etruscan style from Vien. The motive behind this sudden decision was, no doubt, that by 1770 Fragonard's lively Rococo style had already passed from fashion and been replaced in smart circles by a diluted form of neo-classicism, which had the added advantage of being more in keeping with the architecture

of Louveciennes.[14] Thus Fragonard became one of the first to suffer from the changing taste of the times, and the *Pursuit of Love* can be seen as the last flowering of the light and graceful Rococo manner which had evolved under Watteau and his followers.

Fragonard's other great commission from the same period was for a vast decorative scene known as *The Fête at Saint-Cloud*, for the mansion of the duc de Penthièvre, the Hôtel de Toulouse, now the Banque de France. This is one of the least-known masterpieces of French art and represents the climax of Fragonard's decorative style. It depicts the festival held every September under the Ancien Régime in the park of the royal palace of Saint-Cloud, outside Paris, when fountains played, fireworks went off, shopkeepers set up their booths and actors performed to the applause of the crowd who flocked there on foot, in carts and by boatloads up the Seine. It was the great annual popular entertainment for the ordinary Parisians, who appear in Fragonard's painting in little groups, some watching a puppet show, others intent on the actors, while some just loll idly on the ground with their girlfriends. *The Fête at Saint-Cloud* is Fragonard's

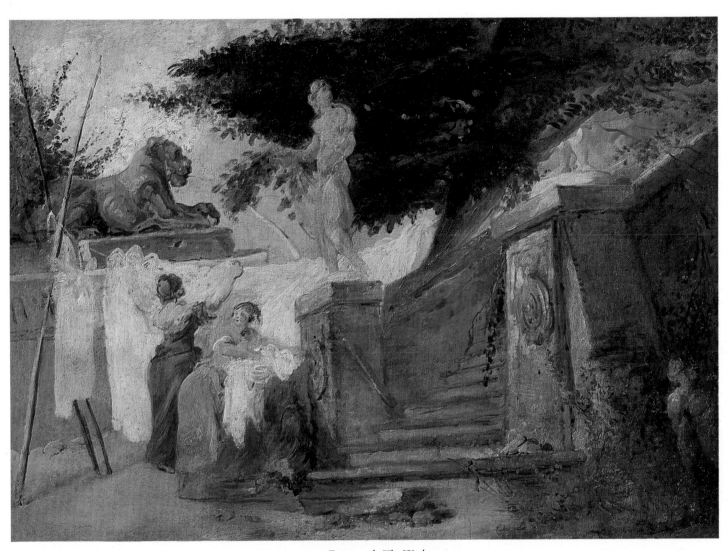

PLATE 19. Fragonard, *The Washerwomen,*
47 × 65 cm. Musée de Picardie, Amiens. Photo: Lauros-Giraudon

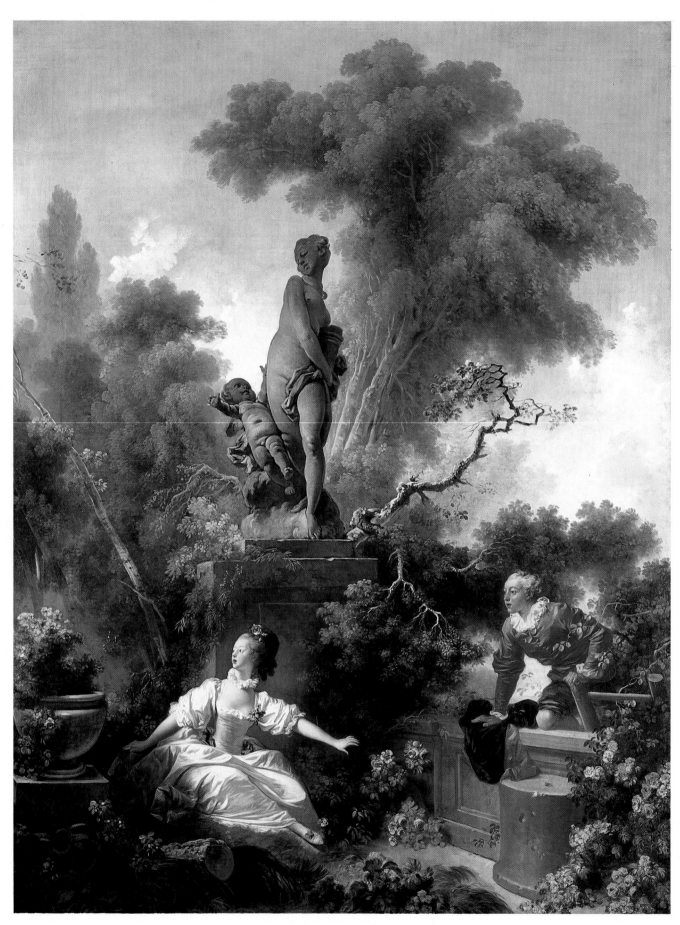

PLATE 20. Fragonard, *The Declaration of Love,*
318 × 215 cm. The Frick Collection, New York

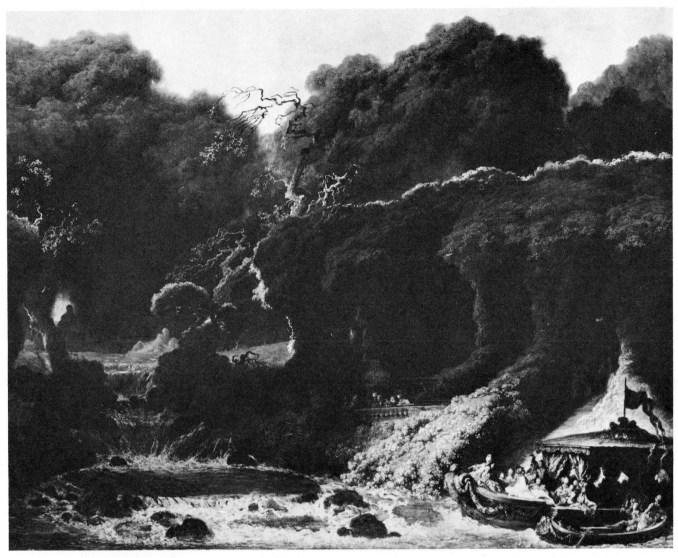

contribution to the cult of nature and the countryside, for unlike Watteau's *Embarkation for the Isle of Cythera*, which it resembles in overall scale and conception, this is no Elysian fantasy but a modern idyll in a naturalistic setting. Though the gigantic trees with their overhanging boughs may look improbable in the Ile de France, these are the same trees which Fragonard had seen and drawn in Italy, only imported here to unify the composition and, perhaps, to suggest the overwhelming forces of nature which can dwarf the miniscule figures and reduce all human activities to mere antics. This same awareness of the elemental force of nature is also strongly present in Fragonard's other great landscape of the mid-1770s, *The Fête at Rambouillet* (Lisbon, Gulbenkian Foundation), showing a gaily-decked boatload of fashionably-dressed people setting out for, or departing from, the Island of Rocks in the park at Rambouillet, which then belonged to the duc de Penthièvre. The foaming waters and gnarled tree in the centre already point to the dramas of Romanticism, but there is a hint of unreality about the scene which suggests that these lovers—distantly echoing those in Watteau's *Embarkment*—are merely indulging in a charade or innocent pastime.

During the last phase of his career, from around 1780 until his death in 1806, Fragonard's art evolved imperceptibly away from the loose texture and liquid paintwork of the Rococo towards more tightly knit compositions, with smooth enamel-like surfaces and evenly laid colours. This subtle change, possibly aided by the collaboration of his sister-in-law, Marguerite Gérard, is fully apparent in *The Stolen Kiss* (Leningrad), one of his most delightful interior scenes, in which a passionate youth snatches a kiss from a tall, willowy girl, who clutches at her satin scarf. The sobriety of execution, the simple rectangular panels of the Louis XVI period and the elongated figures are all in marked contrast to the earlier erotic pieces, with their chubby naked bodies disporting themselves in haystacks or on crumpled beds. But the artist lost none of his *brio* in his later years, as demonstrated in the *Bolt*, in the Louvre, a lurid seduction scene in the best tradition of eighteenth-century *libertinage*. At the same time, Fragonard's later works take on a strange, mythological, allegorical quality, and in paintings like *Le réveil de la nature* (now lost), the *Sacrifice of the Rose* and *Love's*

174. Fragonard,
The Fête at Rambouillet,
72 × 91 cm.
Gulbenkian Foundation, Lisbon

[145]

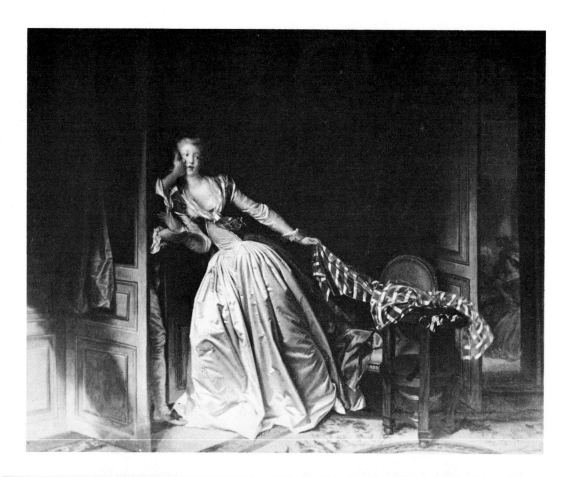

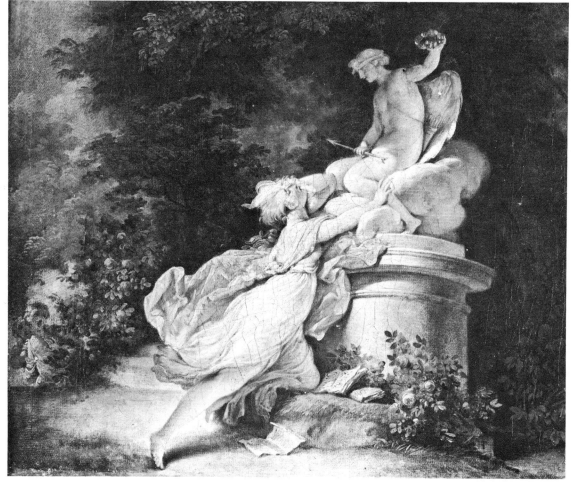

175. Fragonard,
The Stolen Kiss,
45 × 55 cm.
Hermitage Museum, Leningrad.
Photo: Novosti

176. Fragonard,
Love's Torment,
45 × 35 cm.
Musée des Beaux-Arts, Orléans.
Photo: Lauros-Giraudon

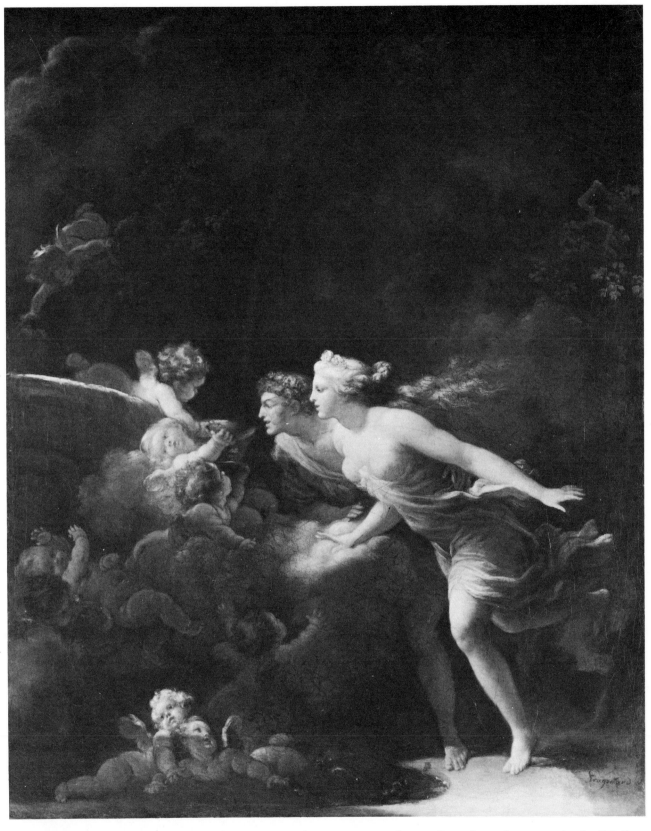

177. Fragonard,
The Fountain of Love,
64 × 56 cm.
The Wallace Collection, London

Torment (Orléans), the artist appears to be moving in the direction of Prudhon and Girodet, towards an unorthodox and somewhat fantastic version of neo-classicism. These paintings may well have their source in obscure works of literature, but their imagery has never been fully investigated. The most familiar of the late allegories is *The* *Fountain of Love*, from the early 1780s, in the Wallace Collection, a work of extraordinary dynamism in which a pair of rhythmically interlocked lovers are drawn by magnetic force to the fountain of desire. This is certainly Fragonard's most 'modern' painting and it provides a fitting climax to the career of an artist who assimilated all

the major artistic strands of the century and combined them in an *oeuvre* of the highest originality. Fragonard was one of the very greatest creative artists. He worked largely according to the dictates of his own imagination and he belongs to no particular category or 'school' of painting; and for this reason he has received scant attention from art historians. In one sense his art is inseparable from the Ancien Régime, its pursuit of pleasure and its cheerful amoral epicureanism, but in another more profound sense, by the sheer range of his imagination and his tacit assumption of the principle of artistic freedom, Fragonard stands firmly in the company of the nineteenth-century Romantics.

The emergence of 'pure' landscape painting in the second half of the eighteenth century is closely linked with the phenomenon of '*sensibilité*' and the cult of nature already discussed. Up till this time, many French artists, including Watteau, Boucher and Fragonard, painted landscapes, often extremely beautiful ones, but were little interested in landscape painting for its own sake; Watteau's graceful trees and Elysian fields are no more than a backcloth for his *fêtes galantes*, while Fragonard can only be considered a true landscape artist in his *sanguine* drawings and paintings inspired by Ruisdael. One notable exception to this rule is François Desportes, who painted a series of remarkably fresh, impressionistic sketches of the countryside round Paris and the Île de France at the beginning of the eighteenth century (for example, the *Landscape* in the Château de Compiègne). But such paintings are extremely rare at this date and anticipate later developments by nearly a century. One

reason for this lack of interest in landscape was the official doctrine of the Academy, which ranked the landscape artist only one stage higher than the genre painter. In order to possess any dignity, the landscape painter had to fill his composition with characters from ancient history or mythology, '*le paysage historique*'. The critic and theorist Watelet distinguished three types of landscape: '*la nature copiée, la nature arrangée, les représentations idéales de la nature champêtre*'.[15] Most French landscape painting of the earlier period falls somewhere into the last two categories, idealized and improved versions of nature.

After 1750, however, as writers, artists and the public began to experience a more direct contact with the countryside, painting also gradually moved away from the artifice of the '*paysage historique*' towards a more natural and spontaneous vision of nature. But this vision remained highly selective; French artists could not escape from their old habit of seeing nature through art and art through nature. As one late eighteenth-century travel writer put it: '*On n'aime dans la nature que ce qu'on voudrait transporter et ce qu'on transporterait avec succès sur la toile.*'[16] As a result, there is no real French equivalent of the simple naturalism of a contemporary English artist like Gainsborough, not even among those artists like Casanova, Loutherbourg and Houel, who followed closely in the steps of the Dutch landscape painters but cannot resist a touch of drama quite foreign to their predecessors. The classical tradition retained too strong a hold on their imaginations to allow them to devote their entire attention to the study of simple, unadorned nature. It was only with Corot and the Impressionists that the process, tentatively

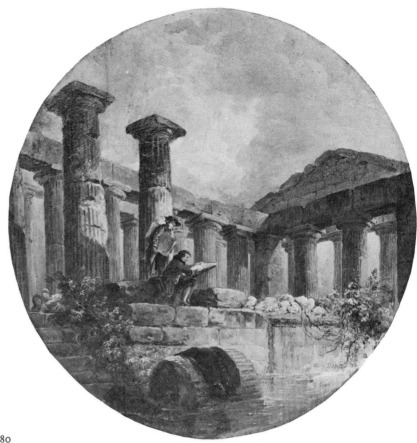

180

begun by artists in the eighteenth century, was carried to its logical conclusion. There are, nevertheless, many examples from the mid-century onwards, especially sketches and preparatory studies, which reveal great sensitivity to landscape and closely echo the celebration of nature in Rousseau, Bernardin de Saint-Pierre and the literature of the period.

One final guise in which the historical landscape survived until the end of the century and later was the painting of ruins. The best-known painter of ruins was Hubert Robert (1733–1808), a master of decorative art, garden designer, lover of classical antiquity and friend of the rich and famous—in fact the complete versatile artist typical of the late eighteenth century. His career runs almost exactly parallel to that of Fragonard and, though his art never quite achieved the latter's supreme fluid ease, it sometimes came close enough for their works to be confused. Robert was more of a highly accomplished dilettante than was his professional rival, a difference which may be explained by his more comfortable, established background. He was born in Paris, where his father was *valet de chambre* to the comte de Stainville (later duc de Choiseul), who was to play a vital part in the artist's career. He was educated at the Collège de Navarre, where he received a good classical education and was taught by the Abbé Batteux, who discovered his talent for drawing. After taking Holy Orders, he went on to study under the sculptor Michel-Ange Slodtz from 1752 to 1753.

At this point, Stainville was appointed French Ambassador to the Papal States and he decided to take his young protégé with him to Rome, where they arrived on 4 November 1754. Although Robert had not been through the Academy and had no prize to his credit, he was allowed to stay as a pensioner at the École de Rome, and soon won the respect of his teachers and fellow pupils. In a letter dated 28 February 1759, the director, Natoire, wrote encouragingly to Marigny: '*C'est un bon sujet qui travaille avec une ardeur infinie. Il est dans le genre de Jean-Paul Panini.*' Like his great predecessor, Hubert Robert became a fervent admirer of classical ruins and spent nearly all his time sketching in the Forum and copying the statues in the Vatican. The grandiose, decaying monuments of Rome were to become his greatest source of inspiration. At the same time, he was fortunate enough to be introduced by Stainville to other influential patrons, including the marquis de Breteuil, who took him to Florence. In November 1759 came the crucial encounter with the Abbé de Saint-Non and Fragonard and their idyllic sojourn in the summer of 1760 at Tivoli, where both young artists, in a spirit of friendship and mutual emulation, helped each other to discover their natural gifts as landscape artists. In the same year, Saint-Non took Robert to Naples, when the two artists visited and sketched such Roman sites as the temple of Paestum. It was in Rome, in 1763, that Robert met another valuable friend and patron, Watelet, the financier, critic and theo-

180. Robert,
The Villa Conti at Frascati,
62.5 × 47 cm.
Musée de Beaux-Arts, Besançon

179. Robert,
Ruins of the Temple of Paestum,
42 × 42 cm.
Musée de Picardie, Amiens

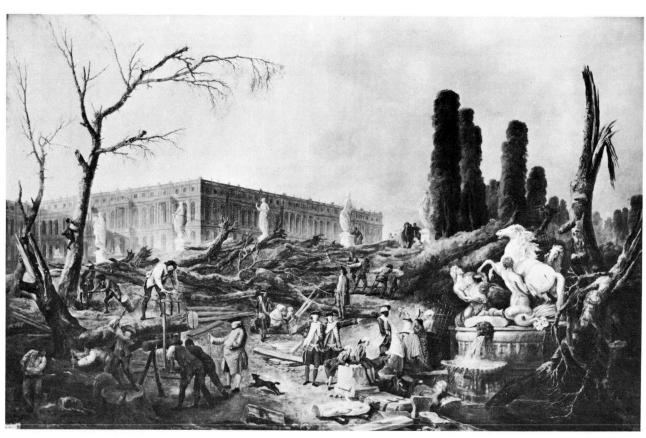

181. Robert,
The Baths of Apollo,
124 × 191 cm.
Château de Versailles.
Photo: Roger Viollet

rist, who later closely associated the artist with his own practice in landscape design at Moulin-Joli.

With the powerful backing of Marigny, Robert found on his return to Paris in 1765 that the door to official success stood wide open. He was easily admitted as a member of the Academy as a 'painter of ruins', a special category, and from then on he was fully occupied with official commissions to paint panels and overdoors for the various royal châteaux. Using his numerous sketches made on the spot in Italy, Robert painted the fine elegant panels of ruins, fountains and overhanging cypresses (as in *The Villa Conti at Frascati,* Besançon) with a few colourful figures in the foreground. They provided just the right kind of decoration for the interiors of the end of the reign of Louis xv and the beginning of that of Louis xvi. Robert was a genial, worldly man; he greatly enjoyed the pleasures of society and was frequently to be found at the houses of the leading figures of the day, Messieurs de la Ferté and de la Reynière, the Abbé Terray, the maréchal de Ségur, Watelet and Madame Geoffrin, whose daily life he painted in a series of delightful intimist scenes. In the words of Madame Vigée-Lebrun: '*Il avait de l'esprit naturel, beaucoup d'instruction, sans aucune pédanterie, et l'intarissable gaieté de son caractère le rendait l'homme le plus aimable qu'on pût voir en société.*'[17]

Alongside his work for private individuals, Robert also enjoyed a highly successful official career. Beginning in 1767, when he exhibited his '*morceau de réception*', *The Port of Rome* (Ecole des Beaux-Arts) with another

[*La vigne-madame*] (Leningrad, Hermitage Museum), he regularly sent numerous works to the Salon until the outbreak of the Revolution. Nor was his reputation confined to painting. He was greatly in demand as a garden designer and landscape artist and made a notable contribution to the development of the French picturesque garden at Ermenonville, Méréville, Moulin-Joli and elsewhere. This side of his creative activity was officially consecrated in 1778, when d'Angiviller called on him to make new designs for the Baths of Apollo at Versailles, consisting of a large rock with a grotto carved out of the middle, to house Girardon's group of sculptures, a project which meant the destruction of many fine old trees planted in the reign of Louis xiv, and was much deplored by some contemporaries.

The result was so enthusiastically received by the new King that the artist was granted free lodgings in the Louvre and the unofficial title of royal landscape gardener. In 1784, he was made the first curator of the new Royal Museum, the Louvre, and executed several designs for the construction of the Grande Galerie. Under the Ancien Régime, he continued to enjoy fame and good fortune until 1793 when, denounced by a jealous rival, he was imprisoned by the Revolutionary authorities in Sainte-Pélagie. After narrowly escaping the guillotine, he was released and lived on peacefully in his lodgings in the Louvre until he died in 1808.

The art of Hubert Robert represents a happy blend of archaeological accuracy and imaginative fantasy. He

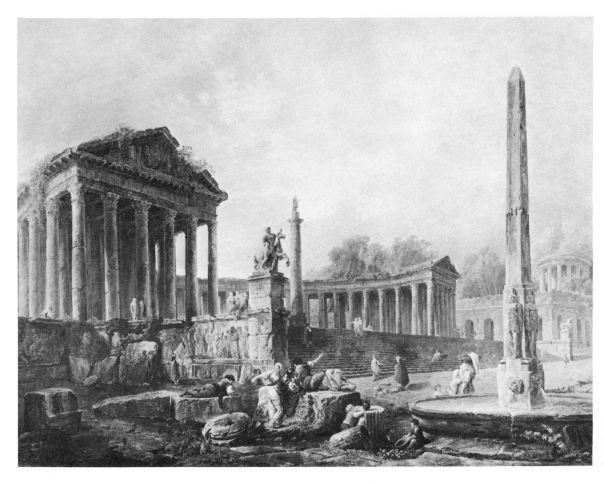

182. Robert,
Architectural Fantasy,
106 × 139 cm.
Bowes Museum, Barnard Castle,
Co. Durham

183. Robert,
Architectural Fantasy,
106 × 139 cm.
Bowes Museum, Barnard Castle,
Co. Durham

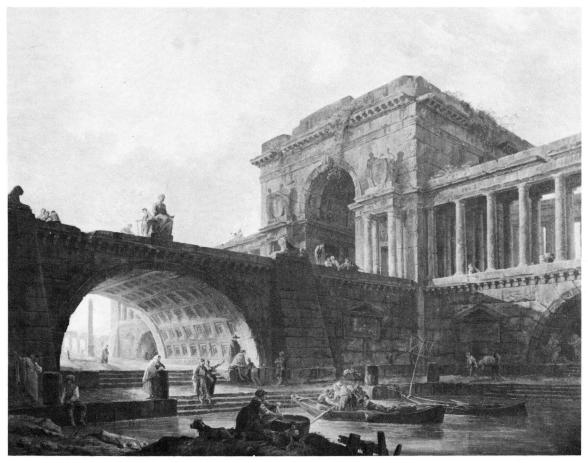

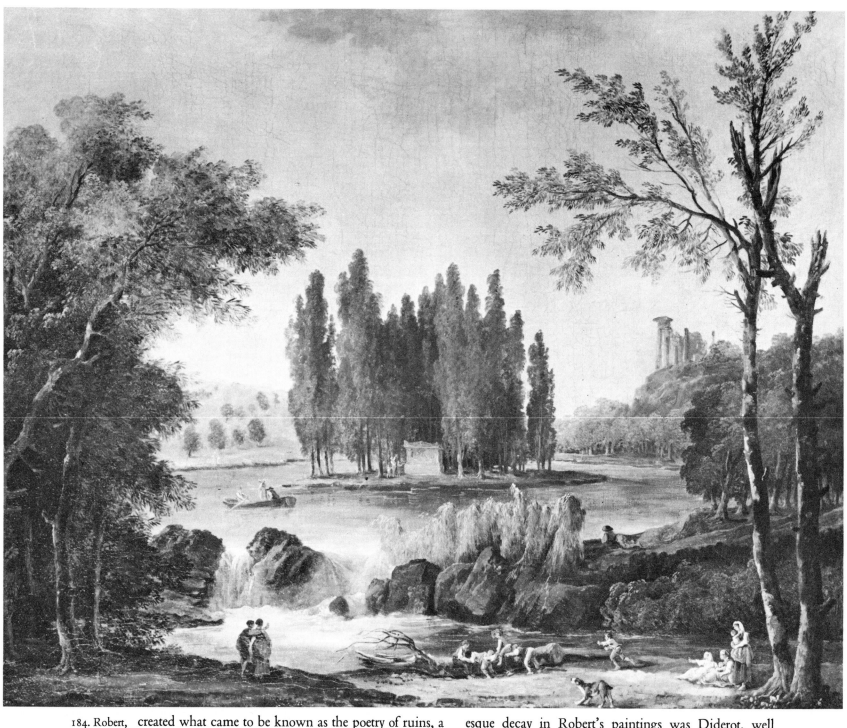

created what came to be known as the poetry of ruins, a nostalgia for the monuments of a vanished civilization, with all its historical associations. Trajan's column, the statue of Marcus Aurelius, the temple of Janus, the catacombs—all these familiar landmarks reappear in his paintings like the grandiose fragments of another age. Unlike Caylus and his circle of academicians, however, Robert was no archaeological pedant. He was less interested in measurements and inscriptions than in creating an atmosphere, a sense of grandeur tinged with melancholy which almost anticipates the mood of Chateaubriand's writings and has much affinity with the Romantic generation. Among the first to perceive this feeling of pictur-

esque decay in Robert's paintings was Diderot, well primed by his own pre-Romantic sensibility. At the sight of the artist's *Large Gallery Lighted from Below* [*Grande Galerie éclairée du fond*], he exclaimed: '*Ô les belles, les sublimes ruines!*',[18] and in a magnificently evocative piece of writing he went on to describe the alternating ideas of eternity, human frailty and solitude aroused in him by their spectacle. ('*Les idées que les ruines réveillent en moi sont grandes. Tout s'anéantit, tout passe. Il n'y a que le monde qui reste …*') For Robert, as well as for Fragonard, ruins were more than the pretext for skilful architectural draftsmanship. He treats them rather as picturesque accidents from the past, with pigeons resting in porticoes and on top of

broken Ionic columns, still part of the everyday lives of the women who disrespectfully string out their washing lines between them. Moreover, he never felt the least compunction in rearranging, or sometimes completely inventing, architectural subjects to make a more interesting or dramatic composition.

Hubert Robert was also one of the most original landscape artists of his time. As we should expect of the man who sketched *Rousseau's Tomb at Ermenonville*, he was an ardent devotee of the philosopher's ideas and he shared Rousseau's passion for nature and all natural phenomena. His art ranges from calm seascapes in the manner of Vernet such as the *Port of Dieppe* to storms over the coast at *Le Havre* (both in the Archevêché de Rouen) and cataclysmic events like the *Destruction of the Old Houses on the Pont au Change* (Paris, Cailleux Collection) and the *Removal of the Arches of the Pont de Neuilly* (Musée Carnavalet), showing the removal of the wooden supports from the old bridge, This last picture is the record of an actual event which took place in September 1772 in the presence of Louis XV and his Finance Minister, the Abbé Terray, watched by a large crowd in the foreground. But many of Robert's most remarkable paintings are pieces of pure historical fantasy, like those in the Musée Carnavalet showing the interior of the Louvre in a state of destruction. The artist is perhaps at his most attractive, however, in the scenes of actual places in the countryside near Paris, for example the *Terrasse de Marly* (c. 1780, Leningrad), an entirely natural scene except for a few classical columns scattered in the foreground, or the *Steps in the Parc de Saint-Cloud* (Duke of Roxburghe Collection). Both of these capture exactly the clear atmosphere of the Ile de France on a fine summer afternoon.

One of the least known aspects of Hubert Robert's career is his activity as a landscape gardener. It is generally agreed that the artist was involved with the creation of new parks at Méréville, Ermenonville and Moulin-Joli, although the precise degree of his contribution has not been established. What is certain, however, is that painting and landscape design were closely associated in the theory of the time, in fact many gardens and parks were directly inspired by painting and often conceived as a succession of varied pictures. As Watelet wrote in his essay on gardens: '*Des arts connus, celui qui a le plus de relations d'idées avec l'art des jardins, c'est celui de la peinture.*'[19] Méréville, near Étampes, was begin in 1784 for the duc de Laborde, and depicted in one of Robert's finest landscapes, *La Terre de Méréville* (Paris, comte de Laborde Collection), showing the park under construction, with the rotunda on the right and the château in the distance. Robert's name is also frequently linked with the new park at Ermenonville,[20] designed by the owner, the marquis René de Girardin on lines partly derived from English notion of the picturesque, but mainly inspired by the ideas

of Rousseau, who lived there as the guest of the marquis for the last few weeks of his life in 1778. The genius of Rousseau still exerts a strong presence over the entire abode, conceived as the ideal retreat from urban civilization, with endless meandering paths and poetic inscriptions inviting the visitor to solitary meditation.

The association between Hubert Robert and the creation of Watelet's estate at Moulin-Joli is less uncertain, since the artist had already known Watelet in Rome; he was also a close friend of his patron's mistress, Marguerite Lecomte, herself an artist of some talent, and he dedicated a series of drawings to her entitled Les Soirées de Rome. Claude-Henri Watelet[21] was born in 1718, the son of a *receveur des finances* for Orléans and as a young man travelled widely in Italy where he acquired a taste for Italian pastoral drama and for simple rustic scenery. An avid collector of Dutch and Flemish prints after landscape painting, he later became one of the leading critics and theorists of landscape gardening with the publication of two tracts, *L'Art de Peindre* (1760) and the *Essai sur les Jardins* (1774). His theory bears the strong imprint of Rousseau's ideas, and he fully shared the writer's abhorrence of urban life and its consequent social evils. Briefly, his conception of landscape rests on the parallel development of two types of garden: the artificial, formal type, corresponding to the needs of town-dwellers, and one which was rustic, and naturally suited to the countryside. His own preference was for the latter, the rural retreat, '*lieu de plaisance*', where the delights of nature, study and quiet contemplation could be fully savoured. In his own words, the ideal park should possess three characteristics, '*le pittoresque, le poétique, le romanesque*'; but pleasure was to be combined with utility, and no modern, well-designed estate could afford to be without such essential adjuncts as a dairy farm, an aviary, a herb garden and so on. These basic ideas guided Watelet in the creation of his park at Moulin-Joli, near Bezons, on the Seine just

185. Saint-Non, Engraved frontispiece after drawing by Le Prince of Watelet's *Moulin-Joli* 1755. British Museum (Courtesy of the Trustees). Photo: John Freeman

[153]

outside Paris. When he bought the property in 1754, it consisted of three islands on the river and a tract of mainland; he then joined these sections up by bridges and opened the terrain out into a series of avenues converging on a central *rond-point*. His own house, a modest pavilion, was probably designed by Boucher, and it has been plausibly suggested that landscape paintings by the same artist lay behind the picturesque rusticity of Moulin-Joli and other parks laid out around this time.[22] Moulin-Joli was, in fact, specifically designed as a sequence of varied and changing pictures, some Italianate, some Flemish in character. The final result can be judged from a series of engravings made after drawings by Le Prince by the abbé de Saint-Non, who was a close friend of Watelet and a frequent visitor to Moulin-Joli. The place soon became a focal point for people of taste and fashion, including Marie-Antoinette and Madame Vigée-Lebrun, and in its half-rustic, half-formal character clearly emphasizes the close link between painting and landscape gardening in the later eighteenth century.

The same craving after an escape from everyday life lies at the root of contemporary notions of the sublime in landscape painting. The French public of around 1760 onwards expected the landscape artist to transport it into another world of idyllic fantasy and excitement and to supply a kind of *frisson* missing from their own experience. They wanted enchanted views of the bays of Baiae and Naples, mountains, caves, cataracts, storms, shipwrecks and eruptions of Vesuvius, which most of them, as town-dwellers, would be unlikely ever to witness in their own lives. This quest for substitute experience in art was something entirely new and can be seen in retrospect as a vital element in the development of Romanticism. It was again Diderot who most clearly defined the appeal of landscape art to the imagination: '*Le grand paysagiste a son enthousiasme particulier; c'est une espèce d'horreur sacrée. Ses antres sont ténébreux et profonds . . .*'.[23]

It is exactly this kind of poetic emotion which is found in the works of Vernet, Loutherbourg, Casanova and many other minor landscape artists of the late eighteenth century. Joseph Vernet (1714–1789) was widely hailed by his contemporaries as the true successor to Claude Lorrain, for he displayed not only the latter's supremacy in the rendering of light, water and atmosphere but also an even greater variety of mood, ranging from becalmed seaports and panoramic views of cities to storm-tossed ships and their wrecked hulks stranded on the shore. In a passage referring to Vernet, C. N. Cochin remarked in his *Salon of 1753*: 'The modern painter understands the variety of nature even better, and produces pictures more diverse in their beauties.' Vernet's favourite theme was the study of nature at different times of the day, from morning to sunset, in all its changing aspects of light and atmosphere; he delighted in the soft, grey morning haze, as well

as in the warm glow of sunset over placid water. His paintings have the typical mellowness of the Mediterranean artist, as if his colours had been filtered through Italian light. Hence his enormous popularity with an aristocratic clientèle, mostly French and English, who prized his pictures as an accurate reflection of the places they had visited on the Grand Tour.

Vernet was born in Avignon, into a family which produced an entire dynasty of talented artists. After receiving an initial training with his father, he went on to study under an obscure local painter, Philippe Sauvan (1697–1792), who probably employed his pupil in collaboration on various commissions for churches and private houses in the region. Vernet next went to work in Aix-en-Provence, where he painted his first recorded pictures for the Hôtel de Simiane, a pair of overdoors representing the Fontaine de Vaucluse and a Roman arena. Around 1730, Aix-en-Provence was the centre of a flourishing cultural life and the young Vernet would have had ample opportunity to study the Old Masters in several outstanding private collections housed in the splendid *hôtels* of the town.[24] It was in the milieu of the cultivated provincial nobility that Vernet met his first patron, the marquis de Caumont, a collector, bibliophile and antiquarian, who paid for the artist to travel to Rome in 1734 and provided him with contacts which were to serve him well for the rest of his career. Vernet stayed in Rome for the next nineteen years, until 1753, and thus spent the greater part of his creative life there. Taking full advantage of his connections, he soon penetrated the highest ecclesiastical and diplomatic circles in the city and, among others, was patronized by the French Ambassador, the duc de Saint-Aignan, who doubtless introduced him to other prominent diplomats, as well as to Englishmen visiting Rome, like Sir William Lowther and Benjamin Lethieullier, who commissioned the four marines and two landscapes for his brother-in-law, Sir Matthew Featherstonhaugh, at Uppark, in Sussex. The English were among Vernet's best clients, partly because his paintings reminded them of their Grand Tour and partly because they were the natural successors to the grand tradition of classical landscape art typified by Claude, Gaspard Dughet and Salvator Rosa. For this reason many fine Vernets can still be found in English country-house collections to this day.

Vernet's art evolved gradually in Rome as he assimilated a variety of styles. He clearly learned a great deal from fellow artists like Adrien Manglard (1695–1760), a topographical and marine painter,[25] as well as from such Italian predecessors as Andrea Locatelli (1693/5–1741) and Orizzonte (1662–1749), who practised a delicate Arcadian vision of Italy inspired by Claude. But probably his most vital artistic impulse came from Nicolas Vleughels, Director of the French Academy in Rome,

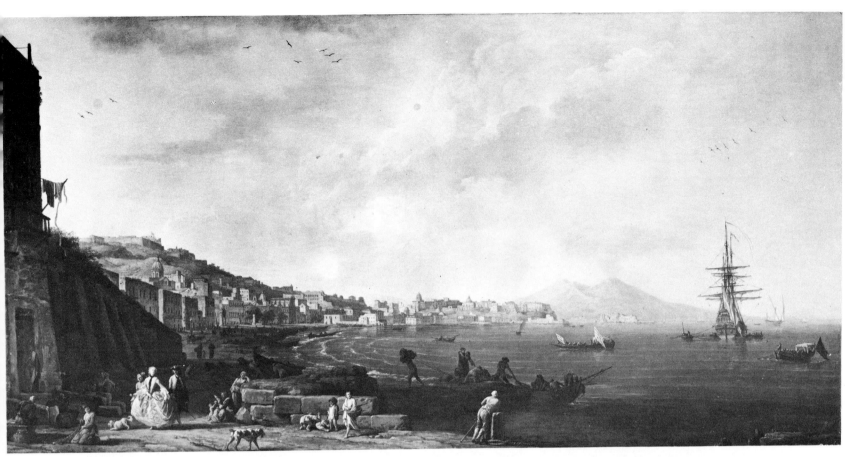

186. Vernet,
View of Naples,
97 × 195 cm.
Musée du Louvre.
Photo: Lauros-Giraudon

who deliberately encouraged his pupils to go out and study the surrounding scenery in an attempt to revive the tradition of landscape painting. Vernet delighted in the natural beauty of the region; he made several excursions to Naples and the stretch of coast between Vesuvius and Portici, which had begun to attract fashionable visitors. These places were to become the chief inspiration of his art. He returned to them time and again in his paintings, sometimes in a purely topographical manner, as in the magnificent wide panoramic views of Naples (1748, in the Louvre, and in the Duke of Northumberland's collection) but more often in a semi-imaginary spirit, taking individual landmarks from various places and recombining them in an original composition. Improbably juxtaposed in the same picture are often found the lighthouse from Marseille harbour, a stretch of the Genoese coastline, elements from the Neapolitan townscape, like the Torre San Vicenzo, and the Villa Reale at Portici. These are the themes on which Vernet composed his numerous elegant variations, with the addition of agile, well-turned figures in the foreground, usually twisting to the motion of hauling in fishing nets or simply disporting themselves in fancy dress by the sea shore, as in the *Harbour Scene* in the National Gallery in London.

If Vernet was not always true to geography, this was because his prime interest was in light, atmosphere and climatic conditions. This was clearly perceived by Mariette, who wrote of the artist: 'Everywhere he studied nature and her effects, and then rendered them with the utmost truth ... It was by studying after nature and working with the greatest application that he learned to render with such truth the different effects of light, the effect produced by the vapour in the air, drawn up towards the sun from the ground or from water. I know no painter, not even Claude Lorrain, who has rendered them better.'[26] These words are particularly apt to describe the superb set of *Four Times of the Day*, commissioned in 1751 together with two seascapes and a pair of river landscapes for Sir Matthew Featherstonhaugh at Uppark, where they may still be seen. Completed by four exact replicas by Vernet's closest follower, Lacroix de Marseille, they form one of the finest surviving ensembles of the artist's work.

In a similar pastoral vein to the two river landscapes at Uppark is *The Shepherdess of the Alps* (1763) in Avignon, inspired by a short romance of the same title by Marmontel.[27] The tale is one of the author's *Contes moraux* (1761) and tells the story of Adélaïde, a young French noblewoman disguised as a shepherdess, and her lover Fonrose, who finally persuades the girl to marry him, despite her strong attachment to the memory of another man. In Vernet's painting, Adélaïde is seen pointing out to Fonrose the grave which she has dug for her first lover with her own hands. The narrative is told in language of total simplicity and unfolds in an almost enchanted, fairylike atmosphere. First read aloud by the author at the

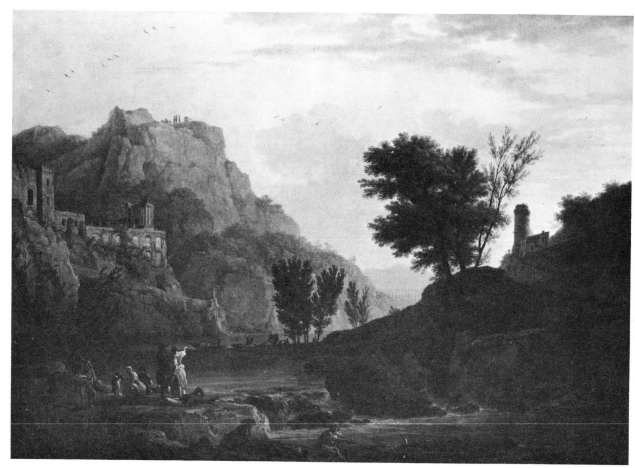

187. Vernet,
River Landscape,
96 × 136 cm.
National Trust, Uppark, Sussex

188. Vernet,
River Landscape,
96 × 136 cm.
National Trust, Uppark, Sussex

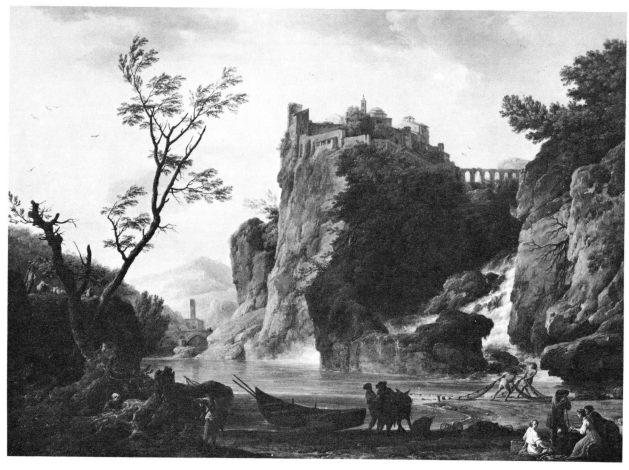

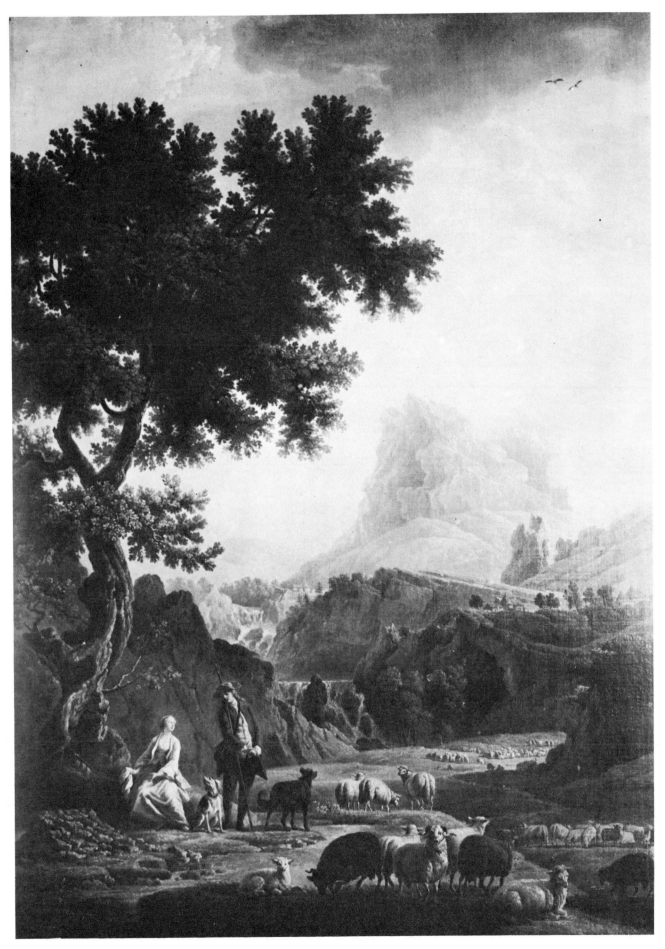

189. Vernet,
*The Shepherdess
of the Alps,*
120 × 86 cm.
Musée Calvet, Avignon

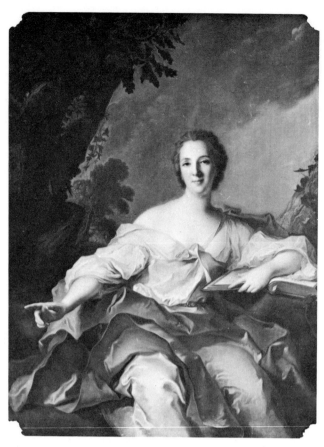

190. Nattier,
Madame Geoffrin,
56 × 44 cm.
Private Collection, Paris

191. Vernet,
The Port of Bordeaux,
130 × 227 cm.
Musée du Louvre.
Photo: Giraudon

192. Vernet,
Building a Road,
97 × 162 cm.
Musée du Louvre.
The Mansell Collection/Giraudon

exercised a constant and vexatious form of dictatorship over artists; never content to leave them to their own devices, she frequently laid down the choice of subject to the last detail and followed its execution step by step. It is hardly surprising that artists sometimes rebelled and referred to her 'tyranny'. But, in general, she earned their gratitude, introducing them to such prominent figures as Gustavus III of Sweden and Benjamin Franklin, who visited her house in 1767.

Vernet was to prove that he could paint not only delightful idylls for private patrons but also large compositions on a grand scale. The climax of his career came in 1750, or very soon afterwards, when he received the royal commission, through Marigny, who had been deeply impressed by Vernet's work in Rome, to commemorate the principal French seaports. Vernet left Rome in 1751 for France, where he spent most of the next two years visiting and closely studying the different places he was to paint—Marseille, Bandol, Toulon, La Rochelle, Rochefort and Bordeaux.[29] The finished works, completed between 1754 and 1755, are among the most remarkable topographical paintings in the whole of European art, conceived on a broad panoramic scale with low horizons and a large expanse of sky. They were, as a Vernet exhibition catalogue points out,[30] envisaged by Marigny as didactic, semi-historical paintings intended to illustrate the various commercial activities of each port and the different types of navigation imposed by the local geography. Thus the artist was to reveal himself a master of descriptive prose as well as of poetic fantasy, with a result that challenges comparison with Canaletto. One of the finest of the series is undoubtedly *The Port of Bordeaux* (1759). This was also the most difficult subject to be tackled by the artist, for the beautiful eighteenth-century city, planned by the architect Jacques Gabriel and recently completed by his son Ange-Jacques, oered nothing but unbroken symmetry. 'There is nothing so pretty as the port of Bordeaux for walking in or looking at; but I have never seen one more contrary to the effect of a painting, and less picturesque,'[31] Vernet complained in a letter to Marigny in June 1757. In the final painting he solved the problem by allowing the pale morning sunlight to play on the bland eighteenth-century façades curving gently round the harbour, while any suggestion of monotony is broken by the ships' masts echoing the few spires on the city skyline and the prominent shape of part of the Château Trompette on the right. The scene is given life by the animated groups of figures in the foreground; on the raised section of the bastion some soldiers are occupied cleaning a cannon, while in the formal gardens small groups of elegantly dressed people are conversing and pointing out the ships in the distance.

The *Ports of France* are, without doubt, Vernet's cumulative masterpiece. When this enormous task was

country house of Baron d'Holbach in September 1759, it evidently delighted Madame Geoffrin, who was present, and she instantly commissioned Vernet's painting. Madame Geoffrin (1699–1777)[28] was the leading hostess of the later eighteenth century, a rich woman of strong autocratic character and decided tastes, who attracted nearly all the most prominent intellectuals and artists to her *salon* on the rue Saint-Honoré, including Diderot, Marmontel, Montesquieu, d'Alembert, Hubert Robert, Vernet and Boucher. The interior of her house is illustrated in an attractive series of paintings by Hubert Robert, for example *Madame Geoffrin's Breakfast*; there were portraits of her by Nattier (1735), showing her in mythological guise, and one attributed to Chardin in which she is seated in front of a table. She was also active as an amateur and patron of the arts, and between 1750 and 1770 commissioned many works from, amongst others, Hubert Robert, Carle Vanloo, Lagrenée l'Aîné, Boucher, Vernet and Drouais. Her personal taste seems to have been for the decorative style of the Rococo (she owned four pastorals by Boucher which hung in her boudoir) to the early classicism of Vanloo, Lagrenée l'Aîné and Hubert Robert. Moreover, she was a close friend of Stanislas Poniatowski, the King of Poland, who in his youth had been placed in her charge in Paris; she was also in close correspondence with Catherine II of Russia. She was therefore well placed to provide French artists with the most prestigious European clientèle. In return for her favours, however, Madame Geoffrin

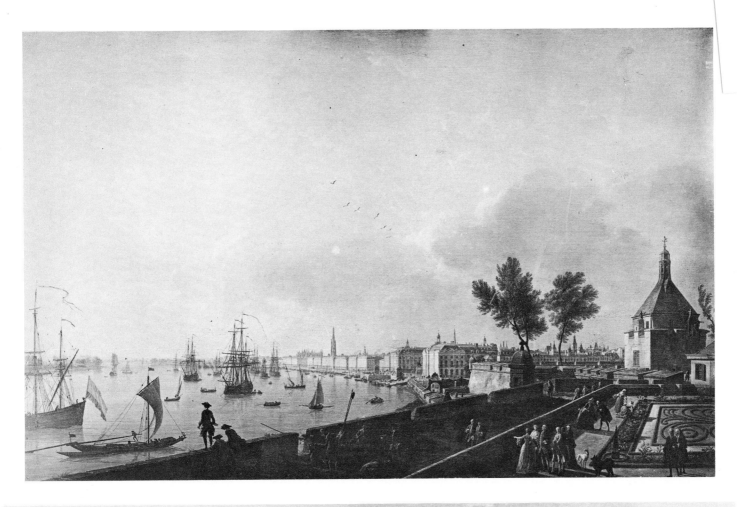

193. Lacroix de Marseille,
Seascape,
94.6 × 167 cm.
Toledo Museum of Art, Ohio

194. Lacroix de Marseille,
Mediterranean Seaport,
95.3 × 131.4 cm.
Hôtel Sandelin, St Omer.
Photo: Lauros-Giraudon

completed, around 1760, the artist was at last free to settle with his family in Paris and to enjoy his fame. But two more paintings from his later period deserve to be singled out, *Building a Road* (Louvre) and the *Approach to a Fair* (Montpellier, Musée Fabre), for they both show the same passion for factual observation combined with a lyrical treatment of nature. The two works were commissioned in 1774 for the Abbé Terray (1715–78), Louis XV's wily Minister of Finance until his fall in the same year, who formed an important private collection, dispersed in 1779, of paintings devoted primarily to the commercial activities of modern France, including the two large scenes by Lépicié, *Customs-house Interior* and *The Market-hall*. Despite his discredited financial methods, Terray was evidently a believer in progress and liked paintings which illustrated the benefits and prosperity his régime had brought to the country. This was certainly the motive behind his commission of *Building a Road* [*La Construction d'une Route*], showing a team of navvies, under the supervision of a group of engineers on horseback, constructing a road through mountainous country, probably somewhere in Provence. As the excellent entry in the Vernet catalogue points out,[32] the chief engineer in this scene is the figure of Jean-Rodolphe Perronet (1708–1794), who was responsible for the construction of many roads and bridges in and around Paris, including the Pont de Neuilly, as well as the design of the ingenious tipping cart seen in action on the right of the picture. The painting can be seen, therefore, both as a tribute to the engineer's achievements and as a demonstration of the improvements in the road system which, in the latter half of the century, contributed in large measure to the development of French trade and industry. It should be added, incidentally, that this programme would not have been possible without a system of forced labour, a much-hated imposition known as the *corvée*, which required all able-bodied non-nobles to spend about a month on road-building. The painting is certainly one of Vernet's finest, conceived in the heroic manner of a classical landscape by Poussin, but with a contemporary, matter-of-fact approach to the subject which directly anticipates the mid-nineteenth century.

It is only with the benefit of hindsight, however, that we can see Vernet as a precursor of later developments in French art and of certain aspects of Impressionism. To his contemporaries he seemed an artist to be collected, copied and pastiched *ad infinitum*, so that there were soon far more Vernets in circulation than Vernet ever painted, even with the help of a large studio of assistants. Today his name is still a convenient by-word for anything with moonlight or sunshine and boats. The problem is further complicated by the existence of numerous followers and copyists: Hue, Le Bel, Lallemand, Lacroix de Marseille, Pillement, Volaire, to name but a few; among them are

attractive artists who deserve mention. All of them repeat Vernet's basic themes, but with their own distinctive imprint. Charles Lacroix de Marseille (c. 1700–1782), Vernet's closest pupil, was capable of an almost exact imitation of his master's style, as can be seen from his replicas after Vernet's *Morning* and *Night* at Uppark. He went to Rome in 1754, following closely in Vernet's footsteps, only departing slightly from the former in his rather more crowded, elaborate compositions and in his excessively sweet, sugary tones. But Lacroix did, on occasion, produce excellent paintings such as the *Mediterranean Seaport* (1750), in Toledo, Ohio, a *capriccio* vaguely inspired by Genoa, and the *Seascape* in the Hôtel Sandelin at St Omer, with its classical rotunda based on the Temple of the Sibyl at Tivoli. Lacroix can usually be distinguished by his use of strong verticals and tall curving ships' masts, which give his compositions a graceful, elongated effect.

Jean-Baptiste Pillement (1728–1808), from Lyon, was not a pupil of Vernet but often echoes his manner in his shipping scenes on the river Tagus, bathed in a soft, grey light as the water laps gently round the boats and their mooring posts. Pillement was one of the most versatile and widely travelled of all eighteenth-century artists. He visited England from 1755 to 1760, then Poland, where he worked as court painter to Stanislas Augustus and decorated the King's palace with charming *chinoiseries*, gouaches and landscapes. In 1767 he went to Vienna to work for the Prince of Liechtenstein. Finally in 1780 he went to Portugal, the country which inspired some of his finest seascapes and the series of paintings of life in the *Gardens of Benfida* just outside Lisbon (1785, Musée des Arts Décoratifs). Pillement's work has the delicate, almost feathery quality of a highly accomplished decorative artist. His landscapes—for example, the *Rustic Bridge* in Lyon—usually include picturesque bridges, rocks, cattle and ruins and are closely inspired by the more classically-minded Dutch artists, like Jan Both and Karel Dujardin.

The Dijonnais artist, Jean-Baptiste Lallemand (1716–1803), a less-known follower of Vernet, is best represented by the collection of his works in his native town.[33] This charming *petit maître* echoes all the familiar themes (*Roman Ruins, Morning, Evening*) painting excellent *vedute* in the Vernet style, such as the *Ponte Rotto* and the *Castel Sant'Angelo*. Paintings like the *View of the Château of Montmusard* and a drawing, *La Place Royale de Dijon*, have an additional topographical interest and portray faithfully the appearance of a typical French provincial capital during the last years of the eighteenth century.

Pierre-Jacques Volaire (1729–1802) is another close collaborator of Vernet whose career has received very little attention. The son of a painter from Nantes who was

195. Pillement,
Rustic Bridge,
43 × 61 cm.
Musée des Beaux-Arts, Lyon

196. Lallemand,
*View of the Château
of Montmusard,*
89 × 118 cm.
Musée des Beaux-Arts,
Dijon

attached to the arsenal of Toulon, Volaire met Vernet in 1754 when the latter was working on the *Ports of France*, and became his assistant until 1762. In 1763, he set up in Rome, where he painted marines '*dans le goût de Vernet*', closely echoing his master's figure style but with rather less elegance. By 1769, he had settled in Naples, and it was there that he painted several attractive views of the Neapolitan coastline, as well as the better-known paintings of the eruption of Vesuvius which struck a responsive chord in the contemporary taste for sublime and majestic imagery. The views of Vesuvius, with their glowing embers and tiny figures of spectators in the foreground, were to exert a strong influence on Joseph Wright of Derby during his Italian tour of 1773–5.[34] Fascinated by moonlight, fire and all the violent contrasts of industry and natural phenomena, Joseph Wright assimilated Volaire's imagery so quickly that even today it is sometimes difficult to differentiate them. Wright's great painting of *Vesuvius* (1774–5), in Derby Museum, was almost certainly inspired by Volaire's example and set a notable precedent in English art in the exploitation of the dramatic and frequently destructive effects of nature.

The same cross-current between France and England is illustrated by the career of Philippe Jacques de Loutherbourg (1740–1812). Although of uneven quality,

Loutherbourg's *oeuvre* spans the entire range of European sensibility in the late eighteenth century, from gentle rustic pastorals, the picturesque scenery of England, Wales and Switzerland, to the sublime horrors of shipwrecks, *banditti* and industrial towns by night. Apart from landscapes, he also dabbled in stage design with the support of the actor David Garrick, and William Beckford of Fonthill, and produced a curious invention, the Eidophusikon, designed to create the illusion of moving scenery by purely mechanical means. Born in Strasbourg in 1740, the son of a miniature painter, Loutherbourg moved to Paris in 1755 and studied first under Carle Vanloo, then with the engraver Jean-Georges Wille, who directed his attention towards the Dutch landscape painters. Loutherbourg also attended the studio of François Casanova (1727–1802), a painter of battles, hunting scenes and pastoral landscapes[35] closely inspired by the example of Philip Wouwermans (1619–1668). It was as a landscape artist in the Dutch tradition that Loutherbourg made his début at the Salon of 1763, with a *Landscape with Figures* now in the Walker Art Gallery, Liverpool. The painting was warmly received by Diderot for the freshness of its colouring and its robust truth to nature: '*Phénomène étrange! Un jeune peintre, de vingt-deux ans, qui se montre et se place tout de suite sur la ligne de Berghem. Ses animaux sont peints de la*

197. Volaire,
Eruption of Vesuvius,
130 × 227 cm.
Formerly with Agnew, London.
Photo: Sydney W. Newbery

[163]

198. Loutherbourg,
*Landscape with
Figures,*
114 × 194 cm.
Walker Art Gallery,
Liverpool.
Photo: John Mills

199. Loutherbourg,
*Landscape with
a Waterfall,*
58 × 81 cm.
Nationalmuseum,
Stockholm

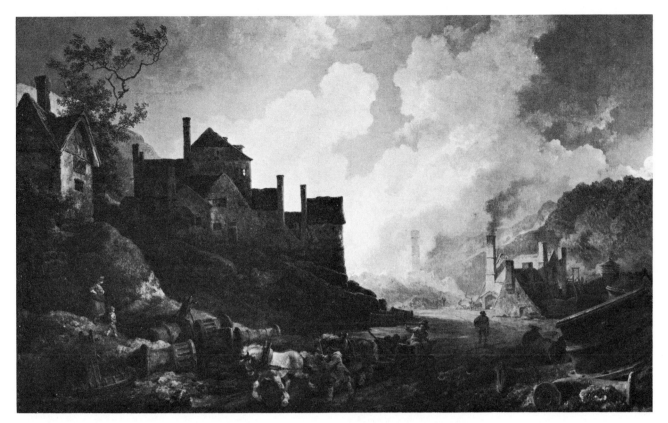

200. Louterbourg,
Coalbrookdale by Night,
68 × 106.7 cm.
Science Museum, London

*même force et de la même vérité. C'est la même entente et la même
harmonie générale. Il est large, il est moelleux; que n'est-il
pas?*[36] This was to be the basic pattern for most of
Louterbourg's landscapes from the early part of his
career, until he left Paris for London in 1771. In contrast
to pastoral idylls by Boucher and Fragonard, his scenes
are full of picturesque animation and a down-to-earth
Dutch simplicity, dwelling on such details as leaves,
rocks and water in a way that no Rococo-trained artist
would have contemplated. Their colouring is fresh and
vivid, but sometimes crude. Unlike his Dutch prede-
cessors, however, Louterbourg cannot escape from the
French habit of 'arranging' nature to seem more pictur-
esque and more dramatic than in reality, as for example in
the superb *Landscape with a Waterfall* (Salon of 1767) in
Stockholm, with its castle perched vertiginously up on the
right. Louterbourg delights in piling up rocks and
mountains in a succession of different planes, leaving the
spectator overawed by their towering presence.

The romantic strain in Louterbourg's art came out
still more strongly after his departure in 1781 for England,
where he spent most of the rest of his life. This was the
time when the wild beauties of Wales, Derbyshire and the
Lake District had recently been discovered, thanks largely
to the writings of William Gilpin[37] and others. Moun-
tains were no longer considered barren wastes, or 'the
desart', as they were by seventeenth-century writers, but
full of scenic interest, with light, shade and mass to add to
the artist's compositional repertory. This new discovery
was all part of a European movement, usually called 'Pre-

Romanticism' by cultural historians, and has its roots in
the writings of Rousseau and the natural scenery of
Switzerland. Louterbourg was clearly influenced by this
movement, and had probably travelled in Switzerland
before moving to England, counting among his friends
several Swiss artists, like Caspar Wolff (1735–1798).

In the same quest for strange and unfamiliar natural
beauty, Louterbourg made several extensive tours in
England and Wales, first in 1778 to Derbyshire, then in
1786, a much longer journey to Wales and the Lake
District. By then such places had definitely ousted Italy
and the Grand Tour in the priorities of artists and
fashionable travellers, and for the first time local top-
ography became a new and important factor in the evo-
lution of landscape painting. Louterbourg himself later
contributed to this development with the publication of
several large illustrated volumes, particularly *The Pictur-
esque and Romantic Scenery of England and Wales* (1805). In
his oil paintings of English scenery, he sometimes ap-
proaches the manner of Richard Wilson, but he paints
in a looser, 'woolier' texture and his compositions are
less formal and symmetrical. Occasionally, as in the mag-
nificent view of *Llanberis Lake* (1786) in Strasbourg, he
manages to convey the austere grandeur of mountain
scenery with a power unequalled by any artist of the day;
the lowering sky and interlocking forms of the mountains
ranged around the dark lake suggest all the daemonic and
supernatural qualities of early Romanticism. The same
streak is evident in his single incursion into the field of
industrial landscape pioneered by Joseph Wright of

[165]

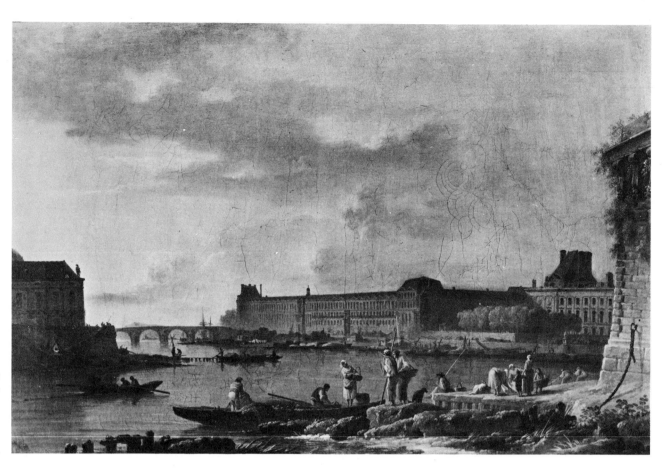

201. Noël,
*The Louvre and
the Pont-Royal
seen from the Pont-Neuf*,
48.5 × 75.5 cm.
Musée Carnavalet, Paris.
Photo: Lauros-Giraudon

202. Houël,
*View of the Loire
between Amboise
and Lussault*,
84 × 161.5 cm.
Musée des Beaux-Arts, Tours.
Photo: Musées Nationaux, Paris

203. Houël,
*View of Paradis,
near Chanteloup*,
85 × 161.5 cm.
Musée des Beaux-Arts, Tours.
Photo: Musées Nationaux, Paris

Derby, *Coalbrookdale by Night* (1801, London Science Museum), showing the kilns and blast furnaces of this small Shropshire town spewing forth a reddish smoke into a moonlit sky. The factories and workers' houses, climbing up the slope on the left, stand silhouetted against the distant glare like a mediaeval castle and create a strange mixture of beauty and ugliness.

The French landscape, however, remained untouched by industry at the end of the eighteenth century. The last generation of the country's artists–Noël, Houel, Moreau l'Aîné, Bruandet, Lantara and a whole host of other minor figures–responded to the natural scenery of France with a freshness and sensitivity which sometimes almost anticipates the early landscapes of the Impressionists. On the whole this group of landscape painters avoided the dramatic contrasts, the mountains and cataracts of the 'picturesque' school. They remained, for the most part, in the Ile de France and preferred the placid rivers, the curving lines of poplars and broad horizons of the northern and central provinces. These painters are, moreover, completely free of the conventions both of the classical landscape and of the pastoral which had dominated French landscape painting until then. Their emphasis is on a faithful rendering of the topographical scene–landscape and townscape–combined with close observation of light and atmosphere. This new direction is well illustrated by the work of two little-known but ad-

mirable artists, Noël and Houël. Alexandre-Jean Noël (1752–1834),[38] a pupil of Sylvestre and Vernet, began as a painter of orthodox seascapes, as in the three *Marines* in the museum of Metz, and shipwrecks in his master's style. But he gradually evolved towards accurate depictions of France and, later in life (in 1826), when the French provinces were actively being explored by the Romantic generation, he published a large illustrated volume entitled *Souvenirs pittoresques de la Touraine*. Some of his best paintings are the views of Paris exhibited in the Musée Carnavalet, for example the *Place Louis XV* (c. 1779), the *Île St Louis* (c. 1780) and *The Louvre and the Pont-Royal seen from the Pont-Neuf*. These are some of the first paintings to capture the beauty of Paris and the Seine, with its clear sky, bridges, houses and water all conveyed in a remarkably free, 'modern' technique.

Jean Pierre Houël (1735–1813)[39] was an even more interesting and varied landscape painter. A pupil of Casanova, he responded to all he saw on his travels with an extraordinarily fresh perception, from antique temples in Rome (two gouaches in Besançon, signed and dated 1772) to the delightful series of gouaches painted as studies for a magnum opus, the *Voyage pittoresque des isles de Sicile, de Malte et de Lipari ...* (Paris, 1782–7).[40] He also displayed his ability as a landscape painter in a set of fine large views of the river Loire, painted in 1769 as overdoors for the duc de Choiseul at Chanteloup and now in the

[166]

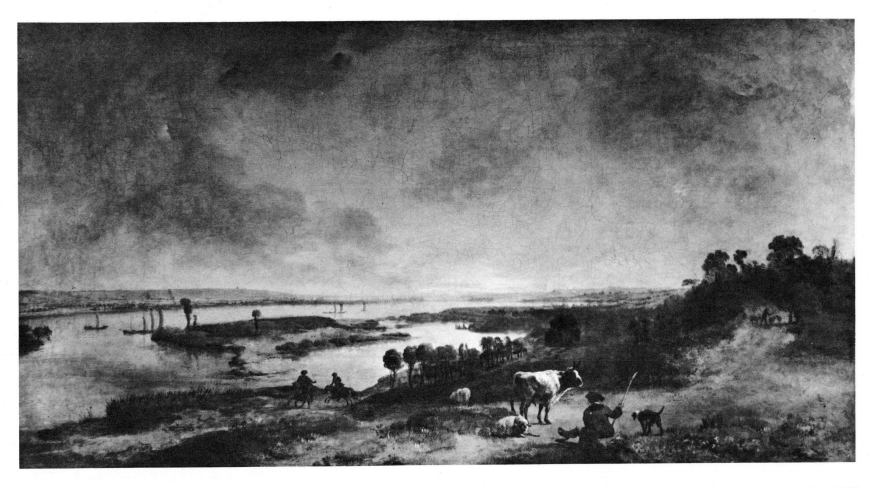

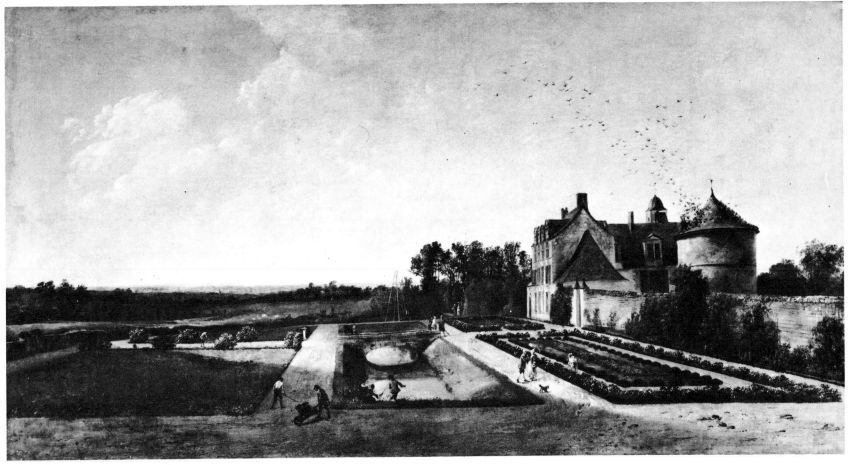

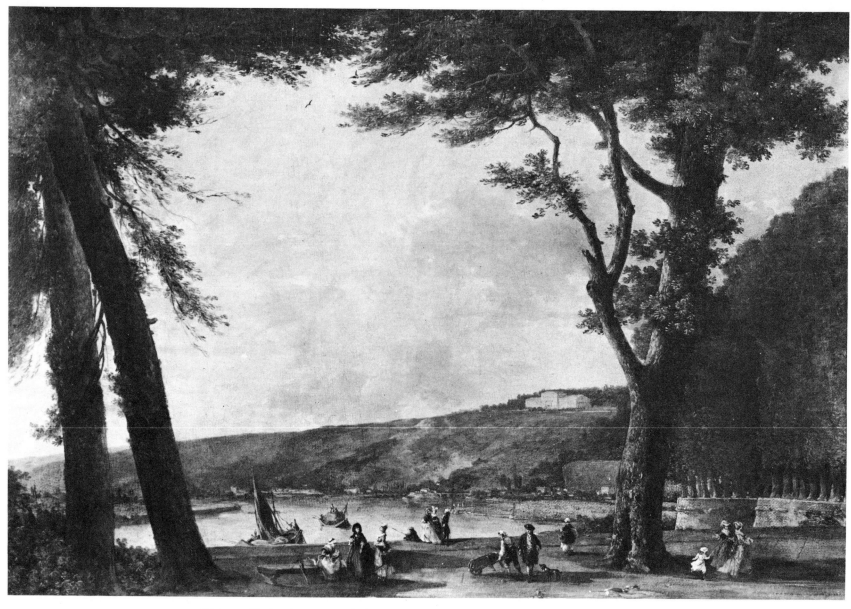

204. Moreau,
*The Heights of Meudon
from Saint-Cloud,*
56 × 81 cm.
Musée du Louvre.
Photo: Lauros-Giraudon

museum of Tours.[41] In the *View of the Loire between Amboise and Lussault* and the *View of Paradis, near Chanteloup* (a small manor house used by Choiseul as an annexe to his main château to accommodate less important guests), Houël reveals great sensitivity to the atmosphere and broad, indolent riverscape of the Loire, stretching away into the distance to meet the sky on a low horizon, as in seventeenth-century Dutch landscapes. These two paintings, placid scenes punctuated by the odd château and clump of trees, afford a precious glimpse of rural France under the Ancien Régime.

The landscapes of Louis-Gabriel Moreau (1740–1806), called Moreau l'Aîné to distinguish him from Moreau le Jeune (1741–1814), the illustrator, echo the themes already treated by Fragonard and Hubert Robert—parks, terraces, flights of steps, rustic cottages—but on a small scale. His sketchy hand delights in the curving forms of willows and poplars bent by a gust of wind, and a patch of sunlight on an old garden wall.

Paintings like *Steps in a Park* [*Escalier dans un parc*] (formerly marquis de Ganay Collection) offer attractive little vignettes of the French countryside, with their tiny figures strolling, fishing and washing their linen in the foreground. The medium he used varied from oil to gouache and watercolour, and he also practised etching. Within his small format, and rarely straying beyond Paris and its close suburbs, Moreau achieved effects of light which sometimes anticipate Corot in their delicacy and tonal precision. From a low horizon giving a large mass of clear sky, in paintings like *The Heights of Meudon from Saint-Cloud,* Moreau captured the distinctive physiognomy of the Ile de France with an accuracy and lightness of touch unique in eighteenth-century art. At last nature had come into its own, with no need of shepherds, swings or any of the pastoral attributes to enliven it. The landscape painters were, in their quiet way, no less revolutionary than David and his followers, but their unspectacular discoveries were only to bear fruit well in the nineteenth century.

Notes

Location of Main Public Collections

Bibliography

Index

Notes

❦

CHAPTER I

1. The comment was made in 1699.
2. A. Schnapper, *Jean Jouvenet, 1644–1717 et la peinture d'histoire à Paris*, pp. 73–85.
3. Pascal, *Pensées*: Misère de l'Homme sans Dieu.
4. A. Blunt, *Art and Architecture in France 1500–1700*, Pelican History of Art, p. 401.
5. L. Dimier, 'Antoine Coypel', *Les peintres français du XVIII siècle*. The chapter is followed by a useful, though dated, bibliography and a catalogue raisonné.
6. Charles Coypel, 'Vie d'Antoine Coypel' in *Vies des Premiers Peintres du roi*, Paris, 1752 (2 vols).
7. A. Schnapper, 'Antoine Coypel: la Galerie d'Enée au Palais-Royal', *Revue de l'Art* 1969, No. 5.
8. M. Stuffmann, 'Charles de la Fosse et sa position dans la peinture française à la fin du XVII siècle', *G.B.A.*, No. 64, 1964.
9. B. Teyssèdre, *Roger de Piles et les débats sur le coloris au siècle de Louis XIV*, 1965. See also A. Fontaine, *Les doctrines d'art en France de Poussin à Diderot*, 1909.
10. See Folkierski, *Entre le Classicisme et le Romantisme*, 1925.
11. Perrault, *Parallèles*, I.
12. *Lettre à l'Académie*: Projet de Poétique. Fénelon also expressed his ideas on the visual arts in his *Dialogues des Morts* (1700) in the form of imaginary discussions between painters.
13. Florisoone, *Le Dix-huitième siècle*, p. 15.
14. de Piles, *Seconde Conversation*.
15. *Cours de Peinture*.

CHAPTER 2

1. R. Picard, *Les Salons Littéraires et la société française (1610–1789)*, 1943.
2. An engraving after Gillot's drawing is reproduced in E. Dacier's account of Gillot in *Les peintres français du XVIII siècle*, p. 167.
3. *Lettres Persanes*, No. 98, Usbek à Ibben.
4. Proust, *Watteau*. First published in *Contre Sainte-Beuve, suivi de Nouveaux Mélanges*, Paris 1954.
5. Nineteenth-century attitudes to Watteau are discussed in S. Simches, *Le Romantisme et le goût esthétique du XVIII siècle*, Paris, 1964.
6. see Xavier de Courville, *Luigi Riccoboni dit Lelio*, Librairie Droz, 1945.
7. Lettres familières de *Boileau Despréaux et Brossette*, quoted in Courville, op. cit., Vol. 2, p. 13.
8. M. Stuffman, 'Les Tableaux de la collection de Pierre Crozat', *G.B.A.*, No. 72, 1968.

9. M. Levey, 'The Real Theme of Watteau's Embarkation for Cythère', *Burlington Magazine*, May 1961.
10. Nerval, *Promenades et Souvenirs*.
11. H. Adhémar, *Watteau*, 1950, p. 5.
12. Michelet, *La Régence* (1863), Chapter XIX.
13. R. Rey, *Quelques Satellites de Watteau*, Paris, 1931.
14. H. N. Opperman, 'Oudry illustrateur: Le Roman comique de Scarron', *G.B.A.*, 1967.
15. Quoted in E. Dilke, *French Painters of the XVIII Century*, p. 104.
16. There are other versions of this painting in the Wallace Collection, The Hermitage Museum and Berlin.
17. See E. K. Waterhouse, 'English painting and France in the eighteenth century', *Journal of the Warburg and Courtauld Institutes*, XV, 1952. Also. Exhibition Catalogue, *The French taste in English Painting*, Kenwood House, 1968.
18. See Exhibition Catalogue, *Philippe Mercier*, City Art Gallery, York, and Kenwood House, 1969.

CHAPTER 3

1. Dilke, 'Jean-François de Troy et sa rivalité avec François Lemoine', *G.B.A.*, avril 1899.
2. Caylus, comte de, 'Vie de François Lemoine', in *Vies des Premiers Peintres du Roi*, Vol. II, Paris, 1752.
3. These are *The Wedding at Cana*, the *Eucharist*, *The Baptism of Christ*, the *Temptation of Christ* and the *Samaritan Woman*.
4. The sketch for this work is in the Musée des Arts Décoratifs.
5. The fresco has suffered from much later restoration; a sketch for it is preserved in the Louvre.
6. Reported in Dézallier d'Argenville, *Vies de Peintres*, Vol. IV.
7. Voltaire, *Siècle de Louis XVI*.
8. Valory, 'Jean-François de Troy', published in *Mémoires inédits sur la vie et les ouvrages des membres de l'Académie Royale . . .* Vol. II, Paris, 1854.
9. The painting of *St Vincent de Paul Preaching* is in the Eglise Saint Pierre at Mâcon.
10. De Brosses, *Lettres familières écrites d'Italie*, Vol. II, Letter XLIV.
11. Caylus, 'Eloge de J. F. de Troy', in *Vies d'artistes du XVIII siècle*, published by A. Fontaine, Paris, 1910.
12. F. Kimbell, *The Creation of the Rococo*, Philadelphia, 1943.
13. Quoted in Levey & Kalnein, *Art and Architecture of the Eighteenth Century in France*, p. 260.

14. Quoted in Kimbell, op. cit., p. 160.
15. On Champs, see E. de Ganay, *Châteaux et Manoirs de France*, Paris, 1938, Vol. II.
16. The eight scenes are: *Psyché accueillie par Zéphir, Les nymphes recevant Psyché au palais de l'Amour, Psyché montrant ses trésors, Psyché contemplant son époux, L'Amour endormie, Psyché sauvée des eaux par les nymphes, Psyché chez les bergers, Psyché défaillant de frayeur en présence de Venus, Psyché enlevée dans l'Olympe par L'Amour.*
17. T. Besterman, *Voltaire on the arts: unity and paradox.* 1973, Zaharoff Lecture, Oxford, 1974.
18. Quoted in the above, p. 6.

CHAPTER 4

1. See A. Blunt, 'The Précieux and French Art', *Essays in Memory of Fritz Saxl*, edited by D. J. Gordon, London, 1957.
2. Quoted in Nolhac, *Nattier* p. 102. Tocqué, *Réflexions sur la peinture et particulièrement sur le genre du portrait*, 1750.
4. Marmontel, *Mémoires*, Vol. I.
5. Proust, *Chardin*, in *Contre Sainte-Beuve et Nouveaux Mélanges*, first published 1954. See also G. May, 'Chardin vu par Diderot et par Proust', *Publication of the Modern Languages Association of America*, June 1957.
6. See P. Ratouis de Limay, *Le Pastel en France au XVIII siècle*, Paris, 1946.
7. S. Mercier, *Tableau de Paris*.
8. E. et J. de Goncourt, 'La Tour' [1867], *L'Art du dix-huitième siècle*.
9. Diderot, Ed. Assézat, Vol. X.
10. Born in Antwerp around 1680, died in Paris 1757.
11. Painter and Professor of the Academy of St Luke. Died in Paris 1747.
12. M. Barrès, 'Une Journée chez Maurice Latour de Saint Quentin', in *Trois Stations de Psychothérapie*, Paris, 1891.
13. Goncourts, op. cit.
14. See G. Wildenstein, 'A Propos des portraits peints par François-Hubert Drouais', *G.B.A.*, January 1958.
15. Exhibited at the Royal Academy, London, 1968, No. 313.
16. Sold Sotheby's December 1978.
17. Also at the Château of Coppet is a fine portrait of *Madame Necker*. There is another version of Necker's portrait in the Musée Nissim de Camondo, Paris.

CHAPTER 5

1. See Exhibition catalogue, 'Louis XV', *Un Moment de Perfection dans l'Art Français*, Hôtel de la Monnaie, Paris 1974.

2. Some idea of their wealth may be obtained by the considerable sums realized on the sale of their collections: in 1776 Blondel de Gagny's collection was sold for 405,000 livres, and in 1777 Randon de Boisset's for 906,000 livres. See H. Carré *La noblesse de France et l'opinion publique au XVIII siècle*, Paris, 1920, pp. 50–55.

3. P. J. Mariette, *Abécédario*.

4. See Wallace Collection Catalogue, *Pictures and Drawings*, Entry numbers P. 484, P. 487.

5. R. S. Slatkin, 'Abraham Bloemaert and François Boucher: Affinity and Relationship', *Master Drawings*, Vol. XIV, Autumn 1976.

6. Marmontel, *Oeuvres Complètes*, edition of 1787, Vol. VII.

7. B. Lossky, 'L'Apollon et Issé dans l'oeuvre de François Boucher', *G.B.A.*, November 1954.

8. Bachaumont: 'All his shepherdesses were like those of Fontenelle and were more coquettish than natural' (*Mémoires secrets*, 5 June 1770).

9. Two of the paintings (*Sylvia cures Phyllis of a bee sting* and *Sylvia freed by Amintas*) are still in the Hôtel de Toulouse, now the Banque de France, and the other two (*Sylvia and the Wolf*) and (*Amintas returns to life in Sylvia's arms*) are in the Museum of Tours.

10. There are several versions of this subject, including one in the Wallraf-Richartz Museum, Cologne, and another in the Museum of Reims, signed and dated 1743.

11. Reynolds, *Discourse Twelve*, 10 December 1784.

12. F. H. Hazlehurst, 'The Origins of a Boucher theme', *G.B.A.*, No. 55, 1960.

13. K. K. Gordon, 'Madame de Pompadour, Pigalle and the Iconography of Friendship', *Art Bulletin*, September 1968.

14. On Tessin, see Ph. de Chennevières, 'Les Suédois en France', *G.B.A*, No. 37, 1888.

15. Diderot, *Salon de 1761*.

16. For further details of this scheme, see Chapter 6.

17. Quoted in Nolhac, *Boucher*, Paris 1925, p. 197.

18. The revival of interest in Boucher and other prominent eighteenth-century artists in the mid-nineteenth century is studied in S. Simches *Le Romantisme et le goût esthétique du XVIII siècle*, Paris 1964.

19. See S. Rocheblave, *Essai sur le comte de Caylus*, Paris, 1889.

20. On Diderot's relations with Caylus, see J. Seznec, *Essais sur Diderot et l'Antiquité*, Oxford, 1957, pp. 86–96.

21. Until 1936, when they were sold at the Hôtel Drouot, these panels were in the collection of the Comte de la Bédoyère.

22. In a painting shown ar the Salon of 1777, now in the Musée Fabre, Montpellier.

23. Diderot, *Salon de 1781*.

24. See E. Wind, 'The Source of David's Horaces', *Journal of the Courtauld and Warburg Institutes*, Vol. 4, 1940–41.

CHAPTER 6

1. The standard and still the best account of this subject is J. Locquin, *La peinture d'histoire en France de 1747 à 1785*, Paris, 1912. This has been supplemented by R. Rosenblum's *Transformations in Late Eighteenth-Century Art*, 1967.

2. La Font de St.-Yenne, *Réflexions sur quelques causes de l'état present de la peinture en France*.

3. Quoted in Locquin, op. cit.

4. Op. cit.

5. Bachaumont, *Liste des meilleurs peintres, sculpteurs, graveurs et architects des Académies Royale de Peinture . . . 1750*.

6. Laugier, *Salon de 1752*.

7. Diderot, *Salon de 1763*.

8. P. Jarry, 'Les Fresques de J-B Pierre dans la Chapelle de la Vierge à L'Eglise St Roche', *G.B.A.* July 1933.

9. Pierre's composition is closely derived from a painting of the same subject by Veronese, formerly in the collection of the Duc d'Orléans and now in the Fitzwilliam Museum, Cambridge. See J. Seznec, 'Diderot et les plagiats de Monsieur Pierre', *Revue des Arts*, V, 1955.

10. *Correspondance de Cochin et Marigny*, Letter of 14 October 1764. The terms of Cochin's suggestion to Marigny were: 'The world has so often glorified warlike actions which have contributed nothing but destruction to the human race; surely sometimes one could depict some good sovereign performing a noble and humane deed which brought happiness to his people? I beg therefore to suggest . . . ' The paintings finally installed at Choisy included Hallé's *Justice of Trajan*, Vien's *Marcus Aurelius distributing bread during a famine* (Amiens), Vanloo's *Augustus closing the doors of the Temple of Janus* (Amiens), and Lagrenée's two overdoors *Justice and Clemency* and *Benevolence and Generosity*. Louis XV, however, had no liking for didactic subjects and they were removed from Choisy two years later, in 1766.

11. See J. Seznec, 'Diderot and the Justice of Trajan', *Journal of Courtauld and Warburg Institutes*, no. 20, 1957.

12. See M. Sandoz, 'Paintings by Jean-Louis-François Lagrenée the Elder at Stourhead', *Burlington Magazine*, September 1961.

13. Quoted in M. Sandoz. 'Louis-Jean-François Lagrenée, dit l'Aîné, Peintre d'Histoire (1725–1805)', *B.S.H.A.F.*, 1961.

14. Diderot, *Salon de 1761*.

15. D'Angiviller, letter to Pierre, 27 June 1775.

16. *De David à Delacroix*, Grand Palais, Paris, 1974.

17. See A. Cobban, chapter on the *Parlements* of France in the eighteenth century, *Aspects of the French Revolution*, London, 1971.

18. Voltaire, *Dictionnaire philosophique*, IV, article 'Parlement de France'.

19. See S. Rocheblave, *Essai sur le comte de Caylus*, Paris, 1889.

20. On Diderot's relations with Caylus, see J. Seznec, *Essais sur Diderot et l'Antiquité*, Oxford, 1957, pp. 86–96.

21. Until 1936, when they were sold at the Hotel Drouot, these panels were in the collection of the Comte de la Bédoyère.

22. In a painting shown at the Salon of 1777, now in the Musée Fabre, Montpellier.

23. Diderot, *Salon de 1871*.

24. See E. Wind, 'The Source of David's Horaces', *Journal of the Courtauld and Warburg Institutes*, Vol. 4, 1940–41.

CHAPTER 7

1. Diderot, *Pensées détachées sur la Peinture*.

2. M. Faré, *Le Grand Siècle de la Nature Morte en France*, Paris, 1974. For the eighteenth century, see M. et F. Faré, *La vie silencieuse en France : la nature morte au 18e siècle*. Paris, 1976.

3. See G. May, 'Chardin vu par Diderot et par Proust', *Publications of Modern Languages Association of America*, June, 1957.

4. Diderot, *Salon de 1763*.

5. Mariette, *Abécédario*.

6. Proust, *Correspondance Générale*, Vol. 6, Paris, 1930–36.

7. There is another version of this painting in the Staatliche Museum, Berlin.

8. E. et J. de Goncourt, *Chardin*, 1863, in *L'Art du dix-huitième siècle*.

9 Dézallier d'Argenville: Notice on Oudry in *Abrégé de la vie des peintres*, Paris, 1762.

10. Published in 1755 in four in-folio volumes by Monsieur de Montevault; Oudry's original drawings were etched by C. N. Cochin fils.

11. Fable XIII, Livre III.

12. Fable IX, Livre VI. The painting depicts the following lines:
 Dans le cristal d'une fontaine
 Un cerf se mirant autrefois,
 Louait la beauté de son bois,
 Et ne pouvait qu'avec peine
 Souffrir ses jambes de fuseaux,
 Dont il voyait l'objet se perdre dans les eaux.

13. In Anita Brookner, *Greuze : The rise and fall of an eighteenth-century phenomenon*, London, 1972.

14. Mercier, *Essai sur l'art dramatique*, 1773.

15. Diderot, *De la Poésie Dramatique*, II.

16. Diderot, *Salon de 1763*.

17. J. Seznec, 'Diderot et l'affaire Greuze', *G.B.A.*, May 1966.

18. P. Wescher, 'Etienne Jeaurat and the French Eighteenth-Century Genre de Moeurs', *Art Quarterly*, Summer 1969.

19. Bachaumont, *Mémoires secrets*, Vol. XXIV.

20. P. Grigaut, 'Marmontel's *Shepherdess of the Alps* in Eighteenth-Century Art', *Art Quarterly*, 1949.

CHAPTER 8

1. E. et J. Goncourt, *L'Art du dix-huitième siècle*.

2. Mornet, *Le Sentiment de la Nature en France*, Paris, 1907.

3. Walpole, *Anecdotes of Painting in England*, Strawberry Hill, 1762–1771.

4. Grimm, *Correspondance Littéraire*, 1750.

5. C. Thacker, 'Voltaire and Rousseau: eighteenth-century gardeners', in *Studies on Voltaire and the Eighteenth Century*, XC, 1972.

6. D. Wiebenson, *The Picturesque Garden in France*, Princeton, 1978.

7. E. et J. de Goncourt, 'Fragonard', first published in *G.B.A.*, 1865, later included in *L'Art du dix-huitième siècle*.

8. F. Zigler, 'Fragonard et l'art napolitain', *G.B.A.*, 1931.

9. L. Guimbaud, *Saint-Non et Fragonard*, Paris, 1928.

10. J. Wilhelm, 'Fragonard as a Painter of Realistic Landscapes', *Art Quarterly*, 1948.

11. For information on this picture I am most grateful to the late David Carritt. Fragonard did not, apparently, see the opera performed on the stage.

12. K. K. Gordon, 'Madame de Pompadour, Pigalle and the Iconography of Friendship', *Art Bulletin*, September, 1968.

13. See also L. Réau, 'L'Offrande du coeur', *G.B.A.*, 1922.

14. F. M. Biebel, 'Fragonard et Madame du Barry', *G.B.A.*, LVI, 1960.

15. Watelet, article 'Paysage' in the *Encyclopaedia*.

16. Guibert, *Voyages dans diverses parties de la France et en Suisse faits en 1775–1785*, Paris, 1806.

17. Vigée-Lebrun, *Mémoires*.

18. Diderot, *Salon de 1767*.

19. Watelet, *Essai sur les jardins*, 1774.

20. See *Ermenonville, Histoire du Domaine*, etc., Touring-Club de France, Paris, n.d.

21. See M. Henriot, 'Un Amateur d'art au XVIIIe siècle, l'académicien Watelet', *G.B.A.*, VI, 1922.

22. Wiebenson, op. cit., p. 17.

23. Diderot, *Pensées détachées sur la peinture*.

24. J. Boyer, 'Les collections de peintures à Aix-en-Provence aux XVII et XVIIIe siècles d'après les inventaires inédits', *G.B.A.*, XI, 1933.

25. A. Rostand, 'Adrien Manglard et la peinture de ruines au XVIIIe siècle', *G.B.A.*, XII, 1934.

26. P. J. Mariette, *Abécédario*, 1751.

27. P. L. Grigaut, 'Marmontel's *Shepherdess of the Alps* in eighteenth-century art', *Art Quarterly*, XLL, 1949.

28. On Madame Geoffrin, see Marmontel *Mémoires*, ed. 1804, Tome II, Livre Sixième. In the same chapter Marmontel made unflattering remarks about the artists who used to meet at Madame Geoffrin's house on Mondays. See also Roger Picard, *Les Salons littéraires et la société française (1610–1789)*, Paris, 1943.

29. Vernet finally painted fifteen *Ports of France*; they are all in the Musée de la Marine, Paris.

30. *Claude-Joseph Vernet 1714–1789*, Kenwood House, London, 1976.

31. Vernet, *Correspondance avec Marigny*.

32. Kenwood House, No. 46.

33. *J.B. Lallemand, paysagiste dijonnais du XVIIIe siècle*, Musée de Dijon, 1954.

34. On Wright's relationship with Volaire, see Benedict Nicolson, *Joseph Wright of Derby*, Vol. I, pp. 78–9, Mellon Foundation, 1968.

35. There are four fine large landscapes by Casanova in the museum of Nancy.

36. Diderot, *Salon de 1763*.

37. Gilpin, *Observations relative chiefly to Picturesque Beauty made in the Year 1772*.

38. *G.B.A.*, II, 1920.

39. For Hoüel, see exhibition catalogue, *French Landscape Drawings and Sketches of the Eighteenth Century*, British Museum, London, 1977.

40. The drawings for this volume are in the Louvre, Cabinet des Dessins; the gouaches are shared between the Hermitage and the Louvre.

41. See B. Lossky, *Peintures du XVIIIe siècle*, Musée des Beaux-Arts, Tours, 1962.

Location of Main Public Collections

The bulk of French eighteenth-century art is, fortunately, still in France. The Louvre contains the richest collection of the period, both paintings and drawings, followed closely by some of the major provincial museums, Amiens, Orléans, Tours, Angers, Dijon and Besançon. The latter were greatly enriched by confiscations of private collections (like the Choiseual pictures at Tours and those of the marquis de Livois at Angers) during and shortly after the Revolution, and so have exceptionally fine collections. Orléans has a remarkable series of portraits, especially pastels by Perronneau, while Saint-Quentin has an almost complete range of pastels by the town's native artist, Maurice Quentin de la Tour. History painting is often the most inaccessible type of art, on account of its size. Many fine specimens were deposited in remote museums in the nineteenth century and are not always favourably hung, or even exhibited; many others hand in dark corners of churches in Paris and elsewhere and are poorly lit. Portraits, on the other hand, are legion in these and the other main public collections, but many are still in private hands, housed in châteaux throughout the country, and so are virtually impossible to see except by special permission. This is why artists like Aved and Tocqué are a comparative rarity in public collections.

French eighteenth-century art enjoyed a great popularity with American collectors around the turn of this century, probably because it seemed to typify the elegance and refinement of the Old World – a trend to which the activities of dealers like Joseph Duveen gave an added impetus. For this reason, some of the most spectacular examples of this art are in America, the Fragonard panels of the *Pursuit of Love* and the Boucher *Seasons* in the Frick Collection in New York, and other superb pictures in the Metropolitan Museum and in Washington. Other American museums with notable collections of the period are Detroit, Fort Worth, Toledo (Ohio) and San Francisco.

In England, by far the finest collection of French eighteenth-century art is the Wallace Collection, formed mainly by the fourth Marquess of Hertford (1800–1870) and his son, Sir Richard Wallace (1818–1890). These paintings can still be enjoyed in an atmosphere similar to that of a private residence of the period, enhanced by contemporary furniture, sculpture and objets d'art. Outside London, and all too rarely visited, is the Bowes Museum at Barnard Castle – a remarkable northern bastion of nineteenth-century taste in eighteenth-century art, created by John Bowes and his wife Josephine. The National Gallery has a small but expanding section of good French eighteenth-century paintings, recently increased by some important acquisitions.

There are, finally, notable collections of eighteenth-century French art in Stockholm, largely bought by Count Tessin, Swedish Ambassador to France under Louis XV; and Catherine the Great's superb pictures in the Hermitage (Leningrad), mostly bought directly from the artists on the advice of Diderot.

The following index of museums is listed by towns; unless otherwise stated the collection is in the town's principal museum. In the case of Paris, the particular museum is always noted: e.g. Paris, Louvre, Paris, Musée Jacquemart-André. An asterisk denotes a particularly good sample of the artist's work. This list is intended only as a guide and makes no claim to completeness.

Nantes
Narbonne
New York
 Frick Collection
 Metropolitan Museum
Paris
 Musée Jacquemart-André
 *Louvre
Reims
Rouen
San Diego
Toledo, Ohio
Toulon
Tourcoing
Troyes
Valence
*Versailles
 Château
Vienna

DESHAYS
Angers
Auxerre
Besançon
Montpellier
Paris
 Musée Cognacq-Jay
*Rouen

DESPORTES
Angers
Brunswick
Chantilly
Compiègne
 Château
Fontainebleau
Grenoble
Karlsruhe
*Le Havre
London
 Wallace Collection
Lyon
Marseille
*Paris
 Louvre
Rouen
Saltram
 Devon National Trust
Stockholm

DOYEN
Arras
Bayonne
Budapest
Leningrad
Paris
 Louvre
 *Église Saint-Roch
 Musée Carnavalet
Parma
Poitiers
Versailles
 Château
There are several important landscape
sketches by Doyen in the Tretiakoff
Museum, Moscow.

DROUAIS
Amiens
Chantilly
La Fère
London
 National Gallery
Melbourne
*New York
 Metropolitan Museum
Orléans
Paris
 Musée Cognac-Jay
 *Louvre
*Sao Paolo, Brazil
Rouen
Stockholm
Washington
 National Gallery

DUMONT LE ROMAIN
Alençon
Azay-le-Ferron
 Château
Besançon
La Fère
Paris
 Louvre
Plessis-les-Tours
 Château
Saint-Omer
 Hôtel Sandelin
Tours

DUPLESSIS
Amiens
Avignon
Bayeux
Brest
*Carpentras
*Chantilly
Chartres
Clermont-Ferrand
Coppet
 Château, Vaud, Switzerland
Karlsruhe
London
 National Portrait Gallery
Metz
Montauban
New York
 Metropolitan Museum
Nice
Orléans
Paris
 *Louvre
 Musée Camondo
Perpignan
San Francisco
*Versailles
 Château
Vienna

DURAMEAU
Besançon
Grenoble
Melun
Paris
 Chapelle de L'École Militaire
 Église Saint-Nicolas
 du Chardonnet
 Louvre
Riom
Versailles
 Opéra

FRAGONARD
*Amiens
Angers
Barcelona
 Museum of Modern Art
Barnard Castle
 Bowes Museum
*Besançon
 drawings
Chartres
Cincinnati
 Art Museum
Columbus, Ohio
Detroit
Fort Worth, Texas
Grasse
 Musée Fragonard
Hamburg
Hartford, Connecticut
Le Havre
Leningrad
*Lisbon
 Gulbenkian Foundation
London
 National Gallery
 *Wallace Collection
Los Angeles
New York
 *Frick Collection
 Metropolitan Museum
Nice
Orléans
Paris
 Musée Cognacq-Jay
 Musée Jacquemart-André
 *Louvre
Pasadena
 Norton Simon Foundation
Quimper
Rouen
Saint-Louis
San Diego
San Francisco
Toledo, Ohio
Troyes
Washington
Williamstown, Mass.
Worcester, Mass.

GALLOCHE
Arles
Caen
Montargis
Nancy
Orléans
Paris
 Louvre
Reims

Rennes
Varzy
Versailles
 Château

GILLOT
Abbeville
*Langres
Paris
 Louvre
Warsaw

GREUZE
Aix-en-Provence
Angers
Baltimore
Boston
Budapest
Besançon
Chartres
Chicago
Detroit
Fort Worth, Texas
Houston, Texas
 Blaffer Foundation
Leningrad
Lille
*London
 Wallace Collection
Lyon
Mâcon
Metz
*Montpellier
Moscow
Munich
Nantes
New Orleans
New York
 Frick Collection
 Metropolitan Museum Paris
 Musée Cognacq-Jay
 Musée Jacquemart-André
 *Louvre
Portland, Oregon
Richmond, Virginia
San Francisco
Stockholm
Tournus
 Musée Greuze
Upton House, Warwickshire
Vienna
Warsaw

GRIMOU
Antwerp
Arles
Avignon
Bayeux
Besançon
Béziers
Bordeaux
Boston
Bourg-en-Bresse
Chantilly
Dijon
 Musée Magnin
Douai
Dresden
*Florence
 Uffizi
Grenoble
Karlsruhe
Lausanne
Le Mans
Metz
Montpellier
Nantes
Nîmes
Niort
Orléans
Paris
 Louvre
Perpignan
Rouen
Saint-Étienne
The Hague
Toulouse
Worcester, Mass.

HOIN
*Dijon
 Musée des Beaux-Arts
Langres
Paris
 Musée Cognacq-Jay
Toulouse

HALLÉ, Daniel
Clermont-Ferrand
Rouen

HALLÉ, Noël
Angers
Dijon
 Musée Magnin
Leningrad
Lille
Limoges
Marseille
Montpellier
Orléans
Paris
 Musée Carnavalet
 Église Saint-Sulpice
 Louvre
 Petit-Trianon
Versailles
Saint-Étienne
Warsaw

HOUEL
Angers
Paris
 Louvre
Rouen
*Tours

JEAURAT
Auxerre
Besançon
Blois
Cambrai
Compiègne
Fontainebleau
 Château
La Fère
Leningrad
Nantes
Orléans
Oxford
 Ashmolean Museum
Paris
 *Musée Carnavalet
 Musée Cognacq-Jay
 Église Saint-Bernard-
 de-la-Chapelle
Roanne

JOUVENET
Aix-en-Provence
Alençon
Amiens
Bâle
Besançon
Bourges
Caen
Château-Gontier
Dijon
Épinal
Florence
 Uffizi
Fontainebleau
Grenoble
Karlsruhe
La Fère
Le Mans
Leningrad
Lille
*Lyon
Madrid
Montauban
Montpellier
Munich
Nancy
Nantes
*Paris
 Louvre
Rennes
*Rouen
Stockholm
Toledo, Ohio
Toulouse
Tours
Versailles
 Salle de Mars
 Grand Trianon

LABILLE-GUIARD
Arizona
 Phoenix Art Museum
Boston
Dijon
 Musée Magnin
Milan
 Scala Museum
Montpellier
*New York
 Metropolitan Museum
Paris
 Musée des Arts Décoratifs
 Musée Cognacq-Jay
 Louvre

Quimper
*Versailles
 Château

LACROIX DE
MARSEILLE
Agen
Amiens
Angers
Avignon
Berlin, Dahlem
Besançon
Bordeaux
Bourg-en-Bresse
Dijon
 *Musée des Beaux-Arts
 Musée Magnin
La Fère
Libourne
Marseille
Montauban
Orléans
Quimper
Rouen
Saint-Omer
 Hôtel Sandelin
Toledo, Ohio
Toulouse
*Uppark
 Sussex, National Trust

LA FOSSE
Agen
Barnard Castle
 Bowes Museum
Compiègne
 Château
Darmstadt
Dijon
 Musée des Beaux-Arts
 Musée Magnin
Frankfurt
Grenoble
Leningrad
Le Puy
Lille
Lyon
Marseille
 Musée Cantini
Moscow
Nancy
Nantes
Nevers
Paris
 Musée des Arts
 Décoratifs
 École des Beaux-Arts
 *Louvre
Rouen
Toronto
Tours
Versailles
 Château
 Grand Trianon

LA GRENÉE
Angers
Aurillac
Bayeux
Brest
Chalon-sur-Sâone
Compiègne
 Musée Vivenel
 Château
Dijon
 Musée des Beaux-Arts
Douai
Fontainebleau
Glasgow
Leningrad
Le Puy
Lille
Madrid
Marseille
 Musée Grobet-Labadié
Montpellier
Morez
Narbonne
Orléans
Paris
 Louvre
*Stockholm
*Stourhead
 Wiltshire, National Trust
Toulon
Toulouse
Warsaw

LALLEMAND
Angers
Bordeaux
Bourg-en-Bresse
Chartres
*Dijon
La Fère
Le Mans
Mâcon
Nantes
Leningrad
Paris
 Musée Carnavalet
Rome
Ypres

LANCRET
Amiens
*Angers
*Berlin
Besançon
Caen
Chantilly
Chicago
Compiègne
Detroit
Dresden
Edinburgh
Fontainebleau
Illinois
 University
 Krannert Art Museum
Karlsruhe
*Leningrad
London
 National Gallery
 Wallace Collection
Lyon
Munich
*Nantes
Orléans
Paris
 Musée Jacquemart-André
 *Louvre
Potsdam
 Altes Schloss
 Sans-Souci
Richmond, Virginia
Rome
 Palazzo Barberini
Rouen
Rotterdam
San Francisco
Stockholm
Toledo, Ohio
Tours
Washington
Williamstown, Mass.

LARGILLIERRE
Abbeville
Aix-en-Provence
Amiens
Arles
Arras
Avignon
Azay-le-Féron
 Château
Besançon
Bourg-en-Bresse
*Chantilly
Châteauroux
Cherbourg
Coughton Court, Warwickshire
Detroit
Dijon
 Musée des Beaux-Arts
 Musée Magnin
Douai
Dresden
Épinal
*Grenoble
Hartford, Connecticut
Karlsrühe
Lausanne
Le Mans
Leningrad
Lille
London
 National Gallery
 National Portrait Gallery
Lyon
Mâcon
Marseille
 Musée Grobet-Labadié
Montpellier
Moscow
Nancy
Nantes

New York
 Metropolitan Museum
Nîmes
Orléans
Paris
 Musée Cognacq-Jay
 *Louvre
Pasadena
 Norton Simon Foundation
Pau
Perpignan
Ponce, Puerto Rico
Rotterdam
Rouen
Saint-Louis
Soissons
Stockholm
Strasbourg
Toledo, Ohio
Toulon
Toulouse
Tours
Warsaw
Washington

LA TOUR
Aix-en-Provence
Amiens
Bordeaux
Dijon
*Geneva
Lille
London
 National Gallery
Munich
Paris
 Musée Cognacq-Jay
*Saint-Quentin
Toledo, Ohio
Washington

LEMOINE
Albi
Angers
Bernay
Besançon
Dijon
Épinal
Hanover
Leningrad
 Hermitage Museum
*London
 Wallace Collection
Marseille
 Cantini
Munich
Nancy
Nantes
 Cathedral
Paris
 École des Beaux-Arts
 Église Saint-Suplice
 Louvre
Sens
 Cathedral
Stockholm
Strasbourg
Toulouse
Tours
*Versailles
 Château
Warsaw

LEPICIE
Abbeville
Amiens
Bourges
Carcassonne
Chartres
Cologne
Dijon
 Musée Magnin
Le Havre
Lille
London
 Wallace Collection
Lyon
Montauban
Paris
 Louvre
Pau
 Château
Rennes
Quimper
*Saint-Omer
 Hôtel Sandelin
Saint-Quentin
Tours
Troyes

LE PRINCE
Angers
Besançon
Dijon
 Musée des Beaux-Arts
 Musée Magnin
Orléans
Paris
 Musée Cognacq-Jay
 Louvre
Riom
Rouen
Saint-Jean-Cap-Ferrat
Toledo, Ohio
Tarbes

LOIR, MARIANNE
Auxerre
Bordeaux
Pau
Tours

LOUTHERBOURG
Amiens
Angers
Bath
Bristol
Dublin
Leicester
Leeds
Leningrad
Liverpool
London
 British Museum
 National Portrait Gallery
 Science Museum
 Tate Gallery
 Victoria and Albert Museum
New York
 Metropolitan Museum
Oxford
Plymouth
Southampton
Stockholm
*Strasbourg
Toronto
York

MANGLARD
Budapest

MERCIER
Dijon
London
 National Portrait Gallery
Strasbourg
York

MOREAU
Chartres
Compiègne
Dijon
 Musée Magnin
Madison, Wisconsin
Paris
 Louvre
The Hague

NATOIRE
Arras
Autun
 Musée Rolin
Besançon
 Cathedral
Bordeaux
Compiègne
 Château
Dijon
Le Havre
Leningrad
Montargis
New Orleans
Nîmes
Orléans
Paris
 École des Beaux-Arts
 Église Saint-Médard
 *Hôtel de Soubise
 *Louvre
Rennes
Saint-Étienne
Stockholm
*Troyes
Versailles
 Château
Warsaw
Drawings:
 Montepellier,
 Musée Atger,

Paris,
 Louvre,
 Cabinet des Dessins

NATTIER
Amiens
Bordeaux
Chalon-sur-Saône
*Chantilly
 Musée Condé
Cincinnati
 Art Museum
Copenhagen
Detroit
Dijon
Dresden
Florence
 Pitti Palace
Frankfurt
Geneva
Leningrad
Limoges
London
 National Gallery
 Wallace Collection
Marseille
Munich
New York
 Frick Collection
 Metropolitan Museum
Oberlin
Orléans
Paris
 Musée Cognac-Jay
 Musée Jacquemart-André
 *Louvre
Ponce, Puerto Rico
Richmond, Virginia
Saint-Omer
San Francisco
*Stockholm
Toledo, Ohio
*Versailles
 Château
Warsaw
Washington

NONNOTTE
*Besançon
Bordeaux
Chaâlis
 Abbaye
Châlons-sur-Marne
Dijon
Lyon
Orléans
Villefranche-sur-Saône

OPPENORD
Drawings:
 Berlin
 Paris
 Musée des Arts Décoratifs
 Cabinet des Estampes
 Louvre

OUDRY
Agen
Amiens
Ansbach
Barnard Castle
 Bowes Museum
Beauvais
Chantilly
Château-Thierry
 Musée La Fontaine
Cherbourg
Compiègne
 Château
Dieppe
Dijon
 Musée des Beaux-Arts
 Musée Magnin
*Fontainebleau
Geneva
Gien (Loiret)
Hartford, Connecticut
Leningrad
Le Mans
Lille
*London
 Wallace Collection
Lons-le-Saunier
Madrid
Metz
Montpellier
Moscow
Nantes
Narbonne

New York
 Metropolitan Museum
Paris
 Musée des Arts Décoratifs
 *Musée de la Chasse
 Louvre
 Musée Nissim de Camondo
*Schwerin
Senlis
 Musée de la Vénerie
Strasbourg
Toledo, Ohio
Versailles
 Château
Warsaw
Worcester, Mass.

PATER
Amiens
Angers
Caen
Chicago
Detroit
Dresden
Edinburgh
Frankfurt
Grenoble
Indianapolis
Leningrad
London
 Dulwich
 Kenwood House
 Victoria and Albert Museum
 *Wallace Collection
Moscow
Munich
New York
 Frick Collection
 Metropolitan Museum
Paris
 Musée Cognacq-Jay
 *Louvre
Pasadena
 Norton Simon Foundation
*Potsdam
 Neues Schloss
Rotterdam
Saint-Louis
San Francisco
Stockholm
Toledo, Ohio
Valenciennes
Versailles
 Petit Trianon
Washington
 Corcoran
 National Gallery
Worcester, Mass.

PERRONNEAU
Bordeaux
Brussels
Chicago
Detroit
Dijon
 Musée Magnin
Dublin
Geneva
Karlsruhe
Leningrad
 Hermitage Museum
Lyon
 Musée des Arts Décoratifs
London
 National Gallery
*Orléans
Paris
 Musée Cognacq-Jay
 Louvre
Saint-Quentin
Tours
Valence

PIERRE
Aix-en-Provence
Antwerp
Arras
Auxerre
Avignon
Caen
*Detroit
Dijon
Karlsruhe
Le Puy
Marseille
Meaux
New York
 Metropolitan Museum
Nîmes
Orléans

Paris
 Église Saint-Suplice
 Louvre
Poitiers
Rouen
Stanford, California
Strasbourg
Versailles
 Cathedral

PILLEMENT
Antwerp
Avignon
Besançon
Béziers
Bordeaux
Carcassonne
Chalon-sur-Saône
Detroit
Dijon
 Musée Magnin
Karlsruhe
Leningrad
*Lisbon
Lyon
*Lyon
 Musée des Arts Décoratifs
Montpellier
Newcastle
Nantes
Orléans
*Paris
 Musée des Arts Décoratifs
Perpignan
Philadelphia
Quimper
Reims
Rouen
Toulouse
Warsaw

ROLAND DE LA PORTE
*Bordeaux
Cambrai
Hartford, Connecticut
 Wadsworth Atheneum
*Karlsruhe
*Paris
 Louvre
Rotterdam

RAOUX
Aix-en-Provence
Arras
*Bayeux
Béziers
Carcassonne
Chartres
Dijon
Douai
Grenoble
London
 Wallace Collection
Lyon
Marseille
Montauban
*Montpellier
Nantes
Niort
Orléans
Paris
 Louvre
Potsdam
 Neues Schloss
Riom
Toulon
Tours

RESTOUT
Angers
Amiens
Arras
Caen
Dijon
Greenville, South Carolina
Grenoble
Le Mans
 Église Notre-Dame de la Couture
Lille
Lyon
Nancy
*Orléans
Orléans
 Église Saint Pierre de Martroi
Paris
 Archives Nationales
 Église Sainte-Marguerite
 Église Saint-Roch
 Louvre

Rouen
Saint-Quentin
Stockholm
Versailles
 Château
Vire
Warsaw

RIGAUD
Abbeville
*Aix-en-Provence
Ascott, Buckinghamshire
Arras
Bar-le-Duc
Besançon
Blois
Bourges
Budapest
Caen
Cambrai
Carpentras
Chartres
Chantilly
Châteauroux
Cherbourg
Clermont-Ferrand
Dieppe
Dijon
Dunkerque
Grenoble
London
 Kenwood House
 National Gallery
 Wallace Collection
Lyon
Marseille
Metz
Melbourne
Montpellier
Nancy
Nantes
Narbonne
Nîmes
Pau
Paris
Pasadena
 Norton Simon Foundation
*Perpignan
Quimper
Reims
Rouen
Saintes
Stockholm
Strasbourg
Toledo, Ohio
Toulouse
Tours
Valenciennes

ROBERT
Amiens
Angers
Avignon
*Barnard Castle
 Bowes Museum
Besançon
Birmingham
 Barber Institute
Bordeaux
Bourges
Bristol
Budapest
Chartres
Château-Thierry
 Musée La Fontaine
Cherbourg
Detroit
Dijon
 Musée des Beaux-Arts
Dole
Épinal
Étampes
Fort Worth, Texas
Le Havre
Leningrad
Lille
Limoges
Lyon
Marseille
Minneapolis
Montpellier
Munich
New York
 Metropolitan Museum
Nice
Orléans
Paris
 *Musée Carnavalet
 *Louvre
Pau

Philadelphia
 Museum of Art
Quimper
Rotterdam
Rouen
Richmond, Virginia
St Louis
Stockholm
Strasbourg
Tours
Troyes
Valence
Valenciennes
Versailles
 Château
Warsaw
Washington
Worcester, Mass.

SANTERRE
Avignon
Dunkerque
Le Mans
Le Puy
Libourne
Lyon
Mâcon
Magny-en-Vexin
Orléans
Poitiers
*Rouen
Tours

SUBLEYRAS
Agen
Aix-en-Provence
*Amiens
Auch
Béziers
Birmingham
 City Art Gallery
Carcassone
Chalon-sur-Saône
Chantilly
Geneva
Leeds
 City Art Gallery
Leningrad
Montauban
*Montpellier
Munich
Nantes
Nîmes
Niort
Orléans
Paris
 Louvre
Rome
San Francisco
Stockholm
*Toulouse
Warsaw
Worcester, Mass.

TOCQUÉ
Amalienborg Castle, Denmark
Amiens
Antwerp
 Van den Bergh Museum
Boston
Chaâlis
 Abbaye
Copenhagen

Dijon
Frederiksborg, Denmark
Grenoble
Leningrad
London
 National Gallery
Marseille
Metz
Moscow
Munich
Nancy
Orléans
Paris
 Musée Carnavalet
 Musée Jacquemart-André
 *Louvre
Stockholm
*Versailles

SANTERRE
Angers
Budapest
Caen
Cherbourg
Dijon
 Musée des Beaux-Arts
 Musée Magnin
Grenoble
Hull
Marseille
*Nantes
Orléans
Paris
 Louvre
Quimper
Rennes
Rouen
Saint-Quentin

TREMOLLIERE
Cholet
Montpellier
Niort
Quimper

TROY, DE
Amiens
Angers
Berlin
 Charlottenburg Palace
Berne
Besançon
Birmingham
 Barber Institute
Cambridge
*Chantilly
Chaumont
Clermont-Ferrand
Dijon
 Musée des Beaux-Arts
 Musée Magnin
Leningrad
Le Puy
London
 National Gallery
 Victoria and Albert Museum
 Wallace Collection
Lyon
Marseille
Montpellier
Nancy
Nantes
*Neuchâtel

New York
 Metropolitan Museum
Nîmes
Orléans
Ponce, Puerto Rico
Paris
 Louvre
Rouen
Saint-Quentin
Strasbourg
Toulouse

VALLAYER-COSTER
*Barnard Castle
 Bowes Museum
Berlin, Dahlem
Dijon
Épinal
Geneva
Le Mans
Nancy
Narbonne
New York
 Metropolitan Museum
Ottawa
Paris
 Louvre
 Musée Nissim de Camondo
Reims
Strasbourg
*Toledo, Ohio
Versailles

VANLOO family
Aix-en-Provence
Alençon
*Amiens
Angers
Besançon
Bordeaux
Cambrai
Châlons-sur-Marne
Chalon-sur-Saône
Chartres
Dijon
 Musée des Beaux-Arts
 Musée Magnin
Épinal
Houston, Texas
 Blaffer Foundation
Le Mans
Lenigrad
London
 Wallace Collection
Lyon
Marseille
Montpellier
Nancy
Nice
Niort
Paris
 *Église Notre-Dame-des-Victoires
 Louvre
Pau
Rennes
Richmond, Virginia
Rouen
Saint-Quentin
Stockholm
Toulon
Tours

VERNET
*Avignon

Barnard Castle
 Bowes Museum
Bristol
Budapest
Cheltenham
Dijon
Hartford, Connecticut
 Wadsworth Athenaeum
Karlsruhe
Leningrad
London
 National Gallery
 Wallace Collection
 Wellington Museum
Minneapolis
Moscow
 Pushkin Museum
Munich
New York
 Metropolitan Museum
Nîmes
Orléans
Oxford
Paris
 *Louvre
 *Musée de la Marine
*Stockholm
Toledo, Ohio
*Uppark
 Sussex, National Trust
Versailles
 Château
*Warsaw

VESTIER
Amiens
Avallon
Dijon
Épinal
New York
 Metropolitan Museum
Paris
 Musée des Arts Décoratifs
 Musée Carnavalet
 Louvre
 Musée de l'Opéra
Pontoise
Tours
Upton House, Warwickshire
Versailles
 Château

VIEN
Abbeville
Aix-en-Provence
Alais
Algiers
*Amiens
Angers
Béziers
Bordeaux
Brest
Douai
Épinal
*Fontainebleau
 Château
Grenoble
La Fère
Langres
La Rochelle
*Le Havre
Marseille
Montpellier
Nancy

Nantes
Narbonne
Nice
Orléans
Paris
 Eglise Saint-Roch
 Louvre
Reims
Rouen
Troyes
Versailles
 Trianon
Warsaw

VIGÉE-LEBRUN
Aix-la-Chapelle
Angers
Avignon
Berne
Bordeaux
Boston
Caen
Chantilly
Cincinnati
 Art Museum
Darmstadt
Detroit
Dieppe
Florence
 Uffizi
*Fort Worth, Texas
Geneva
Grenoble
La Fère
Leningrad
London
 National Gallery
Madrid
Montpellier
*Moscow
New York
 Metropolitan Museum
Paris
 Musée Jacquemart-André
 Louvre
Parma
Ponce, Puerto Rico
Richmond, Virginia
Rouen
Stockholm
Toledo, Ohio
Toulouse
Turin
*Versailles
 Château
Vienna
 Czernin Museum
Waddesdon, Buckinghamshire
Warsaw
Williamstown, Mass.

VLEUGHELS
Angers
Bayreuth
 Neues Schloss
Caen
Leningrad
Paris
 Louvre
Pavlovsk
 Castle
Rome
 Galleria dell'Academmia
 di San Luca
Toulouse

Valenciennes
Versailles

VINCENT
Amiens
Angers
Besançon
Bordeaux
Caen
La Rochelle
Marseille
Montpellier
Orléans
Paris
 Chambre des Députés
 Louvre
Rouen
Toulouse
Valence
Valenciennes
Versailles

VOLAIRE
Agen
Avignon
Clamecy
Derby
Le Havre
Nantes
Narbonne
Richmond, Virginia
Rouen
Toulon
Toulouse

WATTEAU
Angers
Berlin
 *Dahlem
 Charlottenburg Palace
Boston
Caen
Chantilly
Dresden
Dublin
Edinburgh
Glasgow
 City Art Gallery
Hartford, Connecticut
Leningrad
London
 Dulwich College
 Kenwood House
 *National Gallery
 Soane Museum
 *Wallace Collection
Madrid
Moscow
Nantes
New York
 Metropolitan Museum
Orléans
*Paris
 Louvre
Pasadena
 Norton Simon Foundation
Richmond, Virginia
Rotterdam
Stockholm
Toledo, Ohio
Troyes
Valenciennes
Waddesdon, Buckinghamshire
Washington
York

Bibliography

SOURCES AND CONTEMPORARY CRITICISM

Bachaumont, L. P. de, *Mémoires secrets pour servir à l'histoire de la république des lettres en France*, London edition, 1777.
Barbier, *Chronique de la Régence et du règne de Louis XV (1718–1765)*, 8 vols, 1866.
Brosses, C. de, *Lettres familières écrites d'Italie en 1739 et 1740*, Paris, 1869.
Cochin, C.-N., *Voyage d'Italie*, 1758.
d'Argenson, *Journal et Mémoires*, 1859–67 edition.
Diderot, D., *Salons* (edited by J. Adhémar and J. Seznec), Oxford, 1957–67.
Duclos, *Considérations sur les Moeurs de ce siècle*, Paris, 1751.
Engerand, F., *Inventaire des tableaux commandé par les Bâtiments du Roi*, Paris, 1901.
Grimm, *Correspondance littéraire*, edited by M. Tourneux, 16 vols, 1877–82.
Guiffrey, J.-J. (ed), *Livrets of the Salons 1673–1800*, Paris, 1869–71.
La Font de Saint-Yenne, *Réflexions sur quelques causes de l'état présent de la peinture en France . . . 1746*, Paris, La Haye, 1747.
Le Blanc, J. B., *Lettre sur l'exposition des ouvrages de peinture . . . de l'année 1747*, Paris, 1747.
Mariette, P. J., *Abécédario*, published by Ph. de Chennevières and A. de Montaiglon, Paris, 1851–1860 (6 vols).
Marmontel, J. F., *Mémoires*, Paris, 1804 edition.
Mercier, L. S., *Tableau de Paris*, Amsterdam, 1783–9.
du Peloux, Vicomte, *Répertoire biographique et bibliographique du 18ᵉ siècle*, Paris, 1932.
Piles, R. de, *Dialogue sur le coloris*, 1673; *Conversations sur la peinture*, 1677.
Vallière, duc de la, *Dictionnaire de Ballets, Opéra et autres ouvrages lyriques*, Paris, 1760.
Vigée-Lebrun, Mme E., *Souvenirs, 1755–89*, published by P. de Nolhac, Paris, 1910.
Watelet, C. H., *L'Art de peindre, suivi de Réflexions sur différentes parties de la peinture*, Paris, 1760; *Essai sur les jardins*, 1774.

For a fuller bibliography of eighteenth-century art-criticism, see
H. Zmijewska, 'La critique des Salons avant Diderot', *G.B.A.*, 1970.

GENERAL SURVEYS OF THE PERIOD

Bryson, Norman, *Word and Image: French Painting of the Ancien Régime*, Cambridge, 1981.
Conisbee, P., *Painting in Eighteenth-Century France*, London, 1981.
Dilke, Lady E., *French Painters of the XVIII century*, London, 1899.
Dimier, L. (ed.), *Les Peintres français du XVIII siècle*, Paris et Bruxelles, 1928.
Florisoone, M., *Le Dix-huitième siècle*, Paris, 1948.
Goncourt, E. et J. de, *L'Art du dix-huitième siècle*, Paris, 1859–75. *Portraits intimes du dix-huitième siècle*, 1857–8.
Hobson, Marian, *The Object of Art: The Theory of Illusion in Eighteenth-Century France*, Cambridge, 1982.
Kimbell, F., *The Creation of the Rococo*, Philadelphia, 1943.
Levey, M., *Rococo to Revolution*, London, 1966.
Levey, M. and Kalnein, Graf. W., *Art and Architecture of the Eighteenth Century in France*, Pelican History of Art, Harmondsworth, 1972.
Locquin, J., *La peinture d'histoire en France de 1747–1785*, Paris, 1912.
Réau, L., *Histoire de la peinture française au XVIIIᵉ siècle*, Paris, 1925–6.

Rosenblum, R., *Transformations in late eighteenth-century art*, Princeton, 1967.
Thuillier, J. and Chatelet, A., *La peinture française de Le Nain à Fragonard*, Geneva, 1964.

EXHIBITION CATALOGUES OF FRENCH EIGHTEENTH-CENTURY ART (exhibitions devoted to particular artists are listed separately)

De Watteau à David, Palais des Beaux-Arts, Bruxelles, 1975.
De David à Delacroix, Grand Palais, Paris, 1974.
European masters of the 18th century, Royal Academy, London, 1954–55.
France in the eighteenth century, Royal Academy, London, 1968.
Louis XV: Un Moment de Perfection de l'Art Français, Hôtel de la Monnaie, Paris, 1974.

SOCIAL, LITERARY BACKGROUND AND PATRONS

Behrens, C. B. A., *The Ancien Régime*, London, 1967.
Carré, H., *La noblesse de France et l'Opinion Publique au XVIII siècle*, Paris 1920.
Cassirer, E., *The Philosophy of the Enlightenment*, Princeton, 1951.
Corvisier, A., *Arts et Sociétés dans l'Europe du XVIII siècle*, Paris, 1978.
Courville, X. de, *Luigi Riccoboni, dit, Lelio*, [n.d.].
Dacier, E., 'Choiseul collectionneur', *G.B.A.*, 1949.
Ducros, L., *French Society in the eighteenth century*, English translation, London, 1926.
Duncan, C., 'Happy Mothers and other New Ideas in French Art', *Art Bulletin*, LV, 1973.
Folkierski, W., *Entre le Classicisme et le Romantisme*, Paris, 1925.
Fontaine, A., *Les doctrines d'art en France de Poussin à Diderot*, Paris, 1909.
Hazard, P., *La pensée européenne au XVIII siècle*, Paris, 1946.
Lough, J. *An Introduction to Eighteenth Century France*, Longmans, 1960.
Mornet, D., *Le sentiment de la nature en France de J.-J. Rousseau à Bernardin de Saint-Pierre*, Paris, 1907.
Nicolson, H., *The Age of Reason (1700–1789)*, London, 1960.
Picard, R., *Les Salons littéraires et la société française (1610–1789)*, Paris, 1943.
Rocheblave, S., *L'art et le goût en France de 1600 à 1900*, Paris, 1930. *Essai sur le comte de Caylus*, Paris, 1889. *Les Cochin*, Paris, 1893.
Saisselin, R. C., 'Ut Pictura Poesis; Dubos to Diderot', *Journal of Aesthetics and Art Criticism*, Vol. XX, 1961.
Seznec, J., *Essais sur Diderot et l'Antiquité*, Oxford, 1957.
Stuffman, M., 'Les tableaux de la collection de Pierre Crozat', *G.B.A.*, 1968.
Tocqueville, A. de, *The Ancien Régime and the French Revolution*, Fontana edition, London, 1966.
Trahard, P., *Les Maîtres de la Sensibilité Française au XVIII siècle*, Paris, 1933 (4 vols).
Wiebenson, D., *The Picturesque Garden in France*, Princeton, 1978.
Wildenstein, G., 'Un Amateur de Boucher et de Fragonard: Jacques Onésyme Bergeret', *G.B.A.*, 1961. 'L'Abbé de Saint-Non artiste et mécène', *G.B.A.*, 1959.

INDIVIDUAL ARTISTS

The great majority of French eighteenth-century artists still have no adequate monograph. The most valuable source of general information (apart from the standard dictionaries by Thieme Becker and E. Bénézit) on this period are the

various repertories by the Vicomte du Peloux, especially his *Répertoire biographique et bibliographie des Artistes du XVIII siècle français*, 2 vols. Paris 1930-1941, and the *Répertoire général des Ouvrages modernes relatifs au XVIII siècle français (1715–1789)*, Paris 1926. Useful biographies, mostly followed by bibliographies and an attempt at a *catalogue raisonné*, are contained in the *Peintres français du XVIII siècle* (Paris and Brussels 1928) edited by Louis Dimier; the entries, by a team of writers, cover many artists of the first half of the century, including Arnulphy, Bonaventure de Bar, Antoine Coypel, de Troy, Dumont le Romain, Galloche, Gamelin, Gillot, Grimou, Lajoue, Lemoine, Meissonnier, Nattier, Octavien, Oppenord, Oudry, Quillard, Raoux, Servandoni, Subleyras, Tournières, Trémollière, C. de Vermont, Watteau and many others. This work was never completed. For many other artists the only source of information is in exhibition catalogues, of which the following are especially useful: *De Watteau à David. Peintures et Dessins des musées de province française*. Bruxelles, 1975 (with excellent bibliography), *France in the eighteenth century*, R. A., London 1968 (though with many errors) and, for the latter part of the century, *De David à Delacroix*, Grand Palais 1974. For history painters after 1750 the best succinct accounts are still those by J. Locquin in *La peinture d'histoire en France de 1747–1785*, Paris, 1912, which also contains an exhaustive (though now very dated) bibliography. The principal monographs and articles covering artists' work as a whole are listed below.

AUBRY, Etienne
 Ingersoll Smouse, F. 'Quelques tableaux de genre inédits par Etienne Aubry (1745–1781)' *G.B.A.*, 1925.
AVED, Jacques-André-Joseph (1702–1766)
 Wildenstein, G. *Le peintre Aved*, Paris, 1922 (2 vols).
 Wildenstein, G. 'Premier supplément à la bibliographie du catalogue de J.-A.-J. Aved', *G.B.A*, 1935.
BACHELIER, Jean-Jacques (1724–1806)
 Entries in exhibition catalogues *De Watteau à David*, 1975 and *France in the eighteenth century*, 1968.
BARBAULT, Jean (1718–1762)
 Entry in catalogue *De Watteau à David*.
 Rosenberg, P. 'Jean Barbault', *Arte Illustrata*, November 1972.
BOUCHER, François (1703–1770)
 Ananoff, A. *Boucher: Peintures*, Bibliothèque des Arts, Geneva, 1976 (2 vols).
 Cailleux, Galerie. Exhibition catalogue: *François Boucher, premier peintre du roi (1703–1770)*, Paris, 1964.
 Michel, A. *Catalogue raisonné de l'oeuvre peint et dessiné de F. Boucher*, Paris, 1907.
 Nolhac, P. de. *Boucher*, Paris, 1925.
 Voss, H. 'Boucher's Early Development', *Burlington Magazine*, March 1953.
BRENET, Nicolas-Guy (1728–1792)
 Sandoz, M. 'Nicolas-Guy Brenet, peintre d'histoire (1728–1792)', *B.S.H.A.F.*, 1960.
CARMONTELLE, Louis Carrogis (1717–1806)
 'Un gentilhome artiste: Carmontelle. D'après deux documents inédits', *G.B.A.*, 1908.
CHARDIN, Jean-Baptiste Siméon (1699–1779)
 Ponge, F. 'De la nature morte et de Chardin', *Art de France*, 1963.
 Rosenberg, P. *Chardin*, Geneva, 1963.
 Wildenstein, G. *Chardin*, Second edition, Zurich, 1963.
COLLIN DE VERMONT (1695–1761)
 Messelet, J. 'Collin de Vermont', *Les peintres français du XVIII siècle* (Vol II), Paris et Bruxelles, 1928–30.
COLSON, Jean-François Gilles (1733–1803)
 Ponce, N. 'Note sur J. F. Colson, peintre', *Revue Universelle des Arts*, Vol. 20, 1865.
 Tourneux, M. 'Jean-Baptiste et Jean François Colson', *G.B.A.*, 1898.

COYPEL, Antoine (1661–1722)
 Dimier, L. 'Antoine Coypel'. *Les peintres français du XVIII siècle*, Vol. I.
 Wildenstein, D. 'L'oeuvre gravé des Coypel, II: Antoine Coypel', *G.B.A.*, 1964.
DANLOUX, Henri-Pierre (1753–1809)
 Portalis, Baron R. *Danloux et son journal durant l'émigration (1753–1809)*, Paris, 1910.
DAVID, Jacques Louis (1748–1825)
 Delécluze, E. J. *David son école et son temps*, Paris, 1855.
 J. L. Jules David. *Le peintre Louis David (1748–1825), Souvenirs et documents inédits*, Paris, 1880.
 Hautecoeur, L. *Louis David*, Paris, 1954.
 Levey, M. 'Reason and Passion in Jacques-Louis David', *Apollo LXXX*, Sept. 1964.
 Brookner, A. *David*, London, 1982.
DESHAYS, Jean-Baptiste (1729–1763)
 Sandoz, M. *Jean-Baptiste Deshayes 1729–1763*, Quatre Chemis, Paris, 1977.
DESPORTES, François (1666–1743)
 Lastic, G. de. 'Desportes et Oudry', *Connoisseur*, Dec. 1977.
DOYEN, Gabriel François (1726–1806)
 Sandoz, M. *Gabriel François Doyen*, Paris, 1975.
DROUAIS, François-Hubert (1727–1775)
 Gabillot, C. 'Les trois Drouais' [five articles], *G.B.A.*, 1905–1906.
DUMONT, Jacques, called le Romain (1701–1781)
 Lossky, B. 'L'oeuvre de Jacques Dumont le Romain', *G.B.A.*, 1964.
DUPLESSIS, Joseph Siffred (1725–1802)
 Belleudy, J. *J. S. Duplessis, Peintre du Roi*, Chartres, 1913,
DURAMEAU, Louis Jean Jacques (1773–1797)
 Entry in catalogue *De David à Delacroix*, pp 404-7.
FRAGONARD, Jean-Honoré (1732–1806)
 Guimbaud, L. *Saint-Non et Fragonard*, Paris, 1928.
 Mandel, G. et Wildenstein, D. *L'Opera completa di Fragonard*, Milan, 1972
 Portalis, Baron R. *Fragonard, sa vie et son oeuvre*, Paris, 1889.
 Wakefield, D. *Fragonard*, London, 1976.
 Wildenstein, G. *Fragonard*, London, 1960
GALLOCHE, Louis (1670–1761)
 Saunier, C. 'Galloche' *Les peintres français du XVIII siècle*, Vol. I.
GILLOT, Claude (1673–1722)
 Dacier, E. 'Gillot', *Les peintres français du XVIII siècle*, Vol. I.
 Jamot, P. 'Gillot and Watteau', *Burlington Magazine*, September 1923.
GREUZE, Jean-Baptiste (1725–1805)
 Brookner, A. *Greuze. The rise and fall of an eighteenth-century phenomenon*, London, 1972.
 Hautecoeur, L. *Greuze*, Paris, 1913.
 Munhall, E. 'Greuze and the Protestant Spirit', *Art Quarterly*, Vol. XVII, 1964.
 Seznec, J. 'Diderot et l'Affaire Greuze', *G.B.A.*, 1966.
GRIMOU, Alexis (1678–1733)
 Réau, L. 'Grimou', *Les peintres français du XVIII siècle*, Vol. II.
HALLE, Noel (1711–1781)
 Estournet, O. *La famille des Hallé*, Réunion des Sociétés des Beaux-Arts des Départements, 1905, pp. 71–236.
HOIN, Claude (1750–1817)
 Exhibition catalogue: Musée des Beaux-Arts de Dijon, 1963.
 Portalis, Baron R. 'Claude Hoin' [three articles] *G.B.A.*, 1899, 1900.
JEAURAT, Etienne (1699–1789)
 Wescher, P. 'Etienne Jeaurat and the French Eighteenth-Century "Genre de Moeurs"', *Art Quarterly*, Summer 1969.
JOUVENET, Jean (1644–1717)
 Schnapper, A. *Jean Jouvenet et la peinture d'histoire à Paris*, Paris, 1974.
LABILLE-GUIARD, Mme. A. (1749–1803)
 Passez, A.-M. *Adélaide Labille-Guiard*, Paris, 1973.

LA FOSSE, Charles de (1636–1716)
Stuffman, M. 'Charles de La Fosse et sa position dans la peinture française à la fin du XVII siècle', *G.B.A.*, 1964.

LAGRENEE, Louis Jean François (1725–1805)
Sandoz, M. 'Louis-Jean-François Lagrenée, dit l'aîné (1725–1805), peintre d'histoire', *B.S.H.A.F.*, 1961.

LALLEMAND, Jean-Baptiste (*c.* 1710–*c.* 1805)
Exhibition catalogue *J. B. Lallemand, paysagiste dijonnais du XVIII siècle*, Musée de Dijon, 1954.

LANCRET, Nicholas (1690–1743)
Wildenstein, G. *Lancret*, Paris, 1924.

LARGILLIERRE, Nicolas de (1656–1746)
Lastic Saint-Jal, G. de 'Nicolas de Largillierre, peintre de natures mortes', *La Revue du Louvre*, 1968.
Maison, F. and Rosenberg, P. 'Largilliere Peintre d'histoire et paysagiste', *La Revue du Louvre*, No. 2, 1973.
Pascal, G. *Largillierre*, Paris, 1928.

LA TOUR, Maurice Quentin de (1704–1788)
Barrès, M. 'Une Journée chez Maurice de la Tour', *Trois Stations de Psychothérapie*, Paris, 1891.
Bury, A. *Maurice Quentin de La Tour*, London, 1971.
Besnard, A. *La Tour*, Paris, 1928.
Saint-Quentin. *Catalogue de la Collection M.Q. De La Tour* (par E. Fleury and Gaston Brière), Saint-Quentin, 1954.

LEMOINE, François (1688–1737)
Saunier, C. 'Lemoine', *Les peintres français du XVIII siècle*, Vol. I.
Nonnotte, D. 'Vie de François Lemoine', *Société des Beaux-Arts des Départements*, 1912.

LEPICIE, Nicolas Bernard (1735–1784)
Gaston Dreyfus, P. 'Catalogue raisonné de l'oeuvre de Nicolas Bernard Lépicié', *B.S.H.A.F.*, 1922, pp. 135–283.

LE PRINCE, Jean Baptiste (1734–1781)
Hédou, J. *Jean Le Prince et son oeuvre*, Paris, 1879.

LOUTHERBOURG, Philippe-Jacques de (1740–1812)
Exhibition catalogue: *Philippe Jacques de Loutherbourg, R.A. 1740–1812*, Kenwood House, London, 1973.

MERCIER, Philippe (1689–1760)
Exhibition catalogue: *Ph. Mercier*, City Art Gallery York and Kenwood House, 1969.

MOREAU, Louis Gabriel (1740–1806)
Wildenstein, G. *Moreau*, Paris, 1923.

NATOIRE, Charles Joseph (1700–1777)
Boyer, F. 'Catalogue raisonné de l'oeuvre de Charles Natoire, peintre du roi (1700–1777)', *Archives de l'Art Français*, 1949.
Exhibition catalogue *Charles-Joseph Natoire*, Troyes, Nîmes, Rome, 1977.

NATTIER, Jean-Marc (1685–1766)
Nolhac, P. de. *J.-M. Nattier*, Paris, 1925.

OPPENORD, Gilles-Marie (1672–1742)
Huard, G. 'Oppenord', *Les peintres français du XVIII siècle*, Vol. I.

OUDRY, Jean-Baptiste (1686–1755)
Opperman, H. N. *Jean-Baptiste Oudry*, New York and London, 1977 (2 vols).

PATER, Jean-Baptiste (1695–1736)
Ingersoll-Smouse, F. *Pater, biographie et catalogue critiques*, Paris, 1921.

PERRONNEAU, Jean-Baptiste (1715–1783)
P. Ratouis de Limay. *J.-B. Perronneau (1715–1783), Sa vie et son oeuvre*, Paris et Bruxelles, 1923.

PESNE, Antoine (1683–1757)
Antoine Pesne. Beiträgen von Ekhart Berckenhagen, Pierre du Colombier etc., Berlin, 1958.

PIERRE, Jean-Baptiste-Marie (1713–1789)
Seznec, J. 'Diderot et les Plagiats de Monsieur Pierre', *La Revue des Arts*, V. 1955.
Halbout, M. 'Trois oeuvres de J.-B.-M. Pierre dans les musées de province', *La Revue du Louvre*, 1973, No. 4–5.

PILLEMENT, Jean-Baptiste (1728–1808)
Pillement, G. *Jean-Baptiste Pillement*, Paris, 1928.
Mitchell, P. 'Jean Pillement Revalued', *Apollo*, January 1983.

RESTOUT, Jean (1692–1768)
Exhibition catalogue. *Jean Restout*, Musée des Beaux-Arts de Rouen, 1970.

RIGAUD, Hyacinthe (1659–1743)
A. Blunt, *Art and Architecture in France 1500–1700*, pp. 398–402.

ROBERT, Hubert (1733–1808)
Gailleux Gallery, Paris. Exhibition catalogue: *Hubert Robert*, 1980
Gabillot, C. *Hubert Robert et son temps*, Paris, 1895.
Réau, L. 'Hubert Robert, peintre de Paris', *B.S.H.A.F.*, 1927, pp. 207–28.

ROSLIN, Alexandre (1718–1793)
Lespinasse, P. 'Le portraitiste Roslin et les artistes suédois en France', *B.S.H.A.F.*, 1926, 1927.

SAINT-AUBIN, Gabriel de (1724–1780)
Dacier, E. *Gabriel de St. Aubin, peintre, dessinateur et graveur*, Paris, 1929–31 (2 vols).

SUBLEYRAS, Pierre (1699–1749)
Arnaud, O. 'Subleyras', *Les peintres français du XVIII siècle*, Vol. II.

TOCQUE, Louis (1696–1772)
Doria, A. *Louis Tocqué*, Paris, 1929.

TOURNIERES, Robert (1688–1752)
Bataille, Mlle. 'Tournières', *Les peintres français du XVIII siècle*, Vol. I.

TROY, Jean François de (1679–1752)
Brière, G. 'De Troy', *Les peintres français du XVIII siècle*, Vol. II.
Dilke, E. 'J. F. de Troy et sa rivalité avec François le Moyne', *G.B.A.*, 1899.

VALLAYER-COSTER, Anne (1744–1818)
Roland-Michel, M. *Anne Vallayer-Coster*, Paris, 1970.

VERNET, Claude-Joseph (1714–1789)
Exhibition Catalogue *Claude-Joseph Vernet 1714–1789*, Kenwood House, London, 1976.
Ingersoll-Smouse, F. *Joseph Vernet, peintre de marine*, Paris, 1926 (2 vols).
Lagrange, L. *Joseph Vernet et la peinture au XVIII siècle*, Paris, 1864.

VIEN, Joseph-Marie (1716–1809)
Aubert, F, 'Joseph Marie Vien', (five articles) *G.B.A.*, 1867.

VINCENT, François-André (1746–1816)
Lemonnier, H. 'Notes sur le peintre Vincent', *G.B.A.*, 1904.

WATTEAU, Antoine (1684–1721)
Adhémar, H. *Watteau*, Paris, 1950.
Brookner, A. *Watteau*, London, 1965.
Réau, L. 'Watteau' *Les peintres français du XVIII siècle*, Vol. II.

Index